ÉIRE|LAND

Edited by Vera Kreilkamp

McMULLEN MUSEUM OF ART
BOSTON COLLEGE

Distributed by the University of Chicago Press

This publication is issued in conjunction with the exhibition *Éire/Land*, organized by the Charles S. and Isabella V. McMullen Museum of Art, Boston College.

Principal Curator, Alston Conley.
Co-curators: Pamela Berger, Lisabeth Buchelt, Vera Kreilkamp, Katherine Nahum, Nancy Netzer.

February 2—May 19, 2003

This exhibition and catalogue are underwritten by Boston College with an indemnity from the Federal Council on the Arts and the Humanities and additional support from the following:

SPONSORS
Patrons of the McMullen Museum

BENEFACTORS

Cultural Relations Committee
Department of Arts, Sports, and Tourism, Ireland

Cynthia Livingston

SUPPORTERS
James Dalsimer
Nancy and Steven Fischman

Transport provided by:

Aer Lingus ☘

Massachusetts Cultural Council

Library of Congress Control Number 2002112026
ISBN 1–892850–05–2

Distributed by the University of Chicago Press

Exhibition and Publication Coordination by Naomi Blumberg and Bethany Waywell

Copyediting by Naomi Blumberg, Anne Hanrahan, and John McCoy

Designer: Keith Ake
Art Director: Andrew Capitos
Office of Marketing Communications
Boston College
OMC #2172

Printed by Reynolds•Dewalt, Inc.
New Bedford, Massachusetts

Cover: James O'Connor
Pleasure Grounds, Ballinrobe, c.1818
oil on canvas, 16" x 28"
Courtesy of the National Gallery of Ireland

Back Cover: Jack B. Yeats
Farewell to Mayo, 1929
oil on canvas, 24" x 36"
Friends of Boston College

Photo Credits: Veronica Nicholson (nos. 68, 69), Jeff Baird (nos. 84, 85, 86, 87, 88, 89), Joseph Painter (nos. 70, 75, 76), Dana Salvo (nos. nos. 81, 82), David Caras (nos. 64, 65, 77, 78, 79), Gary Gilbert (nos. 8, 34, 35, 47, 49, 53, 83), Stephen Vedder (nos. 3, 11, 27, 39–46, 63, 66, 67, 90, 91, 92, 93, 94) , Susan Byrne Photography (no. 82), Kevin Ryan (nos. 56, 57), Jack Pottle/Esto (nos. 96, 97), British Library Board (nos. 1, 2, 7).

Table of Contents

◇

Editor's Dedication:
Adele Dalsimer, 1939–2000

Vera Kreilkamp

ADELE DALSIMER arrived at Boston College's English Department in the late 1960s, with a Yale doctorate on William Butler Yeats but without a single Irish ancestor. She soon realized that although most of her students were the children, grandchildren, or great-grand-children of immigrants from Ireland, works by Yeats, James Joyce, and George Bernard Shaw were taught only in the context of English literature courses. Characteristically, Adele moved rapidly into action. Within a decade, she and historian Kevin O'Neill had shaped America's most innovative Irish Studies program, bringing virtually every major Irish scholar and creative writer to lecture or teach at the university. Today Boston College attracts American and international students to a rich offering of courses and programs in Irish literature, history, music, dance, and visual art.[1]

In the last decade of her life, as Professor of English and Co-director of the Irish Studies Program, Adele shifted her scholarly focus from literary studies to the arts.[2] Working closely with colleagues in Irish Studies, Fine Arts, and the McMullen Museum, she helped introduce Boston audiences to Ireland's visual heritage and began the process of integrating works of art into the teaching of Irish history and culture.[3] Her first major achievement in this new endeavor was to conceive and edit an innovative collection of interdisciplinary essays, *Visualizing Ireland: National Identity and the Pictorial Tradition* (1993), published to accompany an exhibition of watercolors from the National Gallery of Ireland at Boston College's museum. Although she had already been diagnosed with a serious illness, Adele next directed her indefatigable energy into another project; I had the privilege of working closely with her as we co-curated and co-edited an interdisciplinary catalogue of *America's Eye: Irish Painting from the Collection of Brian P. Burns* (1996). That exhibition and catalogue subsequently traveled from Chestnut Hill to Dublin (1996), to New Haven (1997), and to Washington, D.C. (2000)[4], bringing work accomplished at Boston College into a widening public realm.

After traveling in Northern Ireland and the Republic, visiting galleries, museums, and young artists in their studios, Adele and I co-authored a series of essays on contemporary women artists, including one for the catalogue of McMullen Museum's exhibition, *Re/Dressing Cathleen: Contemporary Works from Irish Women Artists* (1997). During these years of sustained achievement, Mount Holyoke College, the University of Ulster, and the National University of Ireland awarded her honorary degrees. In the last year of her life, she was planning to bring yet another art exhibition to Boston College.

Éire/Land opens just three years after Adele Dalsimer's death. She would be gratified to see how a germinating idea—to display contemporary paintings from the Ballinglen Arts Foundation in County Mayo—has evolved into a wide-ranging examination of representations of the Irish landscape. *Éire/Land* is the most conceptually ambitious installation of Irish art yet attempted at Boston College, both in the chronological sweep of the objects it exhibits and the interdisciplinary imperatives it placed on contributors to this catalogue. The exhibition exists as a fitting reminder of Adele's com-

mitment to collaborative scholarship within the university, a commitment she exemplified in her own teaching career through a series of now legendary courses on Irish literature and history she taught with Kevin O'Neill.

For almost two years a group of Boston College academics—art historians, literary scholars, and social and political historians—worked together to shape this project. Gathering to preview slides of visual objects, they shared perceptions about the relationship of these images to Ireland's social, political, and cultural history. A developing conceptual focus on Irish land and landscape motivated some participants to venture far afield from their disciplinary homes. In this richly collaborative process, contributors exchanged bibliographies, shared drafts of each other's essays, and committed themselves to the rigorous demands of interdisciplinary scholarship. As the broad scope of the project defined itself, scholars from outside Boston College—Síghle Bhreathnach-Lynch from the National Gallery of Ireland; Michelle Brown from the British Library; and Perry Curtis, emeritus professor from Brown University; as well as visiting Professor Claire Connolly from Cardiff University—were invited to contribute their special expertise to the catalogue.

The objects exhibited in *Éire/Land* include archeological artifacts; late nineteenth-century revivalist reproductions of such artifacts; maps from colonial land surveys; eighteenth-, nineteenth-, and twentieth-century landscape paintings; and contemporary video and installation works. Viewed in the historical contexts provided by the catalogue's commentary, these objects invoke the various interactions between nature and man that transformed Ireland's land into a political, social, and aesthetic landscape—now etched with markers of a nation's cultural memory. As contributors worked together and the scope of their concerns broadened, it became increasingly clear that the catalogue might serve not only as an accompanying guide for this exhibition, but could continue to be useful in a larger pedagogical context. During the semester in which *Éire/Land* is exhibited in the McMullen Museum, the publication will serve as a textbook for a newly conceived academic course on Irish land and landscape, jointly taught by a historian, literary scholar, and art historian. Such use encourages me to think of this volume as another enduring material artifact, fulfilling the interdisciplinary and collaborative vision so central to Adele Dalsimer's vision of Irish Studies and the visual arts at Boston College.

I thank all contributors for their steady commitment to this project in the years of its conception and completion. I am especially grateful for Robin Lydenberg's intelligent advice and her willingness to serve as an additional reader of manuscripts. At the McMullen Museum, Publications Coordinator Naomi Blumberg, as well as Intern Anne Hanrahan, provided essential assistance, as did Director Nancy Netzer, in her encouragement and support. ❖

ENDNOTES

1 Undergraduates at Boston College today may minor in Irish Studies; MA students can earn degrees in Irish history or literature and culture; recipients of the Ph.D. degree in history and English who have concentrated on Ireland now teach in American, Canadian, and Irish universities. Each academic year, a major Irish academic joins the Program to teach and do research as the Burns Scholar. Both undergraduate and graduate students participate in a wide-range of study abroad opportunities in Ireland: in intensive Irish language courses through University College, Galway; in a summer drama workshop through the Abbey Theater; and in general undergraduate programs in every major Irish university. Each summer, the Gaelic Roots Program attracts American and international students to study Irish music and dance. The Irish Collection at the John J. Burns Library at Boston College offers rich archival support for members of the Irish Studies Program and a larger public, as does the Irish Music Archive.

2 By this date, she had published many articles on nineteenth- and twentieth- century Irish poetry, drama, and fiction, as well as *The Unappeasable Shadow: Shelley's Influence on Yeats* (1988) and *Kate O'Brien: A Critical Study* (1990).

3 In the last decade, collaborative work between the McMullen Museum and the Irish Studies Program brought five exhibitions of Irish art to the campus and to the Boston community: *Irish Watercolors and Drawings from the National Gallery of Ireland*, Fall 1993; *America's Eye: the Irish Art of Brian Burns*, Spring 1996; *Redressing Cathleen: Contemporary Works by Irish Women Artists*, Fall 1997; *Irish Delftware*, Summer, 1998; *Irish Art Now: From the Poetic to the Political*, Fall 1999.

4 Versions of *America's Eye* appeared at the Hugh Lane Municipal Gallery of Modern Art, at Yale University's Mellon Center for British Art, and at the Kennedy Center of Performing Arts in Washington, D.C.

Director's Preface

Nancy Netzer

◇

ÉIRE/LAND is the most complex and wide-ranging undertaking in the museum's commitment to introduce Ireland's rich visual culture to American audiences. Irish manuscripts, sculpture, and metalwork of the early medieval period have long belonged within the canon of art history taught at North American universities, but the nation's later art—of the eighteenth-, nineteenth-, and twentieth-centuries—has only recently been included in the academic curriculum. Such a broadening of the canon at this University has developed largely through interdisciplinary collaborations, occurring in the last decade as Boston College's Irish Studies Program worked with the McMullen Museum to produce several exhibitions of Irish art.

Planning for *Éire/Land* was initiated by Alston Conley's interest in examining contemporary depictions of County Mayo's contested landscape. Influenced by Vera Kreilkamp's conviction that any consideration of land and landscape in Ireland had a centuries-long story to tell, a more expansive vision of the exhibition took shape. An inter-disciplinary group of scholars, including literary critics and social and political historians, began to meet with art historians to identify the objects that would best chart a visual narrative of Ireland's land. Working together, this group determined that the exhibition should include some of Ireland's finest eighteenth- and nineteenth-century landscape paintings as well as early manuscripts, maps, political cartoons about the Land War, and replicas of nineteenth-century archaeological discoveries produced by cultural revivalists.

Contributors to this catalogue became deeply involved in the planning of *Éire/Land*, and their essays reflect a range of questions that arose in their discussions: for example, what does it mean to make art in a landscape whose ground has been contested for centuries; to what extent do individual works of art produced within such a context reflect Ireland's layered political, economic, and social history; how did cultural revivalists deploy the country's rich medieval art tradition for their own needs; how can we explain an enduring cultural iconicization of the nation's western landscape; how do contemporary Irish artists living in a global community respond to landscape traditions reflecting a more inward-looking nation?

The entire undertaking of exhibition and catalogue could not have been achieved without the tireless work of the curators and museum staff. Principal exhibition curator Alston Conley worked with co-curators— Pamela Berger, Lisabeth Buchelt, Vera Kreilkamp, Katherine Nahum, and myself— seeking out a range of works for inclusion. The curators were aided in identifying contemporary artists by Peter Maxwell and Margo Dolan, founding directors of Mayo's Ballinglen Arts Foundation that provides artists with fellowships to work in Ireland's dramatic western settings. Professor Vera Kreilkamp, who edited this catalogue and worked closely with its writers, brought literary and critical skills, as well as her deep knowledge of the history and culture of Ireland. All contributors to this volume—Pamela Berger, Síghle Bhreathnach-Lynch, Michelle Brown, Lisabeth Buchelt, Alston Conley,

Claire Connolly, Kate Costello-Sullivan, L. Perry Curtis, Robin Fleming, Marjorie Howes, Vera Kreilkamp, Robin Lydenberg, Katherine Nahum, Kevin O'Neill, Margaret Preston, and Robert Savage—chart different avenues of inquiry into Ireland's visual culture. Our debt to each of them is great, and we thank them for participating in this demanding collaborative project. We are grateful also to Seamus Heaney for allowing us to publish his poem in this volume.

Other members of the University's faculty, especially Thomas Hachey (Director of the Center for Irish Programs), Seamus Connolly (Music), Phil O'Leary (English), John Michalczyk (Fine Arts), Robert O'Neill, John Atteberry, and Mark Esser (Burns Library) contributed their expertise to the conception of this project and its accompanying programs. Robert Savage arranged a full series of lectures and films to further explicate the issues examined in the exhibition. The circle of those involved in the exhibition has extended in numerous directions and drawn on the expertise and generosity of many beyond our campus. Special thanks are due Cormac O'Malley, Stephen and Bessie Seiler, Diana Edwards Murnaghan, Brian and Eileen Burns, Peter Nahum, Eric Aho, Mary Armstrong, Sidney Druckman, Brian Tolle, Brian Clyne, Cheryl Warrick, Michael Yeats, Linda Mahoney, Catherine Kernan, Barbara Millen, Michael Kulp, Cynthia Knott, Anne Neely, Gwen O'Dowd, Deirdre O'Mahony, Wendy Prellwitz, Jane Proctor, Cynthia Back, Gordon Loos, David Brewster, Julia Neuberger,

Adam Crescenzi, Henry Barry, C. Michael Daley, Nancy Joyce, Virginia Oliver, Janice Fox, Kevin and Martina O'Toole, Jennifer and Mark Brock, Tim Gardner, Peter Brooke, Anthony Mourek, Dorothy Cross, Janet Murnaghan, Jane Goldman, Kathy Herbert, Sheila Murnaghan, Susan Shatter, Ray Roberts, Stuart Shils, Donald Teskey, Niamh Whitfield, Heidi Lange (DC Moore Gallery); Penelope Fussell (Drapers' Company); Brid McCarthy (Kerlin Gallery); Peter Murray and Anne O'Connor (Crawford Municipal Art Gallery); Barbara Dawson (Hugh Lane Municipal Gallery of Modern Art); Josephine Kelleher (Rubicon Gallery); Peter Barnet, Charles Little, Christine Brennan, Barbara Boehm, Julien Chapuis, Frances Wallace, and Nestor Montilla (Metropolitan Museum of Art); Meg Wilson (Gallery Naga); Anne Donaghy (Fidelity Investments); Michelle Brown, Barbara O'Connor, and Greg Buzwell (British Library); Raymond Keaveney, Síghle Bhreathnach-Lynch, Sergio Benedetti, and Marie McFeeley (National Gallery of Ireland); Daniel Lee (University of Chicago Press), Patrick O'Connell and Evelyne O'Halloran (Aer Lingus).

The staff of the McMullen Museum and others from across the University have been deeply involved at various stages with this project. In particular, Alston Conley designed the installation to provide a virtual walk through the Irish landscape; our exhibition coordinator Naomi Blumberg, and before her Thea Keith-Lucas, and graduate assistants Bethany Waywell and Lisabeth Buchelt

played an invaluable role in the editing and production of the catalogue and in the exhibition's overall organization. Museum Assistant/Registrar John McCoy aided with loans and designed the exhibition's wall text and web site, and our administrative assistant, Helen Swartz coordinated efforts for the opening. We are grateful as well to Stephen Vedder, Gary Gilbert, Lee Pellegrini, and David Corkum for photography, to Anne Hanrahan for proofreading text and drafting labels, to Michael Prinn and Sean Donaghey for arranging insurance, to Rosanne Pellegrini for publicity, and to the members of our Development office, especially Mary Lou Crane, Gemma Dorsey, Lisa Hastings, Marianne Lord, and Maria Mick-Mayer, who aided our funding efforts. In designing the catalogue Keith Ake, under the guidance of Andrew Capitos and Ben Birnbaum of the Office of Marketing Communications, has created an icon of Irish landscape in itself.

Such an ambitious project could not have been attempted were it not for the generosity of the administration of Boston College. We especially thank president William P. Leahy, S.J., trustees John M. Connors and Peter Lynch, academic vice-president John J. Neuhauser, associate dean of faculties Patricia DeLeeuw, and dean of arts and sciences Joseph Quinn. The Federal Council on the Arts and Humanities provided an indemnity for the foreign loans. The Patrons of the McMullen Museum chaired by C. Michael Daley served as Sponsors for this exhibition with contributions from Exhibition Benefac-

tors, Cynthia Livingston and the Cultural Relations Committee of Ireland, and Exhibition Supporters, James S. Dalsimer and Nancy and Steven Fischman. Transport was provided by Aer Lingus.

Finally, we wish to thank an esteemed colleague, the late Professor Adele Dalsimer, who worked with us on previous exhibitions and publications that charted the course for this type of interdisciplinary inquiry of Irish art within American museums. In dedicating the volume to her we hope that it will serve as a lasting tribute to her contribution to this Museum and to Irish Studies at Boston College. ❖

NANCY NETZER
Director and Professor of Art History

Bogland

- For T. P. Flanagan -

Seamus Heaney

We have no prairies
To slice a big sun at evening—
Everywhere the eye concedes to
Encroaching horizon,

Is wooed into the cyclops' eye
Of a tarn. Our unfenced country
Is bog that keeps crusting
Between the sights of the sun.

They've taken the skeleton
Of the Great Irish Elk
Out of the peat, set it up,
An astounding crate full of air.

Butter sunk under
More than a hundred years
Was recovered salty and white.
The ground itself is kind, black butter

Melting and opening underfoot,
Missing its last definition
By millions of years.
They'll never dig coal here,

Only the waterlogged trunks
Of great firs, soft as pulp.
Our pioneers keep striking
Inwards and downwards,

Every layer they strip
Seems camped on before.
The bogholes might be Atlantic seepage.
The wet centre is bottomless.

Opened Ground: Poems 1966–1996
Faber and Faber, 1998.

Introduction:
Toward a History of the Irish Landscape

Marjorie Howes and Kevin O'Neill

BOTH THE EXHIBITION AND THE CATALOGUE *ÉIRE/LAND* HAVE BEEN SHAPED TO EXPLORE THE EXTRAORDINARY CENTRALITY OF THE LAND TO IRELAND'S VISUAL CULTURE—AND TO DEMONSTRATE HOW THAT CULTURE IS DEEPLY INTERTWINED WITH THE COUNTRY'S INTELLECTUAL AND MATERIAL LIFE. INCLUDING AND JUXTAPOSING works of art of various types, *Éire/Land* examines their significance within interrelated social, economic, political, and cultural historical narratives. In order to engage with the complex layering of such histories on the land, the curators of the exhibition have included not only major eighteenth-, nineteenth-, and twentieth-century painting of Ireland's iconicized landscape, but other works such as maps, archaeological artifacts, manuscripts, and political cartoons that have not ordinarily been displayed with such landscape paintings. Viewed together, such images begin to suggest the varied and complex historical interactions between an Irish people and their landscape. In keeping with *Éire/Land*'s juxtaposition of different visual narratives, the essays collected in this catalogue draw on various disciplines— art history, literary criticism, folklore, and history. In combining such a diverse range of objects and modes of analysis, the organizers have sought to be suggestive rather than exhaustive, to raise questions rather than to impose conclusive interpretations. There are many ways to map these objects, many possible narratives about them.

This introduction seeks to situate the works on exhibit and the commentaries collected here in various historical contexts, in order to help viewers and readers construct such narratives and maps. In so doing, we will be sketching a set of interrelated histories. Several broadly economic histories are at work here: an economic and ecological account of human interaction with the landscape, as well as an economic and social narrative tracing the demise of communal forms of ownership and the rise of private property. Closely related are political histories of invasion and colonization, of the appropriation and exploitation of land and labor by a land-owning elite, and an account of the various forms of resistance to colonizers and landlords. Finally, we gesture toward several relevant cultural histories: the cultures of imperialism and capitalism, popular culture, consciousness and memory, as well as a history of the emergence and development of cultural nationalism, and of the changing concerns and conventions of high art in painting and literature. Some of these histories—particularly those reflecting the concerns of a political and economic elite—appear vividly and consistently in the works exhibited. Others represent the material and imaginative transformations of the land that the exhibition's visual objects, for one reason or another, reflect indirectly, or not at all—through absence rather than presence. Both are important contexts; what a particular object cannot register is, in many cases,

as much a part of its meaning as that which it renders visible.

This introduction also further broadens the diversity of materials on display by including a brief example from poetry—yet another discourse that has a rich history of engaging with the Irish land. Seamus Heaney's "Bogland"— dedicated to T. P. Flanagan, an Irish landscape painter—illustrates some of the central preoccupations of the artists in the exhibition and the contributors to this volume. The poem compares two ways of thinking about land and its relation to human history. One conceives the land as empty, wild space, waiting for the forces of civilization to tame it and transform it; this conception belongs to the history of the American frontier and its pioneers. The other belongs to the Irish, who "have no prairies / to slice a big sun at evening." The grand vistas of the American plains fostered fantasies of limitless power and expansion. Like many Western conquerors of foreign lands, early American settlers reveled in the sense that they were "masters of all they surveyed," a phrase that equated territorial acquisition with visual mastery. In Heaney's Irish landscape, by contrast, looking brings constraint and danger rather than mastery, and the viewer is forced to submit to the land: "Everywhere the eye concedes to / Encroaching horizon, / Is wooed into the cyclops' eye / Of a tarn." Heaney repeats the singular "eye" to emphasize its connections to "I," to emphasize that how we see makes us who we are.

The Irish frontier—"our unfenced country"—is a "bog that keeps crusting / Between the sights of the sun." And, rather than expanding outwards to conquer new virgin territories, "Our pioneers keep striking / Inwards and downwards, / Every layer they strip / Seems camped on before." For Heaney, the Irish land was never empty; it is saturated with layer upon layer of human history. Moreover, this history is not made up of reliable facts, events, or narratives; it is not finished or located securely in the past. Rather, it is embodied by the soft, shifting, ill-defined contours of the bog itself, a history whose uncertainties, present implications, and potential dangers are infinite: "The bogholes might be Atlantic seepage. / The wet centre is bottomless." Striking inwards and downwards, Heaney's Irish pioneers confront the wildernesses of the self and of history.

"Bogland" suggests that Ireland and the United States view land differently, and that this difference involves disparate kinds of visual imagination, historical awareness, and political tradition. But Heaney's engagement with the land makes a further point: he also prompts us to re-think what terms such as "land," "place," or "geography" mean. Most cultural traditions about land associate it with permanence, stability, home, and the local. In contrast, "Bogland" describes a landscape in which these features are overwhelmed by other, contradictory elements—instability, movement, and transnational connection. The bog preserves things, like the elk's skeleton or butter, and this capacity gives it an attractive, supportive aspect: "The ground itself is kind, black butter." But such preservation does not indicate stability. Instead, the ground is always "Melting and opening underfoot." In addition, this land is not simply local, but rather connected to and penetrated by other, far-off places. The Atlantic seawater that might be in the bogholes forms a conduit— both literal and metaphorical—to other landmasses in the ocean. It gestures toward a conception of geography based on water, rather than on land. Atlantic geographies lack the clear, fixed borders of land-based geographies; instead they emphasize movements and connections among places. If the image of a house could represent the traditional connotations of land, the best figure for an Atlantic geography might be a ship. In "Bogland," Heaney describes a landscape that invites both these competing geographies. In this sense, then, the poem's title describes both a terrain common in Ireland and a clash between incompatible intellectual systems.

Heaney's claim that the land in Ireland is saturated with a troubled history and its continuing effects, his sense that this makes Ireland different from other places, his critical interest in the visual imagination and the act of looking, his unsettling of established cultural meanings of land, and his engagement with different forms of mapping all appear repeatedly in the works on display and in the commentaries collected in this catalogue. In imagining an Irish landscape that is defined in part by water, Heaney also echoes the subject matter chosen by so many of the visual artists who represent ocean beaches, cliffs, seacoasts, and tidal pools.[1] Such works define Irish land

through its borders and its contacts with the land's apparent opposite, the sea. In this sense, like "Bogland," much of *Éire/Land* offers geographies and landscapes that are as much about water as they are about land. For centuries the sea has also represented the traditional means of emigration. Many objects in the exhibition, such as Seán Keating's 1936 painting *Economic Pressure* (no. 36), contemporary works like Kathy Herbert's site-specific installations (nos. 90, 91, and 92), and Fergus Bourke's photograph *Famine Burial Ground/Flight 133 to Boston* (no. 94) underscore the enormous impact that those who left the Irish land have on how that land is imagined. In important respects, such dialectics—land and water, presence and absence—structure this exhibition.

When poets and painters appropriate aspects of the physical landscape and transform them into complex symbols, we often assume that the actual, natural land is simply that—natural—and that the artist's creative imagination lends the landscape its human dimension. Thus for many audiences, the stunning physical aspects of the landscape, such as those Mary Armstrong presents in the *Ceide Cliffs Looking West* (no. 66), are markers of "nature" at its most robust and pristine. For urban viewers, especially urban Americans, the appeal of this alternative or "natural" world is powerful and enduring. But although such a reading accounts for much of the popularity of modern landscape painting, it suppresses various aspects of the land's human dimensions. One is the rich archaeological history buried beneath the surface of the landscape and represented in

the "Digging" section of the exhibit; another is the material history of the land itself. These buried histories that many of the exhibit's more recent works of art do not enable us to see and that others can only imply have shaped the Irish land and the people who inhabit it in powerful and permanent ways. Supplying this history allows us to gain a fuller sense of the complex, almost bottomless, historical layering that characterizes landscape in Ireland.

This material history reveals that, far from being raw or untamed, the rural Ireland we see today is the product of several thousand years of human engagement with the physical environment. Over those years, in concert with climate change, the landscape of Ireland has been transformed beyond all recognition. What we see is neither "wild" nor "natural" but one of the most wrought canvases upon which humans have worked. Just beyond the field of vision of Armstrong's cliffs in Mayo lie the Ceide fields—one of the earliest known human occupations in Europe. Fifty centuries ago, before the pyramids were built, pre-Celtic settlers created the oldest known enclosed landscape in Europe by deforesting the area and moving over one-quarter of a million tons of stone to form the walls that enclosed their fields.

This intervention in the Irish landscape came with a heavy price. The initial deforestation, coupled with the high rainfall in the area and a gradual change in climate, led to a slow but radical transformation in the local ecology. We do not yet know exactly how these forces were related. Possibly heavy rainfall in the area would have inevitably led to bog formation on

this landscape. But it is also possible that human destruction of a forest canopy absorbing much of the moisture before it reached the soil surface greatly accelerated the leaching of minerals—and that this led to the sterile soil conditions that encouraged bog formation. Perhaps the act of deforestation and enclosure of these fields was sufficient on its own to cause radical deterioration of the soil that supported bog development. We will probably never know the exact nature of the relationship between these human and natural interactions. But we do know the result. Like a slow motion Pompeii, this settlement was buried not by molten rock, but by meters of cold, wet, peat bog. There it remained until archeologists from University College, Dublin began to uncover it in the 1960s.

Over the centuries that followed their arrival, Ireland's early settlers moved beyond their coastal enclaves and cleared extensive areas of forest by felling and burning. At first their primary aim was simply to clear land for agricultural purposes, but as their population increased and their material life became more secure and complex, they found in the forest the source of raw materials for numerous activities. Wood was the major building material for every level of early Irish society. It was used for dwellings, boats, tools, utensils, and even the "corduroy roads" that these early people built to cross the boglands and wetlands that were such an important part of their used environment. Most importantly, the forest was both the primary source of fuel during this period, and a major provider of food. The early Irish har-

vested both flora and fauna directly from the woodland, while the ubiquitous pig relied upon it for its forage. Some idea of the utility of the forest and of the diffuse notion of ownership that the peoples of the Celtic age held is provided by a list of entitlements that belonged "in equal right of every condition [of person]":

The night's supply of kindling from every wood.
The cooking material of every wood.
The nutgathering of every wood.
The frame-work of every vehicle, yoke and plough.
Timber of a carriage for a corpse.
The shaft fit for a spear.

A supple hand implement of a stable (an echlach, or horse-rod, used for guiding horses).
The tapering wood of the three parts of a spancel.
The making of hoops (for barrels).
The makings of a churnstaff.
Every wood not subject to treiniugud.
(Nesson 28)

This tract, along with other evidence, suggests that the inhabitants of Ireland did not conceive of the forest, or even its trees, as something liable to private ownership. A king/chieftain might grant the use of a parcel of forest to a member of the *túath*, but he could not alienate ownership of land from the people of the *túath* (Nesson 24–8 and 33–9).[2] This pre-history of a wooded Ireland contrasts strikingly with the landscape that later visual artists recorded, particularly after the massive seventeenth-century plantation clearances. Many of the paintings in this exhibition depict landscapes barren of trees, for only about ten percent of the Irish woodland existing in the mid 1600s remained at the time of the first edition of the Ordnance Survey of 1830–44. Today, despite efforts at reforestation, forests account for only 7% of the land area of Ireland, one of the lowest percentages in Europe (Aalen, Whelan, and Stout 122–3). In *Éire/Land* the relatively few images that frame scenes with trees—such as James O'Connor's *The Pleasure Grounds, Ballinrobe* or *The Eagle's Nest* (nos. 24 and 26) or George Barret's *Extensive Landscape* (no. 22) depict controlled parklands or follow European conventions of landscape painting, rather than representing typical Irish settings.

The works of art in this exhibition suggest that like its ecological history, the landscape's political and cultural histories begin early as well. Visual and other evidence from the periods just before and just after the Norman invasion indicate that long before the rise of modern nationalism, land was central to the material practices and cultural traditions that structured Irish communities. Collective life of all kinds has important material determinants, but it also always has an imaginative dimension. As Robin Fleming illustrates in "Making and Remaking the Irish Landscape in the Early Middle Ages," for example, ringforts were originally part of a particular form of social organization and collective life, and they had important symbolic, as well as practical func-

tions. Later, such features of the landscape would be appropriated by numerous other cultural and political discourses. Fleming's essay and Michelle Brown's "Shaping and Misshaping: Visual Impressions of Ireland in Three Illuminated Manuscripts" identify one such discourse in Gerald of Wales' 1186 description of a barbarous and backward Ireland. This description is belied by the skilled artistry of the artifacts in the "Digging" section of *Éire/Land*; as Fleming and Brown show, Gerald wrote highly fictionalized accounts in the service of extending Angevin control to the island. Like Seamus Heaney, Gerald found that "the soil is soft and watery," but he drew very different conclusions from such observations. Central to his colonizing discourse was an insistence that the Irish landscape was wild, changeless, and immemorial, and a suppression of any evidence that the island's inhabitants had themselves previously wrought changes upon the land.

In "The Art of *Dinnseanchas*: Excavating the Storied Past of Place," Lisabeth Buchelt explores another early discourse that took the land as a starting point for narratives that were, in large part, about something else—the Irish folkloric tradition of *dinnseanchas* or place lore. In reading the landscape through such traditions, communities are of course reading themselves, and Buchelt's essay reveals the complex nature of this endeavor. Her analysis of two sites near Ballycastle—Dún Briste and Poll na Seantoine—demonstrates that these seemingly ancient and "natural" places are, in fact, recent geological developments on the landscape. These sites are

mapped by layer upon layer of disparate narratives that form a living, changing tradition; often these narratives grapple with the disturbing issues and traumas that threaten to disrupt community life.

Invaders and settlers from elsewhere brought new forms and ideologies of land use that were to have an enduring impact on later history—and thus on the visual imagery in this exhibition. Fleming suggests that during the late Celtic period powerful elites were able to gain increasing power over their communities—an argument that helps us to recognize that Celtic Ireland may have been less isolated from wider European developments than has often been claimed. This trend toward elite control of resources was to accelerate its pace with the beginning of Norman settlement in Ireland. The first Norman conquerors carried a radically different ideology of ownership, one that would be in conflict with indigenous notions of the relationship between authority and natural resources for several centuries. Eoin Nesson notes that "In Irish law it was essentially 'the use of' the land that was granted or transferred. It was liable to re-transferal if the status of the custodian altered." And even when ownership was vested in an individual by a king there were restrictions upon the use of both trees and timber. Equally important, "Irish lordship belonged to the political rather than to the economic order of things. It imported authority rather than ownership" (Nesson 33). These aspects of the Irish social and economic order were directly challenged by Norman notions of private property. The

differences between "ownership" and "custodianship" were to serve as the hinge upon which several centuries of economic and political conflict would turn.

With their tools of conquest, the Normans brought the means to exploit Irish forests, seeking to introduce what Nesson calls the "brutal forest laws of England"(39). This English forest law, the "Assizes of the Forest," was promulgated by Henry II in 1184. It established courts and administered law that was separate from the Common law of England, and hence provided the Norman monarch with the means to circumvent important economic rights that the common law vested in the people (The struggle over these rights provides the context for Robin Hood). Frank Mitchell and Michael Ryan describe how the arrival of the Normans in Ireland introduced a new and provocative way of considering the landscape. They

...cut through the country smelling out the better lands like well-trained truffle hounds. The Anglo-Normans...were only interested in land from which they could hope to draw a dividend on their investment.... This was the first occasion on which financial considerations directly impinged on land use in Ireland. (185)

This pivotal moment in Irish economic and social history set in motion a series of financial considerations that would reconstruct the Irish landscape and help create the deforested environments familiar to Ireland's artists.

The transition from custodianship to ownership and the introduction of novel financial projects created imperatives to see the land in new ways, and to produce visual representations of these new ways of seeing, as the "Mapping" section of *Éire/Land* illustrates. Custodians and communities that had occupied the same land for generations did not need maps; owners and invaders did. As Claire Connolly demonstrates in "The Turn to the Map: Cartographic Fictions in Irish Culture," most of the early visual representations that we have of Irish land were drawn for financial reasons. Early seventeenth-century plantation maps, such as *The Map of Moneymore* (no. 3), advertised the advantages of individual plantations among prospective investors and settlers and provided practical guides to the settlers. More ambitious and official maps, such as those provided with Sir William Petty's Down Survey later in the century (no. 6), offered an ambitious effort to measure the resources of the island. The Down Survey maps gave the exact area of every surviving woodland in Ireland, indicating the great value that Irish timber had for English investors. The Ordnance Survey maps of the nineteenth century are a precocious example of national military mapping that were unequalled for detail in the Europe of the period (no. 8). All of these maps were crafted so that the land could be commodified, consumed, and controlled. The victory of these modern notions of property ownership was now complete on the legal and cartographic levels, but at the popular level older notions survived and entered into an often violent dynamic with the new concept of absolute private property.

The institution of landlordism, which was well established by the eighteenth century, depended on this radical concept of private property and on the imperial viewpoint embodied in maps, but it had cultural implications as well. Two images in the "Possessing" section of *Éire/Land* show that landed elites in Ireland did not merely occupy large tracts of land; they also sought to transform the landscapes under their control in order to reflect their ideas of the superior power, wealth, leisure, and civilization of the Ascendancy. As Vera Kreilkamp observes in "Painting Mayo's Landscape: The Big House, the Pleasure Grounds, and the Mills," these aggrandizing projects embody an imperial aesthetic that positions the landlord as the master of all he surveys and values the land for its symbolic as well as its productive value. Such projects were repeated and reinforced in the conventions of the estate portraits that landlords commissioned of their big houses and grounds. In James O'Connor's paintings of Ballinrobe House (nos. 24 and 25), these conventions coexisted uneasily with acknowledgements of the role that middle-class industry and the working poor played in the rural economy. More commonly, eighteenth- and nineteenth-century paintings of landed estates eliminated such intrusions altogether. The aristocratic drive to aestheticize the land had material consequences for the rest of the population as well; constructing impressive vistas and pleasure grounds generated significant social costs for the tenants displaced in the process.

As the most desirable land was effectively mapped and possessed by the powerful and transformed into private property, country estates became symbols of the landholding elites. Meanwhile, the native Irish were increasingly relegated to Ireland's less fertile, less hospitable terrain. But this land did not simply mark the low social status of the native Irish; it also functioned as symbolic and material resource in their struggles for repossession. Irish rebels, certainly absent from landscapes commissioned for aristocratic patrons, often hid in remote, uncultivated areas, exploiting their superior knowledge of that terrain; one colloquial phrase for them was "hillside men." Secret agrarian societies like the Whiteboys of the eighteenth century, as well as the Rockites, Terry Alts, and Molly Maguires of the nineteenth century, were vivid reminders of an alternative notion of landscape—one that did not deny the existence of ownership, but which insisted upon the rights of the occupier. These agrarian groups both provided "rearguard" protection for communal rights in the land and advanced a tenant's notion of moral economy. They resisted evictions, rack-renting, sectarian settlements, and especially tithes, which tenants were required to pay for the support of the Protestant Church of Ireland. Not only did they contest the nature of "legal" landholding, they also attacked the physical manifestation of the new intensive transformation of the land by destroying weirs, dams, and ditches. Most of these groups have been described by historians as backward looking or atavistic, but such terms fail to convey the significance of these popular movements as means of retaining older notions of the landscape and its role in the social order. Not surprisingly, however, their interpretation of the land seldom found its way into the visual arts, and when it did, as in David Wilkie's *The Peep-O Day Boy's Cabin, in the West of Ireland* (1835–6), it emerged in highly romanticized and picturesque genre painting suitable for English middle-class audiences (Cullen 116–27).

These contests over land use took place in an increasingly pressurized social and economic space. After 1750, rising population, tightening links with British markets, and increasingly efficient exploitation by landlords, clergy, and tax collectors foreshadowed the crisis of the mid-nineteenth century. The pre-Famine landscape saw tillage pushed higher and higher on mountainsides, and an increasingly intensive but ecologically dangerous cultivation system evolved in which grain and potato culture were closely linked—the grain feeding the British market and the Irish landlord, the potato feeding the Irish. The catastrophe of the Great Hunger in the mid-nineteenth century, far from being a "natural" disaster, was in many ways a modern environmental crisis in which human interference with plant/pathogen evolution led to ecological disaster. The new Andean crop, the potato, gave Irish producers an opportunity to increase not only the export of food to Britain, but also the profitability of agriculture and the size of the human population. Although the potato was extremely well suited to Irish climate and soils, it was genetically isolated, unable to evolve through sexual propagation in Ireland, and isolated, temporarily, from its natural pathogens. When the increasing

mobility of the nineteenth century brought the fungus *Phytophthora infestans* to Ireland in 1845, the dangers of such ecological roulette came home with a vengeance.

Margaret Preston gives an account of the vulnerabilities of the rural population and the colonial authorities' inadequate response to the disaster in "Visualizing the Famine in County Mayo." The failure of the potato crop, land clearances and evictions by unsympathetic landlords, emigration on an unprecedented scale, and the decline of the Irish language all combined to make the Famine appear in Irish cultural memory as (among other things) a catastrophic deracination—a separation of the inhabitants from their rightful and native land. We can see the writing of that tragedy, still, upon the landscape. The deserted cottages and villages, the famine roads, workhouses, and monuments pay witness to what occurred.[3] The political legacies of the Famine were also important and long lasting. Although scholars disagree over exactly when the various imagined communities in Ireland first assumed the forms we call nationalism, since at least the mid-eighteenth century, Irish people had been incorporating a national dimension into their ideologies of collective life and privileging that dimension over others. But the emergence of a more radical and militant nationalism is easily dated from the end of the Famine.

Yet even before the Famine, few aspects of British rule in Ireland created more severe or more visible social inequalities, or generated as much resentment, than the complex (and sometimes incoherent) set of procedures, prin-ciples, and circumstances that structured land ownership and use. If the Famine radicalized much Irish resistance to British rule, it also solidified the land's position as the central issue at the heart of that resistance. As Robert Savage argues in "'The soil of Ireland for the people of Ireland': The Politics of Land in Irish Visual Imagery 1850–1936," Irish discontent with colonial land policy was a major catalyst in promoting genuinely popular nationalist movements throughout the nineteenth and early-twentieth centuries. These movements often worked to establish a nation made up of individual owner-occupiers of small farms. The political and economic structures of ancient Irish land use, of course, had been quite different. In this sense, Irish nationalism sought to "return" the land to a people who had never owned it in the first place. But this reality did not lessen the land's catalytic function in precipitating political grievances and nationalist emotions. Indeed, the emergence of a new economic nationalism organized around this goal led to one of the most remarkable moments in Irish history. The Land War that began in 1879 and ended in various land purchase acts dismantled a landlord system with origins in those Norman "trufflehounds" of the twelfth century.

As this exhibition demonstrates, the visual arts incorporated the costs and political legacies of the Famine slowly, and the methods of incorporation varied. In "Observing Irish Romantic Landscape Painting," Katherine Nahum suggests that some nineteenth-century Romantic painting represents a sublimated re-sponse to social trauma; thus she reads George M. W. Atkinson's *A Ship at Anchor at Sunset* (no. 29) as a subtle allegory of famine and emigration. Other engagements were more direct. L. Perry Curtis's essay, 'The Land for the People': Post-Famine Images of Eviction," argues that although few paintings contemporary with the Famine represented its effects, by the 1850s, depicting Famine-era eviction scenes became something of a subgenre. *Éire/Land* contains a well-known example, Robert Kelly's 1848 *An Ejectment in Ireland* (no. 27). The dominant artistic conventions and economic pressures of the mid-nineteenth century, however, militated against such subject matter; Preston observes that Kelly's painting was still so unusual and so politically explosive that it provoked discussion in the British House of Commons. But by the late-nineteenth century, as the political and cultural energies forming the Irish Literary Revival coalesced, more artists produced works explicitly criticizing colonial land policy. Curtis illustrates how, by the beginning of the Land War in 1879, political cartoons (nos. 17–20) frequently represented the trauma of eviction in order to foster nationalist sentiments.

Political struggles among Irish nationalists, unionists, and the British were, on some level, always struggles over the territory of Ireland. In these discourses, the land features as far more than a passive prize. Because the political sovereignty of the modern nation-state is generally conceived as authority over a clearly defined geographical area, like Gerald of Wales, many modern political thinkers appropriated the physical features of the landscape

as part of their arguments. For example, nationalists claimed that the island of Ireland itself formed a nation, an integrated, natural whole bounded by the sea. And nationalist literature increasingly read the landscape itself—and particularly the landscape of the West—as a text invoking Irish freedom. As "The West's Asleep," the popular 1843 poem by Thomas Davis, had argued, "That chainless wave and lovely land / Freedom and Nationhood demand." In contrast, unionists and colonialists argued that England's geographical proximity to Ireland made it inevitable that the latter's political destiny would be forever bound up with that of her powerful neighbor. Even landlords who wanted to clear their estates of tenants and replace them with more lucrative grazing operations advanced claims that the land was inherently more suitable for their agendas.

Although some forms of Irish nationalism imagined their struggles as endeavors to recapture the territory of Ireland, and others as efforts to reform ownership and use, neither of these is a sufficient basis for a modern nation or nation-state. This insufficiency is at the heart of the distinction between a state, which can be based solely on territory, and a nation, which cannot. So, historically, virtually all modern nationalisms have set about constructing other bases for their imagined communities as well, such as shared history, ethnicity, language, or culture. In Ireland such efforts had existed since at least the eighteenth century. These attempts at repossession, many of them forms of cultural nationalism, often imagined intimate

links between the land and the other elements of nationhood to which they appealed.

Nineteenth-century Irish cultural nationalists located a distinctive Irish identity and cultural richness primarily in Ireland's past, and sought to base a revival or regeneration of the national culture on that constructed heritage. As Pamela Berger shows in "Sacred Landscapes and Ancient Rituals: Two Watercolors by George Petrie," that well-known nineteenth-century antiquarian pursued this project through his paintings, as well as through his scholarship. In both, she argues, Petrie displays his understanding of what modern scholars call syncretism, a process through which ancient sacred spaces are rededicated to new belief systems. Like the *dinnseanchas* tradition analyzed by Buchelt, Petrie's work illustrates Heaney's conviction that the land contains layer upon layer of historical meaning. Not all efforts to extract Ireland's venerable cultural history from the landscape were so disinterested. Nancy Netzer's "Art/Full Ground: Unearthing National Identity and an Early Medieval 'Golden Age'" examines how George Waterhouse harnessed the nationalist meanings of the hill of Tara in the service of commercial enterprise when he named, or misnamed, an ancient brooch found ten miles from the hill the "Tara brooch" (no. 11) in order to boost its national symbolic value and the marketability of the replicas he produced.

Increasingly, literary and visual nationalists turned to the Irish-speaking western periphery of the island as the source of identity that was the least modern and anglicized, and the most

Celtic. Thomas Davis's earlier emphasis on the West was widely shared at the turn of the century. Both before and after the establishment of the Irish Free State in 1922, the West was a central icon in the Irish pursuit of national self-definition; in this exhibition, the idealization of that region is perhaps most strikingly exemplified by Seán Keating's 1916 *Men of the West* (no. 37). In "Painting the West: The Role of Landscape in Irish Identity," Síghle Bhreathnach-Lynch observes that turn-of-the-century painters imagined a West embodying a rural, Irish speaking, and Catholic identity. For these cultural nationalists the land represented far more than the geographical area to be repossessed; it also embodied a particularly Irish way of life rooted in a particular landscape through agriculture, family history, and inheritance. Its Catholic and Irish-speaking elements were bound to the region through folk traditions, which often privileged specific locales, as well as through popular religious practices in which, despite the disapproval of priests, communities often retained their syncretic devotion to sites like the holy well painted by Petrie in *St. Brigit's Well* (no. 15). In Charles Lamb's *Loch an Mhuilinn* (The Mill Lake) (no. 32), Bhreatnach-Lynch identifies the socially conservative attitudes of the new nation's mainstream Irish politics and culture: a national identity that demanded traditional gender roles and positioned women as passive and pure, as part of nature rather than of an active male political world.

Such forms of national identity were, however, never monolithic. Rather, throughout the history of modern Irish nationalism, they were

complex and variable, the subjects of debate and change. The stated purpose of Young Ireland's publication *The Nation* in the 1840s was "to create and to foster public opinion in Ireland—to make it racy of the soil" (8), a motto that combined a modernizing conception of national public opinion with an archaic devotion to what L. Perry Curtis, following Seamus Deane, describes as the land when it is ideologically constructed as a "natal source." The period of the Literary Revival saw a number of spirited disagreements about whether Irish literature should be national—inward looking and focused on the Irish land—or cosmopolitan. And the vision of individual artists often underwent numerous changes over the course of their careers. Robert Savage's essay traces the various stages of Seán Keating's engagement with Irish national identity: his early portraits of an heroic rural West in *Men of the West* (no. 37), his later disillusionment over the Civil War and the conservatism of the Free State in 1925 in *An Allegory* (fig. 3 page 96), his renewed optimism in 1929 about alternative forms of Irish heroism embodied in the Shannon hydroelectric scheme in *Night Candles are Burnt Out* (fig. 4 page 97), and his further disillusionment with the grim realities of rural life and emigration seven years later in *Economic Pressure* (no. 36).

Keating's efforts to re-define and critique Irish national identity indicate an important aspect of postcolonial Irish visual art and literature. The Irish Free State has become famous for its economic, social, cultural, and political conservatism and stagnation. In the decades following 1922, it pursued national self-definition through economic isolationism, the legislation of Catholic social teachings, and political neutrality during World War II. Such policies revealed a preoccupation with self-sufficiency, promoting the conviction that Ireland should remain separate from other places, and from the international arena generally (Brown 141–70). They involved a geographical imagination that saw the physical space of Ireland as incontrovertibly local and defined by its borders—despite the constitution's territorial claim on the North of Ireland that introduced some complications into such a view. These policies also involved a continued idealization of the West of Ireland, and of rural life on the land, especially the life of the small farmer. Although the real lives of rural inhabitants were often grim, much public and political discourse imagined a life of simple pleasures, traditional values, and self-reliance. Meanwhile, urbanization and emigration continued to erode the rural population, and government officials worried about how to keep people on the land. Much Irish literature and art turned to realism or satire to register the discrepancies between official ideology and the realities of life on the land, proposing alternative versions of the national imaginary. The title of Patrick Kavanagh's 1942 poem, "The Great Hunger," for example, invokes the Famine of nearly a hundred years earlier in order to offer a withering indictment of contemporary rural life as characterized by spiritual, sexual, intellectual, and emotional starvation. His critique is summed up in the opening image of the land as deadening clay: "Clay is the word and clay is the flesh" (1).

After the late 1950s, the Irish landscape and the ways in which the Irish saw that landscape continued to change; increasingly such changes became apparent in the work of visual artists. New economic initiatives paved the way for Ireland's embrace of international investment and trade. More and more, the landscape became a valuable commodity, drawing tourists to the island. The eruption of the Troubles in the 1960s refocused attention on republican nationalism and on the border, spurring new appropriations of land in political discourses, creating new experiences of the landscape for the population, and provoking new forms of art and literature.

In one sense, its massive emigration rates had made Ireland one of the pioneers of globalization long before commentators began using that term to describe the increasing levels of mobility and interconnectedness that structure the contemporary era. But during the last decades of the twentieth century, Irish culture and society confronted a set of forces—transnational, European, global—that were new, or at least newly visible. Although the categories of an older nationalism had been central to Irish political, social, economic, and cultural thinking, these new forces began to erode such centrality. Ireland's membership in the European Union in 1973, the Good Friday Agreement of 1998,[4] and Irish President Mary Robinson's embrace of the Irish diaspora in a speech three years earlier are perhaps the most obvious features of a process with a long history and far-reaching current implications. Never has it been clearer, despite the surviving impulses of

an inward looking nationalism, that no place—not even an island—can remain an island. The geographical landscapes of contemporary Ireland are marked by Ireland's integration into international circuits of travel, trade, and cultural exchange.

In responding to this integration, many of the artists in the "Responding Today" section of *Éire/Land* engage with an explicitly national history, but also insist that the centrality of the nation-state and nationalism continues to erode. Like Heaney, they often imply that to represent the Irish land is to engage with an infinitely layered history; Jane Proctor's *Black Lines* (no. 63) strikingly suggests such historical or geological layering. Contemporary artists also share Heaney's conviction that Irish history is unfinished business, unstable, murky, and, like the bog, potentially dangerous. Seeking to excavate the buried traumas of that history, they create landscapes that record absence and loss as well as presence. Some of the histories outlined in this introduction that are missing from earlier visual representations make their way into contemporary works. Robin Lydenberg's essay, "From Icon to Index: Contemporary Encounters with Irish Landscape," examines how Kathy Herbert, Dorothy Cross, and Brian Tolle invite us to grapple with an Irish past characterized by famine, migration, and the decline of traditional patterns of life (nos. 90–92, 93, and 95–97). By producing works that offer viewers only partial, fragmented traces of what is no longer there in the landscape, all three insist, suggests Lydenberg, on the limits of representation. These artists do

not nostalgically restore in art what has been lost through history. Rather, they enact and participate in change and loss, frequently creating temporary site-specific installations that refute any notion of an aesthetic timelessness. They often reject official nationalist versions of Irish history. Thus, as Lydenberg points out, Cross, Herbert, and Tolle pursue a critique of a traditional nationalist icon—the rural thatched roof stone cottage. They revise the image of the cottage in order to place absence and loss at the center of it. At the same time, they highlight the mediated and subjective nature of artistic production and foreground the act of perception itself; Cross's video *Endarken* offers one innovative example of this trend. These artists emphasize that how we see and how we remember make us who we are.

Such an emphasis on mediation and subjectivity often coexists with a determination to engage the land directly and materially. As Kathleen Costello-Sullivan's "Responding Today: Dis/Location and the Land" and Alston Conley's "Exploring Place and Artistic Practice in Northern Mayo" demonstrate, unlike previous generations, contemporary artists do not pursue this project through the techniques of conventional Realism. Instead, they use materials, methods, and settings that bring them into close contact with the land itself. Such contact takes various forms. As Conley illustrates, artists such as Mary Armstrong and Catherine Kernan produce their paintings outside in the natural setting, seeking to capture the fleeting singularities of a specific site in the natural light produced at a particular time of

day. Others, such as Deirdre O'Mahony, incorporate the material, physical existence of the land itself in their work. O'Mahony's practice of using wooden boards to collect traces of turf and other material from bogs is as complex and symbolic an appropriation of the land as Heaney's. Costello-Sullivan argues that the very concreteness of her engagement with the landscape produces a high degree of abstraction. Seen from the micro-level of such physical traces, O'Mahony's landscapes could be anywhere; as Costello-Sullivan puts it "all discernable specificity of location is lost in the abundant detail they provide" (123).

These techniques, and the preoccupations with the limited and partial nature of perception and representation they imply, are very different from the accurate, masterful point of view we associate with traditional maps. But, as Claire Connolly's essay shows, despite their histories as tools of imperial and capitalist exploitation of the land, maps and mapping have provided important and enabling figures and procedures for contemporary artists as well. Indeed, Connolly argues that "O'Mahony's methods themselves arguably constitute a kind of mapping: like a cartographer, she conceives of a site within a system and works to convey a precise, accurate and textured sense of that place on what is, finally, a flat surface" (27). She also offers an additional reason why cartography might be so appealing to contemporary Irish culture: read "against the grain," and often for what they do not say, maps, too, can inscribe absence and loss. Contemporary visual artists engage in their own versions of syncretism,

taking up old imperialist and nationalist forms and giving them new cultural meanings.

In figuring an Atlantic geography, a locale permeated by seepage from elsewhere, Heaney's "Bogland" inscribes, not merely the archaic, lost forms of the past, but the contemporary, globalizing forms of the present and future. The history of Ireland's transition from that past to that future—and the competing and equally important history of their continuing contemporaneity—is far too long and complicated a story to tell as a narrative in this volume. Indeed, the visual and elastic commentary upon the Irish land provided by the artists in this exhibition may offer a more effective vehicle for conveying its complexities. Fergus Bourke's *Famine Burial Ground/Flight 133 to Boston* (no. 94) shows a single, gnarled tree on a bare, steep hillside; in the sky above it a jet trail is visible. Perhaps better than any words, this image invokes the powerful dynamic that *Éire/Land* was designed to represent: the dynamic that continues to connect, and to distance, the land and the people, the local and the global, absence and presence, past and present. ❖

WORKS CITED

Aalen, F. H. A, Kevin Whelan and Matthew Stout. *Atlas of the Irish Rural Landscape*. Cork: Cork University Press, 1997.

Brown, Terence. *Ireland: A Social and Cultural History 1922-1985*. London: Fontana, 1985. 141-70.

Cullen, Fintan. *Visual Politics: The Representation of Ireland 1750-1930*. Cork: Cork University Press, 1997.

Davis, Thomas. "The West's Asleep." *The Field Day Anthology of Irish Writing*. Vol. 2. Derry: Field Day Publications, 1991. 54.

Deane, Seamus. "Land & Soil: A Territorial Rhetoric." *History Ireland*, Vol. 2 no. 1 (Spring 1994): 31-34.

Kavanagh, Patrick. *The Great Hunger*. Dublin: Cuala Press, 1942.

Mitchell, Frank and Michael Ryan. *Reading the Irish Landscape*. Dublin: Town House, 1997.

The Nation. Dublin. Oct. 15, 1842.

Nesson, Eoin. *A History of Irish Forestry*. Dublin: The Lilliput Press, 1991.

ENDNOTES

1 See, for example, Nathaniel Hone (no. 30), Paul Henry (no. 34), Jack Yeats (nos. 48 and 53), Cynthia Knott (no. 56), Jane Goldman (no. 60), and Donald Teskey (no. 71).

2 The *tuath* was the basic social and political unit in Celtic Ireland.

3 See contemporary depictions by Dorothy Cross and Kathy Herbert (nos. 90-93)

4 The accord established a power-sharing agreement among the Republic of Ireland, Great Britain, and the Northern statelet.

Mapping

The Turn to the Map:
Cartographic Fictions in Irish Culture

Claire Connolly

◇

FROM THE EARLIEST PERIODS, IRELAND'S NATURAL LANDSCAPE HAS BEEN EXPERIENCED, REPRESENTED, AND REMADE IN VISUAL TERMS. MAPS HAVE PLAYED A KEY ROLE IN THIS PROCESS. THEY TRANSLATE LIVED EXPERIENCE OF PLACE INTO ABSTRACT SPACE, SHAPING IN THE PROCESS A SPECIALIZED LANGUAGE THAT HIGHLIGHTS THE relationship between place and representation. Land is mediated via the map in multiple ways; in this respect the science of cartography underscores the prominence of visual codes in all encounters with landscape, whether touristic, artistic, or literary.

The "Responding Today" section of this exhibition gathers together a series of creative replies to an older tradition of landscape art. Although the rich variety of works on display cannot be reduced to any simple critical formula, they demonstrate a shared desire to renegotiate the relationship between artist and land. In particular, several contemporary Irish artists have sought to escape the self-consciously painterly connotations of "landscape." Kathy Herbert's site-specific installations (nos. 90, 91, and 92) and Dorothy Cross's video installation (no. 93) represent the land but reject landscape understood as the formalized aesthetic codes that dictated how nineteenth-century artists perceived their surroundings. Even among the painters in "Responding Today," the images often reject or distort the panoramic vistas of older canvases, offering instead a close-up focus on soil, rocks, moss, weeds, water.

Some of the most intimate instances of such images are Deirdre O'Mahony's *Surface* paintings (nos. 68 and 69), the product of a "direct" encounter with the environment around the Ballinglen Arts Foundation in County Mayo. Describing her methods, O'Mahony recounts how in Ballinglen she reversed the conventional artistic journey; rather than bringing memories of a place back to the studio, she took her materials to the site she wished to represent, thus "allowing the place to direct the structure of the work." She uses elements from the environment as inspiration, material, and method: dipping her paintings into cuts in the bogs and pressing algae from local pools between sheets of paper so that the "trace" it laid down could shape and direct the resulting image. The *Surface* paintings borrow "the intense green" of the algae and layer it "with passages of fine areas of dense brushmarks." Two related pieces by O'Mahony, *Céide 1* and *2*, have imprinted on their surface "maps of the prehistoric settlements of the *Céide* fields" (O'Mahony).

In seeking new ways to structure images of land, O'Mahony may seem to be shaking off the tyranny of maps and other systems that intervene between a place and its representation. Yet, as the *Céide* examples suggest, maps can provide enabling escape routes as well as confining images. Indeed O'Mahony's methods themselves arguably constitute a kind of mapping: like a cartographer, she conceives of

a site within a system and works to convey a precise, accurate, and textured sense of that place on what is, finally, a flat surface.

Catherine Nash, curator of a recent exhibition entitled *Irish Geographies* and herself a geographer, has contrasted what we might call map art to landscape art. Because maps "highlight relationships of power," Nash suggests, they occupy a less romanticized relationship to territory than landscape, "with its iconography of cottages, cloud skies and hills" (6). Although the evidence of this exhibition indicates just how much can still be made of cottages, cloudy skies, and hills, I propose in my essay to develop Nash's sense of map images as innovative and perhaps oppositional, and to explore what the image of the map signifies in contemporary Irish culture.

TURN AWAY

The first recognizably modern maps of Ireland have their origin in colonial conquest, a direct product of Britain's need to survey, know, and thus control its first colony. Given this history, why have so many Irish writers and artists turned to the map as metaphor, or chosen to thematize cartography in a variety of cultural practices? The interest in maps shown by Irish painters, sculptors, poets, dramatists, and novelists has never been stronger. What is the nature of this enduring cultural curiosity about maps and the meanings they generate?

It is helpful here to revisit the history of Irish cartography and to consider some of the older maps shown as part of the exhibition. My concern is chiefly with late seventeenth- and eighteenth-century maps and the beginnings of modern Irish cartography. Modern mapping is rooted in the conflicts that convulsed seventeenth-century Ireland. After Oliver Cromwell's Irish campaign ended in defeat and dispossession for the Gaelic nobility, proper surveys and maps were needed to facilitate the post-conquest forfeiture and reassignment of their lands. This task fell to William Petty, noted political economist and scientist and Physician General in Cromwell's army. His extensive "Down Survey" (1654–59), as it was known, not only provided the practical underpinnings for the Cromwellian confiscations and later Protestant or "new English" settlement, but also formed the basis of a new all-Ireland map and atlas.

Petty's cartographic achievements might well be understood in terms of Benedict Anderson's influential account of colonialism and nationalism. Anderson argues that maps, like censuses and museums, are classificatory systems that operate as technologies of colonial control (163). J. B. Harley, however, the leading theorist of cartography, would have us remember that maps are "thick texts" (52). Maps "speak," Harley argues, and thus may be analyzed for their discursive strategies. Reading the texts of Petty's maps is rewarding in itself and also suggests the rich ambiguity of maps in our contemporary moment.

The map of Mayo on display in *Éire/Land* (no. 6) is taken from the 1732 (second) edition of William Petty's innovative atlas, *Hiberniae Delineateo*, first published in 1685. Essentially a "book of national, provincial and county maps," *Hiberniae Delineateo* was "conventional" in design and execution but startlingly modern in envisaging counties (rather than, say, individual estates) as the primary administrative unit (Andrews, *Shapes of Ireland* 130, 140). These maps were not entirely accurate or consistent: Achill Island, for instance, is present on this map of Mayo but missing from the larger Connaught map.

Some of what is missing yields meaning in itself. Petty's engravers did not adopt the normal practice of spreading what little information was known across the spaces mapped, but rather "always left a sharp edge between densely packed detail and empty space" (Andrews, *Shapes of Ireland* 136). These empty spaces invite interpretation. We can glean a sense of what is missing from Petty's map by contrasting it with the seventeenth-century Mayo map also on display (no. 4). This earlier map features family names of the Gaelic nobility (Costello, Morris) as markers of territory, whereas Petty's atlas, essentially a mapping of a new political order, eliminates such information. Based on the "Down Survey" and thus the post-Cromwellian land forfeitures in which eighty percent of land in Mayo had been lost to Cromwell's soldiers and undertakers, the *Hiberniae Delineateo* can be read—against the grain—as "an atlas of Catholic Ireland" (Andrews, *Shapes of Ireland* 147). To analyze Petty's atlas in this way, however, is to read the map for what it does not say. The force of such readings helped to turn colonial control into nationalist resistance.

A nuanced understanding of the shift from control to resistance may be gleaned from an

Fig. 1: Repeal Association insignia, front page of the *Ordnance Survey of Ireland*, 1837. John J. Burns Library, Boston College.

analysis of the provenance of this exhibition's 1833 Ordnance Survey map of County Meath (no. 8). The Ordnance Survey Office was established in Dublin in 1824 to carry out a survey of the island for land taxation purposes. By 1846, Ireland had been surveyed at a scale of six inches to one mile, making it the first country in the world to be fully mapped in such detail. Topographical and antiquarian information was also recorded and used to facilitate the Anglicization of Irish language place names. This latter feature has caused the Ordnance Survey to be linked in popular memory with the loss of the Irish language and the defeat of a culture, a chain of connections evoked by and embedded in Brian Friel's play *Translations*, discussed below.

The Ordnance map in this exhibition belonged to Daniel O'Connell and his brother John, and the atlas in which it appears bears the insignia of the library of the National Repeal Association. This organization emerged in the wake of the successful campaign for Catholic Emancipation, granted by the British government in 1829 as a result of O'Connell's pioneering use of the machinery of democratic politics. Founding the Repeal Association, O'Connell then targeted the Act of Union, legislation that since 1801 had formally linked Ireland to Britain. Repeal clubs and reading rooms were both location and vehicle for popular nationalist protest; it is within this context that *Éire/Land*'s 1833 Ordnance Survey atlas found a home.

Rather than simply signifying Britain's tight administrative grip on its nearest colony, then, the Ordnance Survey maps, with their county by county format, may well have equipped O'Connell and his followers with the tools for democratic organization. Anderson describes an incipient nationalist consciousness that would come to organize itself around what he calls the "logo-map," or the map that is devoid of "explanatory glosses" but invested with symbolic meaning: the map as "infinitely reproducible...pure sign." "Instantly recognizable, everywhere visible, the logo-map penetrated deep into the popular imagination, forming a powerful emblem for the anticolonial nationalisms being born" (Anderson 175). Although the logo-map does not appear as one of the nationalist symbols (round tower, harp, wolfhound and tree of liberty; fig. 1) displayed on the Repeal Association insignia stamped inside the exhibited atlas, the history and fate of this particular text suggests the potential of the map to become an icon in the Irish imaginary.

The concept of the logo-map allows us to trace a movement from maps such as Petty's to the representation of cartography in contemporary art and culture. In Rita Duffy's painting *The Hound of Ulster* (1996), for example, a map forms the backdrop to a clutter of symbols (fig 2). Bearing only the names of provinces (Ulster, Leinster, an abbreviated Connaught), this is Anderson's logo-map as seen by a Northern Irish artist undoubtedly aware of the demands partition has placed on the cartographical imagination. Ireland here seems to lean away from the viewer, pictured from above as in the "bird's eye" convention of modern cartography. The dog, however,

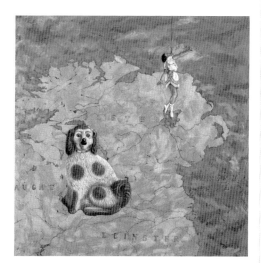

Fig. 2: Rita Duffy, *Hound of Ulster*, 1996, oil, wax, and gesso on linen, 4' x 4'. From *Banquet*, by Rita Duffy (Belfast: Ormeau Baths Gallery, 1997).

Fig. 3: Kathy Prendergast, *Lost*, 1999, compass reworked by the artist, 2 1/2" x 2" x .4". From *Kathy Prendergast: The End and The Beginning*, by Francis McKee (London: Merrell Holberton, 2000).

stares directly out of the painting, creating a disorienting mix of perspectives and scales. At the level of symbol, the painting courts linguistic and iconographic confusion: the "hound" of the title might refer to *Cú Chulainn*, the hero of Irish legend known as the "Hound of Ulster," but the word also verbally echoes "The Red Hand of Ulster," symbol of a defiant Ulster identity. The china dog represented in Duffy's painting appears to favor the former reading, invoking *Cú Chulainn* once more, but also belongs to the parlor. Meanwhile a trapeze artist straight from the circus balances precariously above Ulster's Lough Neagh. Does the painting perhaps figure delicate interpretative or political balancing acts? The role of the bodily and the do-

mestic in national conflicts? Or are such readings too obvious? The power of Duffy's painting lies in its spatial and metaphoric disorder, with the map finally figuring a certain opacity or refusal to conform to any straightforwardly symbolic reading.

As symbols of colonial authority, maps form part of the contested cultural space of twentieth- and twenty-first-century Ireland, on both sides of the border. Duffy's desire to question the symbolic power of cartography echoes the work of Kathy Prendergast, whose drawings, sculptures, and reworked objects present perhaps the most sustained artistic engagement with cartography in contemporary culture. Nash has described Prendergast's "critical, ironic and sometimes humorous approach to traditional Irish landscape art" ("Remapping" 230). Her 1983 *Body Map* series adopted the techniques of engraving and draughtsmanship to produce beautifully detailed surveys that treated bodies as if they were landscape. Later three-dimensional work like *Land* (1991) moved closer still to cartography. Depicting a canvas tent in the shape of a miniature mountain and painted so as to resemble relief markings on maps, the piece matched place to representation. In her description of the sculpture, Nash suggests that "*Land*" appears to give the map's flat surface "volume and height" ("Remapping" 241). Throughout her career, Kathy Prendergast has fully inhabited the world of cartography, getting under the skin of its techniques. Some of her recently exhibited work is entirely absorbed by maps and the meanings they gener-

ate, as in the *Empty Atlas* and reworked compass pictured here (figs. 3 and 4).

Turn Again

Postcolonial critic Edward Said has suggested that Irish writing shares with the cultures of other colonized countries a "cartographic impulse" (79)—a desire to reclaim land and territory that extends beyond a transfer of titles and deeds into the realm of representation, metaphor, and cultural identity. Of course, as Said suggests, ample evidence exists of Irish cultural texts seeking to undo the effects of dispossession or to reclaim psychic territory. But with this psychologized sense of the territorial, relying as it does on a very loosely defined idea of land, also exists a drier and more theoretical interest in the abstract rendering of lived space. Tracing this latter interest through a selection of recent Irish texts, as I propose to do, focuses attention on the map itself as the object of interest. In recent Irish art and literature, maps

Fig 4: Kathy Prendergast, *Map*, 1999. The Times Atlas reworked by the artist; acrylic and paint, 21 3/4" x 15". From *Kathy Prendergast: The End and The Beginning*, by Francis McKee (London: Merrell Holberton, 2000).

are embedded within structures of subjectivity as well as within what Benedict Anderson calls the "grammar" of colonialism (163). They belong, as the following instance should show, to a history that has been experienced at the level of bodies as well as land.

In 1994 Eavan Boland published a poem proposing "That the Science of Cartography is Limited," as part of her collection *In a Time of Violence*. The coolly rational title of the poem imitates the scientific objectivity assumed to characterize cartography. Its opening lines continue with the steady pace of a geometric proposition:

> —and not simply by the fact that this
> shading of forest
> cannot show the fragrance of balsam,
> in the gloom of cypresses
> is what I wish to prove.
> (*In a Time of Violence* 174)

In the following stanzas the poem breaks out of its frame to become a lyric evocation of memory; the poet, young and in love, is travelling west:

> When you and I were first in love we
> drove
> to the borders of Connacht
> and entered a wood there.

As so often in Irish cultural history, the poet's experience of the West transmutes into a troubling encounter with her country's past. The landscape becomes a text that is glossed and explicated for her by her lover, who seeks to show her the meanings of a rocky, ivy covered pathway that ends suddenly: "Look down, you said: this was once a famine road."

A vertiginous descent into history commences, and in another shift of register the tone replicates that of the history lesson: dates, facts, cautiously voiced interpretation. The incomplete road represents the hunger and death experienced in 1847, the worst year of the Great Famine, when relief projects like road building were to assist the starving Irish. The memory of this bodily pain is, in turn, used to indict maps, and the speaker's lyric voice proclaims a passionate rejection of the cold science of cartography:

> and when I take down
> the map of this island, it is never so
> I can say here is
> the masterful, the apt rendering of
>
> the spherical as flat, nor
> an ingenious design which persuades a
> curve
> into a plane,
> but to tell myself again that
>
> the line which says woodland and cries
> hunger
> and gives out among sweet pines and
> cypress,
> and finds no horizon
>
> will not be there. (175)

Boland's poem establishes a powerfully negative view of cartography. It presents a set of oppositions that serve to align the map with colonial authority and not with those oppressed by it, with surface rather than depth, and with inert official codes, not movement or flux. The poet's own body, looking down and leaning away, becomes the vector for the force of memory that challenges the map.

The most obvious antecedent for the poem's deeply felt resentment of cartography is Brian Friel's 1980 play *Translations*, which finds in the history of the Ordnance Survey of Ireland an enabling metaphor for contemporary conditions in Northern Ireland. The play associates cartography with oppression and the violent imposition of alien codes. As a historical drama, *Translations* is rife with anachronistic knowledge of the political future. On stage, characters who dwell in the 1830s are seen to anticipate the arrival of famine in the 1840s and to encounter, more controversially, armed British officers whose later role in Northern Ireland the play adumbrates. *Translations* thus displays an unabashed sense of its own location in the Ireland of 1980; Friel later commented that he could see no harm in "the tiny bruises" that his play "inflicted on history" ("*Translations* and *A Paper Landscape*" 123).

The context for Friel's observation is his dialogue with J. H. Andrews, the distinguished historian of Irish cartography, on whose 1975 history of the Ordnance Survey the playwright drew. Andrews responded to *Translations* first with cautious admiration and later with scholarly puzzlement, noting with some alarm in the early 1990s that "many people do accept Brian Friel's account of the Ord-

nance Survey as historically plausible" ("Notes" 93). Andrews has detailed Friel's slipshod use of cartographic detail, but for my purposes what is perhaps most significant is that in *Translations*, mapping happens off stage. A stray mention of a theodolite aside, the play is concerned with cartography as metaphor, not as practice. Whereas on the one hand *Translations* may be said to have inaugurated the kind of cultural interest in cartography that this essay identifies, on the other the play more properly belongs to what Said would call the "new territoriality" of anti-imperialism, with its "assertions, recoveries, and identifications" (79).

Cartography clearly forms part of *Translations'* contentious claims on public attention, alerting us to a dynamic sense of contest around maps and map metaphors. With such a tension in mind, we might return to Boland and reread her inscription of cartography, this time against the grain. The image of the poet taking down the map and scrutinizing its contours offers an arresting focus on the map as material object. Interrogating her imagined text for what it does not say, Boland conveys both emptiness and a terrible clarity: "the line which says woodland and cries hunger." Here a cartographic marking "says" and "cries" even as its inadequacy is revealed. Accordingly, I would suggest that one value attached to cartography in contemporary culture is its potential to inscribe absence. In Boland's case, absence is surely related to her sense of the missing place of the woman poet in the national tradition, a void so powerfully figured in *Outside History,* the collection that appeared just before *In a Time of Violence.*[1] In her poem, as in Friel's play, the turn to the map matters as much as the dissatisfied turn away.

Wrap it Up

This essay deals with the map as symbol in contemporary Irish culture—especially with attempts to evade its iconic power. Yet an awareness of the frailty of the map also exists in Irish culture, even in contexts where its connection with surveillance and control seem strongest. Ciaran Carson's poem/prose collection *Belfast Confetti* (1989) translates lived city space into cartographic codes. The collection depicts a Belfast that exists as an unreliable map of itself ("the city is a map of the city"). The opening poem, "Turn Again," sets out its wares in the shape of a map that is both tangibly material, yet fragile and insubstantial: "The linen backing is falling apart—The Falls Road hangs by a thread." As in Paul Muldoon's poem, "Christo's," the country is "under wraps"—"'like, as I said, one of your man's landscapes'/'Your man's? You don't mean Christo's?'" (Muldoon 122). Ireland here is secret yet seen, its status as art object conferred by its outline shape. Muldoon's image relates the Ireland enfolded within his text to the "wrappings" of the Bulgarian artist Christo and his wife Jeanne-Claude, whose many achievements include a wrapped German *Reichstag* as well as several Pacific islands entirely covered in fabric: land meets landscape.

No single treatment of mapping (artistic, literary, critical, historical) can exhaust its cultural potential. Eavan Boland's evocation of a remote road that ends suddenly because weak and hungry people have died while making it retains a power beyond my analysis. In the context of this exhibition, Boland's image can be seen to turn toward and to open up a reading of Brian Tolle's *Hunger Memorial* in Battery Park, New York City (no. 97). Tolle's memorial transports the hungry acre of Irish mythology to a city park, where it sits as a living cross section taken from the land whose history it represents. Elevated on and cantilevered over a broad platform of simulated geological strata, the "field" projects over layered textual testimonies to the Famine.

The site's sharp edges and sudden ending are strangely evocative of the Famine roads Boland elegizes. The memorial was inspired, according to its creator, by a trip to the west of Ireland and his sight of "the abruptness of the island's edge as it meets the sea" (Tolle, qtd. in "Governor Pataki"). A similar fascination with Ireland's edges occurs in recent Irish writing. In Anne Enright's *What Are You Like,* a man haunted by memories of a child he has given away dreams of undertaking a journey round the circumference of the island. Encountering its extreme limits, he describes—in both a literary and a geographical sense—the shape of the land: "He worried about piers. Should he travel the length of them, going up the near side and coming back by the far?" (Enright 10). This desire for cartographic precision stands in sharp contrast to the unmapped emotional spaces that the novel charts: adoption, childlessness, sexual

loneliness, a country "where people did the most appalling things, and shut their mouths, and stayed put" (Enright 222). The dream journeys around the island with which the novel opens map cultural dispossession, but not in the sense described by Said or imagined by Friel. Rather than a "cartographic impulse" that seeks to represent, at one remove, something else (history, the death of a language, the Troubles), mapping in this novel is part of a wider effort to renegotiate the relationship between an embodied subjectivity and the social space it inhabits. Cartography becomes a tool with which to measure, assess, and express experiences of the most intimate kind.

What Are You Like? shares with *Belfast Confetti* and with "Christo's" a sense that a place can be a map of itself and, with several of the contemporary artists gathered here, a suspicion of representational codes that seem to impede access to land in its raw immediacy. Rather than simply belonging to the "grammar" of colonialism, maps speak a language with the potential to express a rich array of cultural perspectives. In Ireland, in particular, in spite of (because of?) its troubled history, mapping retains a special ability to arouse creative energies and provoke quarrels. ❖

ENDNOTES

1 Reading "That The Science Of Cartography Is Limited" alongside a poem from the earlier collection would allow a fuller understanding of the connections here. In "The Making Of An Irish Goddess" the poet registers her knowledge of the trauma of famine and seeks to record in her own body "an accurate inscription/of that agony" (Boland, *Outside History* 32).

WORKS CITED

Anderson, Benedict. *Imagined Communities: Reflections on the Origin and Spread of Nationalism.* Rev. ed. London: Verso, 1991.

Andrews, J.H. *A Paper Landscape.* Rev. ed. Dublin: Four Courts Press, 2002.

---. *Shapes of Ireland: Maps and their Makers 1564–1839.* Dublin: Geography Publications, 1997.

---. "Notes for a Future Edition of Brian Friel's Translations." *Irish Review* 13 (1992/3): 93–106.

Boland, Eavan. *Outside History.* Manchester: Carcanet, 1990.

---. *In a Time of Violence.* Manchester: Carcanet, 1994.

Carson, Ciaran. *Belfast Confetti.* Oldcastle: Gallery Press, 1989.

Enright, Anne. *What Are You Like?.* London: Jonathan Cape, 2000.

Friel, Brian. *Translations.* London: Faber, 1981.

---. Friel, Brian, John Andrews, and Kevin Barry. "*Translations* and A Paper Landscape: Between Fiction and History." *The Crane Bag* 7, 2 (1983): 120–122.

"Governor Pataki Announces Design For 'Irish Hunger Memorial.'" 3 August 2002. <http://www.state.ny.us/governor/press/year01/march15_2_01.htm>

Harley, J. B. *The New Nature of Maps: Essays in the History of Cartography.* Ed. Paul Laxton. Introd. J. H. Andrews. Baltimore and London: The Johns Hopkins University Press, 2001.

Muldoon, Paul. *Selected Poems: 1968–1986.* New York: The Ecco Press, 1987.

Nash, Catherine. "Remapping the Body/Land: New Cartographies of Identity, Gender, and Landscape in Ireland." *Writing Women and Space: Colonial and Postcolonial Geographies.* Eds. Alison Blunt and Gillian Rose. New York: Guilford Press, 1994. 227–250.

---. "Introduction." *Irish Geographies: Six Contemporary Artists: Pauline Cummins, Frances Hegarty, Kathy Prendergast, Tim Robinson, Chris Wilson, Daphne Wright.* Ed. Catherine Nash. Nottingham: Arts Centre, University of Nottingham, 1997. 5–9.

O'Mahony, Deirdre. "Statement on the Ballinglen Experience." Interview with Lisabeth Buchelt. 2001.

Said, Edward. "Yeats and Decolonization." *Nationalism, Colonialism and Literature.* Ed. Seamus Deane. Minneapolis: University of Minnesota Press, 1990. 69–95.

Making and Remaking the Irish Landscape in the Early Middle Ages

Robin Fleming

◇

IT IS EASY TO MISTAKE WORKS OF ART PORTRAYING THE IRISH LANDSCAPE FOR HISTORICAL PIECES. PHOTOS LIKE LINDA MAHONEY'S *KILLARY HARBOUR, CO. MAYO* (NO. 72) AND PAINTINGS LIKE ANNE NEELY'S *MY NEIGHBOR'S COWS* (NO. 83) BOTH WITH FIELDS AND PASTURES, STONE FENCES, AND UNCULTIVATED HILLS, CAN

appear as timeless depictions of an unchanging landscape, as portraits of an Ireland that the fifth-century holyman St. Patrick or the tenth-century warrior king Brian Boru would still find familiar. Certainly, George Petrie's paintings, produced in the 1820s and 1830s, make such claims. The pious laypeople in his *Last Circuit of Pilgrims at Clonmacnoise* (no. 16) and *St. Brigit's Well* (no. 15) are shown doggedly returning to ancient hallowed sites that had persisted for hundreds of years, despite British occupation and insult.

This notion of the Irish landscape's timelessness is an old one.[1] Gerald of Wales's *Topograpy of Ireland* (no. 1), first written in 1186, describes at length how the Ireland of his own day was a place that time forgot. The Irish, so he writes,

> live on beasts only, and live like beasts. They have not progressed at all from the primitive habits of pastoral living. While man usually progresses from the woods to the fields, and from the fields to settlements and communities of citizens, this people despises work on the land.... They use the fields generally as pasture, but pasture in poor condition. Little is cultivated, and even less [is] sown. (Gerald of Wales 101–2)

Both modern romantic notions of the Irish landscape and Gerald of Wales's imperialist fantasies are false. All settled landscapes, even Ireland's, are highly changeable and historically constructed. The way land is used and divided, the arrangements by which its fruits are distributed, and the kinds of labor that take place upon it shape the landscape and go a long way in determining its appearance. As society changes, moreover, and as social and political structures mutate, the look of the land changes as well.[2] It is the purpose of this essay to reconstruct the historical landscape of the seventh, eighth, and ninth centuries; in other words, to uncover the land inhabited by Ireland's early saints and kings. We will then witness the landscape's great transformation around the turn of the first millennium and see the beginnings of the Ireland that Gerald of Wales's Angevin contemporaries were so determined to conquer. In doing so, we shall see that the Ireland of the Early Christian period was unlike either twelfth-century Ireland or the Ireland depicted in modern works of art, and learn the ways in which Gerald's depiction of Ireland's primitive and aberrant landscape is a fiction.

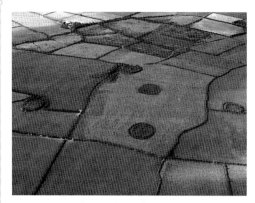

Fig. 1: Five ringforts, each marking the settlement of a single household, near Ardfert, in Co. Kerry. Ringforts were often built in close proximity to one another, and the households living within them probably cooperated during planting, harvesting and booleying. (From G. Stout and M. Stout, "Early landscapes: from prehistory to plantation," in F.H.A. Aalen, K. Whalen and M. Stout (eds.), *Atlas of the Irish Rural Landscape* (Cork, 1993, 31–63; fig. 37, p. 21).

What did the Irish landscape look like in the seventh, eighth, and ninth centuries? What kind of society produced it? And how was the look of this land different from the rest of early medieval Europe?[3] Like the vast majority of people living in northwestern Europe, most Irish in the early Middle Ages did not make their homes in village communities. Instead, they lived on dispersed farmsteads, often within sight of other kinsmen, and close enough to cooperate during plowing, harvesting, or booleying (fig. 1). This thin scattering of human settlement across the landscape would have had much in common with contemporary landscapes in central England, northern France, or southern Scandinavia. Across Ireland, however, the particular form these settle-

ments took was uniquely Irish. Prosperous Irish people, unlike people elsewhere in Europe, built ringforts—sometimes called *raths* or *cashels*—to mark their homesteads.[4] An estimated 45,000 ringforts were built between the beginning of the seventh century and the end of the ninth, and several thousand survive to this day; some are still marked by impressive earthen or drystone walls two meters high or more (fig. 2). One of the strangest and most charming medieval descriptions of a ringfort is found in the satirical poem, *Aisling Meic Conglinne*, or *The Vision of MacConglinne*, which tells of a ringfort made of food:

> The fort we reached was beautiful
> With works of custard thick beyond the
> lock.
> New butter was the bridge in front,
> The rubble dyke was wheaten white,
> Bacon the palisade.
> Stately, pleasant it sat,
> A compact house and strong.
> Then I went in
> The door was of dry meat,
> The threshold was bare bread,
> Cheese curds the side.
> (36)

Ringforts were built for and occupied by a whole spectrum of prosperous people: well-to-do farmers, who owed labor services, a portion of their agricultural surplus and some of their cattle to more powerful men; chieftains with a few followers of their own; and kings with aristocratic retinues and crowds of lesser clients. A

single family, whether modest or grand, comprised of an extended household of relatives, retainers, and slaves, would have lived within each ringfort, usually in two or three houses. And we know from archaeological excavations that many of these sites were inhabited for a century or more.

The poets of early medieval Ireland extolled their antiquity:

> The fort opposite the oak wood
> Once it was Bruidge's, it was Cathal's,
> It was Aed's, it was Aillil's
> It was Conaing's, it was Cuiline's
> And it was Maelduin's—
> The fort remains after each in his time.
> (*Early Irish Lyrics* xvi)

In spite of their name, the walls or ditches that defined these enclosures did not make them well-defended forts. Generally, their drystone or earthen walls could keep livestock in

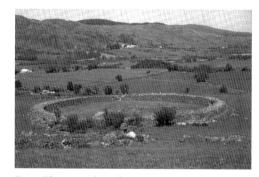

Fig. 2: The restored ringfort at Drumena, in Co. Down. (From Colm J. Donnelly, *Living Places: Archaeology, Continuity and Change at Historic Monuments in Northern Ireland* (Belfast, 1997; fig. 69, p. 68).

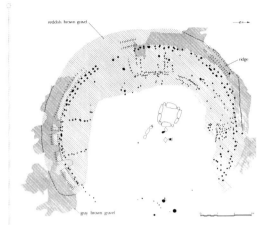

Fig. 3: An early medieval *crannóg*, still in use in the early seventeenth century, is illustrated on Richard Bartlett's 1602 pictorial map of Armagh. National Library of Ireland.

and wild animals out, and they would have discouraged casual thievery, but they could not have withstood concerted attacks by armed men. Ringfort walls could, however, be seen from afar; thus they advertised the prestige of their proprietors to all those residing in or riding through the neighborhood.

The eighth-century legal tract *Críth Gablach* makes clear that the size of a ringfort and the number of its banks and ditches helped to define its owner's social status (McNeill 265–316). Men from the higher ranks of society owned slaves, and they were owed fixed amounts of labor from their free dependents, including help with the construction of ringforts. As a result, the more substantial the ringfort or the more circles of banks and ditches it had, the more clients and human property under its owner's control. This correlation between ring-

fort size and social importance is supported by modern archaeological excavations. The vast majority are somewhere between twenty and fifty meters in diameter, and they are encircled by a single bank and ditch. When excavated, ringforts of this size produce modest jewelry, agricultural equipment, textile and leather working implements, and the detritus from bone and iron working. These would have been the homes of the *bóaire* or *ócaire*, strong farmers rather than great lords, the kind of men one ninth-century poet ridiculed when quipping: "I have heard that he gives no steeds for poems; /He gives what is natural to him—a cow!" (Murphy 91). On the other hand, excavations of the most extensive ringforts—those between ninety and one-hundred-ten meters in diameter or those that are double- or triple-ditched—have uncovered the workshops of luxury craftsmen and scribes. Sites like these were clearly the residences of nobles or kings.

Crannógs, artificial islands built near lakeshores as platforms for settlements, served the same powerful strata of society as the grandest ringforts, although *crannógs* were defensible in a way that only the most elaborate ringforts could be.[5] Because of the huge amounts of timber, stone, and labor involved, the two thousand or so *crannógs* built by 800 AD seem to have been universally of high status, and some, we know from written sources, were, indeed, royal. Gerald of Wales mentions *crannógs* a number of times in his *Topography*, and he was clearly impressed, in spite of himself, by these structures (37, 95, 120). Most were built in the late sixth and seventh centuries,

but, like ringforts, many were occupied for hundreds of years. Indeed, the great cartographer Richard Bartlett's pictorial map of 1602 depicts a *crannóg* still in use (fig. 3).

The houses built in both ringforts and on *crannógs* up through the ninth century were extremely conservative in form. They were roundhouses, a domestic architectural style that had dominated Ireland since the Iron Age (Lynn 81–94). These roundhouses were generally fashioned from double-walled, woven wicker, or from posts and wattle. As far as we can tell, the roundhouses of kings and great lords were larger than those of other men, but they were not better constructed nor built from finer materials than the houses of people of lower social standing. Indeed, the Irish elite seem to have had little interest in expressing their high status through their houses. Instead they asserted their prestige with large herds of cattle, great feasts, extraordinary brooches (nos. 9, 10, 11, 12, and 14), and the high banks and walls of their ringforts.

Cattle farming and dairying, as Gerald of Wales's account suggests, dominated the agricultural practices of ringfort and *crannóg* dwellers; and the size of a man's herd, like the size of his ringfort, was a measure of his status. Nonetheless, and despite Gerald's claims, crop husbandry was of crucial importance to Irish farmers.[6] Kilns, which were used for the drying of grain in Ireland's damp climate, and horizontal water mills, which could process large amounts of cereal, were common in the period. Indeed, Ireland has the largest corpus of early medieval water mill sites in the world. ◇

Through dendrochronology we know that the vast majority were built between 581 and 843 AD, the period when ringfort and *crannóg* construction was at its height.

Kings and nobles, presiding over some 150 circumscribed little territories known as *túatha* and living in this world of cultivated fields and dairy herds, received tribute from their clients, carefully calibrated to the particular social ranks of the parties involved. According to two early law tracts, *Críth Gablach* and *Cain Aigillne*, clients contracted with nobles, who furnished them with set amounts of land, livestock, and/or other material goods, and a promise of legal and military support. In turn, the clients provided set labor services and entertainment. More important, they gave annual renders of milk cows, dairy products, meat, malt, grain, and other foodstuffs, and it was these renders that fed great men and their hangers-on.[7] Most of the players in this system—the small and strong farmers who followed greater men, the nobles, and the multitude of kings—would have all lived in ringforts or *crannógs*, although the few hundred men who sat at the top of this system would have resided in the largest and most impressively bounded settlements.

This settlement pattern, these settlement sites, and the social structures and agricultural regimens that supported them were long-standing and well entrenched by the ninth century. But in the century or so between c. 900 AD and c. 1000 AD, the Irish landscape began to be remade: social relations were restructured and the long-dominant political unit, the *túath*, disappeared as larger political entities came to

the fore. Under these circumstances novel kinds of communities began to form, and a new settlement pattern began to emerge (Warner 47–68; Graham 19 57).

The clearest evidence for all of this is the waning of the ringfort. Ringforts ceased to be built over the course of a single century, and none appear to have been constructed after the year 1000. When Gerald of Wales was in Ireland, the remains of abandoned ringforts could be seen across the countryside:

> To this day, as remains and traces of ancient times, you will find here many trenches, very high and round and often in groups of three, one outside of the other...now standing empty and abandoned.
> (*Gerald of Wales* 119)

During this period of transition, the sites around many ringforts remained occupied, but the spaces bounded by walls were abandoned. Apparently the area within the confines of the ringforts ceased to be an appropriate dwelling space for all but the most powerful kings and nobles. Instead, what we find is that houses were increasingly put up just outside the walls of more middling ringforts. These new houses, moreover, were built in a novel fashion: they were rectangular rather than round, and they were generally built with drystone or turf walls. This dramatic shift in form and materials cannot be explained simply as technological or practical improvements, since hazel-rod construction is remarkably strong and cheap,

and since unmortared stone structures can be damp and drafty. Nonetheless, the millennia-old roundhouse, within the course of a single century, apparently came to be seen as socially unfitting; those who could rebuilt their houses following this new fashion. There is no evidence for rectangular houses in the Irish countryside before the tenth century, but the transition from round to rectangular was almost complete by the year 1000 (Lynn 81–94).

Irish houses, moreover, were now often built in close association with a new kind of structure, the souterrain: a stone-lined, underground passage, sometimes as many as one hundred meters in length. Souterrains, like the ringforts built before them, required skill and large amounts of labor to construct; and like ringforts, they are very impressive monuments. But the 3,500 or so that were built during this period functioned differently from ringforts, since their underground location meant that they could not operate as display structures in the same way that ringforts had. They could, however, act as bolt holes when gangs of slavers were raiding, an increasing problem beginning in the ninth century. Perhaps the ability to protect was the new sign of high social status. Whatever the reasons behind these dramatic transformations, by about the year 1000 the abandonment of the interiors of the smaller ringforts, as well as the construction of rectangular houses and souterrains, was the new order of the day.

A small number of ringforts during this period, however, were evolving differently. Rather than being abandoned, their enclosed

interiors were deliberately raised with dumps of stone and clay and heightened to give their inhabitants better views of the surrounding countryside to make the sites truly defensible, and, perhaps, to set them apart from old-fashioned ringforts. In Ireland sites like these are known as raised *raths,* but in any other European setting they would be called castles, a new form of defensive architecture that was being pioneered on the Continent at just this time. In the same period, many of the great *crannógs* continued to be occupied. Strongly fortified and strategically sited forts, too, were being thrown up from scratch by kings who wished to extend or hold onto their territories. This, also, was happening on the Continent.

More or less contemporary with these changes in high-status sites are hints that relatively large, undefended proto-villages were beginning to coalesce, and the centuries-old pattern of dispersed settlements was starting to evolve toward nucleation. A number of low-status cluster settlements have been found through aerial photography. Most lie along deserted hillsides in the uplands, just beyond the margins of modern agriculture, so the old foundations of early houses and walls have not been damaged by later plowing. One of these settlements has been found outside Ballyutoag, in Co. Antrim. Here, settlement was much more extensive than at earlier ringfort sites. Rather than two or three houses and a single household, this site contained at least twenty-three houses and would have accommodated one hundred people or more. Finds were numerous

there but limited to coarse pottery and the most basic jewelry; this was hardly the site of a silver-wearing, poet-supporting aristocratic household. A similar cluster settlement housing a village-worth of people was developing at the prehistoric tomb at Knowth, in Co. Meath, a site that had served as a royal residence from c. 800 AD. A zone outside the royal compound became the focus of an extensive, unenclosed settlement consisting of thirteen houses and nine souterrains. Concentrations of undefended houses during this period could also be found near some Irish monasteries. Thus, religious communities, secular nobles, and kings seem to have been pioneering new social arrangements with a crowd of people now housed outside their enclosures.

Knowth, Ballyutoag, and a number of monastic sites suggest that clustered, open secular settlements were developing around the same time that most ringforts were disappearing. Social, political, and economic changes must have been driving these transformations. The intensification of agriculture and the pressures of growing population during the seventh, eighth, and ninth centuries probably meant that the number of base clients grew by the ninth century to the point where some men's holdings no longer produced the tributes they needed to give over to their lords in order to meet their social obligations (Monk, "Early Medieval" 33–52). Under these circumstances, failed client families, dislodged from their former homes, may have gravitated toward larger settlements around the compounds of the powerful. Beyond this was the coming of the

Vikings, whose initial terrifying period of raids (795–840) provided great men with a bona-fide emergency and a useful pretext to better their positions at the expense of their neighbors and clients. Simultaneous to this was a noticeable militarization of Irish society. Together, these events signal a growing gulf between the powerful and everyone else.

The changing landscape thus suggests that by c. 1000 AD formerly free farmers were being pressed downward by the hard luck of debt, political disruption, and ruthlessly bargained relationships with their betters. The simultaneous death of the ringfort and rise of nucleated settlement suggest that thousands of families were exchanging prior independence and freedom for a form of servile security. Under these circumstances, those with power—the families settled in raised *raths* or grand *crannógs*—may no longer have been satisfied with free-farmer clients, traditional annual food renders, and a share of their followers' calves. Instead, they may have sought a more subjugated group of underlings, over whose labor, harvests, and herds they had greater control. One wonders if scenes similar to those depicted in Robert Kelly's *An Ejectment in Ireland* (no. 27) or Seán Keating's *Economic Pressure* (no. 36) played themselves out in the brave new world of tenth- and eleventh-century Ireland, or if the dispossessed and missing evoked in the altogether different context of famine-memorial art—the phantoms in Kathy Herbert's *Angel in the Hay, Shadows,* or *Absent,* (nos. 90, 91, 92)—would have found a knowing audience in this earlier period.

Open cluster settlements like the ones at Ballyutoag and Knowth have left few traces, but it was probably places like these that the Angevins, when they came in the late twelfth century, referred to as *baile*. They called them *villae* in Latin, because they found them similar to the villages they had known back home in England and Wales. *Baile* first appear in the tenth century as administrative units, and may well be the social and administrative replacement of the ringfort. By the time the Angevins arrived, the ringfort-dwelling strong farmers seem to have been largely replaced by a more generic group of people called *bíatach*—or tenants. When encountering these rural workers, the Angevins believed them to be the social and legal equivalents of English *villeins*. These people, whose ancestors had been ringfort-dwelling clients, were now rent payers: they had become agricultural tenants of little status (Doherty 288–330).

The dramatic changes outlined above were far from complete by Gerald of Wales's own day, and dispersed settlements and old client relationships persisted into the twelfth century and beyond. Nonetheless, by the time Gerald put pen to parchment, the Irish landscape and Irish lordship had evolved in many of the same ways as they had elsewhere in northwestern Europe. Ireland's new landscape reflected a growing gulf between lords and the people who labored for them, a social difference that was increasingly emphasized in France and England as well. Thus, Gerald's Ireland—with its dearth of cultivated fields, its wild men dressed in animal skins, its savage kings (see endnote 1), and

its people too shiftless to use the plow—was a carefully crafted fiction, concocted to encourage his audience to come, to conquer, and to make the Irish landscape its own. ❖

Endnotes

1 On the commonplace of the notion of Irish timelessness, see Leerssen.

2 For an overview of the history of the Irish landscape, see Mitchell and Ryan.

3 For a comparative study of the Irish, English, and Welsh landscapes and the divergent patterns of lordship that stood behind them, see Fleming.

4 For the most complete and up-to-date study of the ringfort, see Stout.

5 For the most complete and up-to-date study on *crannógs*, see O'Sullivan.

6 For the most recent study of Irish agricultural practices, see F. Kelly, *Early Irish Farming*. See also Monk, "The archaeobotanical evidence for crop plants in early historic Ireland," 315–28.

7 For a study of the intricacies of this system and the archaeological evidence for it, see McCormick.

Works Cited

Doherty, C. "The Vikings in Ireland: a review." Eds. H.B. Clarke, M. Ní Mhaonaigh and R. Ó Floinn. *Ireland and Scandinavia in the Early Viking Age.* Dublin: Four Courts Press, 1998. 288–330.

Fleming, Robin. "Lords, landscape, and labour." Ed. W. Davies. *The Short Oxford History of the British Isles.* vol. 3: *Britain and Ireland in the Ninth through Eleventh Century* (in press).

Gerald of Wales. *The History and Topography of Ireland*, trans. J.J. O'Meara. Harmondsworth: Penguin Books, 1982.

Graham, Brian J. "Early medieval Ireland: settlement as an indicator of economic and social transformation, c. 500–1100 AD." Eds. B.J. Graham and L.J. Proudfoot. *An Historical Geography of Ireland.* London: Academic Press, 1993. 19–57.

Kelly, Fergus. *Early Irish Farming: A study based mainly on the law-texts of the 7th and 8th centuries A.D.* Dublin: School of Celtic Studies, 1997.

Leerssen, Joep. "The western mirage: on the Celtic chronotope in the European imagination." Ed. T. Collins. *Decoding the Landscape: Papers Read at the Inaugural Conference of the Centre for Landscape Studies.* 2nd revised ed. Galway: Centre for Landscape Studies, 1997. 1–11.

Lynn, C.J. "Houses in rural Ireland AD 500–1000." *Ulster Journal of Archaeology.* 57 (1994): 81–94.

McCormick, F. "*Stockrearing in Early Christian Ireland.*" Diss. Queen's University, Belfast, 1987.

McNeill, E. "Ancient Irish law: the law of status or franchise." *Proceedings of the Royal Irish Academy* 38 (1923): 265–316.

Mitchell, Frank and Michael Ryan. *Reading the Irish Landscape.* Revised ed. Dublin: Town House, 1990.

Monk, Michael A. "The archaeobotanical evidence for crop plants in early historic Ireland." Ed. J.M. Renfrew. *New Light on Early Farming: Recent Developments in Palaeoethnobotany.* Edinburgh: Edinburgh University Press, 1991. 315–28.

Monk, Michael A. "Early medieval secular and ecclesiastical settlements in Munster." Ed. M.A. Monk and J. Sheehan. *Early Medieval Munster: Archaeology, History and Society.* Cork: Cork University Press, 1998. 33–52.

Murphy, Gerard. Ed. and trans. *Early Irish Lyrics, Eighth to Twelfth Century.* Oxford: Oxford University Press, 1956.

O'Keeffe, Tadhg. *Medieval Ireland: An Archaeology.* Stroud, Gloucestershire: Tempus, 2000.

O'Sullivan, Aidan. *The Archaeology of Lake Settlement in Ireland.* Dublin: Royal Irish Academy, 1998.

Stout, Matthew. *The Irish Ringfort.* Dublin: Four Courts Press, 1997.

The Vision of MacConglinne: A Middle Irish Wonder Tale. Ed. and trans. K. Meyer. 2nd ed. Felinfach: Llanerch Pub., 1999.

Warner, R.B. "The archaeology of early historic Irish kingship." Ed. S.T. Driscoll and M.R. Nieke. *Power and Politics in Early Medieval Britain and Ireland.* Edinburgh: Edinburgh University Press, 1988. 47–68.

Shaping and Mis-shaping:
Visual Impressions of Ireland in Three Illuminated Manuscripts

Michelle P. Brown

FOR SO MUCH OF IRELAND'S HISTORY, VISITING STRANGERS HAVE PRODUCED THE SOURCES PROVIDING KNOWLEDGE OF THE LAND—OF ITS TOPOGRAPHY, ITS NATURAL HISTORY, ITS PEOPLE AND THEIR CUSTOMS AND CULTURE. EARLY CHRISTIAN EUROPE BENEFITED FROM THE LABOR OF IRELAND'S CLERICS AND SCHOLARS in the aftermath of the Roman Empire and the emergence of the various successor states which came to form the nations of modern Europe. Nevertheless Ireland's rich oral tradition and the literary heritage of earlier ages—chronicles, epic tales, law-codes, and Christian documents—were little known outside of the isolated island. Gerald of Wales's *Topography* was thus the first account of Ireland available to western audiences since the sixth to ninth centuries (the "age of the saints") when Irish missionaries were active throughout much of Europe.[1] Gerald's work inaugurated a tradition whereby outsiders shaped the international perception of Ireland.

Despite its active tenth- and eleventh-century participation in the Scandinavian trad- ing empire, Ireland remained unfamiliar to other medieval audiences. In the late-twelfth century, a clergyman of Welsh and Norman ancestry, Gerald de Barri—known as Gerald of Wales (Giraldus Cambrensis)—wrote the first widely read account of the country. Gerald boasts that the *Topography* was almost entirely his own work, composed without reference to earlier sources, with the exception of the final section for which he consulted some of the Irish chronicles (such as the *Lebor Gabála*). But Gerald's account was by no means an impartial traveler's tale of a little-known land; the alleged topographical treatise is, for the most part, merely a peg upon which to hang more covert messages. Harboring ambitious political and religious agendas, Gerald manipulated and fre- quently invented material designed to foster plans to bring Ireland under the rule of the Angevin monarchy, whose territories included England. Such blatant stratagems attracted the criticism even of some of his contemporaries, and today Gerald is demonized by postcolonial commentators, his work frequently con- demned by the Irish themselves.[2] However, without his achievements our knowledge of medieval Ireland would be much the poorer.

Gerald is best understood as the product of his time and place. In many ways he epitomizes the plight of the Celt caught between worlds; he champions Celtic culture and loves the lands on the wild Atlantic fringes of Europe, but his livelihood was bound to the fortunes and ambi- tions of an increasingly centralized alien gov- ernment. Having bought into the ethos of that modernizing force himself, Gerald was keen to share what he perceived to be its benefits with the Celtic peoples. In the short-term, his ambi- tions enriched the landscape of Ireland through the building of Norman castles and abbeys, and the towns which arose around them. In the long-term, however, the interests of the Celtic

people were subjugated to those of the English crown and aristocracy and of the papacy.

Gerald belonged to the FitzGerald family, many of whose members had initially been employed in Ireland as mercenaries in internecine struggles and, along with other Normans, were rapidly becoming its overlords. His *Topography of Ireland* was designed to be a weapon in his armory of arguments to convince the Angevin ruler of England, King Henry II, to legitimize conquest as an official state enterprise. In the 1186–88 text, to be complemented subsequently by his similar work on Wales, Gerald describes what he allegedly encountered on his visits to the island. In 1185 he accompanied Prince John of England—later of Magna Carta fame—on a tour to improve the prince's education and knowledge of the world. On this, the second of Gerald's three visits to Ireland, he was to preach the Crusade to the Holy Island before the people and the Norman knights living there.

Like generations of displaced Irish living in Britain, Gerald always felt himself to be a fish out of water.[3] Against the backdrop of the internationalism of a French-speaking aristocracy and a Latinate Church, he was, in the words of Robert Bartlett, "a child of a frontier society at the edge of feudal Europe" (6). His identities appear multiple: by turn a denigrator and champion of the Celtic peoples from whom he claimed part-ancestry, a sycophant and critic of kings and courts, an espouser of the militaristic feudal ideals of the Marcher knights of Wales (from whose ranks he sprang), and an idealistic reforming cleric intent upon the unity of Christendom and the independence of the Welsh Church. The grandson of a Norman knight, Gerald of Windsor, and a Celtic princess, Nesta, the "Helen of Wales," Gerald was considered a Celtic outsider at the Angevin court and an English intruder in Wales and Ireland.

Determined to prove his worth, he first embarked on a career of church politics; but as that chosen vocation came to naught, increasingly in his old age he turned to writing. While in retirement at Lincoln early in the thirteenth century, he had a number of copies of his works written and illuminated in the cathedral scriptorium, intending to present them to prospective patrons and church communities. He supervised the creation of these illuminated manuscripts and may have himself had a hand in devising the lively little illustrations in the margins of some copies of his work. Having spent some time dining out on his traveler's tales, Gerald seemingly conceived of these commissioned illustrations as a thirteenth-century equivalent to a slide presentation accompanying his stories.

The version exhibited in *Éire/Land*[4] contains a number of authorial additions to both the text and the image cycle made at Lincoln around 1210—Gerald no doubt peering over the shoulders of its scribe (no. 1a–i). Comparison with other early copies of the work, including one in the National Library of Ireland, reveals that this version is the earliest example of an author "illustrating" his own works and using the space in the margins to explore implications and issues raised by his text. Gerald's achievement inspired a popular response in the more luxuriously illuminated books of the Middle Ages.

That Gerald wrote with a multifaceted agenda is obvious, for his *Topography of Ireland* is no literal version of his experiences. Although his travels in Ireland took him to only the eastern and southern seaboards of the island from Cork to Dublin—perhaps with forays into the interior including visits to Arklow, Wicklow, Kildare, the Shannon near Athlone, and maybe Lough Derg near Donegal—his account stretches northward to Ulster and westward to the Aran Isles. He couches it in the spirit of *The Marvels of the East*, a popular work of Roman and early medieval derivation that sought to introduce western readers to the mysteries and wonders of the people, flora, and fauna of Africa and the East, subjects of particular interest during the crusades. In the *Topography*, Gerald hoped to acquaint his European readers with what he presents as the equally exotic regions at the western edges of the known world. The text of the Dublin manuscript is accompanied by a rudimentary map of Europe, Scandinavia, and Iceland.[5] This map includes Ireland and marks its main rivers and settlements: Shannon, Liffey, Dublin, Slaney, Wexford, Suir, Waterford, and Limerick. Gerald's description of the country, although detailed, is constrained by the limitations of his actual travel experiences.

Ireland is a country of uneven surface and rather mountainous. The soil is soft and watery, and there are many woods and marshes. Even at the tops of high and steep mountains you will find

pools and swamps...some fine plains, but in comparison with the woods they are indeed small. On the whole the land is low-lying on all sides and along the coasts; but further inland it rises up very high to many hills and even high mountains. It is sandy rather than rocky...is rich in pastures and meadows, honey and milk and wine, but not vineyards....The island is divided and watered by nine principal and magnificent rivers.... Of old the country was divided into five almost equal parts, namely: two Munsters, north and south, Leinster, Ulster and Connacht. The prophecy of Merlin predicted that they would all be reduced to one.
(*Gerald of Wales* 34–7 [ch. 1–3])

Until Gerald's mention of Merlin's prophecy in the above passage—a statement adding an element of literary lore to topographical description and one which placed the Celtic Arthurian traditions concerning unification at the service of the Angevin kings—he seems concerned primarily with describing Ireland's geography. The accompanying illustrations of the manuscript similarly provide both realistic information about Ireland's natural history, and some highly literary speculation. In emulation of the bestiary tradition, a merry procession of stags, wolves, beavers, badgers, otters, and other creatures march across the margins of his work (no. 1b). But the manuscript also includes other more distinctive local curiosities

such as the fish in Carlingford Lough renowned for its golden teeth (no. 1c) and the barnacle geese which grew on trees (no. 1a)—a misunderstanding of the classical text relating to the crustaceous barnacle.

Gerald speaks of the manners and customs of the people, praising their love of music and incomparable skill in its performance, and chastising the Normans for their lack of appreciation for such Celtic traits.

It is remarkable how, in spite of the great speed of the fingers, the musical proportion is maintained. The melody is kept perfect and full with unimpaired art through everything—through quivering measures and the involved use of several instruments—with a rapidity that charms, a rhythmic pattern that is varied, and a concord achieved through elements discordant...the very things that afford unspeakable delight to the minds of those who have a fine perception and can penetrate carefully to the secrets of the art, bore, rather than delight, those who have no such perception—who look without seeing, and hear without being able to understand. When the audience is unsympathetic they succeed only in causing boredom with what appears to be but confused and disordered noise.
(*Gerald of Wales* 103–4 [ch. 94])

Already in the thirteenth century, Gerald establishes what has come to be viewed as

the central colonial modes of speaking about the Irish—as imaginative, musical, but in need of discipline—a program perhaps culminating Matthew Arnold's *On the Study of Celtic Literature* (1867).

In another part of his text, Gerald describes how Nature "forms and finishes them [the Irish people] in their full strength with beautiful upright bodies and handsome, well-complexioned faces. But although they are fully endowed with natural gifts, their external characteristics of beard and dress, and internal cultivation of the mind, are so barbarous that they cannot be said to have any culture." Such passages establish the tone of Gerald's narrative: the Irish constitute a people and a country naturally blessed with beauty and imaginative qualities, but lacking the benefits of "civilization." Gerald's major aim, of course, was to be instrumental in bestowing these benefits.

The opening of the manuscript exhibited in *Éire/Land* (no. 1h–1i) depicts a particularly tall tale: Gerald's version of the kingship ritual at Tirconell, Co. Donegal, of the "Kenelcunill" tribe (the Cenél Conaill), in which, so he alleges, the king mates with a white mare and then bathes in a broth of her flesh of which he and his people partake. The image may allude to the ancient Ulster Cycle's symbolic union between the king and a mare—representing the union of the *túath* (tribe) with Nature—a ritual guaranteed by the king and ensuring prosperity for the people. In including the episode, Gerald undoubtedly stresses Ireland's need for enlightened (Angevin) rule.

◇

Elsewhere, and again with a purposeful agenda, Gerald depicts Ireland as the source of a savage bestiality, as a land filled with grotesque and uncivilized figures. Particularly relevant to his covert message is the text's preoccupation with bestiality and immorality. He enlivens the *Topography* with tales of the bearded woman of Limerick who, apart from her flowing beard and hairy spine, "was in other respects sufficiently feminine (no. 1d)." Also making an appearance is the cow-man of Wicklow, allegedly the progeny of man and domestic beast, who became a pet of the FitzGerald garrison until murdered by envious locals. Gerald even alludes to another notorious European scandal concerning bestiality: the mating of Johanna of Paris with a lion (no. 1e). That the papal bull eventually approving Henry II's annexation of Ireland did so on grounds of the land's alleged immorality—including bestiality—suggests that Gerald's inclusion of such details may have helped legitimize that political enterprise and encourage public support of it.

Gerald's tales of Ireland's strong religious tradition, however, offer a more positive view of that society. He includes passages such as that concerning St. Kevin of Glendalough, whose hand, outstretched in prayer through the windows of his cell, became the nesting place of a blackbird (no. 1f). So caring of Nature was the saint that he obligingly remained still until the fledglings were hatched—a tale since celebrated in Seamus Heaney's poem "St. Kevin and the Blackbird"(410–11). Gerald also celebrates a Gospel book at St. Brigid's Church at Kildare (calling to mind the Book of Kells; no. 1c):

> ...if you take the trouble to look very closely, and penetrate with your eyes to the secret of the artistry, you will notice such intricacies, so delicate and subtle, so close together and well-knitted, so involved and bound together, and so fresh still in their colourings that you will not hesitate to declare that all these things must have been the result of the work, not of men, but of angels.
> (*Gerald of Wales* 84 [ch. 71])

Gerald's text also narrates the fate of men who dared set foot within the sacred enclosure of St. Brigid's fire at Kildare. In another episode, however, Gerald tells of sailors who encountered two men in a *curragh*, possibly from the Aran Islands, an area with one of the richest Christian heritages in the country (no. 1i). Although naturally good, these men had never heard of the Christian faith. Even such a more positive tale is designed to justify the need for conquest and conversion. Just as the Jesuit missionaries in sixteenth-century South America celebrated the innocence and innate goodness of the native population while overlooking centuries of history, cultural achievement, and religious observance, Gerald presents Ireland as an Eden gone astray. Ireland is, however, ripe for shaping in the image of the mainstream European community—or in the image of Gerald's particular view of that society.

Gerald's political and religious agenda to assimilate Ireland into Europe ultimately proved successful, but the personal disappointments of his career left him embittered and marginalized in his old age. His paternalistic optimism about the benefits such a program would bestow upon the Irish proved to be sadly misplaced.

St. Patrick's Purgatory:
a Medieval Pilgrim's Tale
The second manuscript exhibited in *Éire/Land*[6] is a compilation put together during the first half of the fifteenth century in England of matter relating to visions, travels, and romances (no. 2). The first part contains the "Travels of Sir John Mandeville," recounting a fictional journey to the Holy Land and the East; the second is a Breton romance, "Sir Gowghter;" the fourth is "Tundal's Vision of Hell." The third, shown here, is an account of St. Patrick's Purgatory, the famous pilgrimage site in Lough Derg, Co. Donegal, which is still the focus of many modern pilgrimages.

This text recounts the vision of William Staunton, an English pilgrim from County Durham, seen by him on Friday, 20 September 1409 (Ward ii, 484; Krapp 58). It is written in Middle English and introduced in the manuscript by a colored drawing of St. Patrick, depicted as a haloed bishop standing on a small patch of ground, representing the island, and surrounded by fiends and souls in torment. The regimen of fasting and grueling physical deprivation and endurance practiced by those visiting Lough Derg surely contributed to its reputation, already well-established in the Middle

Ages, as a place of mystical experiences and visions. Pilgrims traveled to the island from far and wide, including one knight who came from Hungary in hopes of a divine visitation. Glimpses of hell were especially popular visionary experiences, belonging to a long tradition initiated by the Irish St. Fursey in the early-seventh century and culminating in Dante's *Inferno*. Widely circulated accounts of pilgrims' experiences represented one of the few means by which the rest of Europe learned of Ireland during the later Middle Ages.

Illuminated Address Presented to the Marquess of Downshire by his Tenants: a Victorian Vision of the Feudal Ideal

The third manuscript exhibited in *Éire/Land* is an illuminated address presented to Arthur Wills Blundell Trumbull Sandys Roden Hill, Earl of Hillsborough, 5th Marquess of Downshire, celebrating his coming of age on his twenty-first birthday, 24 December 1865—at which time he would have assumed full responsibility for his estates. This much later manuscript perpetuates the medieval traditions of calligraphy and illumination as part of the Victorian Gothic revival.[7] The elaborately bound address was commissioned from the Belfast firm of Marcus Ward and Company by the tenants of the Downshire estates at Dundrum and Ballykinler, Co. Down. The names of the subscribing tenants are included, as is the Marquess's signed reply.

The manuscript opens with the arms of Lord Hillsborough and is written in a formal Gothic book script, set within elaborate illuminated borders incorporating vignettes depicting views of the estates. The Marquess's residences and hunting lodges appear within romantically idealized settings typical of the contemporary landscape tradition; they are occasionally juxtaposed, as in the exhibited image, to the mills and other working buildings of the estates. The image invokes the good stewardship of the land and the constructive working relationship between landowner and tenant. The medieval feudal ideal signaled by the use of Gothic decoration and script was highly appropriate for its purpose, but was in stark contrast to the harsh realities of life experienced by the majority of Irish people in 1865. ❖

Endnotes

1 For more comprehensive discussions of Gerald of Wales see Richter, Bartlett, O'Meara, and Brown.

2 See, for example, Cohen, especially ch. 5, "Hybrids, Monsters, Borderlands: the Bodies of Gerald of Wales," 86–104; Cairns and Richards 3, 20.

3 In this respect Gerald resembles the twentieth-century writer George Bernard Shaw, as they were given the respective epithets "Gerald the Welshman"/"Bernard the Irishman."

4 British Library, Royal MS 13.B.viii

5 Dublin, National Library of Ireland, MS 700, f.48r

6 British Library, Royal MS 17.B.xliii

7 British Library, Additional MS 51314

Works Cited

Bartlett, Robert. *Gerald of Wales, 1146–1223*. Oxford: Oxford University Press, 1982.

Brown, M.P. "Marvels of the West: Gerald of Wales and the role of the author in the development of marginal illustration." Ed. A. Edwards. *English Manuscript Studies* 6, London: The British Library, forthcoming.

Cairns, David and Shaun Richards. *Writing Ireland: Colonialism, Nationalism, and Culture*. Manchester: Manchester University Press, 1988.

Cohen, Jeffrey Jerome. *The Postcolonial Middle Ages*. Basingstoke: MacMillan, 2000.

Gerald of Wales. *The History and Topography of Ireland*. Ed and trans. J. J. O'Meara. Revised ed. New York: Penguin Books, 1985.

Gillingham, John. "The Beginnings of English Imperialism." *Journal of Historical Sociology*. 5.4 (1999) 329–409.

Heaney, Seamus. *Opened Ground: Poems 1966–1996*. London: Faber and Faber, 1998.

Krapp, George Phillip. *The Legend of St Patrick's Purgatory: Its later literary history*. Baltimore: J. Murphy Co., 1900.

Richter, Michael. *Giraldus Cambrensis: The growth of the Welsh nation*. Aberystwyth: National library of Wales, 1972.

Ward, H. *Catalogue of Romances in the Dept. of Manuscripts of the British Museum*, 2 vols. 1883–1893. London: Printed by order of the Trustees.

DIGGING

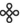

Art/Full Ground: Unearthing
National Identity and an Early Medieval "Golden Age"

Nancy Netzer

A SACRED NECROPOLIS AND FOCUS OF CEREMONIAL ACTIVITY FROM THE NEOLITHIC PERIOD UNTIL THE INTRODUCTION OF CHRISTIANITY, THE HILL OF TARA IN COUNTY MEATH WAS CELEBRATED IN IRISH MYTHOLOGY AS THE CHIEF SEAT OF THE HIGH-KINGS OF IRELAND.[1] IN 1868, ANTIQUARIAN WILLIAM STOKES described the significance of this site within a "national" landscape:

> The Royal Tara, a grassy hill of moderate height, yet commanding a most extensive prospect, is truly the locality in Ireland of the deepest interest to all inquirers into our national history. The oldest bardic legend ascribes to it the honour of having been the seat of a long line of Irish kings, stretching back to the times of the Fir-Bolgs and the Tuatha de Danaan, and down to the time of Patrick and of Christianity, and in addition, notices of Temur of Tara, as a chief seat of government from the third to the sixth century, are held as reliable.
>
> Here, too, the various lives of St. Patrick agree that Christianity was first preached to the King of Ireland, and its spread throughout the country dated from this period. It was natural, then, to anticipate that in the existing remains on Tara Hill, so long a place of great importance, some verification of the ancient manuscripts relating to it would be obtained, while these, in their turn, would throw light on the monuments themselves. (Stokes 1868, 110)

In the 1830s, John O'Donovan, archaeological and place-names officer of Ireland's Ord-nance Survey,[2] produced a map for County Meath (no. 8), the first connecting the manu-script accounts Stokes cites above to extant ar-chaeological remains on the Tara Hill (Ó Ríordáin 9–12; Newman 3–5; Boyne 64–65). O'Donovan's work was soon amplified by his colleague George Petrie (1790–1866) in a paper on the "History and Antiquities of Tara Hill," presented in 1837 to the Royal Irish Academy (Petrie 1839). Artist (nos. 15 and 16), musicol-ogist, antiquarian, topographical surveyor, and a founder of Irish archaeology, Petrie[3] supplied his listeners with a complete compilation of transcriptions and translations of historical ac-counts of Tara, as well as with descriptions of the site's archaeological remains. In systemati-cally assembling empirical evidence to accom-pany their mapping of Ireland, members of the Survey—often led by Petrie—laid the founda-tions for a scientific knowledge and verification of Ireland's distinctive early history and cul-ture. Reacting against the hegemony of English values, Petrie and his circle sought to assemble evidence vindicating nationalist claims for a separate Irish cultural identity.[4] In the context

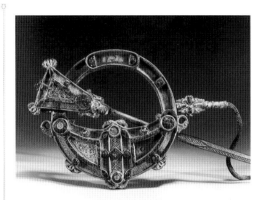

Fig. 1: *"Tara" Brooch*, Ireland, c. 700, Silver, gold, copper alloy, amber, and glass, National Museum of Ireland, acc. no R4015.

of a growing identification of antiquarian research with cultural revival and political nationalism, when an exquisite piece of jewelry[5] was discovered on 24 August, 1850 in County Meath, about ten miles from Tara Hill, its owner bestowed it with the misleading appellation of the "Tara" Brooch (fig. 1).

Although early accounts are inconsistent, the brooch was probably discovered by a poor woman or her children on agricultural land near the seashore "at the foot of a cliff from which a large piece had recently fallen" at Bettystown near Drogheda (Whitfield 1974, 120–142). As a stray find, allegedly plucked from the surface of the earth, the law of Treasure Trove would not have applied to the brooch; therefore it became the property not of Queen Victoria, but of the finder. She reportedly sold her find to Thomas North, a watchmaker in Drogheda, whose cleaning of the brooch revealed the unparalleled splendor of its cast ornament, gold filigree,

trumpet and spiral designs, enamel and amber studs, and plaited silver wire chain. Later that same year, North sold the brooch to the Dublin jewelers Waterhouse and Co. of Dame Street for nearly as many pounds sterling as he had paid pence for it (Waterhouse 7).

An astute businessman and publicist, George Waterhouse belonged to a group of merchants producing widely marketed replicas of Irish archaeological jewelry[6] (Whitfield 1974, 131; Sheehy 86; Dunlevy 14–19). In naming his brooch, he exploited the royal associations of Tara, the site upon which Petrie had recently focused the attention of the Royal Irish Academy. And, in lending its name to the most sumptuous and elaborate example of Irish medieval personal ornament, Tara and its surrounding area arguably derived romantic advantage from Waterhouse's new possession.[7] Indeed, some local people still maintain that the brooch was "dropped by a prince from Tara who came to bathe at Bettystown" (Whitfield 1974, 136). But for Waterhouse, the strategic naming of his new acquisition was a masterful advertising ploy. His appellation implied possible royal ownership of the brooch, bestowing glamour that quickly surrounded the replicas he began producing and marketing (no. 11).

Waterhouse set about elevating his "Tara" brooch to national prominence. He first lent it to the Royal Irish Academy for Petrie to study and display in the institution's museum. The Royal Irish Academy, the recorder of a growing body of material and documentary evidence, was founded in 1785 as a center for encouraging, coordinating, and focusing serious research on

Irish civilization.[8] But amateur antiquarians in Ireland began to pay serious attention to their native early Christian metalwork only in the later 1830s.[9] Such attention coincided with a growing interest in "national monuments," a term and concept that begins to appear with regularity in archaeological publications at this time[10] (Champion 123). By about 1835, the Academy, with Petrie playing a pivotal role, had begun a campaign to reorganize its collection and to acquire newly excavated works in order to establish a National Museum of Antiquities (Mitchell 109–126, 160). Since the eighteenth century, a burgeoning Irish population's use of previously marginal land for improvement, agriculture, and drainage had led to increasing discoveries of antiquities (Cooney 153). But for the most part, the finds unearthed were relatively modest examples of their types—such as the simple penannular brooches (nos. 9 and 10). Gentlemen scholars, including Petrie himself, began to collect these artifacts privately,[11] especially prizing those from sites with high historical profiles. And like Waterhouse, dealers shifted or fabricated connections to the land in order to enhance an object's symbolic and monetary value (Mitchell 130–131; Cooney 153–154).

In methodically organizing and collecting such artifacts for the Royal Irish Academy, and for himself as well (Mitchell 97–98), Petrie sought "to rescue the antiquities of [his] native country from unmerited oblivion and give them their just place among those of the old Christian nations of Europe" (Petrie 1845, v). With the goal of ordering the medieval antiquities into a systematic account of Ireland's

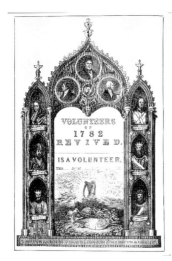

Fig. 2: "Volunteer Repeal Membership Card (1843–47)" with Irish symbols in the center surrounded by heroes, (from Sheehy, p. 28).

Christian past, he developed theories and techniques necessary to establish a chronology (Raftery 154). His efforts made these collections increasingly relevant to the aims of cultural nationalists in the 1830s and 1840s, who sought to construct an identity for Ireland surpassing that of Britain's. Indeed, antiquities in the Academy's collection even appeared as nationalist symbols reproduced on membership cards of Daniel O'Connell's political campaign to repeal the Act of Union. In 1843 and 1845, O'Connell brilliantly staged his "monster meetings" at historically significant sites, including the Hill of Tara.[12] Here, even before the 1850 discovery, members displayed cards printed with representations of antiquities including a penannular brooch (fig. 2)—in place of prohibited political flags and banners—as a

sign of empowerment (Cooney 152; Owens 1994, 37–39 and 1999, 114–115).

Thus, when Waterhouse deposited his "Tara" brooch with Petrie at the Academy in 1850, Petrie surely recognized its potential as a national symbol to be deployed in the ongoing construction of a distinctive Irish identity. Having produced his seminal work on Tara Hill several years earlier, Petrie was careful to refer to the "ancient brooch found near Drogheda" in his 1850 report to the Academy. Dating it in the eleventh or early-twelfth century, a period when "such arts were carried to the greatest artistic perfection" (1850, 38), he described the brooch as similar in genre to other "Irish fibulae," but, in its delicate execution and varied ornamentation, clearly "superior" to previous finds (1850, 36). Citing ancient Breton laws that the size and value of a brooch be in proportion to the rank of the wearer, Petrie speculated that the jewelry had belonged to a prince. Most importantly, he attributed its preservation after its recent discovery to the Royal Academy's efforts "to illustrate the past history of our country, and place it upon a solid basis." To illustrate the progress of such efforts, Petrie noted how previously, when an Irish antiquity had been presented to the Academy, a member queried whether "there exists the slightest evidence to prove that the Irish had any acquaintance with the arts of civilized life anterior to the arrival in Ireland of the English." Declaring that such a remark would now be unthinkable, Petrie concluded his presentation by requesting that as the recipient of "great pecuniary benefit" from the organiza-

tion's efforts to generate interest in such antiquities,[13] Waterhouse donate the brooch to the nation—i.e. to the collection of the Academy (Petrie 1850, 39–40).

Fortified by Petrie's imprimatur of its national importance but as yet unwilling to part with his prize possession, Waterhouse sent the "Tara" brooch and replicas for sale (at prices ranging from two to seven guineas) to represent Ireland at several international exhibitions. The brooch first traveled to London's Great Universal Exhibition of 1851 held in the Crystal Palace in Hyde Park.[14] According to Waterhouse in a pamphlet advertising his wares, "visitors...flocked in crowds to see it" and two replicas were purchased by the ultimate arbiter of taste, Queen Victoria (4–5, 14, 19–20). Such visibility attracted growing public interest in the brooch, seemingly marking a turning point in the deployment of medieval Irish metalwork as visual evidence in the campaign to shape a national identity on the foundation of a glorious Christian past. Subsequently in 1852, the brooch and replicas were displayed at the Belfast meeting of the British Association, the Great Industrial Exhibition of 1853 in Dublin (*Official Catalogue* 1853, 91, no. 1181),[15] in Paris in 1856, and again in London in 1863 (Whitfield 1974, 132; Dunlevy 18). The catalogue of the London exhibition, for example, argues that the brooch evidences "the high state of the art of the goldsmith and jeweller, as practiced in Ireland in ancient days." The entry ends by praising the Tara brooch as the most important relic of its kind yet discovered, and even more significantly,

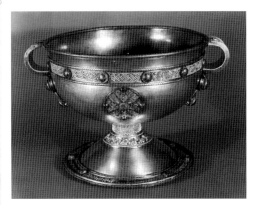

Fig. 3: *Ardagh Chalice*, Ireland, 8th c., Silver, gold, copper alloy, glass, amber, and crystal, National Museum of Ireland, acc. no. 1874:99.

by asserting that a people only recently "considered ignorant of almost everything appertaining to art" possessed a tradition of major artistic achievement (*Exhibition of Art-Industry in Dublin* 39). Ireland's past achievement had now become a means of assessing its contemporary artistry.

Varying in quality, size, and style, thousands of reproductions of the brooch—some even fabricated as bracelets—were commercially produced for private consumption as well as for exhibition.[16] Sold as emblems of an aristocratic past, they were marketed as national ornaments worn by Ireland's ancient chieftains.[17] The royal patronage of "Tara" brooch replicas touted by Waterhouse in his advertisements[18] made the more sumptuous examples fashionable ornaments on the bosoms of upper class Irish and English women. Low-end replicas in inexpensive hollow-stamped metal were consumed by tourists increasingly attracted to

Ireland by Petrie's guidebooks and topographical maps (Washer 118).

But such popularization of a precious artifact was not without risk. During its numerous peregrinations the brooch lost several of its ornamental panels (Whitfield 1976, 5–28), causing increasing concern among antiquarians. Nationalist and antiquarian Henry O'Neill deplored the "irreparable injury" to the brooch since it came into Waterhouse's hands and called for its transfer to the Royal Irish Academy (1863, 50). In a consummate act of self-interested philanthropy, the Waterhouse firm finally sold the "Tara" brooch to the Academy in 1868 for the exorbitant sum of £200, with the condition that it never leave Ireland (Mitchell 130).

In the very year that the brooch moved from commercial ownership to museological protection, a silver chalice[19] (fig. 3), four brooches,[20] and a smaller unadorned bronze chalice[21] were dug up by the son of a tenant farmer during a potato harvest at the site of a Celtic fort (*rath*) near the village of Ardagh, in County Limerick. This hoard was buried on the side of a bank in the fortifications, probably as the result of Viking activity in the late-ninth or tenth century (Bhreathnach 2001, 18–19). The path of this find from farmland to the protective ownership by the Royal Irish Academy was strikingly different from that of the "Tara" brooch that was unearthed eighteen years earlier. St. Mary's Convent, Limerick, the owner of the property and thus of the objects found on it, conveyed the Ardagh hoard directly to the Royal Irish Academy for examination shortly after it was dis-

covered (Dunraven 433–435; Gógan 17–19; Mitchell 138–139, Bhreathnach 2001, 15–16).

For the second time in less than twenty years, Irish land yielded nationalists tangible evidence of the splendor of Ireland's early Christian civilization. So important was the Ardagh discovery that the British expropriated it in accordance with the laws of Treasure Trove and transferred ownership to the Royal Irish Academy.[22] This decision recognized that the objects had been found "buried," not as in the case of the "Tara" brooch, on the surface of the land.[23]

The discovery of the Ardagh hoard fortunately coincided with the vice-presidency of the Academy of Petrie's close friend, Edwin Wyndham-Quin, 3rd Earl of Dunraven (1812–1871). A wealthy amateur antiquarian, steeped in Ireland's landscape and the romantic tradition of medievalism, Dunraven was also a Catholic convert. Having traveled throughout Ireland, drawing and photographing local ruins,[24] he chose the foremost British architect A. W. Pugin (1812–1851), designer of the medieval court in the Crystal Palace, to renovate his County Limerick home in a Gothic Revival style (Sheehy 61). As a committed medievalist, Dunraven enthusiastically embraced the newly excavated Ardagh objects, eager to have them analyzed and to record the circumstances of their unearthing. He immediately requested that Edmond Johnson, a jeweler on Suffolk Street in Dublin,[25] study, clean, and repair the chalice. The results of Johnson's disassembly and investigation formed part of a lengthy paper on the chalice that Dunraven presented to

the Academy at its 22 February 1869 meeting. In memorable language, he spoke of the site and chance unearthing as if recounting a folk tale:

In the parish, and close to the village of Ardagh, in the County of Limerick, there is a rath, called Reerasta. This rath is of the usual character, and of average size, its internal diameter being about fifty-seven yards. It is situated on a farm held by a widow of the name of Quin, and has been partly leveled for the purpose of tillage. She has for many years been under the impression that gold in large quantities was secreted somewhere within its precincts. She informed me that about twenty years ago, while tilling the ground, a beautiful chalice of gold was turned up about fifty yards west of the fort. Upon my inquiring what became of it, she told me that one day her children took it out of the house to play with, and that she never saw it again. Towards the end of September, 1868, her son was digging potatoes in the fort at the south-western side. On reaching the base of the bank, and close to a thorn bush, he found the surface soft; he drove the spade down between the roots of the thorn, and felt it strike against something hard, like metal. While cleaning the earth and roots to see what this could be, he thrust down his hand, and laid hold of the long pin of a fibula. He then excavated to the depth of about three feet,

and found a most beautiful cup laid in the earth, with a rough flagstone on one side of it, and inside the cup was a smaller cup and four fibulae. The small cup was the only article broken by the stroke of the spade. Excavations have since been made in the immediate vicinity of the spot where these articles were found, but nothing has turned up. (Dunraven 433)

Dunraven immediately recognized the ecclesiastical significance of this seemingly secular find.[26] In the very year in which the House of Commons was actively debating a bill for the disestablishment of the Irish church, Dunraven identified the object as a silver chalice. Comprising 354 pieces according to Edmond Johnson's analysis (Dunraven 438), it was splendidly decorated in cast gilt bronze, engraving, delicate punched inscription naming the apostles, enamel, crystal, plaited silver wire, and gold filigree.[27] Such workmanship, Dunraven wrote, displayed "a freedom of inventive power and play of fancy only to be equaled by the work upon the so-called Tara brooch" (439). Unable to locate a *rath* named Reerasta in the historical sources, Dunraven cited local lore to support his claim that the horde was deposited during the Danish invasions. In local tradition, he explained, the Irish took refuge in the fort during Danish persecutions: "The old people say that a great battle was fought on this spot before the time of Brian Boromha; the accuracy of the tradition as to the battle is corroborated by the number of human bones dug up in mak-

ing the present road beside the fort." He reported, moreover, that "in later times" Mass was celebrated at the site, and that a holy well named after St. Molua (d. 622) in the vicinity of Ardagh suggested that an ancient church was founded there by him (Dunraven 483–484).[28] This tradition, in addition to the "extreme beauty, grace and delicacy of the workmanship" especially of the "peculiarly Celtic design called the trumpet pattern," led Dunraven to the conclusion that "this most beautiful example of our ancient art was executed either in the ninth or tenth century" (451–452).

Dunraven's 1869 address before the members of the Royal Irish Academy launched the chalice on a trajectory culminating in its status as national icon. He described it as among Ireland's greatest early treasures and, perhaps, most significantly, as having no rivals in England.

When, in addition, the elegance of form, the rich and harmonious coloring of the component parts, as well as the variety and beauty of the designs, and the surprising skill of the workmanship are taken into consideration, we have every reason to rejoice that so exquisite a specimen of the skill and taste of the workers in metal of this country nearly one thousand years ago has been thus so strangely and unexpectedly brought to light. (452)

Together, the Ardagh chalice and the Tara brooch served as principal catalysts for the Celtic Revival decorative style that remained

fashionable in the British Isles until the 1920s.[29] Their popularity and influence on world design was due, in no small part, to the work of commercial artisans like Edmond Johnson. By means of electrotype—an accurate moulding method that uses both electrolysis and a plating vat—Johnson began to produce replicas of the chalice (no. 13) and brooches (no. 14) in the Ardagh hoard as well as of the Tara brooch (no. 12). His technical analysis of the construction of many other Irish antiquities in the Royal Irish Academy, as well as his impressions and plaster casts of them, informed these replicas. Although he strove to reproduce the originals in size and method of assembly, he "corrected" and "improved" the works by replacing lost elements and areas of wear (Washer 114). In his reproductions, Johnson sought to convey the "magnificence and splendour" of medieval objects that were once in "actual use" (7). He thus fabricated modern works like salvers and sugar bowls that imitated design elements of the newly excavated antiquities (Sheehy 155, pl. 124; Washer 116). Through the dissemination of such commercial products, Johnson transformed ordinary domestic objects into daily reminders of Ireland's medieval past—and, therefore, into ubiquitous emblems of nationality.

Nearly two hundred of Johnson's replicas of Irish antiquities, most reproducing objects from the Royal Irish Academy's collection, were displayed at the 1893 World's Columbian Exposition in Chicago. They ranged from the most sumptuous objects to simple fibulae, brooches, and torques, and varied in quality

(see Smith 108–109). Johnson explained the source of this project in an accompanying booklet:

The idea of making exact facsimile copies of all the most important specimens of our celebrated ancient Irish art metal work occurred to me on the first announcement of the "Great World's Fair" at Chicago. I had peculiar facilities for carrying out this work from the fact that my pattern drawers contained impressions and plaster casts actually taken from these relics of antiquity as they were found from time to time. In nearly every case some slight restoration was necessary to clear the dirt of ages from their fine traceries, and thus they found their way into my hands and those of my ancestors who preserved exact moulds of these art treasures which cannot now be touched in any of the various institutions in which these collections are preserved. (7)

Johnson's electrotype replicas appeared in two sections of the Chicago Exposition: in the British Manufactures area and in the two Irish Villages on the Midway. The latter, an amusement section, juxtaposed them with copies of Irish medieval castles, stone crosses, and Dunraven's photographs of medieval Irish monuments. All of Johnson's facsimiles in the Exposition were bought by the Columbian Museum in Chicago, after which the replicas began to be sold through Marshall Field's and other stores

in the Midwest, as well as at Tiffany and Company in New York City (Washer 114). There, they may have come to the attention of the Metropolitan Museum whose curator of metalwork, John Buck, purchased dozens of replicas between 1906 and 1908, including those in this exhibition (nos. 12, 13, and 14).

Through decades of international exhibitions and commercial exploitation, the Tara brooch and Ardagh chalice, products of what is now termed a "golden age" of Irish art,[30] became the major material sources, along with the *Book of Kells*[31] for constructing icons of Irish nationality. Waterhouse and Johnson's replicas, as well as those by other firms,[32] contributed to a process whereby "the two finest examples of goldsmiths' work of the Christian period in Ireland" (Stokes 1886, 451) gained an audience far greater than that ordinarily available to works of fine arts at the time. In the course of the twentieth century, an original nineteenth-century emphasis on the ground from which these objects came—near Tara in County Meath and in Ardagh, County Limerick—faded before the growing realization of their place in the cultural, historical, and art historical landscape of Ireland.[33] Carefully mapped on a theoretical spatial and temporal grid by 150 years of scholarship, the Tara brooch and Ardagh chalice epitomize the highest achievement of Irish medieval workmanship, with an artistry comparable to that praised by the twelfth-century Cambro-Norman writer Gerald of Wales in his *Topography of Ireland*. A marginal illustration in the earliest manuscript of his text (no. 19), probably illuminated accord-

ing to his instructions, depicts an artist from Kildare illustrating a book that Gerald describes as the "result of the work, not of men, but of angels."[34] Similar language has long been applied to the great discoveries of medieval Irish metalwork: in 1989, for example, the British Museum titled its exhibition including such masterpieces *The Work of Angels* (Youngs). The exquisite detail of the Tara Brooch and Ardagh chalice is now reproduced photographically on ordinary objects like postal stamps and schoolbook covers, and even digitally on computer screens. But despite years of commercial exploitation, the iconic status of these medieval objects, unearthed at a period of evolving nineteenth-century political and cultural nationalism, endures today as a daily reminder of a shared Irish identity. ❖

I thank Vera Kreilkamp and Niamh Whitfield for numerous suggestions that have informed this essay and my undergraduate research assistant Emily Hankle for collecting bibliography.

Endnotes

1 Recent archaeological investigation, however, has led scholars to question whether Tara was a "royal" site. See Newman, esp. xiv–xv; Bhreathnach and Newman 7–19 and for bibliography, Bhreathnach 1995.

2 The Ordnance Survey mapped all of Ireland on the scale of six inches to the mile, recording many neglected monuments. For discussion see Andrews; Boyne 8–50.

3 On Petrie see Stokes 1868; Raftery 153–157; Mitchell 95–99 and in this volume Berger 57–61.

4 For discussion of Petrie and his role in the nationalist movement, see Hutchinson 74–95.

5 National Museum of Ireland, acc. no. R 4015. For detailed discussion of all aspects of the brooch see Whitfield 1974, 1976, 1993, 1997, and 2001.

6 The connection of these replicas to the Irish land was considered so important that Waterhouse advertised the replicas as made "from the mineral products of Ireland," including Wicklow gold and Irish pearls and malachite (Dunlevy 18).

7 Only a limited number of objects have been excavated at Tara. The most well known are two gold torcs dating from about 1200 BC, unearthed in about 1810. From the early medieval period, there is an annular brooch in the British Museum (Youngs 97–98, no. 77) and a block of red enamel (Youngs 201, no. 196) that may have been found there. For discussion and bibliography see Bhreathnach 1995, 29 and 145–148.

8 On the history of the collections of the Academy see Mitchell 106–144.

9 This move coincided with a program of national archaeology throughout the British Isles. The Irish Archaeological Society was founded in 1840, and Petrie was active in founding the Celtic Society in 1845. The British Archaeological Association was founded in 1843, the Archaeological Institute of Great Britain and Ireland in 1845. In addition dozens of county societies, including a prominent one at Kilkenny, were founded in the 1840s and 1850s. For discussion see Champion.

10 For example, the nationalist and antiquarian artist Henry O'Neill devotes an entire book in 1863 to collecting and illustrating examples (including the Tara brooch, 49–54) of Irish medieval craftsmanship that he believes to be in a "completely national" style and "the very finest examples of ornament ever executed" (V). He also devotes a chapter to quotations from non-Irish authors praising the Irish medieval style (9–16). On the "national character" of Irish stone crosses see O'Neill 1857. The uniqueness of the Irish medieval style, for which O'Neill argues, supports his theory of Ireland as a nation unified by an indigenous medieval artistic culture. For discussion and bibliography on Irish stone crosses as cultural emblems see Williams 2000, 1–11, 43–52; 2001, 141–151.

11 At first, excavated antiquities passed through watchmakers and jewelers, but later specialized dealers took over the trade. On private collections, dealers, and excavations supplying Irish antiquities see Mitchell 97–98; 104–112.

12 In his address at Tara (*The Nation*, 19 August, 1843, 707), O'Connell (to whom the Ordnance Survey Map, no. 8 in this exhibition, belonged) reveals how the site was exploited for contemporary political purposes by nationalists: "This is emphatically the spot from which emanated the social power—the legal authority the right to dominion over the furthest extremes of the island, and the power of concentrating the force of the entire nation for the purpose of national defense. On this important spot...I protest against the continuance of the unfounded and unjust union."

13 On the day Petrie presented the brooch to the Academy, 9 December 1850, Waterhouse registered a copyright for a design for his Tara replica (Dunlevy 17).

14 Seeing the Tara brooch alongside its replicas at the Crystal Palace and recognizing that many of the brooch's decorative motifs were similar to those painted in the *Lindisfarne Gospels* (London, British Library, MS Cotton Nero D.IV) may have inspired the then Bishop of Durham in 1853 to commission that manuscript's present metalwork binding based on the book's illumination (Brown forthcoming).

15 The whole collection of the Museum of the Royal Irish Academy, as well as antiquities and replicas of them from other sources, were displayed, to the public virtually for the first time, at the Irish Industrial Exhibition held in Dublin in 1853. This was the best and most comprehensive collection of Ireland's antiquities ever brought before the public. The works shown in an antiquities court—an unusual feature of an industrial exhibition at the time—comprised Irish objects, primarily in stone and metal, from the Iron Age through the fifteenth century. The purpose of the inclusion was clearly stated repeatedly throughout the *Exhibition Expositor and Advertiser*, 24 vols, Dublin, 1853. Seeking to conflate the past and present in people's minds, the organizers used these objects to provide tangible evidence of a period when Ireland was in the forefront of artistic development and to signify that the promise of Ireland's industrialized future lay in the illustrious past of the Irish people.

16 For examples see Sheehy, pls. 11, 70, 76; Camille 20–21.

17 Waterhouse states "Ireland can now boast of the continued use of peculiarly national ornaments, worn by her princes and nobles in ages long since past" (4).

18 For examples of advertisements see the *Conservative* of Drogheda September 7, 1850 and the 1853 *Tourists Illustrated Handbook of Ireland* reproduced in Whitfield 1974, 133 pls. 6a-b.

19 National Museum of Ireland, acc no. 1874:99.

20 National Museum of Ireland, acc. nos. 1874:101–104. See Bhreathnach 2001, 15–16.

21 National Museum of Ireland, acc. no. 18 74:100.

22 For details and discussion of transfer of ownership in the 1870s see Gógan 1932, 19–20 and Mitchell 136–141. In 1861, the crown delegated to the Royal Irish Academy the franchise to administer Treasure Trove in Ireland.

23 For discussion of the "Tara" brooch and the law of Treasure Trove see Whitfield 1974, 122, 133–134.

24 Margaret Stokes published this work after Dunraven's death in *Notes on Irish Architecture*.

25 On the firm see Washer 107–121.

26 For recent discussion of the ecclesiastical significance of the hoard's contents see Bhreathnach 2001, 16–21.

27 The materials and construction of the chalice were analyzed and compared to Johnson's description in the Research Laboratory of the British Museum between 1961 and 1963. See Organ 238–271.

28 Gógan 1932, 20–26 expands upon Dunraven's historical description of the site, again without revealing any important political or historical connections. For the most recent discussion of the site see Bhreathnach 2001, 16–19.

29 Based on decorative motifs from ancient Celtic art in Ireland and Britain and closely related to the English Arts and Crafts movement, the style was used to decorate a wide range of objects including metalwork, textiles, jewelry, wall decorations, and stone carvings. Making its first appearance in the 1840s, the Celtic Revival reached the height of popularity in the 1890s. For discussion see Sheehy 147–175.

30 Both objects are now dated to the eighth century. For a recent and concise discussion of the "golden age" in Irish metalwork from the later seventh to the mid-ninth centuries see Ryan 26–41. The idea of an artistic "golden age" must have been inspired by the same term used by historians, like the nationalist Eoin MacNeill (*Phases of History*, Dublin 1919), for the early medieval period when, he argued, the Irish people unified through Christianity and hence, the Irish nation was formed (Cooney 154–155).

31 Dublin, Trinity College Library MS A.I.6 (58).

32 Including West and Son and Hopkins and Hopkins, which even fabricated a brooch based on the Ardagh Chalice (Sheehy 86–87, 155, pl. 125; Washer 118; Dunlevy 19–20).

33 With the rest of the antiquities in the Royal Irish Academy, the Tara brooch and Ardagh chalice were transferred to Dublin's newly opened Museum of Science and Art, which, with the emergence of the Irish Free State in 1922, changed its name to the National Museum of Ireland. See Mitchell 132–136. The National Museum, where they remain today, is the national repository for portable archaeological material from Europe.

34 See Brown, "Shaping and Mis-Shaping: Visual Impressions of Ireland in Three Illuminated Manuscripts," (44).

Works Cited

Andrews, J. H. *A Paper Landscape: The Ordnance Survey in Nineteenth Century Ireland*. Oxford: Oxford University Press, 1975.

Bhreathnach, Edel. *Tara: A Select Bibliography*. Dublin: Royal Irish Academy, 1995.

---. "The Cultural and Political Milieu of the Deposition and Manufacture of the Hoard Discovered at Reerasta Rath, Ardagh, Co. Limerick." *Pattern and Purpose in Insular Art*. Ed. M Redknap, N. Edwards, S. Youngs, A Lane and J. Knight. Oxford: Oxbow Books, 2001. 15–23.

Bhreathnach, Edel and Conor Newman. *Tara*. Dublin: Government of Ireland, 1995.

Boyne, Patricia. *John O'Donovan (1806–1861) a biography*. Kilkenny: Boethius, 1987.

Brown, Michelle. *The Lindisfarne Gospels: Society, Spirituality and the Scribe*. Lucerne: Facsimile Verlag, forthcoming.

Camille, Michael. "Domesticating the Dragon: The Rediscovery, Reproduction, and Re-Invention of Early Irish Metalwork." *Imagining an Irish Past: The Celtic Revival 1840–1940*. Ed. T.J. Edelstein. Chicago: Smart Museum of Art, 1992. 1–20.

Champion, Timothy. "Three Nations or One? Britain and the National Use of the Past." *Nationalism and Archaeology in Europe*. Ed. M. Díaz-Andreu and T. Champion. Boulder: Westview Press, 1996. 119–145.

Cooney, Gabriel. "Building the Future on the Past: Archaeology and the Construction of National Identity in Ireland." *Nationalism and Archaeology in Europe*. Ed. M. Díaz-Andreu and T. Champion. Boulder: Westview Press, 1996. 146–163.

Dunlevy, Mairead. *Jewelry: 17th to 20th Century*. Dublin: National Museum of Ireland, 2001.

Dunraven, Earl of. "On an Ancient Chalice and Brooches lately found at Ardagh, in the County of Limerick." *Transactions of the Royal Irish Academy* 24, 1867–1874: 433–454.

The Exhibition of Art-Industry in Dublin. Dublin: Virtue & Co., 1853.

Gógan, L. S. *The Ardagh Chalice*. Dublin: Browne and Nolan Limited, 1932.

Hutchinson, John. *The Dynamics of Cultural Nationalism: The Gaelic Revival and the Creation of the Irish Nation State*. London: Allen & Unwin, 1987.

Johnson, Edmond. *Description and History of Irish Antique Metal Work Facsimile Reproductions*. Dublin, 1893.

Mitchell, G. F. "Antiquities." *The Royal Irish Academy: A Bicentennial History 1785–1985*. Ed. T. O. Raifeartaigh. Dublin: Royal Irish Academy, 1985. 93–165.

Newman, Conor. *Tara: An Archaeological Survey*. Dublin: Royal Irish Academy, 1997.

O'Neill, Henry. *Illustrations of the Most Interesting of the Sculptured Crosses of Ancient Ireland*. Dublin, 1857.

---. *The Fine Art and Civilization of Ancient Ireland*. London: Smith, Elder, and Company, 1863.

Official Catalogue of the Great Industrial Exhibition. Dublin, 1853.

Organ, Robert. "Examination of the Ardagh Chalice: A Case History." *Application of Science in Examination of Works of Art*. Ed W. Young. Boston: Museum of Fine Arts, 1973. 238–271.

Ó Ríordáin, Seán P. *Tara: The Monuments on the Hill*. Dundalk: Dundalgan, 1954.

Owens, Gary. "Hedge Schools of Politics: O'Connell's Monster Meetings." *History Ireland* (1994): 35–40.

---. "Visualizing the Liberator: Self-fashioning, Dramaturgy, and the Construction of Daniel O'Connell." *Éire-Ireland* 34 (1999): 103–130.

Petrie, George. "On the History and Antiquities of Tara Hill." *Transactions of the Royal Irish Academy* 18 (1839): 25–232.

---. *The Ecclesiastical Architecture of Ireland, Anterior to the Anglo-Norman Invasion*. Dublin: Hodges and Smith, 1845.

---. "On an Ancient Brooch Found Near Drogheda." *Proceedings of the Royal Irish Academy*, 5 (1850): 36–40.

Raftery, Joseph. "George Petrie, 1789–1866: A Re-Assessment." *Proceedings of the Royal Irish Academy*, 72c (1972): 153–157.

Ryan, Michael. *Metal Craftsmanship in Early Ireland*. Dublin: Country House, 1993.

Sheehy, J. *The Rediscovery of Ireland's Past: The Celtic Revival, 1830–1930*. London: Thames & Hudson, 1980.

Smith, Elizabeth. *Medieval Art in America*. University Park: Palmer Museum of Art, 1996.

Stokes, Margaret. "Inquiry as to the Probable Date of the Tara Brooch and Chalice found near Ardagh." *Proceedings of the Royal Irish Academy* 2 (1886): 451–455.

Stokes, William. *The Life and Labours in Art and Archaeology of George Petrie*. London: Longmans, Green, & Co., 1868.

Washer, Cheryl. "The Work of Edmond Johnson: Archaeology and Commerce." *Imagining an Irish Past: The Celtic Revival 1840–1940*. Ed. T. Edelstein. Chicago: Smart Museum of Art, 1992. 106–121.

Waterhouse & Co. *Ornamental Irish Antiquities*. 2nd ed. Dublin: I. & E. MacDonnell, 1853.

Whitfield, Niamh. "The 'Tara' Brooch: An Irish Emblem of Status in Its European Context." *From Ireland Coming*. Ed. C. Hourihane. Princeton: Princeton University Press, 2001. 211–248.

---. "Corinthian Bronze and the Tara Brooch." *Archaeology Ireland* 11 (1997): 24–28.

---. "The Filigree of the Hunterston and 'Tara' Brooches." *The Age of Migrating Ideas*. Eds. R.M. Spearman and J. Higgitt. Edinburgh: National Museums of Scotland, Alan Sutton Publishing, 1993. 118–127.

---. "The Original Appearance of the Tara Brooch." *Journal of the Royal Society of Antiquaries of Ireland* 106 (1976): 5–30.

---. "The Finding of the Tara Brooch." *Journal of the Royal Society of Antiquaries of Ireland* 104 (1974): 120–141.

Williams, Margaret. "The Sign of the Cross: Irish High Crosses as Cultural Emblems." Diss. Columbia University, 2000.

---. "Constructing the market Cross at Tuam: The Role of Cultural Patriotism in the Study of Irish High Crosses." *From Ireland Coming*. Ed. C. Hourihane. Princeton: Princeton University Press, 2001. 141–160.

Youngs, Susan. *The Work of Angels*. London: British Museum, 1989.

Sacred Landscapes and Ancient Rituals:
Two Watercolors by George Petrie

Pamela Berger

◇

THE GREAT CELTIC REVIVAL OF LATE NINETEENTH-CENTURY IRELAND WAS IN NO SMALL PART INITIATED BY THE WORK OF GEORGE PETRIE. HIS STUDIES OF ANCIENT MONUMENTS AND INSCRIPTIONS, AS WELL AS HIS COLLECTIONS OF EARLY IRISH MUSIC AND METALWORK, LED TO THE FLOURISHING OF A CULT OF Celtic art and history and contributed to the development of cultural nationalism. His studies of motifs from newly discovered sculpture, jewelry, and liturgical vessels became a major source for those who were to translate the ancient Celtic style into a national vocabulary of ornament. By the early-twentieth century, groups working toward political and cultural autonomy looked to this recently resurrected past as they fashioned an Irish identity based on what could be read as a rich, indigenous cultural heritage. Petrie's work thus both anticipated and nourished the achievements of Ireland's late nineteenth- and early twentieth-century Literary Revival.

This paper focuses on a different dimension of Petrie's achievements: two of his watercolors, both dealing with land that had been sacralized in the distant past. *Last Circuit of Pilgrims at Clonmacnoise* (1828) depicts the ruins of a monastic burial ground made holy by the remains of Early Christian monks (no. 16); *St. Brigit's Well* (1830) portrays the pre-Christian cultic site of an ancient therapeutic goddess, a place that, through syncretism, was later dedicated to Saint Brigit (no. 15). Both watercolors bear witness to a deep-seated human attachment to sacred space. Petrie recorded this attachment and valorized such spaces, giving them a new meaning for future generations.

Petrie's career as a scholar was interconnected with his work as a painter. What moved him as an artist impelled him to undertake the precise measurements and descriptions necessary for rigorous archaeological studies. What excited him about the particularity of the Irish landscape drove him to study the strata of cultures on the land. And, in order to arrive at such knowledge, he recorded inscriptions, collected artifacts, and secured ancient manuscripts.

Born in Dublin in 1789, George Petrie was an only son of Scottish parents and thus belonged to a Protestant middle class, rather than to the majority Catholic Irish population or the ruling-class Ascendancy. His earliest journal entries were begun when he was nineteen.[1] In them, he registers the irony that the Irish, with so rich a cultural history, still suffered "under the accumulated evils of poverty and degradation." Even as a young man, Petrie recognized that they were denied access to their history by scholars who had "taken up the subject to bring it into contempt" (qtd. in Stokes 23).

Since the eighteenth century, a growing interest in the past encouraged antiquarians to examine the extant ruins of Ireland's landscape—with a particular focus on the Round Towers appearing throughout the countryside (Leerssen 108). However, these early scholars had none of

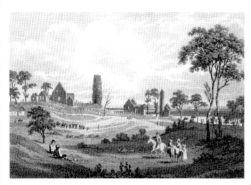

Fig. 1: George Petrie, *Ruins of Clonmacnoise*, Kings County. Engraved by J. and H. S. Storer, in *Beauties of Ireland*, Vol. 2. by J.N. Brewer. London. Sherwood, Gilbert, and Piper. 1826.

the linguistic, textual, or archaeological resources necessary for an accurate determination of either the origin or the uses of these unique architectural structures. Thus, they developed some wild hypotheses: that they were Chaldean fire-structures, phallic emblems, or even Buddhist temples. Basing his work on solid scholarship, Petrie ridiculed these fantasies and derided those supposedly "learned people" who attributed these Round Towers to the Phoenicians, the Persians, or the "Indo-Sythians" (Petrie *Eccles. Arch.* 11–12, 124). He foresaw that eventually his work would undermine assumptions that invading or distant cultures had erected Irish antiquities. Understanding the importance of an accurate national history based on firm knowledge of inscriptions, manuscripts, and archaeological remains, he dedicated his life to that end.

When still young, Petrie began visiting remote pagan and early Christian sites in the Irish countryside and recorded these youthful experiences in his journal. These entries reveal the emotional and intellectual sources of his life-long preoccupation with landscape and the ancient structures on it. He scrambled through underground vaults and guessed that the remains he found within were "human bones burnt" (qtd. in Stokes 2–3). As he walked around circles of standing stones he speculated about the meaning of the strange lines incised on their edges. He learned that pilgrims still flocked to *cromlechs* and practiced rites that he surmised might be thousands of years old. Marveling at cairns rising up to support what he thought might be "pagan altars," Petrie wrote about a pre-Christian "spring well renowned for its medicinal virtue." He realized that many of the Christian sites he explored might be related to the still more distant pagan past, and intuited from his knowledge of recent Irish folklore that ancient ruins were later given Irish names.

Many of his early hunches were corroborated by twentieth-century scholarship. Archeologists now realize that megalithic passage tombs and *cromlechs,* originally constructed at least two thousand years before the first millennium, were used by later peoples as cultic sites where animal bones formed part of the rites. Today, the incised marks on the edges of the Neolithic uprights are recognized as examples of Ogham script, a pre-Latin form of Celtic writing. Scholars have only recently been able to decipher these Ogham inscriptions as memorials.

Petrie grasped that the ancient attachment to the land and the rituals associated with it were part of *la longue durée*. He speculated that the Christian festival manifesting itself in the St. Lammas fairs, celebrated on August 1, was connected with pagan rites; the twentieth-century research of Máire MacNeill demonstrated that such fairs did indeed develop from the pre-Christian Celtic Lughnasa assemblies (287). Indeed, the archaeological vestiges of the many-layered culture of Ireland—Neolithic, Celtic, Christian—were apparent to Petrie, who anticipated the modern scholar's understanding of syncretism, of how a feature of the landscape or a structure on it can be "rededicated" to a new belief system.

From 1817–1821, Petrie studied drawing in England, and upon returning to Ireland, he again explored the countryside, sketching mountains, rivers, waterfalls, and ruins. These images were intended to be turned into engravings for travel books meant for a growing leisure class fleeing England's industrial revolution and seeking "pretty sights"[2] (fig. 1). Ironically, although belonging to a reigning colonial system that contributed to the eradication of Celtic languages and customs, this middle- and upper-class audience delighted in images that included "picturesque" peasants and rustic villages.

Unlike his contemporaries, in his own watercolors Petrie rejected the merely picturesque. Whereas recent research on the patterns of Irish landscape arts suggests that contemporary Victorian artists stayed close to Dublin and Wicklow, Petrie traveled to relatively inaccessible areas, remote from the fashionable tourist sites of the day (Duffy 30). His journals

reveal that he sought out historically resonant landscapes "...composed of several of the monuments characteristic of the past history of our country, and which will soon cease to exist..." Petrie wrote of his desire to "connect with them the expression of human feelings equally belonging to our history..." (qtd. in Stokes 15); he achieved his goal in the 1928 watercolor, *Last Circuit of Pilgrims at Clonmacnoise* (no. 16).

Themes woven into the journal and depicted in the watercolors express many of the central tenets of Romanticism, the dominant literary and artistic movement of the nineteenth century that profoundly influenced Petrie as a young man. Infusing *Last Circuit of Pilgrims at Clonmacnoise* with a light that appears spiritual, Petrie invites the observer to experience something of the sentiments he felt when he first saw the monastic complex.

Let the reader picture to himself a
gentle eminence on the margin of a
noble river, on which, amongst majes-
tic stone crosses and a multitude of
ancient grave-stones, are placed
two lofty round towers and the ruins
of seven or eight churches, presenting
almost every variety of ancient
Christian architecture. A few lofty ash
trees, that seem of equal antiquity
and sanctity, wave their nearly leafless
branches among the silent ruins above
the dead.... On the left still remain
the ruins of an old castle, once the
palace of the bishops, not standing, but
rather tumbled about in huge masses

on the summit of a lofty mound or
rath.... Readers who have had no expe-
rience of the feelings excited in the
mind by scenes like this, can have little
idea of the deep effect they are capable
of producing... (qtd. in Stokes 28–29)

Here, the language of a young man's journal reflects that Romanticism later to be summoned up by his painting of the same scene. Describing ancient Christian monastic architecture as well as old castles or *raths*, Petrie expresses his elevated feelings through words such as "noble," "majestic," and "lofty." Nature in the form of antique, sanctified trees contributes to the silent, elegiac mood. All his senses were alive to—even excited by—the shapes, colors, and sounds of the sacred place.

Although the engraving made from Petrie's early drawing of Clonmacnoise is viewed from an angle similar to that of the watercolor, the earlier image is rigid and dry by comparison (fig. 1). It is dominated by the verticals of the trees, the block-like ecclesiastical structures, and stiff unemotional figures; the funeral cortege in the middle ground fails to elicit any sense of melancholy. In the later watercolor, however, Petrie totally transforms the engraving of Clonmacnoise—imbuing the painting with visual representations of his earliest emotional response to the site. The saffron glow of the sky and the setting sun are reflected off the finely incised grave slab in the foreground. The crevice between the small dark knolls behind the slab opens a trajectory

that leads past a line of three back-lit pilgrims and through the path of sunlight gleaming on the Shannon.

The details of the painting reveal the artist's interest in nineteenth-century ritual suggestive of medieval pilgrimage: the figures participate in a circuit of the faithful. Those closest to the foreground rise up from the dark chasm surrounding the gravestones. The cavernous space out of which they move is reminiscent of the pits from which souls arise in traditional medieval Last Judgements. As the figures in the foreground emerge from the abyss, they proceed to the left and approach a church façade. In front of the arched entrance, a penitent kneels in prayer before she enters. To the right of the church is another stop on the circuit, an ancient stone cross. At the foot of the shaft are worshippers, some prostrate, others kneeling or bending in silent meditation, as the sun illuminates the sculpture that adorns the side of the shaft. The scenes carved on this cross at Clonmacnoise depict the Crucifixion and the Last Judgement, themes pertinent to this watercolor, although Petrie has chosen to set the cross into a hazy middle ground where the sculpted figures are dissolved in tones of gold and gray. One pilgrim has left the circle around the cross and passes into a space crowned by the distant ruins of a Norman castle and a chapel. The stone slabs of the graveyard are arranged so that they form L-shapes leading the eye toward the right. A procession of supplicants passes in front of the round tower and down the slope toward the next holy site, as a pilgrim,

wearing a flowing cloak and holding the traditional staff, points out the way.

The themes woven into Petrie's journal and depicted iconographically and stylistically in this watercolor are part of the fluid movement known as Romanticism. As with other romantic painters, Petrie seeks to elicit a strong emotional response, first through his style, with a highly contrasted palette, warm tones, dramatic lighting, and sweeping diagonal vistas, and then through his subject matter. He has chosen particularly romantic motifs: majestic ruins evoking the distant past; tombs in a graveyard calling forth thoughts of the end of life; thousand-year-old structures representing the long-neglected and rich "medievalism" found in the Irish landscape; churches, crosses, and processions bearing witness to the religious revivalism inspired by the reactions against eighteenth-century rationalism. As with other romantic painters, Petrie is fascinated with the "folk," the peasants enacting their ancient rites. By his thematic choice to portray the poor Catholic supplicants with dignity, he reveals a subtle hostility toward an establishment that demeaned Catholic tradition.

Although the elements of the watercolor—the church, the castle, the round tower, and the cross—are diffused in a romantic haze, the artist's knowledge of archaeology is evident in his imagery. From his study of inscriptions on the slabs of Clonmacnoise, as well as from the early manuscripts he had consulted, Petrie knew that this monastic complex had once been the cemetery of princes desiring burial in sacred ground close to where monks had worked and prayed. He was aware that those medieval monks, who had copied Celtic mythological and early Christian texts, had long been unrecognized and undervalued: "In a dark age," he declared, these monks "marched among the foremost on the road to life and civilization" but were "checked and barbarized by those who were journeying in the same course and ought to have cheered them on" (qtd. in Stokes 34).

The land at Clonmacnoise had been considered holy for over a thousand years: the site of the second Petrie watercolor in the exhibition, *St. Brigit's Well* (no. 15), for over two thousand. In this small painting, Petrie again evokes long-practiced rituals—suppliants petitioning divine powers for health and well being. Both works are grounded in his fascination with the ancient resonances of sacred space. Although the site depicted in *St. Brigit's Well* was nominally Christian, Petrie understood its deep pagan antecedents; as with so many other pagan holy places it was "rededicated" to a Christian saint. Early medieval culture provides many examples of such rededications, the process now recognized as syncretism. A couplet in the "Leabhar Breac"—an Early Christian Irish text—describes the sixth-century St. Columba consecrating a pre-Christian well: "He blessed three hundred miraculous crosses. / He blessed three hundred wells which were constant" (qtd. in Stokes 17).

Again, Petrie visually explored what scholarship has since recognized. In pre-Christian Ireland goddesses were usually linked with the earth, but they were also associated with water. Though *Éire*, the Great Mother goddess, was a personification of the land, the name of the River Shannon reveals that it too was connected with an Ancient Goddess.[3] Even more frequently than rivers, springs are associated with pagan goddesses, especially Brigid, and thus, when the goddess was syncretized with the sixth-century historical figure Saint Brigit, the springs and wells formerly linked with the goddess came to be dedicated to the saint.

Cogitosus, Brigit's eighth-century biographer, verifies this link. He recounts how, to heal her sick foster mother, Brigit drew water from a well and made it into a "tasty and intoxicating" liquid that immediately cured the woman (Cogitosus 123). Later, Brigit produced a miraculous spring when her brothers taunted her by saying that she would be forced to marry: the "...beautiful eye which is in [her] head will be united with a man." "Brigit promptly told them to '...apply... my staff to that sod in front of you.' It was done. A stream gushed forth from the earth" (Cogitosus 125). These tales from the earliest stratum of the Brigit legends are multiplied many times in later texts and folkloric accounts.

Petrie chose a surprising angle from which to depict the site, for his interest is not in the well, but in the petitioners who have come to seek healing. On the right, a stream emerges from a dark cavern screened by craggy branches. The water snakes around a promontory and disappears behind a hillock on the left. The vessels and staff in the right foreground allude to a classical motif; such urns evoke those traditionally held by river gods often reclining

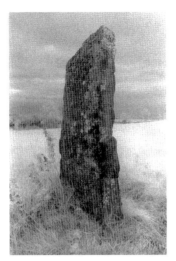

Fig. 2: Stephen Vedder, *Megalithic Upright*, 1988, infrared black and white photograph. Collection of the photographer.

in the corners of earlier classicizing paintings. Petrie paints the pilgrims in garments that, for him, evoked the red and purple colors of traditional Irish dress. The women face what we cannot see, the well of holy water.

In some locales, the practice of visiting therapeutic wells dates only from the last few hundred years. Petrie's holy well, however, has far more ancient resonance, for on top of the grassy mound that shields the well is a standing stone—one of the many megalithic uprights still found in the Irish landscape (fig. 2). Although their purpose remains enigmatic, scholars are confident they date from the Neolithic past (before 2500 BCE). These uprights might have had astronomical relevance or they might have marked a sacred site, as seems to be the case in this image. The Celts incised their own

symbolism or their Ogham script on the uprights. After the fifth-century Christianization of Ireland, these Celtic symbols were supplemented by crosses, a syncretistic effort to newly sacralize the ancient megaliths. Standing stones, such as the one in Petrie's watercolor, bear witness to the Neolithic, Celtic, and Early Christian layers of Irish history.

St. Brigit's Well and *The Last Circuit of Pilgrims at Clonmacnoise* depict sacred landscapes and the rituals they inspired—devotional practices that, in certain cases, have continued until our own time.[4] In these watercolors Petrie celebrates not only the multi-layered history of Ireland, but also the deep emotions that these landscapes and their monuments can evoke. Both his writings and his painting, indeed his whole life's work, call for an appreciation and preservation of the ancient remains that had been ravaged by neglect.[5] Petrie was a pioneer, putting Irish history on a more scholarly foundation and giving value to its monuments of cultural heritage so that they could be protected and preserved. The guardianship of the land was a problem in Petrie's time: how much more so in our own. ❖

Endnotes

1 William Stokes published excerpts from Petrie's journals, as well as his own commentaries in *The Life and Labours in Art and Archaeology of George Petrie*, London, 1868.

2 See *Ireland Illustrated*, by George Newenham Wright, 1840; *The Beauties of Ireland*, by James Norris Brewer, 1926.

3 In Ptolemy's second-century map of Ireland the Shannon is named Senos, the Irish word *sean*, the Welsh *hen*, standing for "Ancient Goddess." See Ó Madagain, 54.

4 Over a dozen holy wells in Ireland are dedicated to Saint Brigit and are now protected by the community. Petitioners still leave votive offerings, crutches, rosaries, ribbons and holy pictures at these wells (Logan 136). Professor Mary Ellen Doona recounts her visit in February 2000 to a Saint Brigit holy site in County Cork. She saw a "bubbling pool of water" below a "Biddy Tree" covered with strips of cloth that had recently been tied on the branches. Beside the tree and spring was a life-size statue of Brigit. (Personal communication).

5 None of the churches, towers, sculpted crosses, or slabs was valued or protected in the 1820s when Petrie first visited Clonmacnoise. The church walls sheltered cattle, weeds thrust out mortar, broken stones were carried away to be reused. Landed proprietors, churchmen, new settlers, and local country people all were contributing to the slow destruction of the architectural remains.

Works Cited

Duffy, P. J. "The Changing Rural Landscape 1750 – 1850: Pictorial Evidence." *Ireland, Art into History*. Eds. Raymond Gillespie and Brian P. Kennedy. Dublin: Town House, 1994. 26–42.

Leerssen, Joep. *Remembrance and Imagination*. Cork: Cork University Press, 1996.

Logan, Patrick. *Irish Folk Medicine*. Belfast: Appletree, 1999.

MacNeill, Máire. *The Festival of Lughnasa*. London: Oxford University Press, 1962.

Cogitosus. "The Old Irish Life of St. Brigit." Trans. M.A. O'Brien *Irish Historical Studies*. Vol. I. No. 2, September 1938. 121–134.

Ó Madagain, Breandan. "The Picturesque in the Gaelic Tradition." *Decoding the Landscape*. Ed. Timothy Collins. Galway: Centre for Landscape Studies, 1994. 48–59.

Petrie, George. *The Ecclesiastical Architecture of Ireland, anterior to the Anglo-Norman Invasion; comprising an essay on the origin and uses of the round towers of Ireland*. Dublin: Hodges and Smith, 2nd edition, 1845.

Stokes, William. *The Life and Labours in Art and Archaeology of George Petrie*. London: 1868.

Possessing

Observing Irish Romantic Landscape Painting

Katherine Nahum

◇

THE TERM "ROMANTIC," ONE OF THE MOST UNWIELDY IN AN ART HISTORIAN'S VOCABULARY, REFERS TO A BROAD, AND SEEMINGLY CONTRADICTORY RANGE OF ART. COMMON TO VARYING DEFINITIONS OF ROMANTICISM, HOWEVER, IS THE NOTION THAT THE MOVEMENT PRESENTS ATTITUDES THAT DIFFERED FUNDA-mentally from those of the eighteenth century in which reason and certainty were thought to underpin all human exchange and artistic expression. These changed attitudes and art are characterized by newly valued extremes of emotions, often experienced by a hero facing an uncertain world. The following observations concerning works in the present exhibition suggest that in Ireland, Romanticism, first associated with the antiquarian movement's redefinition of the country's cultural past,[1] also characterized itself in paintings alluding, often in disguised or sublimated forms, to nineteenth- and early twentieth-century social trauma.[2] Romanticism and its later elaborations increasingly became tied to idealized but para-doxical notions of the West as the site of a Gaelic Irish identity.

In the nineteenth century, the opportunities for Irish artists to appreciate European landscape paintings grew through their exposure to Dutch, French, and English paintings in London where they traveled to find patronage (Crookshank 1978, 211–12). As Ireland experienced the economic and social trauma of poverty and famine, as well as the political disorder accompanying a long struggle for independence, painters were moved to find an artistic language to address such upheaval. As a far-reaching artistic movement comprised of contradictory definitions and themes, Romanticism offered a flexible visual language to express complex responses to the social landscape.

JAMES ARTHUR O'CONNOR

Although O'Connor's *Pleasure Grounds, Ballinrobe*, 1818 (no. 25), has been described as deriving from Claudian pastorales (Hutchinson 12–13) or classical landscapes, its arrangement suggests an early romantic motif. The compositional focus that begins at the river, drawing the eye inward—past gentle hills, a copse of trees, the great house, and the mill in the background—slyly redirects our gaze from bucolic parkland to the small but heroic red-coated figure of a young man. He is a distinct individual, a romantic figure,[3] perhaps the estate owner or a soldier from the barracks to the right. Set before a strict orthogonal path inflected with patterns of light and dark, the figure appears about to embark on some momentous journey or to have arrived at a significant juncture in his life. If he has cast the estate owner as the military hero of his own life and demesne, O'Connor may be cleverly affirming his patron's ascendancy.

◇

Fig. 1: James Arthur O'Connor, *A Thunderstorm, The Frightened Wagoner*, 1832, oil on canvas, 25 1/2" x 30", National Gallery of Ireland.

Whereas O'Connor's earlier landscape frames a subtle, incipient movement toward Romanticism, *The Eagle's Nest*, 1830 (no. 26), is overtly romantic. A wagoner attempts to lead horses into the river, while above loom stormy skies and a rocky crag—sublimely hostile aspects of nature that obstruct any progress along life's journey. This dramatically visual vocabulary culminates in O'Connor's *A Thunderstorm, The Frightened Wagoner*, 1832 (fig. 1), the painting for which the artist is best known. The obstacles imaged in both romantic works may obliquely refer to the social circumstances of the time and the artist's own struggles: the stressful lack of English and Irish artistic patronage and a depressed economy in Ireland after the Napoleonic wars.

George M.W. Atkinson

A recurrent motif of romantic art is the "storm tossed boat," a subject alluding to man's course through life and his spiritual search for meaning.[4] Atkinson had been a ship's carpenter before becoming a self-taught painter in his mid-thirties (Murray 16). The earliest marine paintings we know of imply, through their title or date, the artist's knowledge of the Great Famine;[5] as he sketched and painted the vessels before him, he presumably became aware of the effect of famine on Irish economic and maritime life. These early marines are the stiff, awkward efforts of a fledgling painter, but by the time he undertook *A Ship at Anchor at Sunset*, 1851 (no. 29), Atkinson discovered a befitting artistic vocabulary in Romanticism that transcended the specific horrors of famine and cast them in a universal image: the "storm tossed boat." He may have been aware of Caspar David Friedrich's and Thomas Cole's many paintings depicting boats found in those artists' "Stages" or "Voyages" of life series, for *A Ship at Anchor at Sunset* is far more sophisticated than Atkinson's earlier marines and reflects a familiarity with a broad range of Irish and European romantic paintings. It depicts the same type of ship and employs similar lighting and the mysteriously glowing colors found in *An Emigrant Ship, Dublin Bay, Sunset*, painted by his compatriot, Edwin Hayes in 1853 (fig. 2). That source enabled Atkinson to suggest an allegory of both emigration and the ship of state wracked by famine.

Atkinson may have found in J.M.W. Turner's strikingly romantic *The Fighting Temeraire Towed to Her Last Berth to Be Broken Up*, 1838 (fig. 3), a model upon which to base his own image of Ireland's troubled statehood.

Redolent of Britain's great but diminished naval power after Nelson and the heroic age of the British Empire during the Napoleonic wars, the *Temeraire* is being hauled at sunset to the scrap heap, whereas Atkinson's moldering, three-masted ship has reached its final mooring. The fragments of one mast have floated to the rocky shore where a bird, representing the soul, will soon fly off. The ship as a symbol of human destiny faces the dying sun.

William McEvoy

The Beare Peninsula in Kerry was one of the areas worst hit by the Great Famine, but like Atkinson's nautical work, McEvoy's landscape, *Glengariffe from the Kenmare Road, Evening*, 1862 (no. 28), does not refer directly to that recent social disaster (Marshall 72). The painting's inherent moodiness, however, suggests a romantic response to the social trauma, one that conjures countless paintings by Friedrich, and in particular, *Mountain with Rising Fog*, 1815

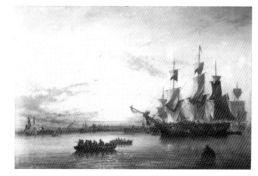

Fig. 2: Edwin Hayes, *An Emigrant Ship, Dublin Bay, Sunset*, 1853, oil on canvas, 23" x 34", National Gallery of Ireland.

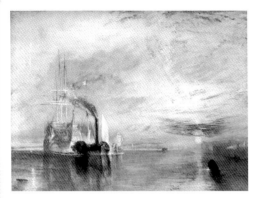

Fig. 3: Joseph Mallord William Turner, *The Fighting Temeraire Towed to Her Last Berth to Be Broken Up*, 1838, oil on canvas, 35 3/4" x 48", National Gallery of London.

(fig. 4). Like McEvoy, Friedrich painted romantic images, but in his case, in disguised response to the aftermath of the Napoleonic wars in Germany. Aware of their own anxious gaze at landscape as a cipher for social disruption, both Friedrich and McEvoy force the viewer to encounter an uncertain world by creating an ambiguous, hovering vantage point above the land. Yet these paintings also express longing for release from painful human events. McEvoy's staffage figures trudge along the Kenmare Road in a shadow cast by something unseen and unknown, even as they move toward the elusive, ethereal light beyond.

Nathaniel Hone

As an engineer working on the Midland Great Western Railway that reached Galway City in 1851, Hone must have been brought face to face with post-Famine poverty (Campbell 18), as well as with the disturbing beauties of the West. Hone's response seems to have been to travel, to flee such painful Irish scenes[6]—yet also to grapple with them through the mediation of art. In 1853, with the first flush of Naturalism, he began his artistic training in Paris; he thus became a model for Irish artists then beginning to look to France, rather than England and Italy, for creative sources. Hone's involvement until 1870 with the Barbizon School identifies him as a romantic landscape painter; his friendships with members of the French avant-garde exposed him to Impressionism and Post-Impressionism, as well as to incipient symbolist ideas.

At the western coast of Clare, Hone painted bold landmasses that invoke the assertive human form. Promontories jut into the sea, marking those transitions into the unknown, as in a Friedrich painting, where the lone romantic self faces the unknown.[7] These paintings, "show[ing] the sublime, romantic side of the artist immersed in nature" (Campbell 120), may accommodate within the romantic mode oblique responses to famine landscapes of the West.

Hone's distant viewpoints in *A View of the Coast, Co. Clare* (no. 30) and *St. George's Head, Kilkee, Co. Clare* (no. 31), both painted in the early 1890s, result in blurred distinctions between sky and sea; yet the land solidly confronts the power of a sublime nature as might the romantic human figure. Hone's physical distance from the motif also suggests his emotional distance, a reserve that Campbell notes did not appeal to those who sought more comforting literary effects of anecdote and sentiment in landscape subjects (13). Emotion has been reinvested in nature's force, in the gestural manner of rendering it, and in the symbolic confrontation of rock edge and open sea. Emotion becomes palpable. We respond more to the abstracted, energized brushstroke than to surging seas and crashing waves, for Hone creates a tension between what is represented and how it is represented. His *St. George's Head*, particularly, exemplifies that contemporaneous, primarily French moment when Naturalism loosened its hold on optical reality and shifted its emphasis toward paint facture, emotion, abstraction, and the symbolic representation of unseen reality. Here the artist moves toward Symbolism, a movement that shares with Romanticism odd states of mind, suggestion, and questioning.

Seán Keating

In the twentieth century, Romanticism becomes associated with the western coast of

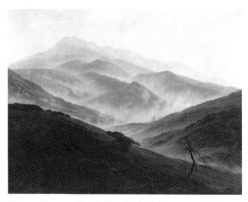

Fig. 4: Caspar David Friedrich, *Mountain with Rising Fog*, 1815, oil on canvas, 21 1/2" x 27 1/2", Bayerische Staatsgemäldesdammulungen, Munich.

Ireland; however Seán Keating's painting, *Economic Pressure*, 1936 (no. 36), boldly exposes the central paradox of the idealized West as the source of Irish national identity. Exalted as an unsullied place preserving ancient languages and customs, the Aran islands were, in reality, almost uninhabitable.[8]

Despite its gritty social realist style, Keating's painting is embedded with romantic themes of longing—for an idealized and exotic place and an anxious confrontation with the unknown. Keating, like many revivalists, idealized Aran as an unspoiled site of Gaelic national identity;[9] but here he honestly records how emigration robs the islands of the best Irishmen. Emigration is the realist subject of his painting, and Realism its style, but romantic theme, symbolic structure, and paradoxical meaning shape the whole. The rock points to the island's barrenness, where life cannot be sustained. The tree is dead. The wizened old man represents past life on the island. In contrast, the health and strength of the young man who represents all the young of Aran will survive only if he quits the place. Keating's boats are not yet storm-tossed, but like ships in paintings by Friedrich and Cole, they suggest the voyages and stages of life for the heroic young man.

Paul Henry

Paul Henry's famously endearing thatched cottages under billowing clouds represent a persistent romantic ideal of the West to which the Irish might repair for psychological sustenance—and one that denied outright the difficulties of that landscape.[10] Unlike Keating's *Economic Pressure*, such images, disguising the paradox of the impoverished West as the site of Irish identity, were broadcast in the Irish Free State Official Handbook (1932).[11]

The two very different Henry paintings in this exhibition, *Turf Stacks in Donegal*, n.d. (no. 35) and *Mulraney Beach*, 1913 (no. 34), mark the artist's transition from romantic moodiness to symbolist abstraction. The first responds to the contradictions of the West by presenting, through its ominous stacks outlined by mauve and its pendulous mauve-gray clouds, a poetically dark world for the uncertain viewer who faces it alone. The second avoids a consideration of a paradoxical West through its non-specificity, its allusive suggestiveness. The site is Mulraney Beach, but it could be anywhere. The space is so flattened that we require the rocks at the right for coordinates. Otherwise we might see the image as a series of diagonal patterns of light and dark blues and cream. We might fail to grasp that the strange scumblings at the lower left are reflections in water of the clouds above, reflections that suggest nameless, hidden truths of nature and the human psyche. The Symbolist Paul Gauguin would likewise isolate an area of the canvas[12] as pure abstraction—as the realm of musings, imagination, memory, and mystery.

Jack B. Yeats

Symbolist musings and memory also formed the realm of landscape for Yeats. Unlike Paul Henry, who "discovered" Achill Island in the West and remained an outsider, Jack Yeats lived in Sligo from age eight to sixteen with his maternal grandparents, the Pollexfens. His experiences with them in an evocative western landscape provided compelling evidence for his life's work. One of the many guises of his beloved grandfather was as an adventurous sea captain. Yeats repeatedly painted such small, solitary but romantically heroic men, who like his grandfather and the artist himself, traversed the land and sea—in reality, in his imagination, and in memory.

Yeats depended on sketchbooks of watercolors and drawings (nos. 39–46) not just for later visual ideas but for "stylistic experiment" and "verbal comment," as well as to explore his deepest reactions and the personal changes that he had undergone and that he would continue to experience (Pyle 1992, I, xviii). Stylistic changes in the sketches are elaborated in the paintings, as in *The Road/Lane to the Pasture*, 1922 (no. 47), and *Derrynane*, 1927 (no. 48), in which Yeats moves from a record of optical reality to a gestural handling of paint that is more personally expressive. Both paintings imply that the artist or the viewer is a romantic traveler[13] to whose searching gaze the landscapes beckon.

In *A Farewell to Mayo*, 1929 (no. 49), Yeats achieves a consummate distillation of realist and expressionist styles with romantic theme, as "[t]wo Men, an emigrant and a Jarvey, travel away into the landscape on a side-car" (Pyle 1992, III, 356). The emigrant looks longingly back beyond the fields at formations of rock, riven by the sea—possibly Mayo's Downpatrick Head—and looming over the Atlantic

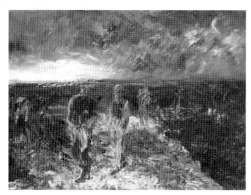

Fig. 5: Jack B. Yeats, *Men of Destiny*, 1946, oil on canvas, 20" x 27", National Gallery of Ireland.

in the distance. Although the power of this image of emigration resides in its painful social allusions and its depiction of a site in the West, Yeats's style universalizes loss, making it far more than a depiction of Ireland's specific history of losses. Painted loosely and seemingly in the full chromatic scale, the image shows horse and sidecar with their burdens moving into our space, as if to involve us directly in this experience. The figures' heads, highlighted by a setting sun, reach above the horizon, and thereby these small men are rendered heroic. Yeats strings both figures and site on the edge between earth and sky.

Death for Only One, 1937 (no. 51), again addresses the romantic theme of loss—in death. For Yeats, the flat horizontal of land and the supine figure contained in it visually refer to what is dead, while the upright figure cuts through that horizontal to suggest the enduring life force. "A dead tramp lying on a headland with another tramp standing by—and a dark

sea and dark sky" was Yeats's description of these small heroes in a large landscape (qtd. in Pyle 1992, 451). Death preoccupied Yeats in the fifteen-year aftermath of the civil war that followed independence in 1921; thus the painting can be read as an image of the living contemplating the long history of Ireland's dead. Retaining an ink sketch of the composition after he sold it (Pyle 1992, 451), Yeats clearly valued *Death for Only One*. He elaborated on its theme in *Men of Destiny*, 1946 (fig. 5), in which Sligo fishermen become heroic representatives of human evolution and history.

The landscape of the West framed by a window in *Evening in Spring*, 1937 (no. 50), seems to form a "painting"—representing what is on everyone's mind in fantasy, memory, or in conversation—within a larger painting of a dinner party.[14] This party appears to gather together figures involved with revivalist nationalism, rather than, as Pyle suggests, Yeats's nostalgically remembered family or those figures, both living and dead, whom the artist would later symbolically join in *A Silence*, 1944 (Pyle 1992, 440). The artist's own distinctive profile appears at the right. He bows his head, possibly reflecting on the creative process whereby freighted land becomes celebrated in landscape art—the painting within the painting. The window's mullions appear as "squaring" used to transform this landscape into an independent image.[15]

A 1907 sketchbook made at Clifden records characteristic images of ships, rowboats, or dinghies (no. 45). Yeats's focus on the enlarged interior of one lavender-blue dinghy trans-

forms it into a psychic space. A harbor scene depicts a rowboat as if it moves to greet the viewer—thereby suggesting the presence of the artist. Generally, these sketches include both heavily re-inscribed and indecipherable words—intriguing palimpsests, as if Yeats were trying to reinforce key memories of his life in the West. Such a handling of words corresponds to the artist's later handling of paint.

Misty Morning, 1942 (no. 52), an image invoking the romantic voyage of life, is worked from such watercolor sketches of small boats. It uses a layered, palimpsestic oil technique to reenliven a moment in the past. A watcher stands at the right edge of the painting looking back into the mists, where a boat carrying a man and a woman floats toward shore. Although Yeats often depicted a foreground figure who seems to speak directly to the viewer about what appears behind, this watcher is turned away. Shoulders hunched, hands in his pockets, he appears to be speaking to himself. The watcher may be the artist remembering a time with his wife Cottie, a time presented as a more radiant painting within the painting. Yeats renders each telling gesture, yet loosened brushstrokes of various blues suggest the shifting moods of the watcher retrieving and shaping past events.

Characterized by fluid, expressive brushstrokes, these late paintings reflect Yeats's emotional state as he retrieves and memorializes his Irish life. As an artist he moves from recording the external world to celebrating a mythic West nurtured in personal memory. He worked first as a realist, then as a romantic, an expressionist, and a symbolist.

For some cultural nationalists, the West's associations with famine and poverty were discounted as they sought to create an idealized motherland; Yeats, however, had no need to disavow Ireland's difficulties. Easy in his own allegiance to his country, he cast familiar, painful, and exhilarating episodes into heroic dimensions, as in *Farewell to Mayo*, *Death for Only One*, and *Men of Destiny*. The West was the site of ancient myth and self-affirming experience for him; as a consequence he could celebrate its complexities and its many guises. Perhaps Yeats alone, among the artists discussed above, transcended the paradox that exalted a western Eden, eliding famine, emigrations, and death. ❖

I wish to thank for their insightful suggestions Benjamin Barber, Pamela Berger, Andrea Frank, Vera Kreilkamp, Robin Lydenberg, Jed Nahum, Jeremy Nahum, Robert Savage, and Gerald Stechler.

Endnotes

1 See in this catalogue, Pamela Berger's "Sacred Landscapes and Ancient Rituals: Two Watercolors by George Petrie," 57–61.

2 Crookshank (1978) 209 alludes to the romantic character of Irish landscape, and Robert Rosenblum in his definition of the northern romantic tradition (1975) notes it as well. *The New Romantics* stressed the importance of the tradition for contemporary art. See Rosenblum et al. (1988).

3 See Vera Kreilkamp's "Painting Mayo's Landscape: The Big House, the Pleasure Grounds, and the Mills" in this catalog, 71–78). As Kreilkamp points out, there are also incidental staffage figures included in the painting.

4 'The Open Window and The Storm-Tossed Boat', two prominent romantic motifs, were first discussed by Lorenz Eitner in 1955.

5 See *U.S.S. Jamestown Arriving at...Cork*, April 13, 1847 (1847) and *An American...Packet Achored in Cork Harbour at the Time of the Great Irish Famine* (1848) in *Antiques*, Vol. 115, March

1979, p. 529, and *Apollo*, New Series 98, Sept. 1973, p. 20 for reproductions of these paintings.

6 South America was one destination, according to Thomas Bodkin, cited by Campbell 18.

7 Contemporary Ballinglen artist Mary Armstrong (nos. 66 and 67) addresses the same romantic quandary.

8 "The West, the most romanticized of all Ireland's regions, was also associated with the most appalling deprivations..." say Livack and Hooper (9). Also see in this catalog Síghle Bhreathnach-Lynch's "Painting the West: Landscape's Role in Irish Identity," 99–104.

9 See in this catalog Robert Savage's " 'The soil of Ireland for the people of Ireland' : The Politics of Land in Irish Visual Imagery, 1850–1936," 93–98.

10 A decade later Gerard Dillon (1916–71) would flee to Connemara to find, restore, and isolate himself from a divided country. Yet *The Little Fields* (no. 55) indicates Dillon felt he might not survive there, for a headstone is inscribed with his own name. See White (1994).

11 For a provocative discussion of the appropriation of Henry's images for nationalism, and the post-modernist difficulties in writing about the artist, see S. B. Kennedy (1999).

12 See for one example, *The Day of the God*, 1894.

13 See Cusack (1998) for a compelling discussion of such travelers.

14 Yeats used the traditional device of a "painting within the painting" frequently.

15 Like many artists, Yeats used squaring to transfer images from small to large scale. See Pyle, 1986, 34–35 for his design for a theatrical backdrop which had to be enlarged to 30 by 18 feet.

Works Cited

Campbell, Julian. *Nathaniel Hone the Younger, 1831–1917*. Dublin: The National Gallery of Ireland, 1991.

Crookshank, Anne. "The Visual Arts, 1740–1850." *A New History of Ireland*. Vol. 4, Eds. T. W. Moody and W. E. Vaughn. London: Oxford University Press, 1986. 499–541.

---. and the Knight of Glynn. *The Painters of Ireland*. London: Barrie and Jenkins, 1978.

Cusack, Tricia. "Migrant Travellers and Touristic Idylls: The Paintings of Jack B. Yeats and post-colonial identities." *Art History*. Vol. 21, No. 2, June 1998. 201–218.

Eitner, Lorenz. "The Open Window and the Storm-Tossed Boat: An Essay in the Iconography of Romanticism." *Art Bulletin*. Vol. 37, Dec. 1955. 281–90.

Hutchinson, John. *James Arthur O'Connor*. Dublin: The National Gallery of Ireland, 1985.

Hooper, Glenn and Leon Litvack. Eds., *Ireland in the Nineteenth Century: Regional Identity*. Dublin: Four Courts Press, 2000.

Kennedy, S. B. "An Enduring View of Irish Identity: Paul Henry and the Realism of Fiction." *Irish Arts Review*, Vol.15, 1999. 98–107.

Marshall, Catherine. "William McEvoy." *America's Eye: Irish Paintings from the Collection of Brian P. Burns*. Eds. Adele M. Dalsimer and Vera Kreilkamp. Boston: Boston College Museum of Art, 1996. 72.

Murray, Peter. Ed. *Irish Art 1770–1995: History and Society*. Cork: Crawford Municipal Art Gallery, 1995.

Pyle, Hilary. *Yeats in the National Gallery of Ireland*. Dublin: The Gallery, 1986.

---. *Jack B. Yeats, A Catalogue Raisonné of the Oil Paintings*. London: Deutsch, 1992.

Rosenblum, Robert. *Modern Painting and the Northern Romantic Tradition: Friedrich to Rothko*. New York: Harper & Row, 1975.

---. et al. A.C. Papadakis. Ed. *The New Romantics*. Ed. A.C. Papadakis, et al. London: Art & Design, 1988.

White, James. *Gerard Dillon, An Illustrated Biography*. Dublin: Wolfhound Press, 1994.

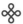

Painting Mayo's Landscape:
The Big House, the Pleasure Grounds, and the Mills
Vera Kreilkamp

◇

IN 1818, DUBLIN ARTIST JAMES ARTHUR O'CONNOR (1792–1841) CREATED A SERIES OF TOPOGRAPHICALLY BASED PAINTINGS OF THE HOUSE AND DEMESNE OF A SMALL MAYO LANDOWNER, COURTNEY KENNY, OF BALLINROBE.[1] TWO OF THESE IMAGES BELONG TO IRELAND'S SUBSTANTIAL ARCHIVE OF ESTATE PORTRAITS—LANDSCAPE PAINTINGS

that proprietors had begun to commission in the eighteenth century to celebrate the houses and parks they were building in the countryside. Increasingly, artists produced images to fulfill the imaginative needs of their patrons—from early map-like "prospects" to romantic views of expansive landscape parks and elaborate big houses.[2] Compared to their English counterparts, Irish painters created proportionately more images of houses and demesnes—a "preferred" or "valued" landscape subject in Irish art until about 1820 (Duffy 38). Occupying their estates under colonial land settlements and often surrounded by native families whom they had dispossessed, eighteenth- and early nineteenth-century Irish landlords welcomed cultural as well as political assertions of ownership.

O'Connor's major critic describes the artist as a conservative, even old-fashioned painter, whose commissioned topographical landscapes may have been neglected because they are "redolent of an Ascendancy ethos" (Hutchinson 11). By examining the Ballinrobe paintings in the context of early nineteenth-century social and economic history, as well as within the formal tradition of estate portraiture, I hope to complicate such a reading and explore a range of forces shaping the artist's construction of his subject. Images of eighteenth-century buildings and parkland in *Ballinrobe House* and *The Pleasure Grounds of Ballinrobe*[3] register a complex social and economic stratification in pre-

Famine Mayo. O'Connor's choice of what to foreground on the canvas and what to relegate to the background, for example, suggests artistic decision-making responsive to his patron's ambivalent identifications—with strong ties both to a growing Mayo market economy and a landed Ascendancy. Despite a general uneasiness with the evidentiary value of elite art by Irish historians,[4] these paintings undermine easy generalities about a country divided simply between the landlord and his impoverished tenantry. In the context of the rapidly changing economic and demographic patterns of pre-Famine Mayo, O'Connor's two serene images, both in their inclusions and in their effacements, respond disparately to pressures for representation in a colonial society.

The depictions of the house and demesne in the two Ballinrobe works participate in a backward-looking genre—one emerging from an older tradition of estate "prospects," which are themselves reminiscent of British topographical paintings popular after the Restoration of the English monarchy in 1660. In this exhibition, the pictorial maps of Sir Thomas Phillips'

◇

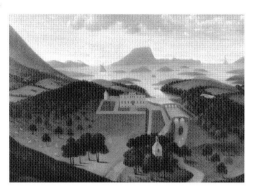

Fig. 1: George Moore, *Westport House*, 1760, oil on canvas. Collection of Lord Altamont, Westport House, Co. Mayo.

1622 *Survey of Ulster* depict Irish land settled by London merchants and tradespeople in the seventeenth-century colonial plantations (no. 3). These images anticipate the eighteenth century's schematic and map-like paintings recording a confident Ascendancy's reorganization of Ireland's landscape. The prospect is typically presented as a flattering bird's-eye overview—a panorama of the patron's house, avenues, and cultivated grounds, surrounded by untamed territory. In George Moore's 1760 prospect of Westport House in Mayo, for example (fig. 1), the limestone Georgian house appears at the center of the canvas, symbolically asserting dominion over a landscape in which even the dramatic setting of Croagh Patrick and Clare Island appear as scenic backdrop. The centrally placed building, the organized park planted with rigid rows of trees, the river domesticated by two bridges, and the estate avenues all become visual metaphors of the big house's civilizing influence on a wilder Irish landscape.

The classicism of the eighteenth-century Ascendancy's architectural program suggests that parts of Ireland were being visually transformed into "little replicas" (Cullen 14) of an England that was increasingly imagining itself as the modern descendant of the Roman imperium.[5] Occupying between six and ten percent of the country, estate demesnes were carefully constructed areas—existing as aesthetically processed land held for private use and occupancy by the landlord. By the nineteenth century, over 7,000 Irish houses featured landscape parks, with about thirty in the isolated western County of Mayo (Aalen, Whelan, Stout 197–202). Such houses and pleasure grounds had long been ripe subjects for portraiture, and in commissioned paintings throughout the eighteenth- and early-nineteenth centuries, artists celebrated their patrons' taste in transforming the landscape.[6]

Significantly, O'Connor's estate portraits, *Ballinrobe House* (no. 25) and *The Pleasure Grounds of Ballinrobe* (no. 24), focus not on a series of buildings visible in the background, but on the park area along the Robe River that was influenced by the rambling eighteenth-century garden designs of "Capability" Brown.[7] Gently sloped lawns, the obligatory water element with a graceful bridge, sinuous paths, and clumps of bushes and trees indicate that the English ideal of tasteful "natural" gardening had established itself in Ireland, replacing the stiff parterre beds of older estate plans on French or Dutch models. The alleé of symmetrically planted trees bordering a brick path in *The Pleasure Grounds of Ballinrobe* retains traces of a more fixed plan, but the carefully laid out grounds convey a new taste for man-made informal landscapes. Such "improved" rolling parklands, sometimes constructed at vast expense through the creation of artificial lakes and hills and the substitution of desirable for unwanted prospects, were easily adapted to Ireland's terrain.

Creating such parks could involve not just construction expense for the landlord, but significant social costs for the tenants he displaced. In England, Brown's leveling of the village of Nuneham Courtenay to create a proper vista for the Earl of Harcourt famously provoked bitter protest from Oliver Goldsmith in *The Deserted Village* (1770):

> The man of wealth and pride,
> Takes up a space that many poor supplied;
> Space for his lake, his park's extended
> bound,
> Space for his horses, equipage, and
> hounds... (451)

Goldsmith's poem indicts a predatory rural capitalism in Ireland as well as in England, as evictions and enclosure acts transformed traditional conceptions of land use. The poet's bitterness undoubtedly also reflects memories of his rural birthplace in Lissoy, Ireland, where a community of cottiers were reportedly "removed" for a rich man's "intended improvements" (Montague 6). A related criticism appears in Irish fiction; in *The Absentee* (1812) Maria Edgeworth, responding to the practices of Irish landlords seeking romantic vistas,

ridicules the "ornamented, picturesque cottages" that a fashionable, but injudicious, landlord builds to improve his visual prospect (108).[8] The history of such removals and intrusions in England and Ireland[9] confirms W. J. T. Mitchell's reading of landscape—developing as a major aesthetic form concurrently with British imperialism—as the "dreamwork" of imperialism (10).

By breaking down the distinction between "cultivated" gardens and "natural" prospects that was now being incorporated into their designs, eighteenth-century landscapers gained access to extensive perspectives; they were improving their employer's property by extending its visual boundaries.[10] Not coincidentally, the first stage of the development of the English landscape park was initiated early in the century by William Kent, whose training as a painter encouraged him to design framed "landscape pictures" through the careful deployment of architectural and sculptural elements (Thacker 187). The invention of the ha-ha, a sunken ditch rather than a raised barrier around the perimeter of the grounds, permitted unimpeded views of an expansive countryside that had become the backdrop of the park or demesne. Now the British or Ascendancy landlord—fully imperial in his aesthetic appetite for territory—could lay claim to a whole outlook. Or as Mitchell suggests, "Empires move outward in space as a way of moving forward in time; the 'prospect' that opens up is not just a spatial scene but a projected future of 'development' and exploitation" (17). In an estate park the visual landscape itself and the vistas giving access to it became valuable commodities; property was required not just for its potential agricultural production, but for its capacity to please the eye. Although in reality parklands were generally used to grow timber and to graze herds and flocks (Aalen, Whelan, Stout 202), the aesthetic value of the pleasure ground depended on its seeming to exist as unproductive land.

Ballinrobe House was constructed on the edge of a market town in 1741 (Kenny 20 May 2002), but O'Connor's paintings foreground an expansive view over tranquil pleasure grounds along the Robe River, thus minimizing the evidence of modernization and commercialization that increasingly supported the owner's wealth and privacy. In the nineteenth century, however, the family's view and access to its prospect was compromised when the Castlebar-Galway road was built directly before the house, separating it from its pleasure grounds. After World War II, workmen digging for a town drainage scheme unearthed a beautiful cut stone archway under the road. Apparently, a late nineteenth-century Mrs. Kenny had insisted that a tunnel be built so she could reach her grounds in safety (Kenny 20 May 2002). This account of one landowner's insistence of accommodation for the loss of unimpeded access to a park resonates in the history of spatial configurations in domestic Ascendancy architecture. Tunnels in big houses were ordinarily constructed—as in Strokestown Park House in Roscommon—to eliminate servants from the owner's view, conveying them invisibly from one area of the big house to another. The Irish landscape painter typically effaced from his canvases the servants and rural workers whose labor supported the estate; architectural design performed analogous work for the landlord.

Despite a few figures in his paintings, O'Connor's serene landscapes are little touched by human activity. In *Ballinrobe House*, two small male forms cast shadows in the sun, and in *The Pleasure Grounds of Ballinrobe* a redcoated man on a bridge crosses the Robe river, while two indeterminate figures appear to be seated on the right slope of the lawn, enjoying rather than working on the grounds. Such small, undifferentiated shapes, recurring motifs in the artist's early work, here exist most obviously as what art historians refer to as "staffage"—conventional visual cues for scale and perspective in eighteenth-century landscapes.[11] Although perhaps anticipating O'Connor's celebrated romantic deployment of the isolated form in his later paintings such as *The Eagle's Nest* (no. 26), the figures in the canvases do little to diminish our sense of an empty parkland of trees, water, and undulating lawns, reserved for a leisure class.

In the Ballinrobe series, presumably undertaken to satisfy a small landlord's pride of property, O'Connor not only excludes estate laborers from the canvas, but also relegates his patron's considerable commercial property to the background of the canvas. But his inclusion of two commercial buildings, albeit harmoniously absorbed into the rural landscapes, represents an aesthetic decision that strikingly distinguishes the two canvases from traditional estate portraits—and gestures towards subject

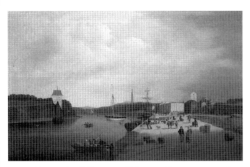

Fig. 2: James A. O'Connor, *Westport Quays*, 1818, oil on canvas, 15" x 23". Collection of Lord Altamont, Westport House, County Mayo.

matter seldom appearing in early nineteenth-century Irish art.[12] Despite the county's enduring post-Famine associations with abject poverty and desolation, pre-Famine Mayo experienced sustained and optimistic commercial growth, even a small-scale process of "urbanization," according to a county historian (Crawford 74). John Wesley, who preached regularly in Ballinrobe, observed in 1791 that the busy market town was "at least as attractive as any other county capital," with a good hotel, two sessions of the assizes and military barracks (qtd. in Crawford 75).[13] O'Connor's awareness of such commercial activity in Mayo is evident in an 1818 image of the Westport quays that he had painted for the Marquis of Sligo in the same year as the Ballinrobe series (fig. 2).

Westport Quays, however, depicting figures engaged in the work of a small port, takes up an unusual subject for early nineteenth-century Irish painting. The activities of a growing middle-class in Ireland were as yet little evident in a cultural form produced for elite customers (Duffy 33). But even in the more traditional house portrait genre represented by *Ballinrobe House* and *The Pleasure Grounds of Ballinrobe*, O'Connor includes similarly anomalous material. Behind the serene parkland—the focus of each canvas—appears an eighteenth-century Georgian house with a fan-lit entrance facing a large mill building directly across the river. In Ballinrobe House, another brick mill building, with a facade of small windows, juts out from behind the big house in the central horizontal plane of the painting. Courtney Kenny, the landlord who commissioned these works in 1818, was the owner and proprietor of three commercial enterprises: a third painting in O'Connor's Ballinrobe series depicts yet another mill (*The Mill, Ballinrobe*, 1818). The two-story, seven-bay Georgian family home was built on the edge of the town, so the eighteenth-century Kennys "could keep an eye on the family corn mill"; rows of small buildings that housed estate employees were constructed nearby (Kenny 30 May 2002). The commercial buildings in which invisible mill employees labored—part of a Mayo landlord/mill proprietor's substantial capital—are visible in both paintings, although foregrounded in neither. In *The Pleasure Grounds of Ballinrobe*, at least one small rooftop appears over a wall that presumably separates the parklands from the town. Commercial Mayo, relegated to the background of the paintings and untainted by any evidence of human activity, hovers serenely about the big house. Culture—evidenced by the harmonious forms of the landscape park—has domesticated both nature and labor.

As O'Connor was painting these canvases early in the nineteenth century, the Kenny mills undoubtedly benefited from the acceleration of a grain economy in Mayo between 1814–25, a period in which the tonnage of oats exported from county ports such as Westport, Ballina, and Killala tripled (McCabe 101). Such an export economy both drove the county's prosperity and indirectly contributed to the disastrous toll of the mid-century Famine. As land was increasingly used for tillage, rents rose, demand for labor increased, and the marriage age dropped. Commercial development of Mayo's towns was thus accompanied by a rapid increase in the rural population and a relentless division of and competition for land. In 1818, less than three decades before the onset of the Great Famine, Mayo was increasingly crowded[14], but as towns improved, conditions in the countryside deteriorated (Crawford 81). Nineteenth-century visitors to the West registered the squalid conditions of the small tenants and landless laborers in Ireland as far worse than those at home. Visiting Ireland in 1822, one Englishman described western peasants as "dirty, superstitious, existing on scanty and bad food. Their habitations presented if possible a still more disgusting sight. A description of them could not be attempted without offending the ears of those who have seen the cottage of the English peasant" (Thomas Reid, *Travels in Ireland*, qtd. in Duffy 33). Even Mr. and Mrs. Hall, in an enthusiastic account of their 1840 tour of Ireland, note the contrast between the prosperous looking towns of Mayo, and their "exceedingly wretched" surrounding areas (2: 393).

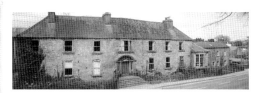

Fig. 3: Ballinrobe House, Ballinrobe, County Mayo—empty and derelict. (Photo: Thomas Kreilkamp, 2002).

When O'Connor created his topographically based works in Mayo, the rural landscape around Ballinrobe was undergoing major transformation. But like most artists painting in Ireland, and certainly those working on commissions for landed patrons, he occludes the most striking visual evidence of such change. Crowded clusters of thatched stone cabins—landscape forms arising in marginal areas in the West—reflected an increasing dependence on the potato as a nutritious and easily cultivated food. Historians agree that this relatively new food source supported the rapid population increase, particularly between 1785 and 1842, when Ireland's population doubled—an unsustainable human and ecological dynamic when occurring on marginal farmland. By 1841, in some areas as many as four hundred people were packed into one square mile (Duffy 33). Even today, stone foundations of abandoned homes and of fields patterned with raised potato furrows appear throughout rural Mayo, as visual reminders of Ireland's loss of three million inhabitants by starvation, disease, and emigration in the 1845–55 Famine decade.[15] A twentieth-century guide to Ballinrobe describes Famine memories of "crowds of starving people who came from the mountainy hinterland…and im-poverished and unproductive land" for relief in the town workhouse (Mulloy 121).

Assumptions of a moral economy—a traditional view of social norms and obligations—slowly eroded in pre-Famine Mayo. Poor harvests, rapidly rising rents, the withholding of rents, and gatherings to protest the desperate conditions of the rural poor anticipated a breakdown of confidence in the landlord that would characterize the post-Famine period (McCabe 101–12). Imagery of the soon-to-be-devastated tenant and cottier class is rare in Irish painting and certainly would be absent in the two prospects of his house and demesne that a Mayo landlord and mill owner commissioned in 1818. O'Connor indeed created a painting that is, as John Hutchinson puts it, "redolent of an Ascendancy ethos," yet the presence of two mill buildings allude as well to a growing market economy and bustling town life in pre-Famine Mayo. The paintings are silent, however, about the most dramatic changes in the landscape, changes that were to figure in catastrophe within three decades and transform Mayo into a center of resistance to Ascendancy land policies.[16]

English landscape paintings of the same period, moving beyond the genre of estate portraiture, frequently incorporate picturesque laborers—in idyllic Georgic scenes of a contented peasantry serving the social good (Rosenthal 31). Even as rural laborers were experiencing the pressures of acute social and economic dislocation in the eighteenth century, Thomas Gainsborough (1727–88) was creating idealized images of them in a fantasized pas-toral English countryside. John Barrell's *The Dark Side of the Landscape*, suggests that in the work of John Constable (1776–1837), a contemporary of O'Connor's, the "*ideal* of the close rural community has replaced the *experience* of it" (135). Barrell notes that around 1821, a time of economic depression and peasant riots in East Anglia, Constable depersonalized his rural figures and allowed them to merge into the landscape as symbolic forms—as un-individualized "tokens of calm, endless industry which confirm the order of society" (149).

The absence of laborers in O'Connor's Ballinrobe commission is of particular interest in that these paintings, executed as English landscapes, began to incorporate rural workers into ideologically framed visions of nationhood. Barrell points out that Constable avoided depicting the poor "as they really are" by reducing the size and distinctness of his figures in order that they "keep their place" in the landscape (134). He postulates that the artist could thus envision the ragged, laboring poor as anonymous

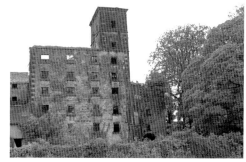

Fig. 4: The ruin of the mill behind Ballinrobe House, Ballinrobe, County Mayo. (Photo: Paula McMahon, 2002).

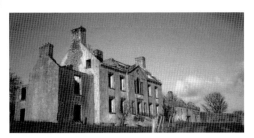

Fig. 5: Ruin of Summer Hill House, Killala, County Mayo. (Photo: Thomas Kreilkamp, 2002).

countrymen plowing and reaping for the social good of England. But such a transformation might well have been less plausible in a colonized Ireland, given the greater barriers between landlords and tenants. We might speculate that an Irish equivalent of the "dark side" of the English landscape that Barrell explores was perhaps *too* dark and squalid for painters to assimilate into a comparatively picturesque rural imagery. O'Connor's Ballinrobe paintings of big house, estate park, and mill allude to the assimilation of a capitalist market economy (the mills) into the forms of upper-class life (the pleasure grounds). However, the growing distance between an increasingly marginalized tenantry—an inescapable visual presence in the landscape for an artist travelling the roads between Dublin and Mayo—and a commercial middle class and gentry was not breached.

Empty and derelict today, Ballinrobe House awaits the fate of many eighteenth-century Irish houses (figs. 3 and 4).[17] The process of land redistribution that began with the Land Act of 1870 encouraged tenants to purchase their own holdings from their landlords. As estates lost rental income and property, land-

lords, although compensated for the sales, increasingly became unable to maintain their homes and demesnes. The burning of approximately two hundred houses between 1920 and 1923 during the Anglo-Irish and subsequent civil war underscored the political hostility elicited by buildings identified with Ascendancy politics. Private stewardship of big houses continued to decline long after independence. Many owners, without the resources to support their former lifestyles, sold their homes for conversion into schools, convents, and hotels, or abandoned them to slow deterioration and eventual ruin or demolition.

Included in this exhibit are artists' images of several other classic eighteenth-century Mayo houses, now central icons in a landscape marketed to tourists. In *Enniscoe, Calm Evening* (no. 85), the contemporary American artist Eric Aho responds to a rural big house that, like the grander Westport House, survives as a site for tourist accommodation through the efforts of family owners. Aho's painting of Summer Hill, that he has titled *Small Ruin, Co. Mayo, 1997* (no. 86), depicts yet another icon in the Irish landscape, a decaying country house in Killala, previously owned by a branch of the Palmers, one of Mayo's major landowning families. According to local informants, Summer Hill was abandoned early in the twentieth century because of political hostility toward the Palmer family's history of Famine and post-Famine evictions. Aho's painting responds to a characteristic marker on the Irish landscape, an eighteenth-century house in ruins (fig. 5); however his painting of the roofless, bleached walls

of Summer Hill in an empty countryside reduces this classic seven-bay Georgian building to color and form. It exists on the canvas as a whitened object in a blue-green landscape—as a building stripped of an individualized historical voice; it is, indeed, simply a "small ruin." Despite its international architectural style, an alien imposition on a native landscape in the mid-eighteenth century, Summer Hill is becoming assimilated into Mayo's countryside, not as a historical marker, but as an aestheticized icon of mutability.

Ballinrobe House, now situated in the center of a thriving provincial town, survived as a private home until the 1980s (fig. 6), with its grain mills operating throughout World War II (Kenny 20 May 2002). The house was sold to the town Rugby Club by Courtney Kenny, a descendant of the early nineteenth-century landlord who had commissioned O'Connor's paintings in 1818. The family's former home is now designated as an "endangered house" by

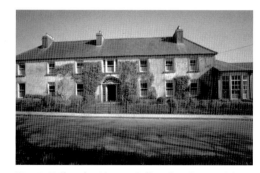

Fig. 6: Ballinrobe House, Ballinrobe, County Mayo, toward the end of a two-hundred and forty year occupancy by the Kenny family. (Photo: Liam Lyons Photography, Westport, Co. Mayo, circa 1980).

An Taisce, Ireland's major environmental organization. Although the façade must be preserved, its most recent owner has submitted plans for multiple apartments to replace the edifice. Today, Ballinrobe House's former pleasure grounds, no longer the private preserve of a Mayo landlord and mill owner, serve as town parkland, open to all. ❖

I want to thank the following for help with the Mayo background of this essay: Perry Curtis, Professor Emeritus, Brown University; John Atteberry, Senior Reference Librarian, John J. Burns Library, Boston College; Maureen Costello, Senior Library Assistant at Mayo Co. Library, Castlebar, Co. Mayo; Anna and Philip O'Malley Dunlop of Castlebar, Co. Mayo; and Courtney Kenny of East Sussex, England.

Endnotes

1 According to *Landowners in Ireland* (310), in the late-nineteenth century, Stanhope Kenny of Ballinrobe owned 598.5 acres, acreage making the Kennys small landlords in County Mayo.

2 The term "big house" is an ambivalently derisive term for the country house that is unique to colonial and postcolonial Ireland. In England the equivalent term is "great house."

3 *Ballinrobe House* and *The Pleasure Grounds of Ballinrobe* are titles for the painting created by Courtney Kenny when he sold them to the National Gallery of Ireland in 1970 (Kenny 30 May 2002). The house has been variously been called Ballinrobe House, Bridge House, and Kenny House. In 1837, Lewis's *Topographical Dictionary of Ireland* referred to the house as Villa Robe, a name suggesting that it was viewed, even then, as a town house rather than a typical big house in its demesne. In this essay I will employ the name "Ballinrobe House" as it appears in the current titles of the paintings.

4 See, for example, Kevin O'Neill and P. J. Duffy's discussions of the historian's reluctance to incorporate evidence from Ireland's visual record.

5 Under the leadership of architects such as Edward Lovett Pearce and Richard Castle, eighteenth- and early nineteenth-century big houses in Ireland adapted wide-spreading classical Palladian and horizontal Georgian block designs already used in England. Ballinrobe House has a seven-bay front and a central Wyatt window above a late-Georgian fanlighted doorway (Bence-Jones 19).

6 See, for example, George Barret (*View of Powerscourt*, 1760–2), William Ashford (sketches of Mount Merrion), James Malton (*Powerscourt House, Dublin*), and Thomas Roberts (*Lucan Demesne*).

7 Lancelot Brown (1716–83), the English landscaper generally known as "Capability" from his references to the natural "capabilities" of the place on which he was consulted.

8 Edward Malins and the Knight of Glin describe the popularity of picturesque elements such as rustic bridges or cottages (a moss house, a woodman's cottage, a Swiss cottage) that Irish landlords built to enhance their prospects in the eighteenth and early-nineteenth centuries (172–78).

9 John Dennis Browne, third Earl of Altamont and first Marquis of Sligo (1756–1809), owner of Westport House in the late-eighteenth century, reportedly employed the architect James Wyatt not only to enlarge his house, but to plan the town of Westport, which, with its residents, was moved from its original medieval site. Throughout the eighteenth century, village and towns in England (Stowe, Chatsworth, Harewood, Kedleston, Ickworth, Milton Abbas, and Nuneham Courtenay) were moved, specifically in the interests of landscape gardening (Malins and The Knight of Glin 106).

10 In his *Enquiry into the changes of taste in landscape gardening*, Humphrey Repton includes a rule specifying that the landscape plan "give the appearance of extent and freedom, by carefully disguising or hiding the boundary" (23).

11 For examples in this exhibition, see *A Landstorm with Waterfall* by Thomas Roberts (no 21), *Extensive Landscape* by George Barret, (no. 22) and *Killarney Landscape* by Jonathan Fisher (no 23).

12 In a later image celebrating the 1865 coming-of-age of a Big House earl (no. 7), the landlord's residences and hunting lodges appear within idealized landscapes and are contrasted with the mills and other working buildings on the estate The medieval form of this celebratory document, commissioned and signed by the estate tenants, suggests a post-Famine need to invoke traditional bonds in a period of increasing hostility to existing land policy. See Michelle Brown's "Shaping and Mis-shaping Visual Impressions," 45.

13 Lewis's *Topographical Dictionary of Ireland* further describes the market town of Ballinrobe as consisting of 441 houses in 1831, "nearly all, well built and slated," with barracks accommodating eight officers and 96 non-commissioned officers and men. In 1818, the land to the right of the Pleasure Grounds in O'Connor's painting belonged to Cavalry and Infantry Barracks (Kenny 20 May 2002).

14 In 1741 the population of Ireland was about three million, in 1785 about four million; in 1841, when a census was taken just before the Famine, the figure had climbed to 8,200,000 (Mitchell and Ryan 331).

15 In this exhibition, imagery invoking such pre-Famine crowding in the west of Ireland appears only in Anne Neely's *All Souls*, a contemporary work painted in Mayo. Significantly, the artist depicts not crowds of the living but symbols of the dead arising from a famine grave (no. 82).

16 Many causes of the Land War and subsequent physical force nationalism in Ireland can be traced to agitation in post-Famine Mayo. Despite the county's limited history of agrarian protest, growing class division resulted in agitation leading to the Land War, which began there in April 1879. Mayo-born Fenian activist Michael Davitt formed the Land League of Mayo in 1878 and the National Land League in 1879.

17 *Vanishing Country Houses of Ireland* calls attention to the "decay, loss and destruction" of 480 country houses in the Republic alone (Glin, Griffin, Robinson vi).

Works Cited

Aalen, F. H. A, Kevin Whelan, and Matthew Stout. *Atlas of the Irish Rural Landscape*. Cork: Cork University Press, 1997.

Barrell, John. *The Dark Side of the Landscape: the Rural Poor in English Painting, 1730–1840*. Cambridge: Cambridge University Press, 1980.

Bence-Jones, Mark. *Burke's Guide to Country Houses: Volume 1-Ireland*. London: Burke's Peerage, 1978.

Crawford, W. H. "Development of the County Mayo Economy, 1700–1850." "*A Various County*" *Essays in Mayo History 1500–1900*. Eds. Raymond Gillespie and Gerard Moran. Westport: Foilseacháin Náisiúnta Teoranta, 1987. 67–90.

Cullen, Fintan. *Visual Politics: The Representation of Ireland 175–1930*. Cork: Cork University Press, 1997.

Duffy, P. J. "The Changing Rural Landscape 1750–1850: Pictorial Evidence." *Ireland Art into History*. Eds. Raymond Gillespie and Brian P. Kennedy. Dublin: Town House, 1994. 26–42.

Edgeworth, Maria. *The Absentee*. New York: Oxford University Press, 1988.

Glin, the Knight of, David J. Griffin, and Nicholas K. Robinson. *Vanishing Country Houses of Ireland*. n.p.: Irish Architectural Archive and The Georgian Society, 1988.

Goldsmith, Oliver. "The Deserted Village." *The Field Day Anthology of Irish Writing*. Vol. I. Ed. Seamus Deane. Derry: Field Day Publications, 1991. 447–53.

Hall, Mr. and Mrs. Samuel Carter. *Hall's Ireland: Mr & Mrs Hall's Tour of Ireland*. Ed. Michael Scott. 2 vols. London: Sphere Books, 1984.

Hutchinson, John. *James Arthur O'Connor*. Dublin, The National Gallery of Ireland, 1985.

Jordan, Donald E. *Land and Popular Politics in Ireland: County Mayo from the Plantation to the Land War*. Cambridge: Cambridge University Press, 1994.

Kenny, Courtney. Letters to the author. 20 May 2002 and 30 May 2002.

Landowners in Ireland. (Dublin, 1876) reprint Baltimore, MD: Genealogical Publishing Co., 1988, 1998.

Lewis, Samuel, *Topographical Dictionary of Ireland*. Vol. 1. London: Lewis & Co., 1837.

McCabe, Desmond. "Social Order and the Ghost of Moral Economy in Pre-Famine Mayo." *"A Various County" Essays in Mayo History 1500–1900*. Eds. Raymond Gillespie and Gerard Moran. Westport: Foilseacháin Náisiúnta Teoranta, 1987. 91–112.

Malins, Edward and The Knight of Glin. *Lost Demesnes: Irish Landscape Gardening, 1660–1845*. London: Barrie & Jenkins, 1976.

Mitchell, Frank and Michael Ryan. *Reading the Irish Landscape*. Dublin: Tower House, 1997.

Mitchell, W. J. T. "Imperial Landscape." *Landscape and Power*. Ed. W. J. T. Mitchell. University of Chicago Press Chicago: 1994. 5–34.

Montague, John. *The Figure in the Cave and Other Essays*. Ed. Antoinette Quinn. Dublin: Lilliput Press, 1989.

Mulloy, Bridie. *Itchy Feet & Thirsty Work*. n.p. Lough Mask and Lough Carra Tourist Development Association, n. d.

O'Neill, Kevin. "Looking at the Pictures: Art and Artfulness in Colonial Ireland." Ed. Adele Dalsimer. *Visualizing Ireland: National Identity and the Pictorial Tradition*. Boston: Faber and Faber, 1993. 55–70.

Repton, Humphrey. *An enquiry into the changes of taste in landscape gardening: To which is added, some observation on its theory and practice, including a defence of the art*. London: J. Taylor, 1806.

Rosenthal, Michael. *British Landscape Painting*. Ithaca, NY: Cornell University Press, 1982.

Thacker, Christopher. *The History of Gardens*. Berkeley: University of California Press, 1979.

Visualizing the Famine in County Mayo

Margaret Preston

◇

AS IRELAND'S THIRD LARGEST COUNTY, MAYO OFFERS STUNNING CONTRASTS; BARREN ROLLING HILLS CULMINATE IN DRAMATIC CLIFF FORMATIONS THAT GREET THE BATTERING FORCES OF THE ATLANTIC. LATE IN THE NINETEENTH CENTURY, MAYO FOUND ITSELF IN THE POLITICAL THICK OF THINGS AS THE BIRTHPLACE OF

Ireland's Land War. In 1879, native son Michael Davitt founded the Land League of Mayo, an organization demanding that Westminster return Ireland's land to its people. Having watched his parents evicted from their home in 1851, Davitt well knew the importance of land ownership. His family's eviction followed the arrival of *phytophthora infestans*, a fungus that between 1845–51 destroyed Ireland's potato crop, wiped millions from the land, and left a specter that haunts the island to the present. For the impoverished population of the West, largely sustained by a potato diet, the Famine spelled unimaginable disaster; Mayo suffered what scholars have calculated to be the highest mortality in the country (Jordan 108 and 110).

Not until the last decades of the twentieth century did scholars begin serious investigations of how the Famine shaped modern Ireland. Although they have recently produced a vast literature of historical analysis based on written records, contemporary visual representations of this traumatic period were meager (Marshall 46). Because nineteenth-century artists generally avoided politically controversial topics (46), surviving Famine imagery provides rare visual evidence of the period. This exhibition includes a key nineteenth-century painting concerned with the Famine, Robert Kelly's *An Ejectment in Ireland*, 1848 (no. 27), as well as Seán Keating's *Economic Pressure*, 1936 (no. 36), which depicts the Famine's later effect on the rural West in the form of emigra-

tion. In addition, several 1996 installation pieces by Kathy Herbert evoke lasting consequences of the Famine: *Letters From an Empty House* (fig. 1), *Absent* (no. 92), and *Angel in the Hay* (no. 90). In order to demonstrate how such imagery illuminates the politically charged themes of eviction, emigration, and depopulation, this article provides historical context for the Famine in Mayo.

Like much of Ireland's western edge, Mayo has a mountainous and generally infertile coastline; even the far eastern region dotted with bogland and lakes is agriculturally forbidding (Jordan 14). Profitable farming was possible only in Mayo's central region—its economic heartland, running from north to south between Killala, Ballinrobe, and Galway (Crawford 71). Thus, at the turn of the nineteenth century, despite increasing agricultural profits for a few, most of Mayo's residents remained isolated and impoverished (Jordan 65; Crawford 80–81).

By the late-eighteenth century, Ireland's increasing agricultural production was largely being exported to England. During the same

period, population grew to such an extent that on the eve of the Famine, Ireland was home to eight million, with huge numbers depending on the potato for nourishment (Kinealy 9). Such extraordinary expansion placed mounting pressure upon the land, as three-quarters of the population lived on twenty or fewer acres, with almost twenty-five percent surviving on five acres or less (Donnelly 8). Crowding was particularly acute in the West where population growth was highest—with Mayo's numbers increasing at the fastest rate of all Ireland's counties (Jordan 45).

The sporadic failure of the potato in the fall of 1845 foreshadowed the coming catastrophe; by 1846, with the entire crop ruined, the crisis was clearly widespread. The resulting devastation was unimaginable throughout much of Ireland, but the West was most affected. The government, now under the leadership of Lord John Russell, soon heard increasing demands for aid. In 1838, the British Parliament had passed Ireland's New Poor Law, creating a nationwide system of Poor Law Unions with some 130 workhouses; as the crisis escalated, however, these workhouses were soon overwhelmed. As a result, in mid-1846 the government implemented a public works program that included road construction and repair, harbor and pier construction, and drainage schemes. Those administering the programs rapidly recognized their glaring weaknesses, particularly the low payment for work in relation to the rising cost of food (Daly 130-1).[1] The North Dublin Union Guardians, for example, wrote to the Poor Law Commission deploring the government's adherence to "the Principle of Political Economy..." when its energies "...should be exercised to the fullest extent in providing a starving population with the means of subsistence at such a rate as would enable them by their earnings to support their families..." (*North Dublin Union*, 4 November 1846).

The demand was daunting: the system was quickly inundated. The government soon concluded that Public Works were neither efficient nor effective and thus next sought to provide food directly to the people by means of soup kitchens. Mary Daly reveals that these kitchens served millions throughout Ireland and whole populations in some parts of the West (133).[2] With local relief committees and poor law unions unable to meet swelling demand, particularly in the western counties, the government declared these areas eligible for further aid in the form of the Temporary Relief Act of 1847, which provided subsidized loans to Ireland's Poor Law Unions (Kinealy 189).[3] This act, however, proved an ineffective means of protecting the small landholders, for it included the infamous Gregory clause that made occupiers of more than a quarter of an acre of land ineligible for state-funded relief. Pauperized tenants were forced to surrender their land before entering the workhouse; and this new legislation enabled deeply indebted landlords to evict tenants unable to pay rent.[4] The Gregory clause thus succeeded in clearing the land of the majority of pauperized smallholders (Donnelly 102).[5]

In Mayo, landlords were soon evicting residents from homes and then destroying the structures (Jordan 110). County evictions numbered 26,000 between 1849 and 1854, second only to those in Clare (Donnelly 156).[6] In 1849, the Connaught Telegraph reported that Sir Roger Palmer's employees, a.k.a. the "Crowbar Brigade," were "...'leveling' the houses of the worthy Baronet's tenantry and hunting the occupants to seek shelter or DEATH!" (*Famine in Mayo* 70).[7] Between 1846 and 1849 the Earl of Lucan, owner of over sixty thousand Mayo acres, leveled hundreds of houses and rid himself of some two thousand tenants. Ever tenacious, Lucan actually wrote the Ballinrobe workhouse to complain that the Guardians had illegally admitted one of his tenants who was "...in possession of over one acre of land" (*Ballinrobe Union* 30 October 1847).[8] Non-evicting Mayo landlords existed, but were clearly among the minority (Jordan 112–113).

First exhibited at the British Institution in 1853, Robert Kelly's *An Ejectment in Ireland* (no. 27) captures the traumatic moment as a family faces the reality of its homelessness. Invoking the experiences of thousands of tenants evicted by morally and monetarily bankrupt landlords, dark clouds metaphorically linger over the soldiers who have arrived like the coming storm to force the family off their land. At the foot of one soldier, a mother desperately beseeches him: where will her children sleep that night? Nearby, a child plays at the feet of a priest, the central figure in black, who raises his free hand toward the bright skies in prayer.[9] He is symbolically represented through Christ-like imagery—invoked by a second woman's posture, her head deferentially

bowed to kiss his hand; by the lamb and child; and the parting skies above. The expression on the priest's face, however, reveals his powerlessness before the landlord and British authority; he can but look skyward in prayer, hoping that the Lord might intervene.

Driven by market forces, Irish artists typically avoided controversial themes, particularly those that would, like *An Ejectment in Ireland*, suggest British culpability in the unfolding tragedy of the Famine (Bhreathnach-Lynch 250, 262). Kelly's painting thus provides a rare contemporary depiction of a common event, its imagery offering a strongly critical view of official policies. The family is victim to a callous landlord, legally empowered to evict his tenants by an unsympathetic British administration. The British soldiers, both those in the foreground and others carrying out evictions in the village below, are indifferent to the results of their actions: homelessness and probable death for families that include children and the elderly. Although only statistical works can reveal the scale of Kelly's subject matter, his image offers a human face to the trauma of eviction.

The details of the painting suggest the artist's complex relationship to artistic conventions of his day. Not only does he choose politically controversial subject matter, but he also portrays the victimized figures in *An Ejectment in Ireland* with considerable dignity. Despite its dire circumstances, the family does not appear extremely destitute and seems both well-fed and -clothed. Here, Kelly may be reflecting visual conventions of his day, for nineteenth-century artists catered to audiences with little interest in witnessing the brutal realities of contemporary life, and with a conviction that such subject matter had no place in high art (Bhreathnach-Lynch 255; Marshall 46).[10] But artists also tended to mirror contemporary stereotypes—including that of the Irish peasant as a buffoonish Paddy—thus reassuring elite viewers that the Irishman's childlike and affectionate nature needed British governance (Bhreathnach-Lynch 261). The dignified and suffering Irish figures in Kelly's painting, however, resist such demeaning stereotypes.

The reception of Kelly's painting reveals much about the power of such politically controversial imagery. Bhreathnach-Lynch notes that nineteenth-century art critics generally focused on conventional material, such as the beauty of a landscape, to avoid commentary on human suffering depicted in a canvas (256–7). But the political implications of Kelly's image were immediately acknowledged and criticized when it was first exhibited, not its romantically turbulent setting. *An Ejectment in Ireland* was so obviously a contentious work of art that it was reportedly the subject of parliamentary discussion.[11]

A grim legacy of the Famine was almost a century and a half of continual emigration. The family in *An Ejectment in Ireland* had but two choices: the workhouse or an emigrant ship. Although emigration was common well before the Famine, some 2.1 million persons departed from Ireland between 1845–1855 (Kenny 97–98). As a result of death and emigration, Mayo's population declined from 388,887 in 1841 to 274,830 by 1851 (*Famine in Mayo* 77); by the early-twentieth century, Mayo had a higher number of emigrants than actual residents (Moran 121).[12] Increasingly, artists paid homage not only to the emigrant, but also to the effect of his departure on the landscape—as in Seán Keating's *Economic Pressure* (no. 36), which visualizes the unremitting hemorrhage of Ireland's youth. Capturing the human costs of emigration, this painting makes a strong political point (Kennedy 49): despite Ireland's independence in 1921, politicians still fail to provide for the island's people.

Referred to as the "painter-laureate" of an independent nation (Kennedy 34), Keating depicts an emigrant's sad farewell to his grieving mother. *Economic Pressure* dramatizes the psychic costs of continual emigration; even the men who wait to deliver the young man to his ship turn away, unable face yet another painful goodbye. The stormy skies reflect the grim mood, though the light on the horizon may offer "the possibility of a brighter future abroad" (Costello-Sullivan 202).[13] Improbably growing on a large rock, a bare tree is indicative of Ireland's rocky, barren West, whose inability to provide fertile soil has resulted in the continued flight of the Irish. Keating's painting dramatizes the indelible impact that continuous emigration had on the country's economy, history, and psyche.

Undoubtedly inspired by the growing historical attention to the Famine in contemporary Ireland, recent artists have begun to explore that subject matter in their work. Herbert, in particular, offers contemporary commentary

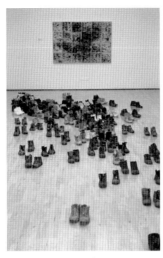

Fig. 1: Kathy Herbert, *Letters from an Empty House*, 1996, Installation, oils and wax on stained paper, Courtesy of the Artist.

on the Famine's legacy of depopulation that Keating had depicted more than a half century earlier. Several of her gallery installation and site-specific works—*Letters from an Empty House* (fig. 1), *Absent* (no. 92), and *Angel in the Hay* (no. 90)—address the desolation experienced both by those who have left Ireland and by those who remain.[14] In *Letters from an Empty House*, Herbert arranged pairs of walking shoes molded out of dirt, straw, and leaves beneath fragments of letters displayed in a quilt-like pattern on the gallery wall. Both shoes and letters invoke those nineteenth-century emigrants, weakened by hunger and disease, who fled Ireland on ill-equipped Famine ships. The shoes, like the emigrants themselves, steadily disappear from view the farther they are placed from the hand-written letters on the wall. The

longed-for letters in Herbert's piece bring news of life abroad and survive as the sole connection between emigrants—most of whom will never return—and their native land. The "Empty House" of the installation's title memorializes both those who have emigrated and those who remain in a landscape now emptied of friends and family.

Herbert's *Absent* reconfigures *Letters from an Empty House*, replacing the letter fragments with a series of photographs of derelict buildings hung above eight pairs of lined-up walking shoes. The artist suggests that "abandoned houses signify 'leaving' as a way of life," and that those who remain in Ireland reside among a growing number of empty stone ruins and a declining population (Herbert). In the central photograph of this installation, underbrush hides an abandoned house, as if literally swallowing the structure in order to erase it from the land. Herbert again uses shoes both to suggest an absence in the land and to recall that humans once interacted with this land, tilling its fields. Cast in cement and scrim, hollow and without soles, these shoes are durable, but lifeless and immobile.

Herbert's installations invoke painful loss, but also a cautious optimism. As Herbert herself noted in reflecting upon the site-specific installation *Angel in the Hay*, "life goes on." The artist also describes her works on emigration as articulating both sadness and optimism: "the trauma of leaving" and "the hope for the future" (Herbert). In this piece she has brushed aside hay on the home's floor to form an angel, imagery that suggests the bringing of light to

dark shadows and to empty houses. One might speculate that such imagery alludes to a striking change in patterns of emigration; in the 1990s, for the first time in Irish history, native born Irish men and women returning home contributed to the island's increasing population.[15] Herbert's *Angel in the Hay* perhaps suggests that the empty house has found new life, thrown open its doors, and is now for the first time welcoming the Irish home.[16] ❖

ENDNOTES

1 For example, authorities soon realized that most were too weak for this physically demanding activity. Wrote one observer, "...poor men sitting on heaps of stones, breaking them for a certain number of hours after walking five and six miles to their work in rags and tatters, more like specters than able-bodied..." (MacDonnell 11).

2 Daly writes that the change in strategy was "handled in an almost criminal manner..." as a result of a delay between the closing of the Public Works and opening of the soup kitchens, during which time the government supplied no additional aid (133).

3 By September of 1847, Mayo's Ballinrobe Union "...was so deeply in debt that the local sheriff seized the property of the workhouse and threatened to sell it." The crisis for Ballinrobe and all Mayo workhouses continued for years, and in June of 1850 the Guardians of Ballinrobe, with over 3,800 persons in residence, noted that the treasurer had only £115 in hand (Kinealy 187 and *Ballinrobe Union* 8 June 1850).

4 As Donnelly notes, the members of Parliament certainly understood that one possible result of the passage of this clause could be clearances (102).

5 In 1850, the Chairman of the Kilrush Workhouse in County Clare declared that evictions were "'extermination,' for it can only be truly described by that term..." (Scrope 9).

6 Tim O'Neill has redressed the eviction issue and argues that overall numbers may be much higher than previously estimated (40). See also Yager.

7 I would like to thank John Coll, Neil Sheridan, and Austin Vaughan of the Mayo County Council and Library for their assistance with this research.

8 The Guardians replied that their admittance of the tenant was not illegal because the quarter acre clause would not be in effect until November (*Ballinrobe Union* 30 October 1847).

9 Although his dress surprises the modern viewer, such attire would have been the norm—including top hat and cane that sit on the ground nearby. For another such example see Aloysius O'Kelly's "Mass in a Connemara Cabin" (O'Sullivan 16).

10 The healthy appearance of the family might also suggest that evictions were now creeping up Ireland's economic ladder. McManamon reports that in 1848 the Poor Law inspector for Ballina noted that "people with eight to ten acres were willing to surrender land" (McManamon 128).

11 Strickland suggests that while Kelly had not intentionally sought to make a political statement, *An Ejectment in Ireland* came under such criticism that it was discussed in the House of Commons (573).

12 Jordan cites that "approximately 44% of the county's Famine population loss was attributable to emigration" (109).

13 I would like to thank Kate Costello-Sullivan for her editing of this piece.

14 *Letters from an Empty House* no longer exists in its original form but was reconfigured as *Absent*.

15 Courtney notes that since 1991 increasing numbers of native-born emigrants have returned; in 1998 the population of Ireland was "higher than at any time over a century" (293).

16 Discussing contemporary Irish migration, Mary P. Corcoran reveals that in 1998 over half of Ireland's 22,800 immigrants were Irish citizens (177).

Works Cited

Ballinrobe Union Guardian Minute Books.

Bhreathnach-Lynch, Sighle. "Framing the Irish: Victorian Paintings of the Irish Peasant." *Journal of Victorian Culture* 2.2: Autumn, 1997.

Connaught Telegraph in *The Famine in Mayo 1845–1850: A Portrait From Contemporary Sources*. Mayo: Mayo County Council, 1998.

Corcoran, Mary P. "The Process of Migration and the Reinvention of Self: The Experiences of Returning Irish Emigrants." *Éire-Ireland* Volume XXXVI: 1–2, Spring/Summer 2002. 175–191.

Costello-Sullivan, Kathleen. "Cover." *Éire-Ireland* Volume XXXVI: 1–2, Spring/Summer 2001. 202.

Courtney, Damien. "A Quantification of Irish Migration with Particular Emphasis on the 1980s and 1990s." *The Irish Diaspora*. Ed. Andy Bielenberg. England: Pearson Education Limited, 2000. 287–316.

Crawford, Margaret. "The Great Irish Famine 1845–9: Image Versus Reality." *Ireland Art into History*. Eds. Raymond Gillespie and Brian P. Kennedy. Dublin: Town House, 1994. 75–88.

Crawford, W.H. "Development of the County Mayo Economy, 1700–1850." *"A Various Country:" Essays in Mayo History, 1500–1900*. Eds. Raymond Gillespie and Gerard Moran. Mayo: FNT, 1987. 67–90.

Daly, Mary. "The Operations of Famine Relief." *The Great Famine*. Ed. Cathal Póitéir. Dublin: Mercier Press, 1995. 123–134.

Donnelly, James. *The Great Irish Potato Famine*. England: Sutton Publishing, 2001.

Hebert, Kathy. *Absent* 1996. Unpublished typescript, 1996.

Jordan, Donald. *Land and Popular Politics in Ireland: County Mayo from Plantation to the Land War*. Cambridge: Cambridge University Press, 1994.

Kennedy, Brian P. *Irish Painting*. Dublin: Town House, 1993.

Kennedy, Brian P. "Irish Landscape Painting in a Political Setting, 1922–1948." *Aspects of Irish Studies*. Eds. Myrtle Hill and Sarah Barber. Belfast: Institute of Irish Studies, 1990. 47–57.

Kenny, Kevin. *The American Irish*. New York: Longman, 2000.

Kinealy, Christine. *This Great Calamity: The Irish Famine 1845–52*. Dublin: Gill & MacMillan, 1994.

MacDonnell, Eneas. *County of Mayo Its Awful Condition and Prospects And Present Insufficiency of Local Relief*. London: John Ollivier, 1849.

Marshall, Catherine. "Painting Irish History: the Famine." *History Ireland* Autumn, 1996. 46–50.

McManamon, Sean P. "Landlords and Evictions in County Mayo during the Great Famine." *Cathair na Mart* no. 18, 1998. 125–134.

Moran, Gerard. "Mayo God Help Us! Emigration from Nineteenth-Century Mayo." *Cathair na Mart* no. 21, 2001.

North Dublin Union Guardian Minute Books.

O'Neill, Timothy P. "Famine Evictions." *Famine, Land and Culture in Ireland*. Ed. Carla King. Dublin: University College Dublin Press, 2000. 29–70.

O'Sullivan, Niamh. *Aloysius O'Kelly*. Dublin: Hugh Lane Municipal Gallery of Modern Art, 1999.

Scrope, Esq. M.P., G. Poulett. *Draft Report Proposed to the Select Committee of the House of Commons On The Kilrush Union*. London: James Ridgway, 1850.

Strickland, Walter G. *A Dictionary of Irish Artists*. Dublin: Maunsel & Co., Ltd., 1913.

Yager, Tom. "Mass Eviction in the Mullet Peninsula during and after the Great Famine." *Irish Economic and Social History*. Vol XXIII, 1996. 22–44.

"The Land For The People":
Post-Famine Images Of Eviction

L. Perry Curtis, Jr.

IN THE BEGINNING—BEFORE THE COMING OF THE STONE-AGE PEO-PLE—THERE WAS THE LAND; AND MUCH OF THE LAND WAS GOOD. THE EARLIEST INHABITANTS LIVED OFF THE LAND IN A NOMADIC MANNER, HUNTING AND FISHING AND DWELLING IN CAVES AND PRIM-ITIVE HUTS. SOME 6,000 YEARS AGO THE NEOLITHIC SETTLERS BEGAN to domesticate cattle and plant crops for both human and animal sustenance, using techniques that endured throughout the Bronze and Iron Ages.[1] For almost a thousand years—from 500 BC to 500 AD—the Celtic peoples who came into Ireland produced some of the finest gold and bejeweled ornaments in all of Europe. Relying on a pastoral economy, the dispersed communities or tribes of early Irish society gradually increased their cultivation of both cereal and green crops as Christianity spread across the country. After their arrival in the Waterford area in 1169–70, the Anglo-Norman invaders built a number of fortified settlements in order to extend their control. Over the next several centuries their descendants established a series of castles and towerhouses in eastern Leinster, where their stronghold became known as the Pale. Appropriating the most fertile land, these feudal lords introduced Anglo-Norman institutions along with the concept of absolute ownership subject only to the obligations due to their superior lord; they relied on subinfeudation and the open-field system to extract profit from the soil.

Because they regarded the native or "mere" Irish as barbarians or worse, the Tudor conquerors and settlers ignored the sophisticated body of Brehon law and simply assumed that the kings, lords, or chieftains of the many *tuatha*, or extended family communities, had no legitimate claim to the land. To the new owners of the land, Irish society seemed lawless and primitive. Driven by political impera-tives, social and economic ambition, and sexual fantasies, the Tudor commanders and courtiers imagined Ireland as a virgin country blessed with beautiful hills, valleys, plains, and bays. Like a nubile woman "she" was theirs for the taking. Numerous acts of settlement and bills of attainder resulted in the confiscation and transfer of vast tracts of land from Gaelic lords to English adventurers and royal fa-vorites. Since all the land in the various king-doms belonged to the Crown, every colonizer held his Irish acres at the pleasure of the reign-ing monarch.

After the accession of Queen Elizabeth, English armies pushed deeper into the Gaelic lordships, suppressing rebellions, confiscating vast tracts of land, and planting them with loyal tenants. Orchestrated by such ruthless Lord Deputies as Sir Henry Sidney and Charles, Baron Mountjoy, this strategy of re-pression, expropriation, and plantation became much more "thorough" once the Protestant Re-formation added the lethal element of religious intolerance to the political conflict between two cultures. Countless Irish Catholics were forced

to work for the new owners of the land they had once occupied. From the Elizabethan wars and the flight of the Ulster Earls in 1608 to the Plantation of Ulster in 1609–14, the rebellion of 1641, the Cromwellian conquest of the 1650s, and the Williamite settlement in the 1690s, the number of Irish and Old English landowners steadily declined. By 1700, little more than five percent of the country remained in the hands of Catholics. Whether English, Welsh, or Scottish in origin the new owners were fervent Protestants who comprised the Ascendancy that ruled Ireland firmly for the next two centuries. In the meantime most of the aristocratic Irish Catholic families were driven into exile on the Continent. Known as "the Wild Geese," they supported the Stuarts' futile quest for restoration by means of money and soldiers.

The prolonged trauma of colonization created an enduring grievance among the "native" Irish, for whom the land carried both the positive idea of possession and the negative notion of dispossession. In fact, a defining slogan of Irish democratic politics in the nineteenth century was "the land for the people." But what did this battle cry mean? Far from signifying a return to some idealized system of collective or communal ownership, it meant replacing the Galls or foreigners with native-born Gaels on the basis of individual tenure. In addition, the idea of the land evoked something much more personal than sweeping vistas of mountains, valleys, plains, rivers, lochs, strands, and cliffs. It included the small green field in the West that Bull McCabe cultivated so obsessively in John B. Keane's play "*The Field*" as well as forty

acres of rich tillage soil and a bit of bog in Meath, Kilkenny, Carlow, or Tipperary. It also meant fields filled with flax in mid-Ulster and lush grassland for not only milk cows in north Cork but also beef cattle in eastern Connacht. After the Act of Union in 1801, it took on the biblical connotation of "the promised land" of independence or Home Rule.

In a suggestive essay Seamus Deane has drawn on the writings of James Fintan Lalor and Michael Davitt to make a clear rhetorical distinction between the concept of "soil as material-metaphysical possession and land as a political-legal entity." The former, he contends, "is what land becomes when it is ideologically constructed as a natal source, that element out of which the Irish originate and to which their past generations have returned. It is a political notion stripped, by a strategy of sacralisation, of all economic and commercial reference." In Lalor's famous words, "The soil of Ireland for the people of Ireland, to have and to hold from God alone who gave it—to have and to hold to them and their heirs for ever, without suit or service, faith or fealty, rent or render, to any power under Heaven." To this end he envisaged a glorious future wherein the peasantry would be "rooted like rocks in the soil of the land." And he insisted that "the entire soil of a country belongs of right to the people of that country, and is the rightful property not of any one class, but of the nation at large" (Deane 31–2).

At first sight this distinction seems plausible. But the meanings of words are neither fixed nor static because they depend so heavily on intention as well as context. Ireland's colo-

nial experience endowed both keywords with a sense of loss or theft through expropriation of the ancient birthright. Primarily associated with the cultivation of earth, "soil" (as in topsoil) may imply more soul—not to mention the verbal association with smearing, staining, or defiling—while "land" embraces every form of terrain from mountains and valleys to plains, lakes, and rivers. It also implies such rational and commercial elements as location, size, tenure, productivity, and value. However, both words bleed into each other at many points and they both signify the basic means of sustaining life as well as achieving status and wealth. When prefaced by "father" or "mother," *land* carries just as much ideological baggage as *soil* or *country* or *nation*. In the Irish context countless tenant farmers yearned to own the soil or land they cultivated.

As the noted English poor law reformer, George Nicholls, observed after visiting Ireland, land hunger had grown so intense by the mid-1830s owing to population growth that peasants regarded the acres they occupied "as conferring an almost interminable right of possession." Moreover, the lack of any statesponsored relief for paupers, combined with constant subdivision into ever smaller holdings, meant that land had become "the great necessary of life." Given the supreme priority of providing for one's family, the quest for land, in his view, often resulted in the violation of all "the restraints of law and humanity" (Nicholls 160–1).

From time immemorial the forcible loss of homestead or homeland—not to mention

expulsion from the Garden of Eden or paradise—has played a crucial role in human affairs. Next to the death of loved ones, eviction is the most traumatic loss a family can sustain. The act of being driven out of one's house and onto the road or into exile has not only caused intense emotional and physical pain but has also inspired many works of art, wherein the victims are depicted in sorrowful postures against a bleak background (Nicholls 160–1). In Irish history the cycle of conquest, confiscation, and plantation revolved perforce around eviction, and to make matters worse the evictors often leveled the house or cabin so as to prevent reentry. However legal such a proceeding might be, it could easily lead to starvation and in extreme cases to death. If the eviction was final, the only alternatives were squatting in a nearby ditch, hut, or barn, migrating to a town, or emigrating abroad.

At the height of the Famine in June 1847, Parliament passed the infamous Gregory clause that had the effect of forcing thousands of tenants holding more than a quarter acre to surrender their farm in order to qualify for public relief. Emboldened by this statute and anxious to consolidate their uneconomic holdings into larger and more profitable farms, many proprietors resorted to mass evictions. During the three years 1849–51, almost 50,000 families—or 262,600 individuals—were forced out of their homesteads and only 26 percent of these were allowed to reenter as caretakers on terms that placed them even more at the mercy of the owner. On Colonel Crofton Vandeleur's estate around Kilrush, County Clare, some

16,000 persons were evicted over a three-year period and many of their houses were destroyed. Among other landlords who expelled their poorest tenants and consolidated their holdings were Sir John Benn-Walsh, Lord Lansdowne, and Major Denis Mahon. Using the lure of passage money and the lever of eviction, Lord Fitzwilliam's agent induced 6,000 tenants of all ages to surrender their holdings on the Coolattin estate in County Wicklow and emigrate to Canada (Nicholls 160–1). Those who survived the ordeals of eviction, disease, starvation, and the trans-Atlantic voyage in unsanitary ships could never forget, let alone forgive, the callous behavior of landlords and officials. The horror stories they lived to tell in Greater Ireland overseas reverberated through successive generations.[2]

Apart from black-and-white sketches of the victims of starvation and disease published in the *Illustrated London News*, few contemporary pictures (and no photographs) of the "great hunger" exist.[3] The best artistic testaments to this catastrophe date from the 1850s and after when genre painting with its emphasis on sentimental story-telling was much in vogue. These images of evictions possessed much the same mournful and romantic qualities as Thomas Faed's (1826–1900) painting of the Highland Clearances in *The Last of the Clan* (1867).

A fine example of the eviction subgenre was painted around 1848 by the Dublin-born artist, Robert George Kelly (1822–1910), who moved to England shortly after finishing this work. *An Ejectment in Ireland* dramatizes the plight of a

three-generation family condemned to wander the roads (no. 27). Behind them—in the middle ground—stands their substantial farmhouse with the chimney still smoking, surrounded by red-coated British cavalry troops. In the foreground the artist has juxtaposed the binary forces of spiritual and secular power, represented by the priest on the right with his arm raised to heaven and the two Irish police constables armed with rifles and fixed bayonets on the left. While the grandmother begs for mercy, her aged husband gazes in despair at the priest. Standing tall in the center is their handsome son, whose tan breeches, waistcoat, and clean white shirt suggest a strong or prosperous farmer. His eviction appears all the more unjust because he is no simple-minded, dirty, and ragged peasant of the "Paddy" variety. The stick or cudgel he holds in his right hand was presumably used to beat the man—perhaps a bailiff or land agent—who lies on the road near the empty car in the background. As if bent on arrest, one constable grasps the farmer's shoulder, while the other tries to disarm him. Kneeling next to her husband with her back to the viewer, the imploring wife holds the priest's right hand. A tiny baby is almost hidden in the folds of her dress and her young daughter cradles a lamb signifying innocence or purity and helplessness. On the far right an untethered goat—symbolizing temptation or carnal desire—grazes in the field. Clinging to his father's leg, the brave little boy vainly attempts to push the menacing policeman away. Despite its static appearance, Kelly's visual narrative is filled with action; except for the landlord, it

◇

portrays virtually all the principal actors in the struggle for the land.

Apart from matters of dress, these images of forcible dispossession had a timeless quality. In his stark painting, *The Irish Famine* (1849–50), George Frederic Watts (1817–1904) depicted a homeless family seated on a pile of stones in the midst of a barren landscape with night drawing nigh. Once again a young mother holds a sickly infant in her arms. Several years later the Scottish artist, Erskine Nicol, who traveled through Ireland during the famine, painted another well-dressed and three-generation family forced out of their homestead and onto the road in *The Eviction* (c. 1853). And in 1890 Lady Elizabeth Butler (1846–1933), the talented painter best known for her battle scenes, completed an evocative painting, *Evicted*, that reflected her conversion to both Roman Catholicism and Irish nationalism. Here a barefoot young woman, dressed in the traditional Connemara attire of a full red skirt, white blouse, and black sash stands alone. Radiating sorrow, she epitomizes what Margaret Kelleher has called "the representation of famine and its effects through images of women" (2) Bereft of children and husband, she is framed by the stony ruins of her recently demolished house. Behind her loom treeless moors and mountains suggestive of Donegal. On the left, far beyond the pile of broken furniture, the evicting party may be discerned with its escort of police and soldiers marching towards another hovel destined for demolition.[4] As might be expected, some British critics found this painting too "melodramatic," if not too political, by half.

By 1879 a new form of Irish popular art had appeared in this "age of mechanical reproduction." Several nationalist weekly newspapers began to insert folio-sized color cartoons in their Saturday editions. These chromolithographs or "Supplements" were designed for framing and hanging on a wall. Representing many facets of the agitation for Home Rule and tenant rights and against coercion, they cast the leaders and martyrs of Irish nationalism as heroes pitted against such traditional villains as Irish landlords, British politicians, and the police. A remarkable convergence of print-media technology, editorial enterprise, and artistic talent made possible these colorful cartoons, and both the *Weekly Freeman* and *United Ireland* deserve credit for using this form of visual melodrama to galvanize the propaganda war in the heyday of Charles Stewart Parnell and Michael Davitt. Most of these striking images were accompanied by captions as well as rough and ready verses or doggerel.[5]

After the summer of 1878, the combination of bad weather, poor harvests, and low prices plunged tenant farmers deeper into debt. During the post-famine era many of those with larger holdings had invested heavily in livestock or pasturage, shifting their money and energies from corn to horn. As Gerald Fitzgibbon, a leading Dublin lawyer, put it, "the Irish race of farmers are tenacious of the national pastoral habit" especially where the best grazing lands lay.[6] For reasons both economic and political, they were not about to surrender their cherished pasturage without a fight simply because they had fallen behind with the rent. By the

autumn of 1879 a militant tenant-right movement had emerged in County Mayo under the leadership of resourceful ex-Fenians, who had decided to support the non-violent strategy and tactics of the New Departure that linked together the land and national questions.[7] In October 1879 they joined forces under Davitt's leadership to launch the Irish National Land League that enjoyed close ties to the Home Rule party. Soon local branches of the League were demanding rent reductions of at least 25 percent; if the landlords refused, they would organize a partial rent strike. The resulting impasse moved many landlords to evict not only the League activists on their estates but tenants whose arrears exceeded two or three years.

The agitation for lower rents and against eviction rapidly escalated, and League members began to organize boycotts—a new word for the old tactic of social ostracism arising out of the ordeal of Lord Erne's land agent, Captain Charles Boycott—against anyone who defied their will. Between 1880 and 1881 the number of agrarian outrages as well as evictions almost doubled, as landlords resorted to the threat or reality of ejectment in the hope of squeezing some rent out of their recalcitrant tenants. By the end of 1882, the number of agrarian outrages had reached 11,320 (of which 62 percent were threatening letters), and many of these were inspired by 11,215 final evictions. Despite the Land League's official commitment to moral rather than physical force, at least ten landlords and land agents were murdered in the early 1880s, not to mention the killing, wounding, and intimidation of tenants

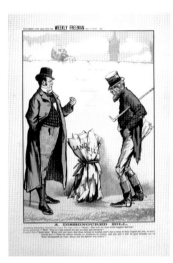

Fig. 1: Anon., *"A Dishonoured Bill,"* *Weekly Freeman,* August 6, 1887. Courtesy of the National Library of Ireland.

who had taken an evicted holding or helped a victim of boycotting.

The myriad supporters of both Home Rule and the Land League were fortunate to have on their side three such talented artists as Thomas Fitzpatrick (1860–1912), John Fergus O'Hea, otherwise known as "Spex" (c. 1838–1922), and John D. Reigh (fl. 1875–c. 1914). Unlike the "senior" political cartoons in *Punch* produced by such gifted artists as John Leech, Sir John Tenniel, and Bernard Partridge, these chromolithographs contained scant humor or comic wit because they were designed to inspire anger, dismay, sadness, and even hatred. Endowed with a sharp or serrated cutting edge, they featured stark contrasts between the flawless heroes of the national struggle and such familiar villains as rack-renting landlords, Dublin

Castle officials, British ministers, the Royal Irish Constabulary, magistrates, Emergencymen, and Orangemen.[8]

Besides producing flattering portraits of Parnell and his lieutenants, these artists delighted in demonizing the agents of eviction and coercion. Week after week they produced images of satanic or sadistic ministers mistreating the imprisoned but still unbowed leaders of the nationalist movement. A frequent presence in these cartoons was Erin or Hibernia, the always beautiful, beguiling, and pure symbol of the Irish nation. Far from being a helpless victim of British despots, this iconic figure often wielded a sword or cross like a latter-day Joan of Arc while urging her followers to pursue the noble goal of independence.

Fond of depicting coercion-minded Chief Secretaries and Lord Lieutenants as devils incarnate, Dublin's cartoonists also cherished two stereotypes of the landlord class. The first and favorite type was lean and mean, as can be seen in "A DISHONOURED BILL." Here the rack-renting landlord complains that the new Land Bill is "a bad reward for all my servility and savagery" (*Weekly Freeman*, August 6, 1887; fig. 1). Facing this sadistic evictor is "Farmer Pat." The handsome and well-dressed tenant farmer urges the "seedy" landlord to "become an Irishman" and befriend the tenantry: "those fellows in London," embodied by the prime minister, Lord Salisbury, who is peering over the wall at the rear, "don't care a snap of their fingers for you, no more nor for me." Another sort of landlord was rich and fat—someone who enjoyed living high off the

backs of his rack-rented tenants. A good example is the bloated, red-coated, and red-nosed symbol of Irish landlordism under whose weight the prosperous tenant farmer staggers across the Irish Sea in Fitzpatrick's "THE IRISH SINBAD AND HIS OLD MAN" (*Weekly Freeman and National Press*, June 23, 1894; fig. 2). Grasping his money bags filled with rack rents, this miserly version of the villain in the original tale, who was called "The Old Man of the Sea" is not going to be easily dislodged from Pat's sore shoulders. The cartoonist's choice of Sinbad's fifth voyage from *The Arabian Nights* implies, of course, that Pat will vanquish his corpulent oppressor as soon as he arrives in Ireland.

Running through many an eviction cartoon was the *leitmotif* of the razed or "tumbled"

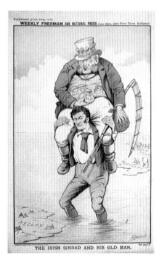

Fig. 2: Thomas Fitzpatrick, *"The Irish Sinbad and his Old Man,"* *Weekly Freeman and National Press*, June 23, 1894. Courtesy of the National Library of Ireland.

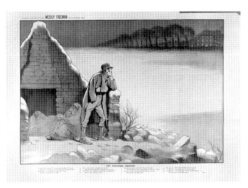

Fig. 3: Anon., *"Two Christmas Hearths," Weekly Freeman*, December 18, 1886. Courtesy of the Burns Library, Boston College.

homestead. The former inhabitants are usually shown huddling against the cold after the brutish eviction party has burnt down and broken the roof beam of their hovel in order to prevent re-entry. In "TWO CHRISTMAS HEARTHS" (*Weekly Freeman*, December 18, 1886; fig. 3), an injured and homeless farmer gazes resentfully across a snowy field at the lights burning brightly in the Big House where Yuletide festivities are under way. By contrast, the evicted tenant's family sits shivering under thin blankets behind him amidst the ruins of the old homestead. The caption consists of the following verses:

Look at this scene–Two homes are
 pictured here,
One full of comfort where the fire shines
 bright.
The other, to its tenants once was dear;
 Squalid and bare to-night!

Out in the cold, to famish, or to die,

The parents and their little ones are sent.
The man has worked, and toiled
 incessantly–
But cannot pay the rent.

He cannot pay–The sheriff won't forbear
He pleads for time–the landlord will not
 wait.
Father, and mother, children–all are
 there.
Homeless, and desolate!

Homeless! The very sound is like a knell!
See in those faces sorrow is depicted–
They know the meaning, which words
 cannot tell,
Of that foul word–Evicted!

Such cartoons made no allowance for the reality that almost one quarter of all eviction proceedings ended in the reinstatement of the tenant after he had come to terms with the agent by means of a token payment. According to nationalist propaganda every eviction was final and irreversible and accompanied by the destruction of the house or hovel. In "AR-RAN ISLES–1894" (*Weekly Freeman and National Press*, April 21, 1894; fig. 4) the grim reaper on the left sits beside the dead tenant lying on a bed of rocks. Opposite them the Shylock-like landlord counts a few coins in his hand. His gleeful leer is made all the more sinister by the can of paraffin oil and the tools of destruction that lie at his feet. In the background other members of the evicted family bemoan their fate.

Like Kelly's painting, these eviction cartoons focused on the pain and suffering caused to every member of the family regardless of age. Inspired by the rash of evictions on estates where tenants had resorted to a collective rent strike known as the Plan of Campaign, "THE TORY IDEA OF 'CONCILIATION'" (*Weekly Freeman*, December 10, 1887), features a group of brutish Emergencymen, or hired bailiffs, who are helping two policemen and a soldier operate the battering ram against a fortified house (no. 17). Standing behind this contraption—one that became notorious despite its infrequent use—a pompous officer armed with a broom supervises the action, while in the rear, a fireman directs a stream of water through the roof. Several members of the family huddle inside the broken door praying for deliverance.

In "THIS DEVIL'S WORK" (*Weekly Freeman*, March 3, 1888) Fitzpatrick has cast the Irish Chief Secretary, Arthur James Balfour, M.P. as a grinning Satan (no. 18).

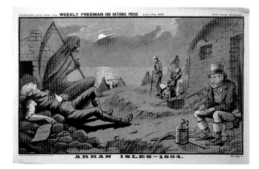

Fig. 4: Thomas Fitzpatrick, *"Arran Isles – 1894," Weekly Freeman and National Press*, April 21, 1894. Courtesy of the National Library of Ireland.

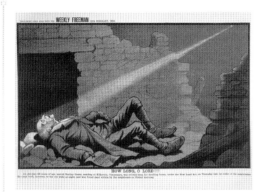

Fig. 5: Thomas Fitzpatrick, *"How Long, O Lord!!!,"* *Weekly Freeman*, February 18, 1888. Courtesy of the Burns Library, Boston College.

Standing on the left, "Bloody Balfour," as nationalists liked to call him, gazes fiendishly at the evicted family huddling against the elements. The contrast between evil and virtue is highlighted by the brilliant red of Balfour's mantle and the crepuscular green-blue color, suggesting oppression and death, that dominates most of this image. The title derives from a libel suit brought against Lord Clanricarde by his land agent after evictions on the Marquis's Galway estate had been described as "this devil's business."[9]

A much more morbid cartoon, "EVICTING TO DEATH (*Weekly Freeman*, October 20, 1888, refers to James Dunne, who died on October 11, 1888, shortly after being removed from his hovel on Captain H. S. Singleton's estate at Belpatrick near Collon, County Louth (no. 19). Ignoring warnings that this sickly, eighty-year old man would not survive the ordeal, the bailiffs carried him away from his warm hearth and left him sitting outside on a stool. Several hours later some workers moved him to an unheated barn or stable where he died shortly after dawn. The doggerel accompanying this cartoon denounced such daily crimes and appealed for mercy from "the sons of Albion." After this message came a summons to action: "Then pluck these despots down—Our country's curse, thy country's shame."

Fitzpatrick's cartoon resembled his recent work, "HOW LONG, O LORD !!!" (*Weekly Freeman*, February 18, 1888; fig. 5) that commemorated the death of another aged farmer, Bartley Geary of Kilkerrin, Connemara, who had "crept back" into his ruined cottage only to die within hours. Here the dead man lies on his back with mouth agape, amidst the stony ruins of his house. In his bony hand he clutches the ejectment warrant. A shaft of light from a distant star illuminates his head. Dunne's death triggered angry protest meetings around the county and both the local and national press deplored this callous deed. The inquest, held in a crowded courtroom in Ardee, dragged on for an unprecedented nine days and the *Freeman's Journal* reported each session in detail. At one point James M'Mahon, editor of the nationalist *Drogheda Independent*, who had witnessed the eviction and warned the sheriff about the danger of turning Dunne out into the cold, entered the courtroom and displayed John Reigh's representation of Dunne's death that had appeared in *United Ireland* (October 20, 1888; fig. 6). "THE VINDICATION OF THE LAW" reveals the dying old man stretched out on a thin bed of straw inside a barn suffused by the light of the moon.

Enraged by M'Mahon's bold move, the lawyer representing the landlord and his agents called it "a monstrous violation of every decency in a court of justice," and demanded that the editor be held in contempt of court. Whether or not they were swayed by Reigh's cartoon, the jurors decided that the landlord's two prominent solicitors and agents from Dublin, who had ordered the eviction and overseen the proceedings, "did feloniously kill and slay" Dunne. Following this verdict of manslaughter, the coroner promised to obtain warrants for their arrest, and the defendants' lawyer declared that he would lodge an appeal with the Queen's Bench Division. Several months later the judges in the latter court ruled that the National League had unduly influenced the coroner's jury and acquitted the two solicitors of any crime. If Dunne's death went unpunished, however, it did not go unnoticed.[10]

Nationalist cartoonists rarely missed a chance to denounce the coercive measures

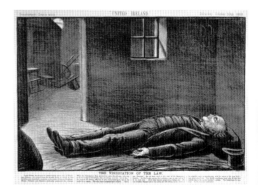

Fig. 6: John D. Reigh, *"The Vindiction of the Law,"* *United Ireland*, October 20, 1888. Courtesy of the National Library of Ireland.

applied by both the Liberal and Conservative regimes. One example out of literally hundreds of cartoons on subjects other than ejectment, must suffice. "LLOYD'S 'CIRCULAR' TOUR THROUGH CLARE" (*Weekly Freeman*, April 29 1882) arose out of a renewed offensive against agrarian outrage launched by the newly appointed special magistrate in County Limerick, Clifford Lloyd, who was also a barrister (no. 20). Alarmed by the rise in agrarian crime, the senior police officer stationed at Ennis in Clare, County Inspector Henry Smith, issued a "Police Circular" authorizing his men to shoot anyone suspected of harboring lethal intentions. To protest this policy of shooting first before asking questions, the artist drew the almost Amazonian figure of "Humanity" trying to prevent the police from killing innocent citizens. In the foreground a young woman with an infant weeps over the body of her dead husband, while the policeman on the left explains to "Humanity" that he has been ordered "to kill everybody that might commit murder."[11]

For anyone born before 1840, all of these melodramatic images of wicked landlords relying on brutish bailiffs and police to evict helpless peasants revived memories of the Great Famine and strengthened the resolve of tenant farmers to ensure that the horrors of the latter 1840s would not be repeated. For this reason O'Hea, Fitzpatrick, and Reigh deserve credit for having aided and abetted the agitation orchestrated by the Land League. Taken together, these political cartoons reminded Irish nationalists that they were involved in a desperate struggle for their livelihoods, if not their lives—one that would require many more sacrifices before they saw the sun of freedom shining on Erin's green and Gaelic land. ❖

Endnotes

1 For an introduction to Ireland from the Neolithic to the Celtic eras, see Sean Duffy (ed.), *Atlas of Irish History*, 2nd edition 10–23. A much more detailed and sumptuously illustrated study of Irish geography, geology, and land use may be found in F. H.A. Aalen, Kevin Whelan, and Matthew Stout (eds.), *Atlas of the Irish Rural Landscape* 4–49.

2 For recent scholarly assessments of the Famine and its consequences see James S. Donnelly, Jr., *The Great Irish Potato Famine*, Christine Kinealy, *This Great Calamity: The Irish Famine 1845–52*, and Cormac O'Grada, *The Great Irish Famine*.

3 Many of these images may be found in Noel Kissane, *The Irish Famine: A Documentary History*.

4 These paintings are reproduced in Donnelly, *The Great Irish Potato Famine*, on the front jacket and 84–85.

5 See L. Perry Curtis, Jr., *Apes and Angels: The Irishman in Victorian Caricature*, 68–88.

6 See Gerald Fitzgibbon, *Ireland in 1868, The Battle-Field for English Party Strife*, 137. Fitzgibbon wrote this book while a Master in Chancery.

7 The New Departure was a working alliance forged in 1878–9 amongst Michael Davitt, Charles S. Parnell, and the prominent Irish-American republican, John Devoy, who agreed to wage a non-violent popular campaign against both landlordism and the Union of Great Britain and Ireland. Moody has analyzed this momentous two-front strategy at length in *Davitt and Irish Revolution*, 1846–82.

8 The term Emergencymen refers to the Protestant agricultural laborers who were hired by landlord combinations like the Property Defence Association in the 1880s to break up boycotting on evicted holdings by harvesting crops and ensuring the sale of the livestock and produce of farmers proscribed by the land League. They also assisted the bailiffs at evictions. Usually recruited on northern estates, these heartily hated men carried weapons in case of ambush by the League's enforcers. The Orangemen belonged to the Orange Order or Institution founded in the mid-1790s for the purpose of upholding the Prostestant ascendancy, maintaining the union with Great Britain, and keeping the Catholics in a servile position. Concentrated in the Presbyterian areas of Ulster, the Orange lodges organized elaborate parades and ceremonies every summer to commemorate the victories of King William III over the Catholic forces of King James II in the early 1690s. See Marianne Elliott, *The Catholics of Ulster: A History* 344–61.

9 For details of the libel case and Lord Clanricarde's attempt to obtain a new trial, see *Freeman's Journal*, Dec. 5–8, 1887 and May 8, 1888.

10 For the particulars of the Dunne case, see *Freeman's Journal*, Oct. 12, 13, 15, 16, 18, 19, 23, 25 and Nov. 3, 6, 9, 10, 22, 1888; also Jan. 16, 17, 23, 1889.

11 For details of Clifford Lloyd's coercive measures and the notorious Police Circular in County Clare, see *Freeman's Journal*, April 21–22, 1882.

Works Cited

Aalen, F. H. A., Kevin Whelan, and Matthew Stout. *Atlas of the Irish Rural Landscape*. Cork: Cork University Press, 1997.

Curtis, L. Perry, Jr. *Apes and Angels: The Irishman in Victorian Caricature*. Rev. ed. Washington: Smithsonian Institution Press, 1997.

Deane, Seamus. "Land & Soil: a territorial rhetoric." *History Ireland*, Vol. 2, No. 1 (Spring 1994): 31–34.

Donnelly, James S. Jr. *The Great Irish Potato Famine*. Stroud: Sutton, 2001.

Duffy, Sean. Ed. *Atlas of Irish History*. 2nd ed. Dublin: Gill & Macmillan, 2000.

Elliott, Marianne. *The Catholics of Ulster: A History*. New York: Basic Books, 2001.

Fitzgibbon, Gerald. *Ireland in 1868, The Battle-Field for English Party Strife*. London: Longmans, Green, Reader, and Dyer, 1868.

Freeman's Journal (Dublin).

Gibson, Sarah and Paul Kuntz. "Expulsion." *Encyclopedia of Comparative Iconography*, Vol. 1. Ed. Helene E. Roberts. Chicago: Fitzroy Dearborn, 1998. 299–305.

Kelleher, Margaret. *The Feminization of Famine: Expressions of the Inexpressible*. Cork: Cork University Press, 1997.

Kinealy, Christine. *This Great Calamity: The Irish Famine 1845–52*. Dublin: Gill & Macmillan, 1995.

Kissane, Noel. *The Irish Famine: A Documentary History*. Dublin: National Library of Ireland, 1995.

Moody, T. W. *Davitt and Irish Revolution, 1846–82*. Oxford: Clarendon Press, 1981.

Nicholls, Sir George. *A History of the Irish Poor Law*. New York: A. M. Kelley, 1967.

O'Grada, Cormac. *The Great Irish Famine*. Basingstoke: Macmillan, 1989.

Rees, Jim. *Surplus People: The Fitzwilliam Clearances 1847–1856*. Cork: Cork University Press, 2000.

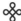

"The soil of Ireland for the people of Ireland":
The Politics of Land in Irish Visual Imagery, 1850–1936

Robert Savage

◇

"IRELAND HER OWN—IRELAND HER OWN, AND ALL THEREIN, FROM THE SOD TO THE SKY. THE SOIL OF IRELAND FOR THE PEOPLE OF IRELAND, TO HAVE AND TO HOLD FROM GOD ALONE WHO GAVE IT—TO HAVE AND TO HOLD TO THEM AND THEIR HEIRS FOREVER, WITHOUT SUIT OR SERVICE, FAITH OR FEALTY, RENT OR RENDER, OR ANY POWER UNTO HEAVEN."

—JAMES FINTIN LALOR

In the midst of the Great Famine, the above words by Irish radical James Fintan Lalor appeared on the pages of the nationalist newspaper the *Irish Felon* (qtd. in Buckley 36). Lalor's passionate appeal resonated in Ireland long after his untimely death in 1849 at the age of forty-two. Later in the century, constitutional nationalists and radical republicans alike embraced his argument that the land could be the engine that would pull the train of independence. Mobilize the land-hungry Irish peasantry around the emotive issue of land reform, Lalor maintained, and a political movement would arise to destroy the landlord's domination. With the defeat of the landlords, a unified Irish people would achieve independence.

Lalor's insistence on the centrality of land in Irish national consciousness was to dominate political life until and even after independence in 1921. A growing resistance to earlier colonial land policy and an idealization of the landscape of the West characterized late nineteenth- and early twentieth-century Irish nationalism. Images in the exhibition *Éire/Land* attest to the striking interdependence between Ireland's political and cultural preoccupations. Such interdependence is increasingly evident in elite art destined for galleries and dominates the more ephemeral imagery appearing as political cartoons in the popular press during the late nineteenth-century Land War. By providing a historical narrative to contextualize such images, this essay seeks to explore the relationship between a turbulent period in Irish political life and the country's visual culture—with particular attention to the highly politicized iconography of Seán Keating.

In the 1870s and 1880s, food shortages and evictions once again threatened vulnerable communities in the West, especially in County Mayo. Memories of the catastrophic Great Famine and the evictions of that era haunted tenants who were only a few decades removed from trauma of the famine decade of 1845–55. During this period and into the twentieth century, the contentious issue of land—who owned it, who exploited it, and who was exploited by a colonial system of proprietorship—unsettled Irish society.

The Land War (1879–1882) that helped destroy the economic and political power of Irish landlords emerged from the New Departure of 1878, an alliance of constitutional nationalists and radical republicans. The

alliance's strategy was to create a united front, mobilizing forces both in the imperial parliament at Westminster and in rural Ireland. Organizers deployed constitutional means as well as physical force tactics to demand that the unjust institution of landlordism be reformed or, better yet, destroyed. Cartoons from the *Weekly Freeman* (nos. 17, 18, 19, and 20) vividly capture the political passions characterizing this violent period.[1]

During the Land War vulnerable tenants mobilized to demand better terms from their landlords. These farmers invented tactics such as the "boycott" to punish landlords, their agents, and even neighbors whose actions were perceived as a threat to the welfare of the community. Portraying a Famine-era eviction, the polemical painting *An Ejectment in Ireland*, 1848 (no. 27) invoked terrifying memories of conditions that were returning to Mayo thirty years after the Great Famine. In this 1848 image, Robert G. Kelly captures the despair and sense of injustice that was the root cause of much violence both during the Famine and later in the century during the Land War.[2]

By the end of the century, Lalor's strategy proved prophetic: the economic and political power of the landlords was undermined by a combination of land agitation and parliamentary initiative. The New Departure also empowered Charles Stewart Parnell, a Protestant landlord who became leader of the Irish Parliamentary Party, in his effort to gain Home Rule. Parnell created a mass political movement and a formidable political force around the issue of land reform. Although unsuccess-

ful in achieving Home Rule, his party played a critical role in destroying the political and economic power of the landlords by forcing the British Government to make substantial concessions to tenant farmers.

Lalor's beliefs—particularly his emphasis on the repossession of the land for the people—inspired twentieth-century Ireland. Even after the Wyndham Land Acts (1903) had all but destroyed the institution of landlordism, his convictions were embraced by yet another generation of Irish radicals. For example, Patrick Pearse, later executed for his role in the 1916 rising, recognized the enduring role of land in the nationalist consciousness. Pearse praised Lalor and his "new gospel" for its emphasis on the repossession of territory in the struggle for independence. Pearse's own idealized vision of a nation in control of its natural resources was deeply influenced by Lalor's ideas.

A free Ireland would not, and could not, have hunger in her fertile vales and squalor in her cities. Ireland has the resources to feed five times her population; a free Ireland would make these resources available. A free Ireland would drain the bogs, would harness the rivers, would plant the wastes, would nationalize the railways and waterways, would improve agriculture, would protect fisheries, would foster industries...would in short, govern herself as no external power—nay, not even a government of angels and archangels could govern her. (qtd. in Brown 13)

In addition to being a committed republican leader, Pearse was an innovative educator and poet, dedicated to promoting the Irish language and many of the goals of the literary revivalists. The revival was committed to reclaiming a "lost" or forgotten national identity for Ireland, an identity grounded on that same "soil of Ireland" that Lalor's rhetoric celebrated. Many revivalists advocated not only the Irish language, but also an Irish folklore and literature arising from native sources—from a rich cultural tradition distinct from England's. Augusta Gregory and Douglas Hyde, for example, recovered, collected, and disseminated a Celtic folklore and saga literature, preserving it from what they considered were patronizing and oppressive colonial attitudes. Either directly or indirectly, by focusing their attention on an indigenous cultural tradition, cultural revivalists prepared Ireland for a political independence many believed inevitable.

At the turn of the last century, poets, artists, and writers looked to the West of Ireland for inspiration. They concluded that there—on the periphery of the island that was furthest from English influence—existed the essence of Irishness; there lived a people who lived simply, spoke the native language, and followed the traditions of their Gaelic ancestors. In a celebrated probably apocryphal episode that has come to epitomize the revival's westward gaze, William Butler Yeats encouraged the playwright John Millington Synge to visit the Aran Islands and "express a life that never found expression" (qtd. in Foster 197). The "primitive" life of the islanders Synge

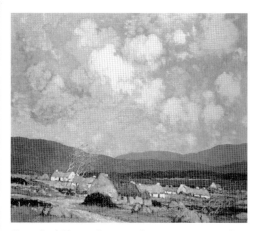

Fig. 1: Paul Henry, *Spring in Connemara*, c. 1930, oil on canvas board, 23 1/2" x 27 1/2", Courtesy of the John J. Burns Library, Boston College.

idealized in his memoir of his Aran sojourn influenced countless literary figures and visual artists. Scores of earnest cultural enthusiasts made their way to the West to learn the language and experience life in a community that they believed still retained an authentic Celtic identity. For many, this identity—based on their construction of an idealized indigenous Irish culture—was to provide the foundation for an independent nation.

In this catalogue, Irish artists painting the landscape of the West were also engaged in nation building. Influenced by the literary revival, Paul Henry, Jack B. Yeats, and Seán Keating created a visual tradition for an emerging nation. After reading *Riders to the Sea*, a tragedy about life on Aran, Henry recalled how "there was something in Synge that appealed to me very deeply. He touched some chord, which resounded as no other music ever had done" (qtd.

in Kennedy 154). In 1912, Henry traveled to Achill on the coast of Mayo, intending to spend a pleasant two-week holiday. He became so captivated by island life, however, that he made Achill his home for seven years. Living there or traveling elsewhere in the West, Henry produced many of his major paintings. *Spring in Connemara* captures the majestic western landscape, with Henry's signature big sky dominating the painting (fig. 1). Whereas the thatched roofed dwellings with their whitewashed walls suggest rural tranquility, the sky and clouds invoke the uncertainty and excitement of the turbulent natural landscape. Several of Henry's many commercially successful paintings of the West were used by the new state in tourist brochures, posters, and government publications—thereby becoming iconic representations of the Irish nation.

Following in the footsteps of Synge and Henry, Seán Keating also traveled to the Ireland's western islands, immersing himself in local life and language. Keating was fascinated by the Aran life he observed in 1914 and described the islands as a revelation (Kennedy 34). Now widely viewed as virtually the "painter-laureate" of a newly independent Ireland, as a young man Keating had supported Ireland's struggle for independence. His 1916 *Men of the West* (no. 37), interpreted as celebrating the 1916 Easter Rising, was painted in the aftermath of the rebellion. Although the rising failed as a military operation, the British Government's draconian response quickly alienated public opinion in much of Ireland. In the aftermath of executions, mass arrests, and a declaration of

marshal law, a revolutionary event that most Dublin residents had initially perceived as a reckless act by a small band of republican fanatics was transformed into a heroic stand by brave citizens against an oppressive occupying force. Already inspired by the cultural revival, Keating openly sided with the rebel cause and after the rising involved himself in fundraising efforts to relieve the families of internees in British prisons. At his initiative, *Men of the West* was reproduced in print form, with copies sold to raise money for these families in need. Considered subversive by the British, these prints were seized by authorities lest they incite further sedition (Breathnach-Lynch 45).

The figures in *Men of the West*, with their vests, bandanas, hats, and guns, may appear to Boston viewers as cowboys out of the nineteenth-century American West (Gibbons 23). However, to an Irish audience the three men (including the self-portrait of the artist on the left) are recognizably dressed in the traditional costume of Aran islanders. Indeed, here are the "agile men and barren landscape" that the artist had earlier praised in his visits to Aran (Kennedy 34). The look of resolve on their faces suggests a heroic determination, whereas the guns and tricolor emphasize a commitment to revolution. Keating's imagery suggests that Ireland's future lay with the new Ireland that these men represent—and thus with an emerging rural nation with its own distinct tradition and culture. Although the fighting in 1916 occurred primarily in the urban environment of Dublin, the artist, with a distinct nationalist agenda, intentionally moved the revolution to the West.

◇

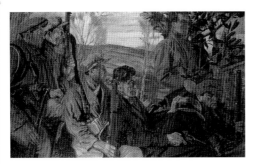

Fig. 2: Seán Keating, *Men of the South*, 1921, oil on canvas, 50" x 80", Crawford Municipal Art Gallery, Cork, Ireland.

As Bhreathnach-Lynch suggests, "the decision to present the men in this way served ideologically to link the remote West, with its distinctive, Gaelic way of life, to the emerging concept of national identity" (43).

As the War of Independence (1919–1921) unfolded, Keating paid tribute to the Irish Republican Army and the guerrilla tactics that IRA "flying columns" employed in their violent skirmishes against better-equipped conventional British forces. His 1921 *Men of the South* (fig. 2), depicting IRA members waiting in ambush for a British patrol, pays remarkable attention to details of the combatants' appearance. In preparation, Keating traveled to Cork where he photographed leading IRA officers for the painting. However by 1922, a brutal Civil War followed the Anglo-Irish treaty of 1921, which had partitioned the island and created the Irish Free State. Keating's disillusionment is evidenced by *An Allegory*, 1925 (fig. 3). Here, both soldiers of the newly established Irish Free State and their Civil War opponents dig a grave for a tricolor-draped coffin; in effect, they are burying the revolution. The Irish soil, once the source of inspiration, is now transformed into a burial ground for nationalist ideals. The ruin of a "big house" in the background symbolizes the fall of the once powerful Ascendancy or landlord class; these structures were targets of frustrated anti-treaty republicans who put many houses to the torch during the Civil War. As the hope and promise of the revolution are being buried, a priest and businessman stand impassively behind a nursing mother, suggesting the conservatism and stagnation that characterized the 1920s. Sprawled on the ground in front of a great tree is a listless, dispirited man, again a self-portrait of the artist; Keating's depression and alienation is palpable.

Keating would, however, rebound to become an important cultural figure, who chose on occasion to paint strikingly untraditional landscapes for the new nation. The Irish Free State that emerged from the War of Independence and Civil War had little interest in social reform. A key member of the government, Kevin O'Higgins, actually boasted, "We were probably the most conservative minded revolutionaries that ever put through a successful revolution" (qtd. in Lee 105). The government was so obsessed with fiscal responsibility that it resorted to cutting old age pensions and reducing the wages of policemen and teachers in order to balance the national budget. The decision to capture the Shannon's energy to generate electricity represented an important departure from the conservative orthodoxy characterizing the regime. Keating responded dramatically to the Shannon Scheme, the most daring project taken on by the government; perhaps he recognized that the future Pearse had predicted in 1915 could become a reality. Pearse had envisioned an independent Ireland that would "harness the rivers," precisely what the Shannon Scheme achieved in the 1920s. The project was a powerful metaphor for the emerging Irish Free State, proving as it did, that the natural world could be harnessed for the good of the nation.

Night Candles are Burnt Out (fig. 4) captures Keating's renewed optimism as he now envisions an energized nation taking control of its own destiny. When the painting was first exhibited in 1929, the artist explained that it depicted "the transition of Ireland from a country of ancient stagnation to a state of freedom and progress" (Delany and Collier 19). The massive state-of-the-art electrical works symbolize a dynamic nation moving forward, as

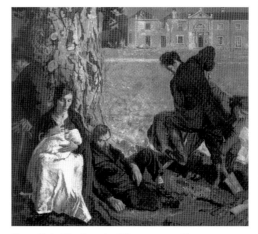

Fig. 3: Seán Keating, *An Allegory*, 1922, oil on canvas, 40 1/8" x 51 1/8", National Gallery of Ireland, Dublin.

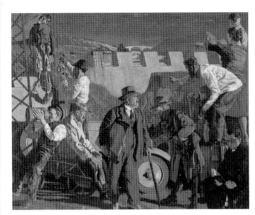

Fig. 4: Seán Keating, *Night Candles are Burnt Out*, 1928–1929, oil on canvas, 39" x 41", Oldham Art Gallery, Lancashire, England.

the young family on the right gaze at the un-folding engineering marvel that will bring needed power to an under-developed nation. Once again, the artist inserts himself into his painting, this time as the father with his young family, pointing forward towards a promising future. In the center, a businessman focused on industrial development looks contemptuously upon the gunman—now, in an emerging nation, an unsympathetic symbol of instability rather than of heroism.

Night Candles are Burnt Out dramatizes the transformation of the nation and the reclamation of the landscape by a newly independent government dedicated to modernization. Historically, the Shannon River marked the geographic border between east and west—and thus served as a psychological barrier separating the progressive East from the primitive West. But Keating presents a precious natural resource being tamed for the good of the whole nation; he depicts the Shannon Scheme as pulling the nation together and providing the energy needed to move decisively into a modern future.

A decade later in *Economic Pressure* (no. 36), another of the artist's major works in this exhibition, Keating confronts the failures of the new nation. The enthusiasm of *Night Candles are Burnt Out* is gone, as the artist ad-dresses the tragedy of emigration challenging independent Ireland through much of the twentieth century. By 1936, Eamon de Valera's Fianna Fail party had been in power for four years and was to remain there until 1947. During these long years, economic pressure forced thousands of Irish men and women from their homeland.

Embracing Paul Henry's bucolic landscape paintings of quiet country life as icons for a new Ireland, de Valera understood that even in the middle of the twentieth century, the land still held a critical place in Ireland's imagination. On St. Patrick's Day, 1943, he initiated a na-tional election campaign with a much-quoted speech, "The Ireland that We Dreamed Of." In it, de Valera presented the idyllic image of a na-tion of small farms and whitewashed cottages peacefully nestled in a countryside where peo-ple enjoyed "frugal comfort":

a land whose countryside would be bright with cosy homesteads, whose fields and villages would be joyous with the sounds of industry, with the romp-ing of sturdy children, the contests of athletic youths, the laughter of comely maidens; whose firesides would be the forums for the wisdom of serene old age. (Moynihan 466)

Despite his nostalgic rhetoric, de Valera understood that the small farms he extolled were simply no longer viable; years before his famous speech, he had admitted that "the flight from the land is a fact...it is difficult to see how people can be kept back on the farm" (qtd. in Savage 9). By 1959, when he retired from active politics, de Valera was replaced by a generation of politicians no longer com-mitted to the rural ideology that defined his era; the modernizing forces that subsequent Irish governments endorsed would under-mine his cherished notion of a nation of small strong farmers working the land. *Eco-nomic Pressure* has come to represent the fail-ures of independent Ireland and serves, per-haps unfairly, as a visual indictment of the de Valera leadership.

Whereas many of Keating's earlier paint-ings were strongly propagandistic homages to the struggle for independence or portraits of a hardy western people epitomizing a new na-tion, *Economic Pressure* captures the undeniably grim reality of rural life. The desolate and in-fertile landscape suggests a nation incapable of supporting its most precious resource, its peo-ple. The repossessed land, which according to Lalor and Pearse was to liberate the population, has instead failed to sustain them. The dead or dying tree clutching the rocky shore invokes a dying nation, still unable to provide a future for its young. The *curragh* waiting to take the

young man to the hooker in the distance suggests that Keating depicts an Aran scene; the next step in the emigrant's voyage will be the boat to England.

In this landscape, the West invokes despair and desolation, not renewal. The son's face is hidden in his mother's embrace, but the woman's face and her hands holding her boy convey the grief of both mother and son. To the left two men wait, the older one in profile seemingly resigned to such relentless losses to the community. The other looks away awkwardly, perhaps reluctant to intrude on an all-too-familiar moment in the early decades of the nation. Brendan Kennelly's poem "Westland Row" captures the mood of such seemingly endless departures:

> Brown bag bulging with faded nothings;
> A ticket for three pounds one and six
> To Euston, London via Holyhead.
> Young faces limp, misunderstanding
> What the first gay promptings meant—
> A pass into the brilliant wilderness.
> A capital of hopeless promise.
> Well, mount the steps: lug the bag:
> Take your place. And out of all the crowd,
> Watch the girl in the wrinkled coat,
> Her face half-grey.
> Her first time. (2)

Seán Keating's shifting attitudes toward post-revolutionary Ireland reflect analogous transformations in the cultural and political consciousness of the nation. In the first decades of the century, the artist moved from triumphal celebration of the struggle for independence in *Men of the West* and *Men of the South*, through a disillusioned vision of the post-war state in *Allegory*, a revived optimism in *Night Candles are Burnt Out*, and finally to *Economic Pressure's* sad recognition of the nation's failure to sustain its people. In these iconic paintings, Keating's imagination remains focused on the Irish landscape, seen initially and traditionally as a rural source for national pride and self-sufficiency, only to become, in the despondent *Allegory*, the burial ground for such revolutionary optimism. By shifting his focus to new landscape forms of hard-edged industrialization in *Night Candles Burnt Out*, Keating celebrates a striking visual transformation of de Valera's iconic rural Ireland. This new industrial landscape anticipates the modernization that would eventually halt the depletion of population crippling the nation until the 1960s. Although traditionalists still mourn the slow erosion of a rurally based Ireland, Keating's great paintings of the Shannon Scheme anticipate a technologically advanced and economic self-sufficient state, a nation able to halt that tragic dependence on emigration portrayed in *Economic Pressure*. ❖

ENDNOTES

1 See Perry Curtis's analysis of these cartoons in this catalogue: "'The Land for the People': Post-famine Images of Eviction," (85–92).

2 See in this catalogue Margaret Preston's "Visualizing the Famine in County Mayo," (79–83) and Perry Curtis, "'The Land for the People': Post-famine Images of Eviction" (85-92).

WORKS CITED

Breathnach-Lynch, Síghle. "Framing Ireland's History: Art, Politics and Representation 1914–1929." *When Time Began to Rant and Rage, Figurative Painting from Twentieth-Century Ireland*. London & California: Merrell Holberton, University of California and Berkeley Art Museum, 1999. 40–51.

Buckly, David N. *James Fintan Lalor: Radical*, Cork: Cork University Press, 1990.

Brown, Terence. *Ireland A Social and Cultural History, 1922 to the Present*. Ithaca, N.Y: Cornell University Press, 1985.

Delaney, Brendan and Delo Collier. *The Sean Keating Collection*. Dublin: Electricity Supply Board, 2001.

Foster, R. F. "Good Behaviour: Yeats, Synge and Anglo-Irish Etiquette." *Paddy and Mr Punch*. London: Allen Lane, 1993. 195–211.

Gibbons, Luke. *Transformations in Irish Culture*. Cork: Cork University Press, 1996.

Kennedy, S. B. "'An Irish School of Art?' Depictions of the Landscape in a Critical Period, 1880–1939." *Famine Land and Culture in Ireland*. Ed. Carla King. Dublin: University College Dublin Press, 2000. 153–68.

Kennedy, Brian P. *Irish Painting*. Dublin: Town House and Country House, 1993.

Kennelly, Brendan. *Collection One*. Dublin: Allen Figgis, 1966.

Lee, Joseph, J. *Ireland 1912–1985 Politics and Society*. Cambridge: Cambridge University Press, 1989.

Moynihan, Maurice. *Speeches and Statements of Eamon de Valera*. Dublin: Gill and MacMillan. 1990.

Savage, Robert. *Sean Lemass*. Dundalk: Dundalgan Press, 1999.

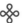

Painting The West:
The role of landscape in Irish identity

Síghle Bhreathnach-Lynch

◇

SOCIETIES AND COMMUNITIES ACROSS THE GLOBE IMPOSE THEIR MARK ON THE PLACES THEY INHABIT. THIS MAN-MADE TERRAIN, INTERSECTING AS IT DOES WITH THE NATURAL LANDSCAPE, ENABLES THOSE WHO LIVE ON THE LAND TO EXPERIENCE THEIR ENVIRONMENT AS AN EXTENSION AND REFLECTION OF THEIR OWN collective identity; thus they develop strong ties with the land (Collins viii). Because territory indicates power, wealth, and prestige, the intensity of this relationship is naturally heightened when ownership is in dispute. Over the last two thousand years in many parts of the globe, those who owned or controlled the land controlled political power; lack of access to land resulted, inevitably, in conflict, poverty, and starvation for the dispossessed.

The act of repossession has never merely signified the physical/geographical reclaiming of territory; repossession has, rather, always carried symbolic value (Keller 89). Because territory is the basis of the nation, the imaginative possession and the characterization of the land are deeply implicated in the development of nationalism as well as the formation of a national identity. The visual arts, literature, and music, directly or evocatively, reconstruct chosen tangible sights, images, and sounds of the nation (Smith 92). Across seventeenth- and early eighteenth-century Europe, for example, visual artists recreated the paintings, sculpture, and architecture of ancient classical worlds for monarchs. The display of these artifacts served not merely aesthetic goals, but also announced that these monarchical reigns were manifestations of a new Golden Age in the tradition of earlier classical models. Composers such as Bedrich Smetana, Edvard Grieg, and Antonin Dvorak, deeply influenced by nationalist ideals, created music that was largely based on folk tunes evoking distinctive ethnic sounds.

Figures as diverse as the Russian writer Leo Tolstoy and Finnish folklorist Martti Haavio generated nationalist feelings in their writings. The landscapes of the John Constable and J.M.W. Turner transmitted symbolic as well as aesthetic value—serving both to promote and to reflect the concept of England as "a green and pleasant land."

This essay examines painting of the Irish West by Jack B. Yeats, Paul Henry, Seán Keating, Charles Lamb, Mainie Jellett, and Gerard Dillon. It contextualizes both content and style in the ideological function of landscape painting within the periods before and after partial political independence in 1922. In the decades of Free State government, Ireland's overwhelming desire to envision itself as uniquely different from its erstwhile ruler Great Britain led to the construction of a national identity: the new nation was to be viewed as a pure unitary race, rural-based, Irish-speaking and Roman Catholic. A multilayered reading of the imagery of the Irish western seaboard reveals this category of fine art to be both signifier and signified. As

elsewhere across the globe, landscape not only existed as a locus for artistic inspiration, but also participated in the construction of a national identity. Evoking an immediate and emotional response from the viewer, landscape painting concretely communicated the tenets of an abstract ideology.

Beginning in the nineteenth century, Irish cultural life was marked by a growing sense of national identity embracing the whole population—an identity linked always to a Celtic past (Sheehy 7). Increasingly aware of themselves as politically and culturally different from England, the Irish began to demand control of their own destiny. Thus, after centuries of colonization the country was obliged to re-invent itself as a nation. This task, however, was far from simple: a nation's identity is not something that exists already formed, only waiting to be discovered by zealous nationalists, and then to be passively absorbed into public awareness. National identity is far more than a "glow of patriotic awareness" (Billig 60). Nationhood involves, rather, a distinctive imagining of a particular sort of community rooted in a particular location. That geographical space, however, is not just a physical setting, for like a national community, the national place must be fully imagined. In Ireland, the remote western coastline—an area of wild beauty, rugged mountains, flat bogs, and fields running into the sea—was imagined as the historic home of the Irish people, as the sacred repository of their memories.

As the furthest geographical point from England, the West provided a perfect foundation for that new identity. Although for its inhabitants existence was a constant struggle against grinding poverty, to the outsider this community possessed an unchanging lifestyle, seemingly untouched by wars, political upheavals, and urban industrialization. The country people of the West spoke Irish and wore exotic peasant costume; here, folklore customs had been preserved, and music and storytelling were passed on from one generation to the next. From the late-nineteenth century this distinctive location and its inhabitants increasingly attracted literary and visual artists who rejected the urban landscape. The laying of railway lines from Dublin to destinations in Clare, Sligo, and Donegal opened up the west coast to creative figures who saw this area as "pure" and always "different" from other parts of the country. In visualizing the West, these artists left a rich legacy of art and literature that constructed a distinctive cultural identity.

Such significance accorded to "unspoiled" places is not unique to Irish artists. Brittany had long been a favorite destination of European and American artists fleeing the metropolis. Newlyn in Cornwall was perceived as a haven from the world of factories and heavy industry. From the mid-nineteenth century, the pretty village of Betws-y-coed and its surrounding area in Wales became the preferred resort for young Welsh and English artists. Although many flocked to these places to paint beautiful landscapes, others were also committed to creating an indigenous culture. In Wales[1] as in Ireland, a growing sense of political assertiveness accompanied the conviction that a national Welsh art was essential "if the national life is to attain its fullness and completeness" (Williams 97). By 1920, a group of Toronto-based artists (the Group of Seven) were depicting the wilderness of the North of the country as the quintessential Canada. Landscape's ideological role is thus widespread and seemingly inevitable. In her analysis of landscape and nationalism, Patricia Cusack points out that if territory is the basis of the nation, it follows that the "imaginative possession and characterization of the lands through visual art is important to nationalism."[2]

The imagery of Jack B. Yeats and Paul Henry—pre-eminent among the visual artists inspired by the West—played a significant role in affirming Irish distinctiveness. Critic Thomas McGreevy insisted that Yeats's

Fig. 1: Jack. B. Yeats, *The Man from Inishmore*, 1905, watercolor, 15" x 11", National Gallery of Ireland.

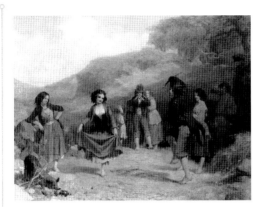

Fig. 2: Trevor Fowler, *Children Dancing at a Crossroads*, c. 1838, oil on canvas, 28" x 36", National Gallery of Ireland.

imagery constituted a national art precisely because it so vividly expressed every aspect of the nation's life. Even six decades later, Bruce Arnold agreed that Yeats occupies a central position among artists who help formulate a national identity (61). By 1905, Yeats had given visual expression to the heroic peasant (fig. 1) as a new representation of Irishnesss. Although in the nineteenth century, Ireland was commonly depicted as a rural country, such rurality was conveyed primarily through an escapist imagery of happy peasants dancing and drinking (fig. 2).[3] Such a representation, itself an active agent in reinforcing colonial stereotypes of the indigenous Irish as a feckless people, is very different from Yeats's proud, even somewhat menacing figure. Here is no cowering peasant, but an Irish man who confidently dominates his world. This imagery was in part shaped by Yeats's personal response to the West; but the artist's vision was also influenced by his work

illustrating texts by John Millington Synge, whose writings conferred a super-heroic identity on Aran and Connemara country people.[4]

Yeats's earliest western landscapes date from 1906.[5] During the next decade he worked systematically on the west and south coasts, and after the 1920s he created both fantasy and realistic landscapes (Pyle xx). Painted *in situ* with a sharp observant eye, the latter recall the earlier images of Nathaniel Hone the Younger, whose canvases *Coast of Clare* and *St. George's Head* (nos. 30 and 31) capture the bleak beauty of the wild Atlantic shore. Like Hone, Yeats acquainted himself with the physical and visual aspects of a particular place; his style is characterized by a unity of tonal coloring, enlivened by free-flowing brushwork. His important 1927 painting *Derrynane* (no. 48) was awarded a silver gilt medal at the Dublin *Aonach Tailteann* (Tailteann Games) in 1932. This athletic and cultural festival—held in 1924, 1928, and 1932—expressed the new Irish state's eagerness to proclaim its independence and, through a commemoration filled with Gaelic spectacle, to flaunt the symbols of its cultural heritage to the world.

Derrynane, a pleasing depiction of land, mountain, and sea, was undoubtedly considered noteworthy more for its ideological import than for its transparent aesthetic appeal. During the 1920s the West became a major theme in nationalist discourse. But as Joep Leerssen suggests, the significance of a chosen place's marginality is far from a "mere neutral fact of the distribution of landmass and ocean: a whole set of connotations and commonplace topoi is

attendant upon this notion of marginality" (3). For political and cultural nationalists, this distinctive vision of an Ireland far removed from the urban industrial image of Britain offered what Ciaran Benson has called "the national sense of self" (20). A painting that so strongly projected the peripherality of place, a location outside normal historical progress, perfectly articulated Ireland's post-independence sense of national self.

Paul Henry, the other leading painter of the Irish West, is cited by S.B. Kennedy as the most influential landscape artist of the century.[6] Almost single-handedly Henry forged a distinctive school of landscape painting, for his way of seeing influenced countless other artists. His imagery significantly influenced how post-independence Irish identity was defined at

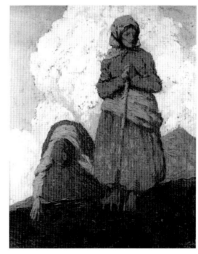

Fig. 3: Paul Henry, *The Potato Diggers*, 1912, oil on canvas, 20" x 18", National Gallery of Ireland.

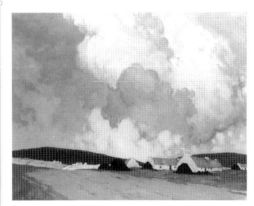

Fig. 4: Paul Henry, *Connemara Cottages*, 1936–7, oil on canvas, 20" x 18", National Gallery of Ireland.

home and abroad. His deeply held conviction that the West represented the "real soul of Ireland" shaped his response to the people and landscape of the area (Henry 93). The heroic peasants of Synge's texts and Yeats's imagery populate his early pictures, in which men and women digging potatoes, cutting turf, and fishing are observed with dignity and empathy (fig. 3). Artistically, these figures recall the earlier tradition of Jean François Millet;[7] but more personally they reflect Henry's admiration for these hard-working people, an admiration that he expresses in his autobiography, *An Irish Portrait*.

Although Henry's early genre scenes are part of a broader movement away from former stereotypes, his approach to landscape painting is unique. His scenes appear utterly unlike those of the nineteenth century—those evoking the Arcadian landscapes of Claude, depicting picturesque stage-Irish figures, or interpreting the land in a realistic academic mode.[8] Henry's images are remarkable for their utter

simplicity of composition and their impression of timelessness. He sparingly depicts essential elements of mountain, lake, bog, and cottage (fig. 4). His acute sensitivity to the effects of light and atmosphere peculiar to north-western Europe distinguishes these evocative images. Henry's vision of Ireland as a rural utopia coincided with the state's construction of national identity during the 1930s, 40s, and 50s. Because his western imagery was widely reproduced and used commercially to promote tourism at home and abroad,[9] his paintings became iconic, fixing what was to become the public's quintessential image of Ireland. But although Henry's art became synonymous with the ideological program of the new state, he himself was not politically motivated.[10]

The new canon of Irish genre and landscape, so innovatively represented by Yeats and Henry, was articulated in the next several decades by other painters, united by a desire to create an art which expressed, what Charles Lamb termed, "the national essence" (Power). Among them are Seán Keating, Charles Lamb, Mainie Jellett, and Gerard Dillon. Of these, Keating and to a lesser extent Lamb, were motivated by strongly held nationalist convictions. Keating's themes are always patriotic in intent—in his romantic image of the fighting men of the Easter Rebellion and of the War of Independence, his portraits of agile handsome Aran islanders, as well as his images of more everyday Irishmen. *Men of the West* (no. 37), begun some time in 1916, is a romanticized image of those involved in the Rising of that year. Dressed in distinctive peasant costume and

bearing arms, the figures stand in heroic pose against a backdrop recalling the desolate landscape of Aran. In spite of the largely urban nature of the Rising, Keating implies that these fighting men of the West are the authentic representatives of the Irish race. By placing them in a western setting, he links that region to the emerging concept of national identity.

Although the landscape of the West identified the Irish male as strong and steadfast, it anchored the Irish female to a nurturing role.[11] Keating's *Aran Fisherman with his Wife* (fig. 5), painted in 1916, depicts the fisherman as provider of the family. His proud pose and forthright gaze suggests he is master in the relationship, whereas his wife, overshadowed by the standing male figure, represents the homemaker and mother. That she recalls the Virgin

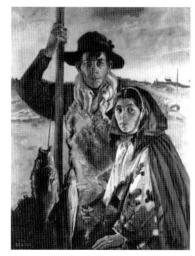

Fig. 5: Seán Keating, *The Aran Fisherman with his Wife*, 1916, oil on canvas, 49" x 39", Hugh Lane Municipal Gallery, Dublin.

Mary is no coincidence, for in this period Mary, regarded as the perfect role model for Irish women, was signifier of moral purity and sexual innocence.[12] In the decades following independence, Irish men were encouraged to be strong, virile, and active in the affairs of the country. First and foremost, however, women were expected to be mothers. The central meaning of their existence derived from their families; their space was confined to the domestic sphere. As painted by many artists, the image of the peasant woman in her rural habitat provided a suitable iconography for this domestically enshrined woman. For example, in Charles Lamb's *Loch an Mhuilinn* (The Mill Lake; no. 32), painted in the 1930s, a woman washes clothes by the water's edge surrounded by the typical motifs associated with the West: thatched cottages, dry-stone walls, *curraghs*, stacks of turf, distant mountains. Her small stature in the landscape reinforces the links being established between the female and natural world; in the painting she exists merely as another component of nature. Only the artist's use of a strong red to depict her clothing permits her to stand clear of her environment.

Irish artists engaged in portraying the West, unlike the French Impressionists or the Canadian Group of Seven, never worked as a cohesive group. The western paintings of Mainie Jellett are notable for their abstract rhythmic forms that gesture toward rather than describe the landscape (no. 54). Unlike most Irish painters, she did not believe that painting "complacent coloured photographs of cottages and Irish scenery" constituted a na-

tional art (Jellett 5, 7). Instead, she was strongly influenced by the design qualities of early Christian art. Gerard Dillon's wonderfully naïve *Little Fields* (no. 55) more directly alludes to the ancient past by including a carved monastic figure, a Celtic cross, ruined castles, and megalithic tombs. However for the most part, western imagery was grounded in an academic style, or, as in the case of more avant-garde painters like Paul Henry, in a style that was not *too* daringly modern. Ciaran Benson argues that the new Ireland was no revolutionary country driven by an urgent fervor to introduce sweeping changes (20). Rather it was a rebellious country, psychologically motivated to return to some previous real or imagined state of affairs. Ireland had undergone a conservative rebellion and its conservatism was Catholic and nationalist. This conservatism, suggests Benson, explains why the preferred visual articulation of the nation was traditional and academic.

According to D.W. Meinig, every nation has its symbolic landscapes—landscapes that are "part of the iconography of nationhood, part of the shared ideas and memories and feelings which bind a people together" (164). Like artists elsewhere, Irish painters made major contribution to the development of such national iconographies. In constructing a distinctive identity in the first half of the twentieth century, Yeats, Henry, as well as others, lovingly depicted the location then imagined as the "real" Ireland—projecting the perceptions, values, and aspirations of their sponsoring society. Whereas many of

these artists were aesthetically motivated to paint the dramatic landscape of the West, others consciously expressed a corporate sense of cultural and national identity. Yet whatever their intentions, their western images became not only part of that national identity, but central to it. ❖

Endnotes

1 For a comprehensive account of artistic activities in this part of Wales and its significance in the growing interest in establishing a Welsh identity separate from that of England, see Lord.

2 I am grateful to Dr. Cusack for providing me with a copy of this unpublished paper.

3 For a study of nineteenth-century depictions of the Irish peasantry by Irish and British artists, see Bhreathnach-Lynch, "Framing the Irish: Victorian Paintings of the Irish Peasant." McConkey notes the change from earlier stereotyping of the Irish towards the end of the century in *A Free Spirit Irish Art 1860–1960*.

4 Yeats created twelve line drawings for Synge's *The Aran Islands*, (1907). Both Yeats and Synge also collaborated in producing a series of illustrated reports on the congested districts of Connemara and Mayo for the English newspaper *Manchester Guardian*, 1905.

5 According to Hilary Pyle, the only extant 1906 landscape is *Low Water, Spring Tide, Clifden, Co. Galway*.

6 For a fully detailed, scholarly biography of Henry, see Kennedy.

7 For an analysis of the depiction of the peasantry by Jack B. Yeats and Paul Henry, see Bhreathnach-Lynch, "The Peasant at Work: Jack B. Yeats, Paul Henry and Life in the West of Ireland."

8 Kenneth McConkey deals with this subject in some detail in chapter 1 of *A Free Spirit*.

9 According to Kennedy, Henry's painting *Connemara* (1924–5) was the most sought after. The London Midland & Scottish Railway reproduced it as a poster. Over 900 copies of it were sold by the company to the public.

10 Kennedy states that early in Henry's career, at the time of the centenary celebrations of the 1798 rebellion, he flirted with the idea of Irish nationalism but on reflection decided that it was based on sentiment rather than conviction.

11 For further study on this topic see Bhreathnach-Lynch, "Landscape, space and gender: their role in the construction of female identity in newly independent Ireland."

12 Keating's painting was chosen by the Department of
Education as the frontispiece for a school reader in the 1930s.

Works Cited

Benson, Ciaran. "Modernism and Ireland's Selves." *Circa*. 61 (1992). 19–23.

Bhreathnach-Lynch, Síghle. "Framing the Irish: Victorian Paintings of the Irish Peasant." *Journal of Victorian Culture* Autumn 1997: 245–263.

---. "The Peasant at Work: Jack B. Yeats, Paul Henry and Life in the West of Ireland." *Irish Arts Review Yearbook* 1997: 13, 143–151.

---. "Landscape, space and gender: their role in the construction of female identity in newly independent Ireland." *Gendering Landscape Art*. Eds. Steven Adams & Anna Greutzner Robins. Manchester: Manchester University Press, 2000. 76–86.

Billig, Michael. *Banal Nationalism*. London: Sage Publications, 1995.

Bruce, Arnold. "Jack Yeats and the Making of Irish Art in the Twentieth Century." *When Time Began to Rant and Rage:Figurative Painting from Twentieth-Century Ireland*. London: Merrell Holberton, University of California and Berkeley Art Museum, 1998. 52–62.

Collins, Timothy. "Introduction." *Decoding the Landscape*: Ed. Tomothy Collins. Galway: Centre for Landscape Studies, 1997. viii–x.

Cusack, Patricia. "The Irish Cottage Landscape and 'Banal' Nationalism." Unpublished paper, presented at the Art Historians Association conference, 1998.

Henry, Paul. *An Irish Portrait*. London: B.T. Batsford, 1951.

Jellett, Mainie. "The R.H.A. and Youth." *Commentary*. May 1942: 5, 7.

Keller, Christian. "The Theoretical Aspects of Landscape Study." *Decoding the Landscape*. Ed. Timothy Collins. Galway: Centre for Landscape Studies, 1994. 79–98.

Kennedy, S.B. *Paul Henry*. New Haven: Yale University Press, 2000.

King, Carla, ed. *Famine, Land and Culture in Ireland*. Dublin: University College Dublin Press, 2000. 1–4.

Leerssen, Joep. "The Western Mirage: On the Celtic Chronotope in the European Imagination." *Decoding the Landscape*. Ed. Timothy Collins. Galway: Centre for Landscape Studies, 1994. 1–11.

Lord, Peter. *Clarence Whaite and the Welsh Art World : The Betws-y-coed Artists' Colony 1844-1914*. Aberystwyth: National Library of Wales, 1998.

McConkey, Kenneth. *A Free Spirit Irish Art 1860-1960*. London: Antique Collector's Club in association with Pyms Gallery, 1990. 17–26.

McGreevy Thomas. "Three Historical Paintings, Jack B. Yeats." *Capuchin Annual* (1942) 238–251.

Meinig, D.W. "Symbolic Landscapes: Some Idealizations of American Communities." *The Interpretation of Ordinary Landscapes*. Ed. D.W. Meinig and John Brinckerhoff Jackson. Oxford: Oxford University Press, 1979. 164–192.

Power, Arthur. "Charles Lamb 1893-1964, a Memoir by Arthur Power." *Charles Lamb 1893-1964 Catalogue*. Dublin: Municipal Gallery of Modern Art, 1964. n.p.

Pyle, Hilary. *Jack B. Yeats A Catalogue Raisonné of the Oil Paintings*. London: Andre Deutsch, 1992.

Sheehy, Jeanne. *The Rediscovery of Ireland's Past: the Celtic Revival 1830-1930*. London: Thames & Hudson, 1980.

Smith, Anthony D. *National Identity*. London: Penguin Books, 1999.

Wilson, William. *Folklore and Nationalism in Modern Finland*. Bloomington and London: Indiana University Press, 1976.

Williams, Iona. "Welsh Art." *The Welsh Review* 1 (1906): 97.

RESPONDING TODAY

Exploring Place and
Artistic Practice in Northern Mayo

Alston Conley

◇

THE NATURAL LANDSCAPE OF NORTHEASTERN MAYO—SEA, LIGHT, HEDGEROWS, ROCKY GREEN FIELDS, STONE COTTAGES, AND DRAMATIC GEOLOGICAL FORMATIONS OF CHASMS AND STACKS IN THE SEA—DRAWS POWERFUL RESPONSES FROM THE ARTISTS WHOSE IMAGES APPEAR IN THE FINAL SECTION OF *ÉIRE/LAND*. THESE paintings were, for the most part, produced by Fellows at the Ballinglen Arts Foundation, an organization that brings American and Irish artists to live and work in Ballycastle, a small rural coastal village in Mayo. Painters at the foundation fall into two broad groups: some work outdoors, responding directly to the natural world; others paint in studios, conceiving their imagery from a variety of other sources and experiences. Artists working outdoors explore the local landscape by car, bicycle, and foot; they use portable canvases that can be transported easily as they search out sites from which to capture coastal Ireland's mercurial shifts of the weather and light. Others, who paint on large-scale canvases or build complex surfaces, choose to work in the studio, often after making preliminary studies or excursions in the landscape. By describing these different practices, both conceptual and technical, this essay seeks to convey the variety of private exchanges between contemporary Ballinglen artists and the vast landscapes of North Mayo.

Despite painting directly from observation in the natural world, which in earlier generations might have resulted in an exacting realism, artists working in the landscape combine topographical description with a degree of personal expression. Stuart Shils observes that "on the coast of North Mayo, form and mass dissolve, eroded and battered by the assault of light, weather and the rush of time—all of which act as powerful solvents, essentially destroying the presumed stability of the visible world as we usually know it" (2). Shils paints oils on paper with a brush, but more often with a palette knife, a tool that precludes delicate representations and detailed drawing. His choice of paper, a more fragile surface than canvas, limits reworking or overpainting. These methodological choices support Shils's emphasis on form and structure in his paintings, exemplified by the unadorned underlying geometry of road, fields, and buildings in *Ballyglass Fields From the Turf Road* (no. 75). The simplified forms of the image allow him to focus on the expressive qualities of paint—on its application and surface textures—as he seeks to capture Mayo's rapidly changing light. Like Eric Aho and Wendy Prellwitz, Shils uses variations of the demanding *a la prima* oil technique, in which fresh paint is delivered 'wet-into-wet' onto a prepared dry ground—the canvas, board, or paper. In the quest for a seamless whole, failed areas in the painting must be scraped off and repainted. Aho's broad, paint-loaded brushstrokes or Shils's palette-knife geometry can look effortless and masterful—or awkward and incompetent. The risk of failure raises the

stakes; each successive stroke is a decisive, intuitive assault. The painterly depiction of atmosphere dominates Eric Aho's images, in which the forms of buildings contrast with nature; light, or the lack of it, fills his skies and backgrounds. *Behind Balleycastle* (no. 84) depicts small village houses and *Enniscoe, Calm Evening* (no. 85), a grand Georgian house—architectural forms with resonant historical associations in Irish social history. But working in the landscape, Aho focuses not on sociological content, but rather on the expressive qualities of light captured by paint. He strives to capture the specific moment and place—that instant in which *a la prima* brushstrokes congeal into the image—before the light or colors shift.

Shils and Aho paint an inhabited land, but both of Prellwitz's canvases explore Downpatrick Head, a rugged peninsula rising from the mainland that is a striking geological phenomena dominating the Ballycastle coastline. She depicts a cave carved into the land by Atlantic waves, whose relentless erosion caused the ceiling of the cave to collapse—opening a "blow-hole" in a field a hundred feet inland. Using color-filled brushmarks, Prellwitz delineates the strata that expose the cliffs' sedimentary rock layers as markers of time. Her *a la prima* delivery incorporates scrapes and scratches to carve away paint and divulge color underneath, a process paralleling that of the sea carving the stone on Mayo's cliffs. *Downpatrick Cliffs #2* (no. 64) reveals the erosion-carved cave from the ocean's entry point into it, whereas *Blow Hole* (no. 65) depicts that same abyss from above, where ground gives way to air and sea.

Working on-site, she paints the colors of warm sun-bleached stone and the cool shadows of the cave that both catch a specific moment in time and reveal the massive geology of this place.

Working outdoors like Prellwitz, Mary Armstrong searches out vistas having even greater depth. Her paintings delineating the edge of the land are studies in dramatic contrasts—morning's east opposing afternoon's west, the forms of the land against those of the sea. To describe such contrasts she employs the formal language of light and dark, as well as of horizontals and verticals. In *Ceide Cliffs, Looking East* (no. 67), the morning light reflecting off the sea isolates the dark cliffs of Downpatrick Head in a horizontal mass stretching from the land. In *Ceide Cliffs, Looking West* (no. 66), late daylight surrounds the dark, undulating cliffs and the edges of green fields. Armstrong's drawings in oil pastel on paper are not unlike oil paintings in effect, but the pigment comes bound in a waxy-oil stick rather than in a tube; thus it erodes as it is applied directly to paper. Since she works outdoors in the hot sun, the softened pastel more closely approximates paint, with colors mixing together as she adds each additional layer. However, the small mark of the pastel applied layer over layer creates a heavily worked surface. This hard-wrought impression—in which the effort of pulling an image out of gooey pigmented wax and of catching the moment before the surface turns to mud—is visibly different from the *a la prima* painter's graceful delivery.

Also working outdoors, Catherine Kernan shares Armstrong's interest in capturing

different times of day—in studies of a particular light viewed from a specific place. In *Keerglen Ravine* and *Pollaphouca Ravine*, (nos. 77 and 78), Kernan discovered isolated and unvisited ravines reputed to be the dwelling places of spirits, sites offering glimpses of what lies beneath surfaces and suggesting that terrestrial openings may also be psychological ones. The ravines are vistas in shallow spaces that lack horizon lines. These geological cavities drain the surrounding Mayo hills, gathering the runoff rain and becoming lush areas of brush and scrub trees that border creeks. Kernan's watercolors capture the wet environs of these glens— light, form, water, and reflection. Working within the landscape, she makes a few watercolors everyday day, each different in point of view, or simply changed by her recording of the passage of time. Her small watercolor sketches may serve as source material for prints or paintings that she will create later in her studio.

Artists who work on a scale that limits their mobility choose to paint primarily in studios provided by the Ballinglen Arts Foundation. Developing practices only possible in the studio, they often distill their imagery indoors after a period of visual note taking in nature. Both Susan Shatter and Jane Goldman, for example, make visual studies—small paintings and photographs—to gather information they will later use as reference material as they work indoors. Layering transparent washes of watercolors, they paint on large sheets of paper laid flat on oversized tables in their studios. Their palettes move from light to dark as they repeat applications to achieve their darkest

effects. Both artists create recognizable images that are built from a formal language of brush-strokes, in which each mark of color describes part of a form. When viewed from a distance, these forms create the illusion of space, and a recognizable image comes into focus. Seen from a closer point, the brushstrokes—an extension of the hand and thus emblematic of human presence—appear individually distinct, each holding its place on the picture plane and rendering the image flatter and more abstract. Using a wide panoramic perspective, Shatter often focuses down into the water, but in *Irish Moss* and *Sea Ledge* (nos. 58 and 59), she includes the horizon, distant shore, cliff, and an atmospheric edge of sky. Goldman's *Tidal Pool #2* and *Tidal Pool #14* (nos. 60 and 61) look down into the shallows at sea's edge, recording the variety of life: seaweed, kelp, snails, and the surge of each wave.

The practice of some artists dictates repeated reworking, the building up of a surface or the pushing of formal issues to achieve balance or tension. These repeated painterly assaults or corrections are best accomplished in a studio, even when the process begins in the natural world. Overwhelmed by the presence of water in coastal Mayo—the sea, rain, springs, waterfalls—Cynthia Back, for example, begins by making studies of the sea outdoors. But she then creates large oils in the studio, layering repeated glazes (thin washes of dark paint over light) and scumbling (brushy semi-transparent marks of contrasting value) oils onto canvas. Her process builds the surface while honing the image through repeated revi-sions. The underlying triangular forms structuring *Seaweed & Rocks at Ballycastle Pier* (no. 70) develop through persistent alterations in the balancing of lights against darks and color contrast. Finally Back distills a tightly constructed and luscious picture of a richly colored underwater world.

Similarly, Cynthia Knott develops deliberate practices that draw imagery from the process of painting as well as from observation of nature. She seeks not a frozen moment in time, but a period of transition that is visible at dusk, at dawn, or during the approach or aftermath of a storm. Painting on a hill near the bogs of the Ciede Fields, she stored her easel and canvases in a peat shack. There she made small watercolor studies and started the larger paintings that she later completed in her Ballycastle or New York studios. Knott started both *Eminence* (no. 56) and *Casir* (no. 57) outdoors, using encaustic paint sticks and a malleable cold encaustic—a mixture of beeswax, linseed oil, damar varnish and pigments that are kept in a buttery consistency to be applied and scraped with palette knives (Knott). While building the encaustic surface layer upon layer, the palette knife occasionally gouges the surface revealing the earlier hidden colors. For months in her studio, Knott reworked her surfaces until she achieves the desired transparent light, atmosphere, and surface. The resulting effect, "a skin of memory" according to Knott (qtd. in Moore 1), changes with the light, revealing layers of hidden colors.

Donald Teskey and Gwen O'Dowd also derive imagery from a process combining observation in nature and the painting process itself. Teskey makes drawings or watercolor sketches that inform the work he later produces in his studio; there he builds up and reworks layers of thick paint applied with plasterers' trowels, in the process occasionally destroying and then reviving a work. Andrew Lambirth observes that Teskey's work involves memory and imagination; "he paints his response to shape and forms and the fall of light, but his art is less an emotional excursion than a reaction to visual information" (3). Another commentator notes that the artist is drawn to places at the margins "marked by both separation and confrontation—the tension between land and sea is not resolved in these paintings but internalized" (Horne 2). The unease of straddling these contrasting impulses infuse images such as *Benwee Head III* (no. 71) with a cryptic tension between exterior stimuli and interior responses.

Although the North Mayo coast inspired *Uaimh* (no. 62), and Gwen O'Dowd made initial studies for the whole *Uaimh* series there, her painting's life began in a Dublin studio. O'Dowd's demanding technique requires an indoor environment, for her mixed-media process includes the use of encaustic, a pigment in beeswax that is mixed on a hot-plate palette and applied to a surface before it cools. The painting's structure—its dark center, the placement of light and color as well as its surface—shifts as she works. O'Dowd distrusts initial attempts at resolution. "[I]t would have to be reworked and reworked before I'd allow it to survive" (qtd in Conley 127). Although

evoking the edges of the land, her images of blowholes intentionally border on the abstract; her paintings "become a vehicle to portray emotions, so that both mood and topographic elements are necessary and, perhaps, inseparable" (O'Dowd qtd. in Mulcahy 21). Disconnected from a specific place, these paintings encourage open metaphoric readings. According to Angela Bourke, O'Dowd's Irish-language title *Uaimh* implies both "what is seen and what is hidden"(69). The paintings express mystery, a dialogue of tension not only between land and sea, but also between the known and unknown.

Other artists prefer the studio because they work from various stimuli—for example, from memory, intuition, or texts. They synthesize a combination of experiences, not specific as to time and place, but drawn from multiple encounters. The structure of Cheryl Warrick's work—fragmented scraps of images held together in a quilt-like organization—hints at such a multiplicity of sources. Landscape imagery is juxtaposed with an archetypal tree, schematic house, or a floral pattern derived from textile. Warrick's interest in oral tradition leads her to use proverbs and folklore texts in her paintings. As if contained in the land itself, written passages from Irish proverbs emerge from graphic marks evoking the land. In *A Dry Spell* (no. 81), a proverb is translated into English; but in *Take your Bad Luck* (no. 80), it remains in Irish, introducing conversation-like murmurs into the painting.

Peter Brooke walks the Ballycastle landscape studying its details, but later paints from memory onto mylar in his studio. His larger pieces were created in Vermont, where he drew from his remembered experience in Ireland. The tall *Foidin Mearaidhe* (no. 74) reflects the vertigo of standing on the edge, with sky-land-sea as a netherworld, alternately swallowed and revealed by shifting clouds. Such dislocation creates a foreign space that disorients ordinary perception and order, yet the influence of a specific Mayo landscape is clear in the title: *Foidin Mearaidhe* is Mayo-ism for a type of bogfly, born in specific local weather patterns. *Suiffin* (no. 73), structured as a square within a square that fragments two disjoint views, evokes a stream opening into a highland bog. Both small mylars and larger panels use transparent oil glazes, opaquely layered for the darks that when scraped away and reworked reveal light.

Both Jane Proctor and Deirdre O'Mahony, eschewing topographical recording, share Warrick's and Brooke's refusal to depict a specific time and place. Proctor's method resembles the surrealists' "automatic drawing," a process of making unmediated marks and imagery drawn from the subconscious and unconnected to observation. Walking through the landscape to gather inspiration, she produces her art in the studio. Proctor works without preliminary study, intuitively responding to the rhythmic mark-making process of applying pen to paper and striving for immediate connections that come without self-conscious decision making; in an interview she notes that "when I'm thinking I'm not as good" (qtd. in Conley). In her drawing *Black Lines* (no. 63),

India ink lines move across the page horizontally, each rising and falling as rolling waves, or stacked like cliff strata. Or perhaps, they are, as she suggests in a description of these elements, just lines.

By mapping microcosms of nature, Deirdre O'Mahony's unique conception of painting combines a rich engagement with the natural world with later studio enhancements. Her outdoor processes capture literal traces of a place that guide her in the studio where she develops these initial markings into completed works. In *Wrap #1* (fig. 1), made in the Burren region of County Clare, O'Mahony transferred a diagram of the land's surface to her canvas by wrapping the canvas around a boulder and rubbing it with mud or grass to press an image onto it. The unwrapped canvas records

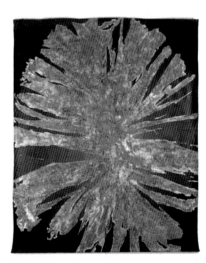

Fig. 1: Deirdre O'Mahoney, *Wrap #1*, 1998, acrylic and cotton duck on stretched canvas, 118" x 79". Courtesy of the Artist.

forms—like a topographer's flattened image of a globe—and becomes her guide in the studio. For the *Cut* and *Pool* series made at Ballinglen, O'Mahony used a related methodology, collecting "direct imprint or trace element from the landscape"(O'Mahoney) onto compressed-wood-fiber boards. She placed the boards into cuts in the bogs to collect traces of turf and insect life; such markings from nature later suggested the direction of her brushmarks. To make the *Pool* series, *Surface #2* and *Surface #3* (nos. 68 and 69), she gathered trace images by pressing the algae from ponds around Balleycastle between sheets of paper, subsequently enhancing the imagery with watercolors.

The above description of the methods, techniques, and practices of Ballinglen artists suggests a range of individual responses to the rural land, small villages, and rocky coast of north Mayo. Clearly painters respond to this extraordinary place in distinct ways, working both directly within the natural setting and in their studios: some record what they have observed with an eccentric topographical accuracy; others internalize the land's imagery, investing it with deeply emotional resonances; still others, drawing on a multiplicity of lived experiences, respond to the bewildering displacements of modernity even in this most rural of Irish landscapes. In a sense, the experience of viewing and decoding these paintings becomes a virtual walk, not just through the particular sites artists have encountered, but through the artistic languages developed to respond to such places. The Ballinglen Arts Foundation serves the local community, the artists for whom it provides fellowships, and those viewing the painting by facilitating this creative investigation of the rural Irish landscape. ❖

WORKS CITED

Bourke, Angela. "Exploring the Darkness: Gwen O'Dowd's *Uaimh*." *Re/Dressing Cathleen: Contemporary Works from Irish Women Artists*. Eds. Grinnell, Jennifer and Alston Conley. Chestnut Hill, MA: McMullen Museum of Art at Boston College, 1997. 69-73.

Conley, Alston and Mary Armstrong. "An Interview with Gwen O'Dowd." *Re/Dressing Cathleen: Contemporary Works from Irish Women Artists*. 126-27.

Conley, Alston. Unpublished telephone interview with Proctor. 2002.

Horne, John. *Island Crossings*. Dublin: Rubicon, 2001.

Knott, Cynthia. Unpublished Artist's Statement for *Waxing Poetic: Encaustic Art in America*. Montclair Art Museum, 1999.

Lambirth, Andrew. *Donald Teskey: Paintings 1993-1999*. Dublin: Rubicon. 1999.

Moore, Bridget. *Cynthia Knott: Blue Charm*. DC Moore Gallery, 1999.

Mulcahy, Rosemarie. *Gwen O'Dowd*. Dublin: Gandon. 1994.

O'Mahony, Deirdre. *Statement Regarding the Ballinglen Experience*. 2002.

Shils, Stuart. *Stuart Shils: Lightscapes: Monoprints and Oil Pastels from Ireland*. Woodmere Art Museum, 2001.

The Art of Dinnseanchas:
Excavating the Storied Past of Place

Lisabeth C. Buchelt

◇

A SENSE OF PLACE DEVELOPS AS PEOPLE EXPERIENCE REPRESENTA-TIONS OF PRESENT AND PAST LANDSCAPES NOT ONLY VISUALLY, BUT ALSO THROUGH NARRATIVES INSPIRED BY AND ABOUT THE ENVIRONMENT. THOSE WHO INHABIT A PARTICULAR LANDSCAPE EXPERIENCE IT THROUGH A FUSED AESTHETIC ENCOUNTER WITH THE land that is inherent in our sense of regional identity and "geographic understanding" (Duffy 64). In Ireland, the stories told of and by the landscape are codified into a particular body of tales. Sean Ó Túama defines *dinnseanchas* as the lore of places—especially sacred places. Since the early Middle Ages in Ireland, no professional poet was considered educated if not fully acquainted with this discipline (Ó Túama 255), which gives voice to the mythical, ideological, or psychic landscape manifested by and layered into the physical one.

The palimpsestic landscape around Ballycastle, the northwestern coastal village in Mayo housing the Ballinglen Arts Foundation, exists as a visual text recording the layered history of a region in geographic, political, and mytho-logical transition. Here, according to folk tradi-tion, the Children of Lir spent the last three hundred years of their exile; according to a story cycle from Patrician hagiography, St. Patrick drove the snakes into the sea from Downpatrick Head (fig. 1). This headland, as well as the geological formations Dún Briste and Poll na Seantoine, has generated over one thousand years of *dinnseanchas* and also served as subject for generations of visual artists. Three hundred feet from Downpatrick is the "stack" called Dún Briste ("Broken Fort"), an amputated fragment of the headland, rising about two hundred feet above the sea (figs. 2 and 3). Poll na Seantoine, a deep thirty-by-ninety-foot gash near the center of the penin-sula, is yet another geological oddity, a blow hole open to the sea below (fig. 4). In Irish, such sites are known as *uaimh*, a word used to de-scribe a cave, den, souterrain, grave, or pit.[1] For members of the community and visiting artists, this strange and dramatic geological landscape around Ballycastle embodies the es-sential experience of the place, generating rich story cycles, some involving national charac-ters like St. Patrick and Crom Dubh, others recording deeply painful events in community history. Poll na Seantoine, the mysterious abyss into the sea, provides Ballycastle with access to a private Otherworld and serves as symbolic repository for community trauma.

Northwestern Mayo has been drawing artists for well over a century; Jack B. Yeats, for example, painted views of both Downpatrick Head and Dún Briste, and executed several wa-tercolors of the Ballycastle courthouse interior during his stay in the summer of 1909.[2] As in Yeats's time, Downpatrick Head and Dún Briste haunt the paintings of nearly every artist who visits Ballycastle. This essay explores the productive interaction between the local *dinnseanchas* tradition and two contemporary

Fig. 1: View looking back from near the end of the Downpatrick peninsula. The statue of St. Patrick was erected in the late nineteenth century inside the site of an older small chapel—the ruins of the lower wall still visible—which in turn was built on the traditional site of the original chapel built by St. Patrick himself. The pile of rocks to the left of the chapel is a holy well. The fence at the far left is that surrounds the blow-hole of Poll na Seantoine.

visual interpretations of these unique geological and mythical places near Ballycastle: *Blow Hole* by Wendy Prellwitz (no. 65) and *Uaimh #69* by Gwen O'Dowd (no. 62).

The peninsula and its severed landmass of Dún Briste are witnesses to the powers of wind and sea. Despite the ancient look of this amputation, the stack was part of the mainland until a recent period (in geological terms). The *Annals of the Four Masters*—parts of which derive from the earlier medieval *Annals of Macfirbís*—mentions that in 1393 an especially violent storm hit Downpatrick Head, destroyed what had been a narrow isthmus, and thus created Dún Briste—from which inhabitants were rescued by a ship's ropes. On the stack are the remains of a small monastic community, in addition to remnants of a church and a holy well

said to have been constructed by Patrick, as well as vestiges of a pre-Christian or medieval stone fort. Three-hundred-fifty-million years of geological history are visible in the multi-colored layers of rock on the cliff-face of Downpatrick Head and the stack of Dún Briste. Layered both on and within the blow hole of Poll na Seantoine are markers of yet another thousand years of early medieval Christianity, of the coming of the Normans, the Penal Law era, the Famine—as well as of countless days of relentless sea winds and brilliant sunshine. And crowded into local memory are layers of stories about each of these places.

Paddy Winters, one of Ballycastle's local *seanchai*, can provide several explanations for the imaginative control these geological formations wield over residents and visitors.[3] A master storyteller who always begins with the most recent tale, Paddy carefully orders and constructs his various stories, slowly peeling back layers to carry his listener deeper into his landscape's narrative past. In one account, he speaks of St. Patrick's efforts to convert Crom Dubh, a pagan living on Downpatrick Head. Crom Dubh flatly refused to convert to Christianity, and Patrick, in anger and frustration (Paddy is quick to point out that Patrick was not yet a saint), struck the ground with his crosier. The ground split apart, leaving the pagan stranded on what came to be known as Dún Briste. In a variant tale, St. Patrick's crosier, rather than cleanly severing the stack from the mainland, inflicted the deep wound within Downpatrick Head itself: that chasm is Poll na Seantoine.

Local lore about the blow hole explicates the wound in the landscape as a frightening point of departure from this world or alternatively, as a source of desperate release: as a secret place of escape and protection that can turn suddenly violent and destructive. Explaining the various names of the chasm, Irish language folklorist Máire MacNeill reveals an academic impulse to seek clarity in ambiguity:

[It] appears to mean simply the "Hole of the Old Wave." Another tempting etymology would make it Poll na Seantuine, "the Hole of the Old Woman," and this translation is actually given in the Ordnance Survey Namebooks. A local legend attempts to explain it as Poll na Sean Teine, "the Hole of the Old Fire," a proof that the name was a puzzle to the country-people and required some explanation. (108)[4]

Local tradition, however, rather than finding the name a "puzzle" provides accounts that

Fig. 2: View of the end of Downpatrick Head and the top of Dún Briste.

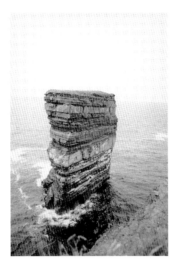

Fig. 3: Dún Briste.

encompass all possible translations of Poll na Seantoine, including one legend that combines the opposing elements of fire and water into a single narrative. Community lore surrounding this mysterious place begins as recently as twenty-five years ago, but recedes about fifteen centuries to the time of Patrick. The stories move between tales of private, domestic trouble and public strife over spiritual power to those of political antagonism within the community and elemental battles between the forces of nature. The pit now has a derelict fence around it to warn people walking on the headland of its existence. Paddy starts his recitation of *dinnseanchas* about Poll na Seantoine with this tragic tale. How did the fence come to be there? It is soon told.

About twenty-five to thirty years ago, according to Paddy, a pregnant woman trapped in a brutal marriage took herself and her three young children—ages three, four, and five—out for a drive. They had a picnic near the magnificent cliffs at the Ceide Fields and then drove further down the coast to Downpatrick Head. Walking out onto the headland, they were observed by a local man fishing a little way off on the peninsula. When he next looked, their car was still there, but they were gone. He raised the alarm, and the community discovered that she had thrown her three children into Poll na Seantoine before flinging herself into the abyss as well. And so the fence was raised. In the nineteenth century, a seaweed gatherer, the only wage earner for his family, fell into Poll na Seantoine during heavy mist. His widow keened for him at the edge; some say that in despair she also threw herself in after him, others that she gradually faded from the community. And so Poll na Seantuine, based on these stories, means "Hole of the Old Woman."[5]

Yet further back in history exist even more stories. The plaque erected near Poll na Seantoine is dedicated to a group of rebels who were placed inside by their families during low tide in order to conceal and protect them as they fled the enemy in 1798. The women and children hid themselves in the hills, hoping the enemy would move quickly through the land so they could return to bring their men out of the pit before the tide rose. But they could not return in time, and all the men perished at high tide. The bottom of the plaque records a traditional saying that offers multiple interpretations of this tragic narrative: "*Ar dheis dé go raibh a nanam dílis*" ("At God's right hand were their loyal souls"). But when were their loyal souls "at God's right hand"—while they were safely hidden within the Poll na Seantoine's palm or after the tide came in, first crushing their bodies against the rocks, and then releasing them from worldly care and sending them to their God? And so, according to this story, Poll na Seantoine means "Hole of the Old Wave."

How did such a treacherous chasm—at once potentially protective and destructive—come into being? In geological terms, Poll na Seatoine was formed through millions of years' of erosion under the cliff-face by the sea (fig. 5). But knowing the mythic landscape within the geological one, initiates such as Paddy Winters offer alternative explanations. Once, before St. Patrick condemned Crom Dubh to live out his days isolated from, yet within sight of civilization on Dún Briste, he found the pagan lord

Fig. 4: Poll na Seantoine.

Fig. 5: View of the Downpatrick Head cliffs facing Dún Briste, and showing how the tide undercuts the cliff-face. Eventually, the cliff-face under the peninsula is so worn away that the tunnel created can no longer support the weight of the land above, and part drops into the ocean, forming the blow holes.

celebrating around a huge bonfire on Downpatrick Head. Patrick implored him to put out the fire and turn from his heathenish ways. When Crom Dubh refused Patrick's plea to extinguish the fire and turn from paganism, the saint struck the fire with his crosier: the ground opened beneath it, and the fire plunged straight through the earth until it was quenched in the depths of the sea. And so Poll na Seantoine means both "Hole of the Old Fire" (Poll na Sean Tuine) and "Hole of the Old Wave." These are all the tales about this site entrusted to Paddy, layered into his imagination as the keeper of communal memory.

The palimpsestic *dinnseanchas* surrounding Poll na Seantoine reflect the ambiguous, polyvalent nature of the site's name.[6] Rather than one "authentic" narrative for this place or "correct" explanatory translation of the placename, several exist—but each with a single element in common. All the narratives, from the most recent story of the murder-suicide to the stories of Patrick's sixth-century battles with Crom Dubh, speak of violent resistance to social pressures. They speak of an accompanying fear of the unknown and the unknowable. Joep Leerssen argues that types of romantic landscape—those viewed as uncontrollable, as beautiful yet savage—belong to geographical areas that are the "least integrated in the homogenizing centripetal forces of the social institutions." He identifies these geographic areas as "those parts where central control was slowest in being effectively established, where local particularities...lingered longest" (5). Around Ballycastle reminders of distant human histories and even more distant geological pasts remain everywhere; the sublime aspects have migrated from their "proper" place on the fringes of society to become the dominant imaginary force. For some participants in these narratives—for example, those involving Patrick and Crom Dubh and the transition from paganism to Christianity—fear is manifested in the creation of divisions: the stack of Dún Briste or the abyss of Poll na Seantoine. Crom Dubh, unwilling to make the transition from one religious tradition to another, is literally marginalized by the new centripetal social force. Yet he is still present, visible on the periphery as he stares across the narrow but impassable strait separating his Dún from the mainland. The destructive natural forces of wind and water that once answered to Crom Dubh's celebratory pagan fire now respond to Patrick and his new religion; the battle leaves a monumental scar upon the land *in memoriam*.

For other participants in the *dinnseanchas* narratives, these geological phenomena become disturbing sites of desperate escape from hardship. The murder-suicide—occurring as it did within living memory—marks not only a new addition to the *dinnseanchas* cycle attached to Poll na Seantoine, but also inscribes a site that contains disruption. Domestic violence, possible alcoholism, economic hardship, child abuse, clinical depression—and the social stigma that attaches itself to each of these problems—have undoubtedly disturbed the Ballycastle community. These stories are told in the hopes of banishing such deviance to the Otherworld from whence it came. They help resolve the social or personal conflicts of unstable members of society, for once inassimilable social elements disappear into the *uaimh* ("pit") of Poll na Seantoine, social order can be restored. Explanations for the violent marking of the landscape have been provided, disruption is contained, and the story ends. However, like the fence erected around the abyss of Poll na Seantoine, stories responding to what is known but which also must remain hidden provide only temporary protection for the community. Eventually the fence itself will fall into the ever-widening gash of the *uaimh*. Poll na Seantoine and its gateway to the Otherworld will once again threaten those who walk upon the headland, generating new stories of traumatic loss.

Two paintings of this site, Prellwitz's *Blow Hole* and O'Dowd's *Uaimh #69*, invoke themes of instability and containment and thus add visual layering to the *dinnseanchas* tradition. But

these images of Poll na Seantoine undermine and complicate narrative attempts to frame and contain the unsocialized and unstable in the community. By erasing the boundaries of the pit, both *Blow Hole* and *Uaimh #69* visually transgress the border between this world and the Otherworld. Both paintings attempt to speak the unspoken; they offer representation of an unknowable that exists beyond and after the experience of the abyss depicted in the narratives. The images situate viewers within moments of transition from one state of being into another, within that instant of passage from this world into the Otherworld of the *uaimh*.

Prellwitz's *Blow Hole* is the more representational of the two depictions of Poll na Seantoine, for hers is a landscape in the conventional sense of the genre, a painting of an existing natural feature (no. 65). The grass grows over the edge of the pit, and the horizontals of the exposed center of the headland are implied through brushstroke and color. In painting the blow hole, Prellwitz makes significant representational decisions: she banishes the protective fence, and the painting's angle eliminates the stabilizing fourth edge of Poll na Seantoine's rectangle. Through these choices she seeks to evoke the dark and unpredictable elements suggested by the *dinnseanchas* narratives. *Blow Hole* guides the viewer's eye through the strong line between pale green earth and pale gray sky. As the eye travels down the image, and so into the pit, the image descends into darkness. Without the controlling horizontal of the foreground edge of the hole to guide their eyes, viewers experience a sense of

vertigo. The painting thus visually invokes a sensation analogous to that which Crom Dubh might have experienced as he looked over the edge of Poll na Seantoine and watched his fire fall into its depths; or that felt by the men of 1798 as they were lowered by their families into the pit's protective embrace; or, even, that seen by a desperate woman seeking a last refuge from pain. Prellwitz adds to the disorientation of her image by her choice to make it brightest where internal visual logic would seem to dictate—given the indications of the horizon line—the pit should be the darkest, shadowed from above by the earth itself. She creates a vertical shadow within the painting that begins in the darkness of the lower left and disappears into brightness—a visual invocation of the narratives' themes of transition.

When considered alongside the *dinnseanchas* tradition, perhaps the play of light and shadow invokes spiritual states like those experienced by the local people whom Patrick converted from the darkness of paganism to the light of Christianity or the transformation felt by the drowning men as they were transported to God's right hand. By removing the fence from her image, Prellwitz seeks visual means of opening the wound in the landscape. Metaphorically, her representation of the unbarricaded abyss of Poll na Seantoine allows layers of traumatic local stories to escape.

Through her contrast of the quotidian—the grass, the sky—and the extraordinary gash in the physical and psychic landscape, Prellwitz invites us into the themes present in the narratives. But Gwen O'Dowd's *Uaimh #69* offers no

comforting, sunny horizon to provide a visual contrast between this world and the Otherworld (no. 62). Although O'Dowd suggests the layered rock face making up the interior of the crevice and depicts the formidable cliffs of Downpatrick Head, such confining walls appear without boundaries in her image. The bright blue-white splash in the lower right, as well as the red-orange of the implied rock, attracts the viewer's eye, but the trailing wisps of color forces us further into darkness. *Uaimh #69* plunges us inside the wound—essentially moving beyond the *dinnseanchas* narratives. Rather than seeking to invoke the motion of a tale's narrative thread and to gesture towards its themes and conflicts, O'Dowd's painting captures the silent, unspoken moment after narrative transition occurs: that resolution hidden from both storyteller and listener. When viewed with the *dinnseanchas* tradition in mind, her image seeks to visualize despair—the void inhabited by the spiritually bereft, the empty space at God's right hand.

O'Dowd's and Prellwitz's images force us into the abyss, into archetypal moments of pain, of loss, of violent change leading to transformation. Through its topographical qualities, Prellwitz's *Blow Hole* is more visually rooted in a specific, geographical place. However, in her decision to remove the visual containment of the fence that exists as part of the actual landscape, Prellwitz quite literally opens Poll na Seantoine to her viewers, as if to deploy the image to perform a narrative function similar to that of the *dinnseanchas* surrounding the site. Although viewers of her painting may never

visit the blow hole, it remains a visual repository for the monstrous, uncontrollable, and unstable within both public and private psyches. O'Dowd's image, *Uaimh #69*, universalizes the site further by removing any visual ties to a specific geographical location.

Collectively the sites of Downpatrick Head, Dún Briste, and Poll na Seantoine, as well as their surrounding narratives and visual representations, evoke nineteenth-century romantic notions of the sublime (see especially nos. 21, 26, 30, and 31). These romanticized landscapes are often perceived as timeless, as landscapes in which the mythic and the mythic past live on. Downpatrick Head, Dún Briste, and Poll na Seantoine, in both their physical and psychic geographies, also might seem to exist outside the specificities of time and place. The sites speak to a romantic fascination with ambiguity and transition, existing as they do adjacent to the sea, and in "almost a liminal setting, a transitional zone between the historic reality of the mainland and the eternal dreamscape of the ocean" (Leerssen 9). But the *dinnseanchas* tradition renders these sites central to the community's identity, integrating them into its historical and fictional cultures. Although Poll na Seantoine exists both literally and metaphorically as a site for transition or banishment, its imposing physicality, as well as its ubiquitous community presence in the *dinnseanchas*, undermines the definitions of marginality that Leerssen would bestow on such sublime landscapes.

Sublime elements in the landscape of Downpatrick Head—recorded in both the evolving narrative and visual records—are fully integrated into the centralizing social institutions of the region surrounding Ballycastle. The sites discussed above function as centripetal social forces, not simply as Leerssen's ahistorical conduits between a time-bound mainland and an eternal seascape. Although they invoke remote geological and human pasts, they are emphatically present in their spatial and temporal reality. Thus Downpatrick Head, Dún Briste, and Poll na Seantoine are integrated into Ballycastle's cultural imagination as necessities for community cohesion and survival. Poll na Seantoine, in particular, as imaginative entrance into Ballycastle's dark Otherworld, serves a crucial social and psychic local function. But like all that is genuinely local and particular, it participates in common themes. Poll na Seantoine, in both the *dinnseanchas* tradition and in Prellwitz's and O'Dowd's depictions of it, becomes an imaginative as well as visual representation in a more universal register of narratives about transition, change, fear, courage, and the possibility of redemption. ❖

I would like to thank Boston College's McMullen Museum of Art and Graduate School of Arts and Sciences for their aid in funding my visit to Ballycastle, Co. Mayo, and the Ballinglen Arts Foundation for their kind assistance during my stay there, in July 2000. This essay would not have been possible without their support.

Photos by Lisabeth C. Buchelt

Endnotes

1 Angela Bourke writes, "[s]tories about places called *uaimh* deal with what is seen and what is hidden. Ostensibly about landscape and community, they are also about imagination" (69). As Bourke points out, there are many similar places along the north Mayo coast called "poll na seantoine" all blow-holes of this kind.

2 See Pyle, *Catalogue Raisonné* numbers 6 through 11. This same courthouse houses the library and gallery of the Ballinglen Arts Foundation, established in Ballycastle in 1992.

3 All stories from Paddy Winters were obtained during a personal interview with the author over the course of an evening spent in his bar and between card tricks in July 2000. I thank him for his hospitality. Versions of all his stories, as well as others about these sites, are recorded in Máire MacNeill's *The Festival of Lughnasa*. See pages 107–112; 442–444; 495–500; 511–512; 540–541; 586–587; 596–597; 612.

4 For accounts of the nineteenth- and twentieth-century pilgrimage traditions associated with this site, see MacNeill 108–112.

5 MacNeill discusses another tale in which Crom Dubh has a fairy mistress who aids him in controlling the seasons, wind and sea; it is she hurtling towards Hell at Patrick's demand that formed the blow hole.

6 I would like to thank Dr. Gearóid Denvir of the National University of Ireland at Galway for his patient discussion and clarification of the grammatical and linguistic possibilities for translating the name Poll na Seantoine.

Works Cited

Bourke, Angela. "Exploring the Darkness: Gwen O'Dowd's *Uaimh*." *Re/Dressing Cathleen Contemporary Works from Irish Women Artists*. Eds. Jennifer Grinnell and Alston Conley. Chestnut Hill, MA: Charles S. and Isabella V. McMullen Museum of Art at Boston College, 1997. 69–73.

Duffy, Patrick J. "Writing Ireland: Literature and Art in the Representation of Irish Place." *In Search of Ireland*. Ed. Brian Graham. London: Routledge, 1997. 64–83.

Leerssen, Joep. "The Western Mirage: On the Celtic Chronotype in the European Imagination." *Decoding the Landscape: Papers Read at the Inaugural Conference of the Centre for Landscape Studies*. Ed. Timothy Collins. Galway: Centre for Landscape Studies, 1997. 1–11.

Mac Neill, Máire. *The Festival of Lughnasa*. London: Oxford Universtiy Press, 1962.

Ó Túama, Seán. "Celebration of Place in Irish Writing." *Repossessions: Selected Essays on the Irish Literary Heritage*. Cork: Cork Universtiy Press, 1997. 248–266.

Pyle, Hilary. *Jack B. Yeats: A Catalogue Raisonné of the Oil Paintings*. London: Deutsch, 1992.

Responding Today:
Dis/Location and the Land

Kathleen Costello-Sullivan

◇

CONTEMPORARY IRISH ARTISTS JANE PROCTOR AND DEIRDRE O'MAHONY'S CONTRIBUTIONS TO THE *ÉIRE/LAND* EXHIBITION IMPLICITLY COMMENT ON THE INHERITED CONVENTIONS OF THE IRISH LANDSCAPE TRADITION. AS THE CENTRAL COMPONENT IN AN AGRARIAN ECONOMY, THE FOCUS OF POLITICAL TENSION UNDER centuries of British dispossessions and colonial rule, and as a dominant icon of nineteenth- and early twentieth-century nationalism, land has long held a privileged place in the Irish cultural imagination.[1] In their effort to construct a national community, cultural nationalists and the founders of a new state looked to the land, and particularly to the West, as a timeless harbor for an inviolate, essential "Irishness."[2]

This construction of the land as timeless and as intimately connected to national identity mirrors developments in the European tradition of landscape painting. Helen Langdon, for example, notes that in creating a landscape tradition, some late nineteenth-century artists "withdrew from reality and used landscape to create an imagined and timeless world" (716).

Influenced both by the conventions of a European genre and the historical pressures of nationalism, the Irish painter was thus drawn to this subject matter for complementary political and aesthetic reasons. Síghle Bhreathnach-Lynch explains how early twentieth-century landscape imagery was appropriated by the state to forward its political agenda:

At an official level, independent Ireland was promoted as a rural utopia, peopled by a society whose way of life epitomized a distinctive Gaelic culture. Beginning in 1910, visual artists like Paul Henry, Charles Lamb, James Humbert Craig, and Seán Keating came to the West to paint its desolate beauty. Seeking spirituality and authenticity, they created a major group of landscape paintings....Although Henry...came to the West for primarily aesthetic reasons, in the decades following independence his image of Ireland was exploited for political purposes. (47)

The Irish landscape thus carries the dual valance of aesthetic appeal and political efficacy: the traditions of both landscape painting and cultural nationalism envisioned the land as a timeless, even hallowed, locale.[3]

O'Mahony and Proctor engage with the weight of this dual inheritance. As contemporary artists working in an abstract mode, they resist representations of the land proffered by an earlier realist tradition. However, because these traditions—realism and abstraction—are deeply entwined, O'Mahony's and Proctor's abstract paintings evolve from and respond to earlier landscape imagery, even as the artists work through and against traditional modes of representing the land. Both respond to the

changeability, heterogeneity, and presentness of their subject matter. In so doing, their abstract works simultaneously relocate the Irish terrain as physical space and dislocate the stability of its traditional connotations.

The advent of abstraction challenged prior representations of the Irish landscape. By its very nature, abstraction resists the specificity of place and sense of scale so critical to many earlier representations of the land that focus on a particular geographical locale, such as Henry's *Mulraney Beach* or Craig's *In County Mayo* (nos. 34 and 38) in this exhibit. However, despite its stylistic opposition to more directly representational work, abstraction does not exist in isolation from such work. "To *abstract* is to generalize…. Abstraction and REPRESENTATION are at the opposite ends of a continuum" (Atkins 39). Abstraction may seem to harbor goals contradictory to those of representational art, but it is nonetheless fundamentally connected to that earlier mode, both contesting and incorporating elements from it. Although reference to an "abstract landscape" may read as a contradiction in terms, as Nelson Goodman suggests, it need not be (88). Abstraction's ability to offer multiple interpretations can open up possibilities, challenging imposed meanings and giving new expression to the land.

Deirdre O'Mahony and Jane Proctor demonstrate how abstraction can both respond to and renew an Irish landscape tradition. While other contemporary Irish artists address the sometimes stifling symbolic weight of this tradition, O'Mahony and Proctor privilege the land's *sensory* nature, its physicality and variety.[4] By invoking topographical images but resisting any specificity of place, they undermine claims to transparency or verisimilitude. They emphasize the texture and "feel" of the land itself, so often ideologically buried in traditional landscape paintings.[5] As I will suggest, O'Mahony and Proctor play with the concept of background to challenge readings of the land as symbol of fixity and essence. However, through their experiments with issues of proximity and distance, as well as with depth, they simultaneously evoke these prior traditions.

Although she admits that she "avoided [the Irish influence] like the plague for years," Deirdre O'Mahony specifically engages with the loaded cultural and artistic landscape traditions that preceded her work (*Post* 16). She credits her sense of *estrangement* as formative in her representations of the Irish landscape: "My vision of this landscape is shaped by my life beyond Ireland, the experience [of] being Irish in London and an outsider in the small rural community where I now live" (*Conception*). Ironically, O'Mahony's physical and artistic distance from the Irish landscape and its traditions enables her engagement with them, often in work that resists imposed meanings. Like those artists who have influenced her, O'Mahony "question[s] the hegemony of the landscape tradition" (*Conception*).

Such *estrangement* is also characteristic of the genre in which she works, for abstraction generally connotes alienation from the object of representation: "non-representational painting is abstract in that it lacks a certain function or feature that is usual for and expected of paintings in general" (Goodman 88). Thus both her interaction with the land and the medium through which she represents it allow O'Mahony to revise and renew the traditions she inherits.

O'Mahony's *Surface* pieces, produced at the Ballinglen Arts Foundation, literally engage with the land itself, employing its physicality as both medium and subject. The artist describes her methodology as "a direct encounter with the place." She takes "materials directly from the beaches, bogs and fields…allowing the place to direct the structure of the work" (*Conception*). As W. J. T. Mitchell suggests in a different context, she thus treats the land as "an agent of power," enabling it to determine its own representation (2). O'Mahony describes herself as *confirming* the work done by nature: "I used the algae as a drawing tool pressing it between sheets of watercolour paper, the trace image left when the algae was removed was then verified with fine brushmarks" (*Conception*). Working on and over the landscape's own self-presentation, she metaphorically embodies the process of landscape representation itself in her *Surface* series and enables the land to circumvent its own elision. Rather than concretely representing an ideological conception of the land, she abstracts a concrete, literal impression.

O'Mahony's emphasis on texture, a focus underscoring the variety and depth of her subject matter, also undermines traditional assertions of unchanging or timeless identity. Instead, her paintings offer imagery of accretion and flux. Whereas *Surface #2* (no. 68), with its

colorful enmeshment of brown and green, is reminiscent of sand and stone, *Surface #3* (no. 69) invokes marshland and water. Such semblances of stone and sea emphasize depth and layering. Earlier landscape tradition, of course, also evinces an interest in the interplay between surface appearance and what lies beneath, as, for example, in the work of Paul Cézanne (Langdon 716–7). However, the focus of this earlier tradition on surface elements of the landscape, such as mountains and lakes, often results in an emphasis on timelessness rather than in a sense of mutability and depth.[6]

Although O'Mahony's concentration on texture invokes some aspects of earlier landscape painting, her emphasis on change and flux, particularly as expressed through the use of physical elements of the earth, reorients that tradition. "By treating nature's 'residues' as living, and as having relevance for the 1990s, she refuses to see history as that which has happened and passed. Time is neutralized as history (and landscape) are animated" (Williams). Shifting from an emphasis on the visual to a tactile valance, O'Mahony's *Surface* series engages with the sensory appeal of the landscape. Presenting this visually less concrete yet physically more proximate image of the land emphasizes its presentness, its physicality and variety.

The *Surface* pieces also experiment with questions of distance and proximity so central to the sweeping vistas of traditional landscape painting. Through a detailed representation of their sources and their rich textures, O'Mahony's works convey a sense of close

proximity to their subject; however, they simultaneously resist overgeneralization and highlight their own specificity. With its bright, mottled greens, for example, *Surface #3* evokes the familiar color so prevalent in nationalist representations of Ireland, even as the painting clearly eschews traditional imagery. Whereas O'Mahony's use of the actual terrain in her artistic process makes these pieces regionally precise, her site-specific gesture has the ironic effect of deterritorializing the works—as all discernible specificity of location is lost in the abundant detail they provide. Yet her close examination also emphasizes the diversity of the land and its physical components. Although these pieces "abstract" nature to the point of indeterminability, such abstraction emerges from the paintings' very concreteness.

Mirroring her own relationship to Ireland, O'Mahony's works thus reflect estrangement and proximity, engagement and dislocation. Her close interaction with the Irish landscape dislocates it; by allowing the land to represent itself, the landscape becomes abstract and, ironically, unrepresentational. In the act of privileging the land's physicality, O'Mahony thus undermines the privileging of Ireland's landscape as unique and timeless. By focusing closely on specific Irish terrain, she allows its unique attributes to *resist* the very claims to uniqueness and homogeneity often implicit in the landscape tradition.

Jane Proctor's art also responds to traditional representations of the Irish landscape; yet unlike O'Mahony, she does not consciously engage with the land, with a

specifically Irish tradition, or with other artists currently working with those conventions. Indeed, she does not necessarily focus on the landscape at all. Although she acknowledges that being Irish and subject to its traditions may unconsciously influence her work, Proctor describes her artistic process as proceeding "instinctively": "I don't set out to draw cliffs," she notes; "but sometimes [when she views her work] I think I must have been influenced, by the layering of the rock or by the sea...." Instead, Proctor experiences her work as a multiple sensory experience:

My work is more musical than painterly. It has more to do with the *sound and rhythms* of the landscape. When I was younger, I was sometimes accused of having no content, and it was quite upsetting for me. However now I think, I have a different kind of content. When you think in terms of music, you don't have to say what it's about. It's more about what it sounds like and how you feel. (Interview)

Done in India ink on Japanese paper and worked in black and white, Proctor's *Black Lines* (no. 63) reflects such rich sensory experience, even as it avoids the images of green field, blue sea, and rocky bluff that populate so many paintings of the West of Ireland.[7] Like O'Mahony's, her representation of the land is complex and multifaceted, emphasizing texture, with lines of varying thickness and length; form, through basic geometrical figures; and

Fig. 1: Jane Proctor, *Dark Black Lines,* watercolor and gouache on Japanese paper, 24" x 71", Ballinglen Arts Foundation.

nature, through the evocation of earth, water, and stone. The distortion of background in her work emphasizes commonalities over exclusions—what is interchangeable in life and art over exceptionality and unitary representation. Her use of artistic excisions, elisions, and layerings responds to earlier landscapes by evoking their traditions, even as she avoids what is supposedly essential to Irish identity.

Proctor's abstraction presents images that are not identified with or confined to any one geographical place. The wavy, uneven lines of *Black Lines,* like those in *Dark Black Lines* and *Long Black Lines* (figs. 1 and 2), read as a palimpsestic layering that their two-dimensionality belies. This layering, rich in texture yet repetitive in form, evokes various patterns occurring in nature. The densely layered

strokes of *Black Lines* and *Long Black Lines* suggest, for example, a geological strata and heavily packed earth—a sense of temporal and physical accretion. Similarly, the wavy repetitiveness of *Dark Black Lines* and *Long Black Lines* conjures images of water, inconstancy, and fluidity.

By emphasizing heterogeneity and accumulation through such layered repetitions, Proctor works against the assumptions tacitly implied by traditional representations of the Irish landscape.[8] The palimpsestic layerings in her works emphasize what is prior or lies beneath as of equal relevance to that which is uppermost or surface, suggesting the contemporaneity of past and present instead of a timeless, unchanging essence. The fluidity embodied in the pieces similarly emphasizes changeability, in stark contrast, for example, to the image of an unchanging, rural West carrying the burden of Ireland's cultural past.

Proctor's self-professed sense of the "sound" of the land aptly captures both the variety and repetitions in her work; her emphasis on tactile and even aural elements of the land supplements the privileged visual representations of the earlier tradition, even as it engages with and critiques them. Because the borders of each of her abstract images are uneven, each painting implies that it represents something greater—a cliff face, a stratum of earth, a current. Such imprecision suggests that the scenes represented are interchangeable: any cross-section of a locale would do. Yet because these shapes almost fill the canvas, they simultaneously convey extreme specificity. Like O'Mahony's *Surface*

pieces, Proctor's work abstracts the landscape through the concreteness of its representation: her precision negates any discernible specificity. By thus elaborating on the landscape tradition's emphasis on topography, Proctor privileges the land's physical essence.

Proctor's *Untitled* color painting (fig. 3) similarly works both with and through the previous tradition. Also emphasizing form through the use of simple geometrical shapes, this work could arguably represent a sea horizon. A gold triangle—possibly a sail or the sun—is centered in the top portion of the piece, floating in the midst of a blue background. Below, horizontal blue lines fill a gold block. This evocation of a seascape is disrupted, however, by a hollow gold rectangle located beneath. Like the *Black Line* series, this work resists any specific geographical placement. Both evoking and resisting a traditional seascape, Proctor reduces the work to its most basic geometrical forms. She thus playfully subverts the tradition she conjures; her focus on form ironically undermines the uniqueness of place.

The spatial distortion of Proctor's art also engages with traditional representations of landscape. Because of the density and variety of lines in the *Black Line* series, as well as the tight

Fig 2: Jane Proctor, *Long Black Lines,* Indian Ink on Japanese paper, 71" x 24", Collection of the Artist

Fig. 3: Jane Proctor, *Untitled*, watercolor and gouache on Japanese paper, unframed, 35" x 24", Collection of the Artist.

alternation of black and white, it is difficult to discern a clear background in these works. These drawings thus suggest an interactive relationship between background and foreground, past and present, which resists the suggestion of "timelessness" promoted in some representations of the land. Proctor's *Untitled* reflects a similar distortion. Because the forms in the piece are of the same shades but of differing proportions, it becomes unclear whether the triangle and smaller rectangle overlay the blue, or whether the gold has been revealed from beneath the blue. The distortion of background in the work is thus spatial, causing all elements within the frame to become relative: background slips into the foreground and foreground into background as the distinct colors become positionally interchangeable. Like

Black Lines, this piece highlights the tenuous nature of what is given artistic priority—and perhaps provides a metaphorical commentary on what is given cultural priority, as well.

Given the status of the past in Irish cultural nationalism, Proctor's work may provide an ironic commentary: in her art, the background is literally written over and crossed out. The aesthetic undermining of background thus implies an artistic resistance to the historicizing of landscape as background. Simultaneously, however, Proctor's artistic engagement with such representations, through its evocation and elaboration into greater proximity or formal essence, builds upon that very tradition. Through its unavoidable association with the loaded significances of landscapes, Proctor's work challenges the reality of what is elided in Irish identity, questions the centrality of that which is purportedly to the fore, and elaborates on that tradition to relocate the actual land within the landscape.

Because their work is modern and abstract, Proctor and O'Mahony resist expectations of Irish artists as necessarily regional or local—evincing, like some other contemporary Irish artists, what Declan McGonagle has called "a panoramic sense of Irishness that includes interaction with the world" (190). The abstraction of their forms, coupled with complex variations in texture, transform the traditional inscriptions of what constitutes an Irish landscape by emphasizing heterogeneity, resisting containment within larger structures (geographical or ideological), and seeking to give concrete voice to the land. The ambiguity of

background presented in their work offers an alternative to representations of the Irish landscape as timeless. Finally, the evocation of fluidic and geographical layering implies the difficulty, even impossibility, of homogenizing differing representations of Irish identity.

By elaborating upon the very landscape traditions that their works contest—employing the land's multiple sensory valances, providing a closer proximity to the land, and using a precision that ironically undermines specificity—Proctor and O'Mahony reinsert the land into the landscape, dislocating an ideological weight they have inherited in favor of a concrete abstraction. They thus renew the landscape tradition with which they engage. O'Mahony and Proctor's pieces emphasize the vibrant, changeable nature of Irish landscape; its resistance to unitary representation; and the complexity and diversity of the identity it metaphorically represents. ❖

I thank Vera Kreilkamp, Robin Lydenberg, and Margaret Preston for their helpful readings of earlier drafts of this paper.

ENDNOTES

1 For a brief review, see Terence Brown, "Cultural Nationalism, 1880-1930."

2 On the mythology of the West see Patrick J. Duffy, "Writing Ireland: Literature and Art in the Representation of Irish Place." On the role of the West in Irish landscape painting, see Síghle Bhreathnach-Lynch's article, "Painting the West: Landscape's Role in Irish Identity," in this collection. 99-104.

3 This is, of course, only one interpretation of the Irish landscape. On visual art as inherently a "locus for competing cultural traditions," see David Craven, *Abstract Expressionism* 17.

4 For a consideration of other modern artists' response to the Irish landscape tradition, see Caoimhín Mac Giolla Léith, "Six Artists in Search of a Landscape."

5 On ideological impositions on the Irish landscape, see Bhreathnach-Lynch, "Painting the West," 99–104.

6 See Bhreathnach-Lynch in this catalogue on Henry's depiction of "essential elements" of the landscape and the resultant "impression of timelessness" in his work ("Painting the West," 102).

7 On artistic engagements with such nationalist imaginings, see Mary Cosgrove, "Paul Henry and Achill Island." It is tempting to read Proctor's use of foreign materials as a metaphor for estrangement from place; however, she attributes this choice to being "drawn to the delicate yet strong qualities of these materials." *Email to the author*, July 14, 2002.

8 The authoritative discussion of cultural layering—and its resistance—is Gayatri Chakravorty Spivak's "Can the Subaltern Speak?" I borrow the idea of a palimpsestic layering from her.

Works Cited

Atkins, Robert. *ArtSpeak: A Guide to Contemporary Ideas, Movements, and Buzzwords, 1945 to the Present*. 2nd ed. New York: Abbeville Press Publishers, 1997.

Bhreathnach-Lynch, Síghle. "The Irish Collection in the National Gallery of Ireland." *Éire-Ireland* Special Issue: The Visual Arts. Ed. Vera Kreilkamp and Nancy J Curtain. Fall/Winter 1998 and Spring 1999, XXXIII: 3 and 4; XXXIV. 13–49.

Brown, Terence. "Cultural Nationalism, 1880–1930." *The Field Day Anthology of Irish Writing*. Ed. Seamus Deane. Derry: Field Day Pubs, 1991. Vol. II: 516–520.

Cosgrove, Mary. "Paul Henry and Achill Island." *Landscape, Heritage and Identity: Case Studies in Irish Ethnography*. Ed. Ullrich Kockel. Liverpool: Liverpool University Press, 1995. 93–116.

Craven, David. *Abstract Expressionism as Cultural Critique: Dissent during the McCarthy Period*. Cambridge, England: Cambridge University Press, 1999.

Duffy, Patrick J. "Writing Ireland: Literature and Art in the Representation of Irish Place." *In Search of Ireland: A Cultural Geography*. Ed. Brain Graham. London: Routledge, 1997. 64–83.

Goodman, Nelson. "Abstraction." *The Dictionary of Art*. Ed. Jane Turner. New York: Grove Dictionaries Inc., 1996. Vol. I: 88–89.

Langdon, Helen. "Landscape Painting." *The Dictionary of Art*. Ed. Jane Turner. New York: Grove Dictionaries Inc., 1996. Vol. 18: 700–720.

Mac Giolla Léith, Caoimhín. "Six Artists in Search of a Landscape." *Éire-Ireland*. Special Issue: The Visual Arts. Fall/Winter 1998 and Spring 1999, XXXIII 3 & 4; XXXIV: 1. 266–285.

McGonagle, Declan. "From the Poetic to the Political." *Éire-Ireland*. Special Issue: The Visual Arts. Fall/Winter 1998 and Spring 1999, XXXIII: 3 & 4; XXXIV: 1. 189–90.

Mitchell, W. J. T. *Landscape and Power*. Chicago: University of Chicago Press, 1994.

O'Mahony, Deirdre, "Deirdre's Blend of Art and Soul." Interview with Victoria Clarke. Irish Post, May 4, 1991, 16.

---. "The Conception and Perception of Landscape in Post-Modern Ireland." Unpublished statement.

Proctor, Jane, personal interview, July 1, 2002.

Spivak, Gayatri Chakravorty. "Can the Subaltern Speak?" *Marxism and the Interpretation of Culture*. Ed. Cary Nelson and Lawrence Grossberg. Urbana: University Illinois Press, 1988. 271–313.

Williams, Emer. Review of Deirdre O'Mahony for the Guinness Hopstore, Dublin. November-December 1996.

From Icon to Index:
Some Contemporary Visions of the Irish Stone Cottage

Robin Lydenberg

◇

LTHOUGH MANY OF THE ARTISTS IN THIS EXHIBITION REPRESENT THE IRISH LANDSCAPE WITH PASSIONATE COMPLEXITY, POLITICAL AND CULTURAL FORCES HAVE OFTEN SIMPLIFIED SUCH IMAGES FOR THEIR OWN IDEOLOGICAL PURPOSES. ARCHETYPAL ELEMENTS LIKE THE THATCHED COTTAGE, GREEN HILLSIDE, OR ancient monument have been put into circulation in a range of discourses from the Gaelic revival and nationalist politics to the modern heritage and tourism industries. Some artists have begun to expose the distortions of those symbolic icons; in place of fixed stereotypes they seek out the indexical—the more direct physical traces of the land behind the landscape.[1] Recognizing the land as process rather than fixed object or sign, seeing it as a continual cycle of decay and renewal and an interactive site where man and nature struggle for survival, these artists transform landscape into environment. Their aim is often to transform the viewer, as well, from passive consumer into active participant in the historical specificity and lived materiality of the land.

A "crisis of representation" transformed art practice in the 1970s, as many artists turned away from iconic representation and toward a "grounding" of art in the physical immediacy of matter and place (Krauss 196–219; Foster 80–90). This indexical turn has posed particular challenges for the practice of landscape art. In its most traditional form, this genre posits both artist and viewer as detached and distant observers of a scene already framed by a variety of stylistic conventions (picturesque, pastoral, sublime). The aesthetic goal of such traditional landscapes is to harmonize and unify all the natural and manmade elements of the scene.[2] Alternative modes of landscape art abandon this illusion of a unified prospect to engage with the land itself as continually fragmented,

intermittently accessible, and haunted by absence and loss.[3]

Several contemporary works in this exhibition (Dorothy Cross's *Endarken*, Kathy Herbert's *Shadows* and *Angel in the Hay*, and Brian Tolle's design for the New York City *Irish Hunger Memorial*) grow out of this postmodern relationship with landscape. All three artists engage self-consciously with one of the most ubiquitous images of "Irishness"—the rural thatched-roof stone cottage. These artists transform this familiar icon by situating it within an ongoing material history of abandonment and decay.

The thatched cottage is an integral element in the late eighteenth-century picturesque tradition's idealized construction of rural life. The rules for achieving picturesque effects in landscape painting set out by Rev. William Gilpin, for example, prohibit the representation of human labor or struggle; the rural cottage stands in for a rural population whose realistic depiction would disrupt the desired aesthetic effect.[4] Beginning in the mid-nineteenth century, a combination of political and

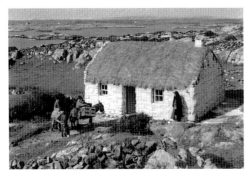

Fig. 1: John Hinde, *Thatched Cottage, Connemara, Co. Galway, Ireland,* color photograph by John Hinde, F.R.P.S. From *Hindesight: John Hinde Photographs and Postcards John Hinde Ltd. 1935–1971.* Dublin: IMMA, 1993: 50.

natural disasters, including the Great Famine and subsequent massive emigration from rural areas to Irish cities and abroad, left many stone cottages abandoned. This new variation on the pastoral icon, now roofless and in ruins, resonated for some artists as an emblem of this tragic period. Yet such derelict dwellings were also easily assimilable into an aesthetic of the ruin popular since the eighteenth century. An abandoned landscape merely enhanced the effect of romantic isolation, and the remaining ruins reinforced the touristic promise of Ireland as a living archaeological terrain.

Although by the 1920s the intact and inhabited stone cottage was becoming increasingly rare, it was adopted by the Irish Free State as an ideal emblem for a national identity based on austerity, frugality, and the morally uplifting struggle of a people living in intimate connection to the land. Serving both internal national identity construction and external touristic appeal, the thatched cottage and its environs signified an alternative to urbanization, industrialization, and modernity in general. Irish landscape paintings like those of Paul Henry, already shaped in part by a tradition that favored the distant and idealizing prospect, served well as icons of an essential and unchanging Irish identity rooted in the beauty of the landscape (Cosgrove, Deane). In the 1950s, color photographs of rural Ireland by John Hinde perpetuated this national ideal, emphasizing in their cheerful scenes a life of rural contentment rather than struggle. Postcards of the sunlit neat thatched cottage as a scene of happy family life made their way around the world, as this iconic signifier followed the paths of those who had emigrated abroad (fig. 1). By this time, however, such images could only be read through a mist of nostalgia, presenting a way of life already known to be on the verge of extinction and "crystallized in the archetypal image of the thatched cottage" (Gibbons 40). The proliferation and commodification of images by Henry or Hinde on stamps, postcards, and posters were no longer models for a future national identity, but rather appealed to what Craig Owens describes as a "desire to rescue from historical oblivion that which threatens to disappear" (52-3). Although the majority of the Irish relocated to towns and cities by the 1970s, the stone cottage still has tremendous currency, and interventions by contemporary artists in this iconography of the Irish landscape are part of an ongoing cultural debate.

Dorothy Cross's video, *Endarken* (2000), engages the history of the perception and representation of rural Irish life with elegant simplicity (no. 93). The viewer sees a ruined famine cottage in the austere landscape of Connemara, set against a stormy sky and wind-swept trees. Although the video is in color, the effect (unlike Hinde's highly colorized images) is stark and gray. Something like the imperceptible erosion of wind and rain on stone is made visible in accelerated time, as a tiny black dot appears at the center of the image and gradually expands until it obliterates the entire scene. This process of the appearance and disappearance of the cottage is repeated continuously in one-minute loops. By representing this image cinematically rather than as a photographic still, Cross puts the cottage and our perception of it into real time; and because it is always in a state of change, the cottage resists being reduced to the fixity of an icon.

For Cross, temporal change brings both transformation and loss, and much of her work confronts the difficulty of perceiving and representing those effects.[5] The spreading black dot in *Endarken*, for example, suggests a dilating pupil that paradoxically sees less and less; the cottage and the entire way of life it signifies are obliterated not just by history and weather but also by our very habits of seeing.[6] Resembling the early cinematic device of the iris shot, the black circle seems at first about to disclose an interior view of the cottage. The expanding blackness denies us that inside view, but in another sense that blackness is the

inside view of the death and abandonment enacted there. Cross shows us in *Endarken* the very impossibility of seeing such loss directly. The cottage is never illuminated in its unmediated purity, but rather always "endarkened" by the limitations of representation and the ideological and personal blind spots that obstruct our vision.

In an effort to move away from the distancing and alienating visual iconography of traditional landscape to the more intimate touch of the indexical traces left on and by the land itself, Cross and other contemporary artists have turned increasingly in recent decades to temporary site-specific installations.[7] Against both the timelessness and fixity of the stereotypical landscape and the commodification of the art object, temporary site-specific works "[court] their own destruction" (Meyer 25). Some artists focus in particular on derelict and abandoned buildings, which they approach from a point of view that acknowledges the disappearance of those sites as functional living spaces (Duve).

The work executed by Kathy Herbert during her Ballinglen residency brings the rural stone cottage into this complex genre of site-specific art. Like Cross, Herbert is drawn to the obsolete and abandoned, and to the problem of the representation of loss. The works displayed in this exhibition are selected from a larger body of work entitled *Absent* (1996), a project concerned with global migration, but more specifically with the depopulation of the Irish countryside (Herbert, "Essay" 2). The documents used in *Absent*, Herbert explains, "tell the story of emigration and migration from the point of view of the house and the place left behind" ("Absent").

For the two site-specific installations documented in this exhibition—*Shadows* and *Angel in the Hay*—Herbert chose not to reoccupy the cottages, as she had done in a related project ("Journey: Memories of Place"[1996]), but to conjure up the ghosts of absent dwellers in the form of indexical shadows or silhouettes (nos. 91 and 90). This work is not about the past restored or simulated as in the manner of the heritage industry, but about the memory traces of the place itself, each cottage allowed to speak its own loss and abandonment. In theorizing about memory, some argue that a place is merely the screen on which humans project their desire and will to remember (Nora 19); others insist that matter, like culture, has its own ways of remembering (Bal 172). Herbert's artistic process suggests that human desire and the materiality of place can collaborate in the work of productive recollection. Using only material gathered in and around these cottages, Herbert produces representations *with* rather than *of* the landscape.

In *Shadows*, the artist approximates on the outside wall of one cottage the vague silhouettes of two brothers who lived and died there. The shapes are painted with bog mud collected nearby, and a mound of fallen stones is assembled at their base. The peat bog, which preserves bodies by covering them up, is put into artistic service here to figure forth disembodied traces of bodies long absent from the site.[8] The house has been transformed into a monument to the brothers; the standing wall remembers and retains their cast shadows, and the stones of the fallen walls gather in a memorial mound. Yet these anonymous and almost shapeless figures also demonstrate the impossibility of recalling those lives in their intimate particularity. All we can retrieve from the cottage is the memory of the shadow of a missing body—a veritable allegory of the limits of representation.

Inside a different derelict cottage, most recently used as a hay barn, Herbert cleared away some of the hay covering the floorboards to create another outline. In front of the hearth, that center of domestic life, there is only an empty space in recognition, the artist explains, "of all the living which happened in this house over the years" ("Absent"). The title of the installation, *Angel in the Hay*, recalls the childhood game of making "Angels in the Snow," but Herbert's wingless angel seems more mournful than joyous. Below the clear outline left on the wall by the mirror that once hung there, Herbert has propped two surviving fragments, reminding us that representation or reflection can only be partial, fractured. The ghostly presences conjured up here are vulnerable and ephemeral: the bog mud will be washed away, the figure in hay will be displaced by drafts. These cottage installations, remote and inaccessible as well as ephemeral, survive only in photographic documentation; such artifacts verify that representation is always belated, offering up no more than the traces of something always already gone. Unlike the durable and repeatable representations of the iconic thatched cottage, these in-

◇

stallations are delicate and endangered indexical traces of something just out of reach.

For Herbert, the abandoned stone cottage functions like other ruins and monuments of the Irish countryside: not as evidence of the persistence of a past, but as a "testament to the continual movement of peoples through the ages" ("Essay" 2). Her work is suspended between an impossible desire to reconnect with some "sense of origin, of anchor, of base," and a recognition of the necessity of perpetual "leaving and dissemination" ("Essay" 2–3). Herbert's site-related work, including an earlier version of the installation *Absent* prepared for this exhibit, has a strong affinity with an alternative style of memorial art in which, as Peggy Phelan puts it, objects do not reproduce what is gone, but "restage and restate the effort to remember what is lost" (147).[9]

Whereas Dorothy Cross's *Endarken* dramatizes the limitations of perception and representation, reenacting our blindness to a way of life that erodes along with the ruined cottage, Kathy Herbert relies on representation, in the form of photographic documentation, to "hoard...and retain" ("Absent") the fading traces of the cottages' inhabitants. In his *Hunger Memorial* design, however, Brian Tolle gestures beyond representation, delivering a particular stone cottage in its literal and tangible presence. Like Cross and Herbert, he uses the cottage not as an iconic or symbolic recreation of the past, but as an index of its present condition of abandonment and decay.

The artistic representation of loss finds in the Great Hunger of the mid-nineteenth century one of its most difficult challenges: to memorialize the Famine without reducing it to maudlin sentimentality, and without commodifying it for touristic consumption. Can the artist depict the living history of the Famine's victims without obscuring specific effects of power under generalizations that naturalize and even aestheticize their suffering?[10] In his design for the New York City *Irish Hunger Memorial*, Tolle takes up this challenge, and in the process contributes to the reanimation of the genre of the public monument by creating a hybrid work that is part memorial and part site-specific installation (nos. 95, 96, and 97).[11]

Many memorials of the Irish Famine represent human suffering in bronze family groups shown emigrating from a land that is either relegated to incidental background or entirely effaced. Tolle's design, in contrast, includes no human figures but rather is directly inspired by and constructed out of the land itself. On a research trip to Ireland to generate ideas for the memorial, Tolle visited Achill Island, County Mayo, returning (ironically) to the source of Paul Henry's romanticized images of an Arcadian Ireland. Tolle discovered there instead the striking remnants of the abandoned village of Slievemore, a truly indexical memorial to the Famine and its aftermath. Although he had used techniques of simulation in earlier works, in this case Tolle eschewed the limitations of simulation and heritage reconstruction. He wanted the landscape of famine incorporated into his memorial design to retain its integrity as a material object; an actual Irish fieldstone cottage on its own quarter-acre plot forms the centerpiece of his sculpture. Concerned that the historical specificity of the land not be lost in transit, the artist worked explicitly to undermine icons of "Irishness" that had dehistoricized and idealized the landscape for centuries.

Although from a distance one might read the memorial as a slice of archetypal Irish landscape, one cannot escape the incongruity of this precariously cantilevered slope so starkly out of place in New York's busy metropolitan center. This dislocation is not a disruption of the scene, but its very condition writ large; this microcosm of a landscape, surrounded by an overwhelming modernity, exposes the vulnerable fragility of rural life. The memorial design also supports recent theorists' speculations that a sense of location and identity is established as much by displacement as by stasis (Clifford 2)—and that we are all "emigrants even without leaving home," living in exile in the "exhilarating and confusing surrounds of the globalized, post-industrial, post-modern world" (O'Toole "Ireland" 22).

The visible and ongoing effects of time that are inherent in the memorial's design destabilize fixed and timeless icons of the Irish landscape. The cottage will remain unrestored; the terrain will change continually with the weather, its mixture of wildflowers and weeds at times reduced to mud, the site smelly and "very palpable" in its materiality (Wittwer qtd. in Dunlop 8). In spite of these demythologizing strategies, some early responses to the memorial design by public officials show the

persistence of the old stereotypes. The memorial was celebrated by several government officials for having captured the "essence of Ireland," "forever free, forever green," and for offering some visitors an opportunity "to touch the sod of our heritage"("Governor Pataki" 1). Tolle noted in a recent interview that the "rugged landscape" that bears witness to the devastation of the Famine invariably becomes romanticized in the press as "rolling hills" (Karzen 62).

In his ongoing construction and revision of the memorial, Tolle did not simply dismiss these reactions, but responded to them artistically. Several elements of the final project reflect the artist's ongoing collaboration with the Irish government, the Battery Park City Authority's planning committee, and the first wave of visitors to the site. As its symbolic contribution to the memorial, for example, the Irish government offered to donate a stone from every county in Ireland. This idea recalls the Irish Fair held in New York City over a century ago, in which a giant map of Ireland was constructed on the floor, the space of each county filled with actual dirt from that region. Although the sentimental responses that installation provoked in many visitors may appear to the postmodern sensibility as pure "kitsch," Tolle recognized something more genuine and deeply felt in the literalness of the connection of Irish and Irish-Americans to the land itself.[12] Out of respect for the various "living constituencies" served by the memorial, Tolle included the stones, but dispersed them randomly in the landscape, avoiding any resemblance to a map of the counties. Because the stones are not clearly displayed or identified, they function indexically rather than symbolically in the site. So many visitors to the memorial expressed a keen desire to locate and touch the stone from their county of origin, however, that the artist subsequently provided a "map" marking the stones' random locations.

Tolle designed the memorial to invite and incorporate the viewer's active engagement with the land and its history rather than with vague nostalgia or the iconography of fixed and sentimentalized stereotypes. One entrance into the memorial leads visitors through an underground passageway up into the ruined cottage. As one reviewer notes, this corridor resembles an Irish burial mound or tumulus (Smith B1). The walls of the passageway are constructed of alternating sedimented bands of stone and frosted glass on which official and unofficial testimonies from those who experienced the Famine are cast in shadows. This sculptured layering evokes the geologically and historically sedimentary aspect of the Irish landscape. Hunger is not naturalized or aestheticized here but contextualized historically and politically, giving forceful articulation, for example, to the failure of British officials to alleviate massive starvation. Entering the quarter acre of Ireland through this buried history, viewers cannot simply delight in the landscape as idealized icon: the cottage interior is cramped and exposed, the "rolling hills" are the remnants of uncultivated potato furrows. Visitors may also enter the installation by stepping directly onto the sloping earth and climbing up through the landscape to the ruined cottage and its prospect; there they discover, belatedly, the textual history buried below. Whether the memorial is entered from above or from below, the charm of the landscape and its violent history exist in productive tension.

This memorial makes no claim to enlighten visitors with a totalizing narrative of the Irish Famine; the texts create a mixture of facts, political propaganda, and personal experience—the imaginative work of fantasy, desire, and hope. Tolle's design offers a transitional passageway through fragmented, often anonymous, voices in the embedded texts and an accompanying audio collage, both of which will be revised, updated, and expanded periodically in response to continuing crises in world hunger. The narrative is discontinuous, full of gaps and silences; Tolle teases out multiple meanings by placing fragments in shifting juxtapositions rather than in fixed narrative sequence. A heritage industry presentation of history as a recoverable and repeatable past to be fixed "like a fly in amber"(Brett 158) is displaced here by what Mieke Bal calls a "preposterous history" that multiplies uncertainty and doubt (7). This alternative mode of history calls for an alternative mode of memorial, one that would, in Fintan O'Toole's terms, defy easy readability and consumer satisfaction to communicate instead dissatisfaction, complexity, and a sense of loss ("When Mullaghmore").

Brian Tolle's design approaches those goals by remaining, appropriately, in process and thus incomplete. Or perhaps it finds completion in the space once occupied by the cottage in

County Mayo, a space that will not be preserved as a void but rather reconditioned for modern use. It will, however, bear a plaque indicating the old cottage's new location and function in the New York City monument. Tolle insists that the landscape in the *Hunger Memorial* has not been "transplanted" or "uprooted," but rather it is "suspended between here and there. Not just between Ireland and the U.S., but also between past and present," between a real place still lived in and changing and an imaginary place "frozen in [the] mind[s]" of those who left it behind (Karzen 62).

The current exhibition, like the New York City *Hunger Memorial*, might be understood as a transatlantic collaboration. Many of the representations of Irish landscape assembled for *Éire/Land* are haunted by an absence and loss that can only be perceived in its indexical traces, pointing always toward an irrecoverable elsewhere. ❖

ENDNOTES

1 The field of semiotics distinguishes between three types of representation: the iconic, based on resemblance between sign and referent (as in a "realistic" portrait); the symbolic, based on arbitrary conventions that assign a certain meaning to a given sign (a cross for the church); and the indexical, based on some physical cause and effect connection between sign and referent (a shadow or footprint). As in this case of representations of the Irish landscape the three modes often overlap.

2 For an excellent overview of the landscape tradition in Western art see Andrews and Mitchell.

3 The scope of this article does not permit discussion here of the strikingly indexical work of Deirdre O'Mahony, whose art often involves direct collaboration with the landscape. As she facilitates and captures the inscriptions of pond algae (as in *Surfaces*, included in this exhibit), fossilized slate, or glacier-sculpted boulders, O'Mahony's focus is on the produc-

tive fertility of even the most barren landscape rather than on absence and loss. For more in depth analyses of O'Mahony's work see in this catalogue Kate Costello-Sullivan (121–126) and Claire Connolly (27–33).

4 On the picturesque tradition see Andrews; on the "construction of rurality" and the picturesque tradition in Ireland see Kneafsey and Brett. On the effect of the pastoral idyll or stone age ruin as an occlusion of actual conditions of rural poverty in England and Ireland respectively see Barrell and Cosgrove. For specific analysis of the motif of the Irish thatched cottage see Kennedy.

5 One particularly striking example is her site-specific installation *Ghostship* (1999). This piece consisted of a decommissioned lightship that Cross painted with phosphorescent paint and then moored in Dublin Bay. Intermittently illuminated and left to glow and fade at twenty minute intervals, *Ghostship* reenacted repeatedly the fading away of a way of life in which the Irish once lived in intimate proximity to the sea. Cross chose not to simulate or recreate that past, but to make the process of its disappearance visible. For an insightful analysis of this project see Ryan.

6 For a discussion of the visual in Cross's recent work see Lydenberg,

7 For an excellent overview of site-specific art see Suderberg collection (especially essays by Suderberg, Kwon and Meyer).

8 Herbert also participated in the 1990 group show *Boglands*, for which sixteen artists created temporary works using only the material from a Wicklow bog site. Herbert's piece *Container* engaged with the bog as "a holder of evidence of the past" (Herbert, Curriculum Vitae 1)

9 In *Letters from an Empty House* (1997) Herbert positioned multiple pairs of walking boots (moulded in indigenous hay, turf, leaves and cement) across the gallery floor as if in collective migration. These decaying and ephemeral sculptures are replaced in the current installation *Absent* with more durable boots modeled in cement, PVA and scrim, and neatly lined up on metal display shelves. Here the artist emphasizes not so much the human connection to the land and its deterioration as the conventions by which we try to document and preserve that connection.

10 I am indebted to Margaret Kelleher for her excellent analysis and overview of Irish Famine memorials and for her exploration of the tension between the conventions and therapeutic functions of memorials and the facts of lived history in "Hunger and History: Monuments to the Great Irish Famine."

11 This hybrid project involved Tolle in fruitful collaboration with 1100 Architect, landscape architect Gail Wittwer-Laird, and Irish Studies scholar Prof. Maureen Murphy. In her review of the memorial, Roberta Smith describes its hybrid style as a "populist postmodernism, a combination of reality and simulacra, of high and low, a layering of different historical periods and contrasting points of view...[blending] Realism, Conceptual Art and Earth Art" (B3).

12 Simon Shama notes in his review that the memorial's landscape is "stripped of sentimentality but not of emotion" (60).

WORKS CITED

Andrews, Malcolm. *Landscape and Western Art*. Oxford: Oxford University Press, 1999.

Bal, Mieke. *Quoting Caravaggio: Contemporary Art, Preposterous History*. Chicago: University of Chicago Press, 1999.

Barrell, John. *The Dark Side of the Landscape: The Rural Poor in English Painting, 1730–1840*. Cambridge: Cambridge University Press, 1980.

Brett, David. *The Construction of Heritage*. Cork: Cork University Press, 1996.

Clifford, James. *Routes: Travel and Translation in the Late Twentieth*. Cambridge: Harvard University Press, 1997.

Cosgrove, Mary. "Paul Henry and Achill Island." Ed. Ullrich Kockel. *Landscape, Heritage and Identity: Case Studies in Irish Ethnography*. Liverpool: Liverpool University Press, 1995. 93–116.

Deane, Paul. "Paul Henry on the Achill Islands: Paintings and Drawings." *Éire-Ireland* 24.1 (1989): 59–65.

Dunlop, David. "Memorial to the Hunger, Complete with Old Sod." *New York Times* (March 15, 2001): 1, 8.

de Duve, Thierry. "Ex Situ." *Cahiers du Musée National d'Art Moderne* 27 (Spring 1989): 39–55.

Foster, Hal. *The Return of the Real*. Cambridge: MIT Press, 1996.

Gibbons, Luke. *Transformations in Irish Culture*. Cork: Cork University Press, 1996.

Herbert, Kathy. "Absent" (artist's information sheet)

———. "Curriculum Vitae"

———. "Essay" (unpublished)

Karzen, William. "Interview with Brian Tolle." *Bomb* 76 (Summer 2001): 56–63.

Kelleher, Margaret. "Hunger and History: Monuments to the Great Irish Famine." *Textual Practice* 16.2 (2002): 41–68.

Kennedy, Brian R. "The Traditional Thatched House: Image and Reality, 1793–1993." Ed. Adele M. Dalsimer. *Visualizing Ireland: National Identity and the Pictorial Tradition*. Winchester, MA: Faber and Faber, 1993. 165–80.

Kneafsey, Moya. "A Landscape of Memories: Heritage and Tourism in Mayo." Ed. Ullrich Kockel. *Landscape, Heritage and Identity: Case Studies in Irish Ethnography*. Liverpool: Liverpool University Press, 1995. 135–53.

Krauss, Rosalind. E. *The Originality of the Avant-Garde and Other Modernist Myths*. Cambridge: MIT Press, 1987.

Kwon, Mikon. "One Place After Another: Notes on Site Specificity." Ed. Erika Suderburg. *Space, Site, Intervention: Situating Installation Art*. Minneapolis: University of Minnesota Press, 2000. 38–63.

Lydenberg, Robin. "Dorothy Cross: Ways of Seeing." *Contemporary* (January 2002): 26-31.

Meyer, James. "The Funcitonal Site; or, The Transformation of Site Specificity." Ed. Erika Suderburg. *Space, Site, Intervention: Situating Installation Art*. Minneapolis: University of Minnesota Press, 2000. 23-37.

Mitchell, W.J. Thomas. *Landscape and Power*. Chicago: Chicago University Press, 1994.

Nora, Pierre. "Between Memory and History: Les Lieux de Mémoire." *Representations* 26 (Spring 1989): 7-25.

O'Toole, Fintan. "Ireland." *Irish Art Now: From the Poetic to the Political*. Declan McGonagle, Fintan O'Toole, Kim Levin. London: Merrell Holberton, 1999. 21-26.

---. "When Mullaghmore becomes more than just a 'hungry hill'." *The Irish Times* (February 17, 1993): C 10.

Owens, Craig. *Beyond Recognition: Representation, Power, and Culture*. Berkeley: University of California Press, 1992.

Phelan, Peggy. *Unmarked: The Politics of Performance*. London: Routledge, 1993.

Ryan, Raymond. "Memory Vessel." *Blueprint* 158 (February 1999): 24-5.

Shama, Simon. "A Patch of Earth." *The New Yorker* (August 19 & 26, 2002): 58, 60.

Smith, Roberta. "A Memorial Remembers the Hungry: Unforgiving Irish Earth, Recreated Downtown." *The New York Times* (July 16, 2002): B1, 3).

Suderberg, Erika. "Introduction: On Installation and Site Specificity," Ed. Erika Suderberg. *Space, Site, Invervention: Situating Installation Art*. Minneapolis: University of Minnesota Press, 2000. 1-22.

U.S. Press Release: "Governor Pataki Announces Design for 'Irish Hunger Memorial.'" (March 15, 2001).

Contributors to the Catalogue

◇

PAMELA BERGER is Professor of Art History at Boston College and has produced and/or directed several historical feature films. Her publications include *The Goddess Obscured: Transformation of the Grain Protectoress from Goddess to Saint* (1985); "The Historical, the Sacred, the Romantic: Medieval Texts into Irish Watercolor" in *Visualizing Ireland* (1993); "Modern Propagators of Ancient Legends and Traditions: Mythic Memory or Serendipity?" in *Re/Dressing Cathleen: Contemporary Works from Irish Women Artists* (1997); "Sculpted Body Parts from Ancient Healing Sanctuaries" in *The Plume and the Palette* (2001).

SÍGHLE BHREATHNACH-LYNCH is Curator of Irish Paintings at the National Gallery of Ireland, Dublin. Among her publications are *Discover Irish Art* (co-authored with Marie Bourke) (1999) and "Landscape, space and gender: their role in the construction of female identity in newly independent Ireland" in *Gendering Landscape Art* (2000). Her research interests cover all aspects of nineteenth- and early twentieth-century Irish paintings and sculpture.

MICHELLE P. BROWN is Curator at the British Library and Series Editor of the British Library Studies in Medieval Culture. Her published works include *Anglo-Saxon Manuscripts* (1991); *The BL Guide to the History of Writing* (1994); *The Book of Cerne; Mercia, an Anglo-Saxon Kingdom in Europe* (ed., 1996); *The Transformation of the Roman World* (ed., 1997); *A Guide to Western Historical Scripts* (1990, reprint 1999); *Understanding Illuminated Manuscripts; The Historical Source Book for Scribes* (1999). She is currently writing the commentary volume to accompany a new facsimile of the Lindisfarne Gospels.

LISABETH BUCHELT is a doctoral candidate in English at Boston College. She is a currently a Fulbright Fellow in Dublin. Her dissertation research examines medieval literature and culture of Ireland and England; her secondary specialization is in nineteenth- and early twentieth-century Irish art.

ALSTON CONLEY is Chief Curator of the McMullen Museum and designer and installation manager of all the exhibitions there, as well as Adjunct Senior Lecturer at Boston College. He has published interviews with contemporary Irish artists in catalogues and in a special arts issue of *Éire-Ireland: an Interdisciplinary Journal of Irish Studies*. He has curated several exhibitions and co-curated *Re/Dressing Cathleen: Contemporary Works by Irish Women Artists* and co-edited its catalogue (1997).

CLAIRE CONNOLLY is a lecturer in English literature and cultural criticism at Cardiff University and a visiting Associate Professor at Boston College for 2002–2003. Her scholarly editions of Irish authors include Sydney Owenson's *The Wild Irish Girl* (2000) and Maria Edgeworth's *Ormond* (1999), *Vivian* (1999), and *Manoeuvring* (1999). She has also edited the collection *Theorizing Ireland* (2002) and is the author of essays on Edmund Burke, the Act of Union, Elizabeth Bowen, and postcolonialism and Ireland. She is currently working on a cultural history of Irish Romanticism.

L. PERRY CURTIS is Professor Emeritus of History at Brown University, specializing in nineteenth-century Irish history and modern culture and media. He is the author of *Coercion and Conciliation in Ireland* (1963), *Anglo-Saxons and Celts* (1968), the recently revised *Apes and Angels: The Irishman in Victorian Caricature* (1997), *Jack the Ripper and the London Press* (2001), and *Images of Erin in the Age of Parnell* (2000) that accompanied an exhibition of cartoons at the National Library of Ireland. He is currently researching Irish landlordism during the Land War and the era of land purchase.

KATHLEEN COSTELLO-SULLIVAN is a doctoral candidate in the English Department and Irish Studies Program at Boston College. She has published articles on Michel Foucault, Jonathan Swift, and Anglo-Irish women's literature, and has articles forthcoming on Maria Edgeworth and Rudyard Kipling. She is currently working on her dissertation, tentatively titled, "Communities of Isolation: Ireland, Modernity, and the Haunting of the English Imperial Imagination."

ROBIN FLEMING, Professor of History at Boston College, is currently a fellow at the Institute of Advanced Studies at Princeton University. She has published *Kings and Lords in Conquest England* (1991); *Domesday Book and the Law: Society and Legal Custom in Early Medieval England* (1998); and "Britain and Ireland in the Ninth through Eleventh Centuries" in *The Short Oxford History of the British Isles*, vol. 3. She has also edited early medieval texts and written on medieval forgery, liturgy, and economic history and nineteenth-century medievalism.

MARJORIE HOWES is Associate Professor of English and Irish Studies at Boston College. She is the author of *Yeats's Nations: Gender, Class, and Irishness* (1996), co-editor of *Semicolonial Joyce* (2000), and contributing editor to *The Field Day Anthology of Irish Writing*, volume 4 (2002). Her current research interests include the nineteenth-century Irish American Atlantic in popular culture and twentieth-century writing by Irish women.

VERA KREILKAMP is Professor of English at Pine Manor College, visiting scholar with the Irish Studies Program at Boston College, and co-editor of *Éire-Ireland: An Interdisciplinary Journal of Irish Studies*. With Professor Adele Dalsimer, she co-curated and co-edited the catalogue of *America's Eye: Irish Painting from the Collection of Brian P. Burns* (1996). She publishes on contemporary Irish artists and Irish Ascendancy fiction, including *The Anglo-Irish Novel and the Big House* (1998). Her current research is on fiction and empire.

ROBIN LYDENBERG is Professor of English at Boston College, currently teaching visual culture and literary theory. She has published articles on Dada and Surrealism, psychoanalysis, and twentieth-century fiction, and the book-length study, *Word Cultures: Radical Theory and Practice in William S. Burroughs'* *Fiction* (1987). In addition, she has co-edited *Feminist Approaches to Theory and Methodology: An Interdisciplinary Reader* (1999). More recently she has been working on contemporary Irish artist Dorothy Cross, publishing essays on the artist's work and completing a full-length monograph on Cross's site-specific installations.

KATHERINE NAHUM is Adjunct Assistant Professor of Art History at Boston College. She has taught the history of modern Irish art and worked on earlier exhibitions of contemporary Irish art at the McMulllen Museum. Her articles on Irish artists have appeared in museum catalogues and in a special arts issue of *Éire-Ireland: an Interdisciplinary Journal of Irish Studies*. Her other major research interests are modern architecture, psychoanalytic perspectives on art, and nineteenth-century European art.

NANCY NETZER is Professor of Art History at Boston College and Director of Boston College's McMullen Museum of Art. Her publications include articles on Irish medieval manuscripts and the monograph, *Cultural Interplay in the Eighth Century: The Trier Gospels and the Making of a Scriptorium at Echternach* (1994). In addition, she has written "Picturing an Exhibition: James Mahony's Watercolors of the Irish Industrial Exhibition of 1853" for *Visualizing Ireland: National Identity and the Pictorial Tradition* (1993). She is currently completing a monograph on the *Book of Durrow*.

KEVIN O'NEILL is Associate Professor of History and Director of the Irish Studies Program at Boston College. His publications include "The Star Spangled Shamrock: Memory and Meaning in Irish America" in *Meaning and Memory in Irish History* (2001); "Looking at the Pictures: Art and Artfulness in Colonial Ireland" in *Visualizing Ireland* (1993); and *Family and Farm in Pre-Famine Ireland: The Parish of Killashandra* (1984). His research concentrates upon the interaction of traditional agricultural societies and a growing world economy.

MARGARET PRESTON is an Assistant Professor at Augustana College in Sioux Falls, SD. Her publications include "The Good Nurse: Women Philanthropists and the Evolution of Nursing in Nineteenth-Century Dublin" *New Hibernian Review* (Spring, 1998) and "Discourse and Hegemony: The Language of Charity in Nineteenth-Century Dublin" *Ideology and Ireland in the Nineteenth Century* (1998). Her academic interests focus upon modern Ireland, Britain, and India.

ROBERT J. SAVAGE is an Irish historian and the Associate Director of the Boston College Irish Studies Program. He has published articles about contemporary Ireland and the representation of Ireland in the electronic media, as well as three books: *Ireland in the New Century: Politics, Culture and Identity* (1996); *Sean Lemass: A Biography* (1999); and *Ireland: Politics, Culture and Identity* (forthcoming 2003). His current research project explores how television in Ireland was shaped and influenced by a society experiencing significant economic, political, and social change.

WORKS IN THE EXHIBITION

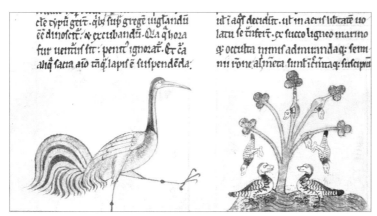

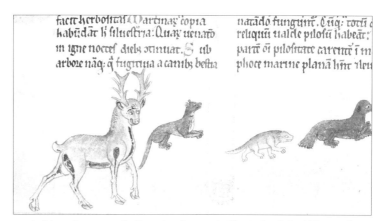

1a. fol. 8v Lower margin: *Crane standing on one leg (ch. 10)
and barnacles that are born of the fir-tree (ch. 11).*

1b. fol. 10v Lower margin: *Procession of stags and wild animals in Ireland (chs. 18–21).*

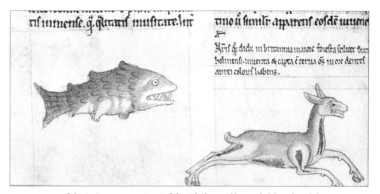

1c. fol. 16v Lower margin: *A fish with three golden teeth (ch. 43) and the
stag with golden teeth from Dunholm Wood.*

No. 1 a–c
Gerald of Wales (b. 1146 – d. 1223)
Topography of Ireland (Topographia Hibernica), c. 1210
pigments on vellum, 10 7/8" x 7 1/4" x 1 1/4"
British Library, Royal MS 13.B.viii

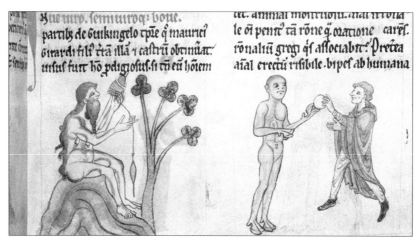

1d. fol. 19r Detail, lower margin: *A woman with a beard and a mane on her back* (ch. 53); *A man that was half an ox and an ox that was half a man* (ch. 54).

1e. fol. 19v *Cow that is partly a stag* (ch. 55); Lower margin: *Goat that had intercourse with a woman* (ch. 56); *Lion that loved a woman* (ch. 57); *Cocks in Ireland crow differently than the crows in other countries* (ch. 58).

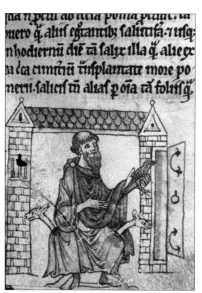

1f. fol. 20r Detail, lower margin: *St. Kevin with the blackbird nesting in his hand* (ch. 61).

No. 1 d–f
Gerald of Wales (b. 1146 – d. 1223)
Topography of Ireland (Topographia Hibernica), c. 1210
pigments on vellum, 10 7/8" x 7 1/4" x 1 1/4"
British Library, Royal MS 13.B.viii

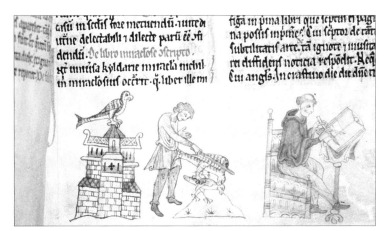

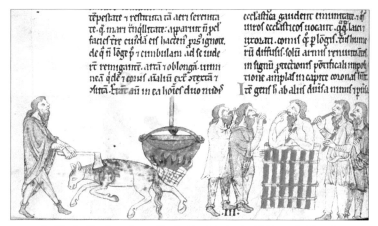

1g. fol. 22r Lower margin: *The falcon in Kildare that was tamed and domesticated, that perched on the tower of St. Brigid's Church and was killed by a rustic with a staff* (ch. 70); *An early medieval Irish scribe writing a book so intricate in its details that it might be thought the work of angels* (ch. 71).

1h. fol. 28v *Slaughter of mare, King bathing in its broth with his people* (ch. 102).

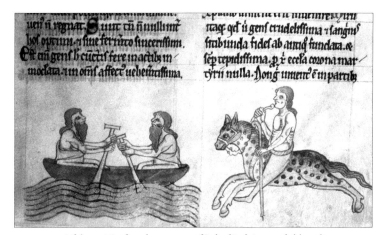

1i. fol. 29r *Men from the west coast of Ireland in their curragh* (ch. 103);
Naked warrior riding mare.

No. 1 g–i
Gerald of Wales (b. 1146 – d. 1223)
Topography of Ireland (Topographia Hibernica), c. 1210
pigments on vellum, 10 7/8" x 7 1/4" x 1 1/4"
British Library, Royal MS 13.B.viii

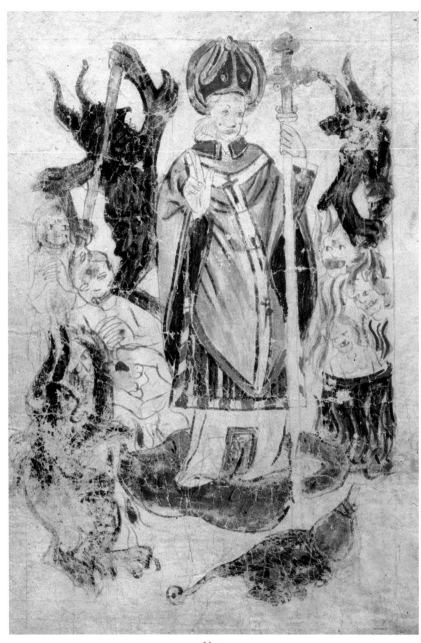

No. 2

St. Patrick standing on the island known as 'St. Patrick's Purgatory' in Lough Derg, Co. Donegal, and tormented by demons, 15th Century
pigments on vellum, 8 1/4" x 5 3/4" x 2"
British Library, Royal MS 17.B.xliii, f. 132v

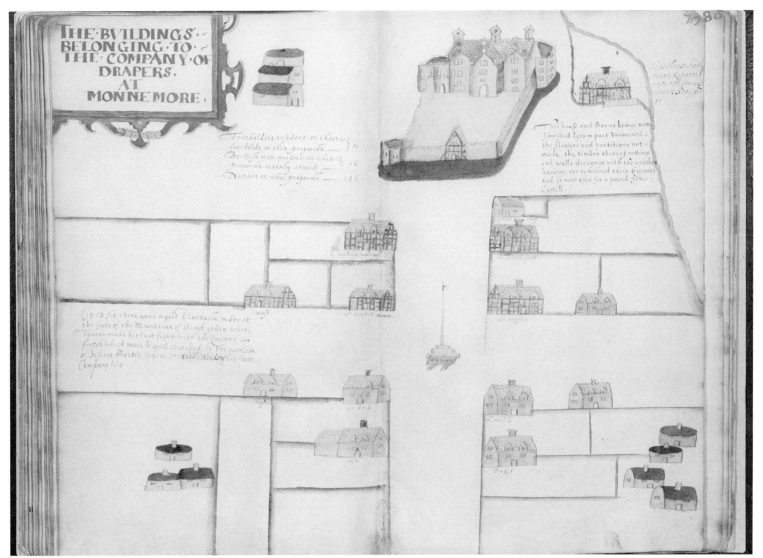

No. 3
Thomas Raven (b. 1572 – d. 1640)
The Buildings Belonging to The Company of Drapers at Monnemore from *Sir Thomas Phillips' Survey of Ulster*, 1622, England
ink and watercolor on paper bound in calfskin, 14 1/3" x 9 5/6" x 1 2/5"
The Drapers' Company of the City of London

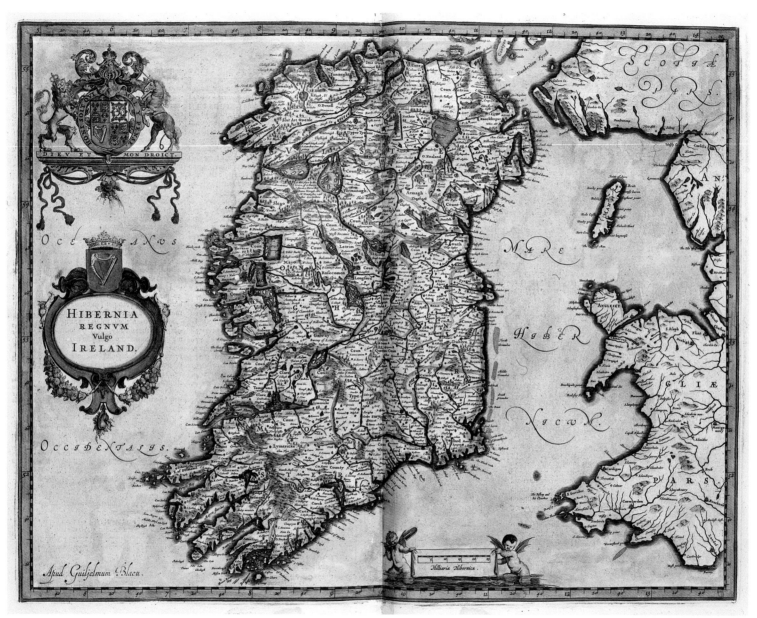

No. 4
Joan Blaeu (b. 1596 – d. 1673)
Hibernia Amsterdamus, 1654, Amsterdam
engraving with watercolor on paper, 18 1/2" x 27" open
John J. Burns Library, Boston College, G1864B5

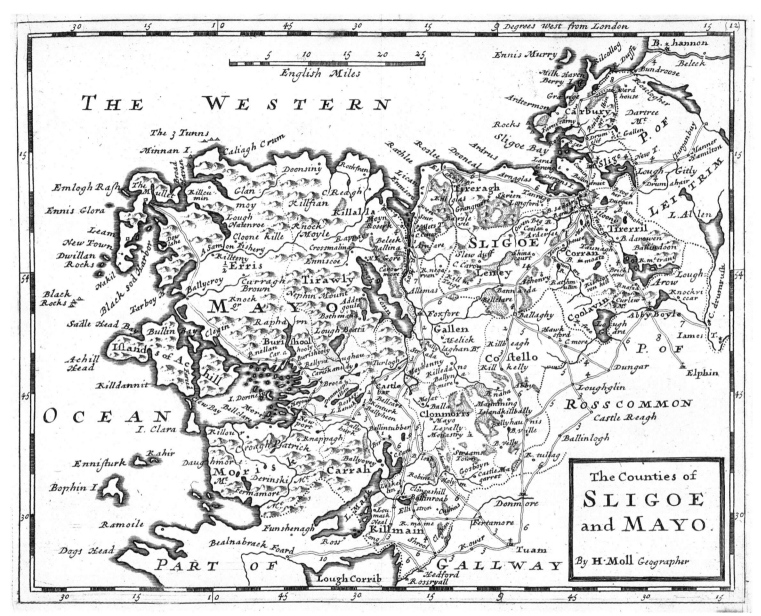

No. 5
Herman Moll (Dutch, d. 1732)
Counties of Sligo & Mayo, 1728, England
engraving on paper, 9" x 28 1/2" open
John J. Burns Library, Boston College, G1864M6

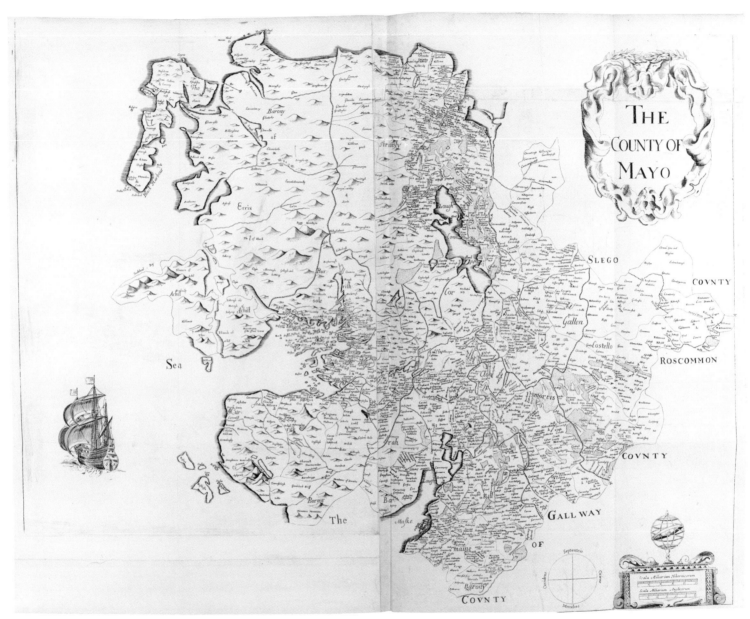

No. 6
Sir William Petty (b. Romsey, Hampshire 1623 – d. London 1687)
Hiberniae delineatio, Map of Mayo, 1732, England
engraving on paper, 23 1/2" x 30 3/16" open
John J. Burns Library, G1830P4

No. 7
Marcus Ward and Company of Belfast
Illuminated Address, Earl's residence and the mill on his estate (Presented to the Earl of Hillsborough in 1865)
watercolor, gold, and pigments on paper on board, bound in gilt-tooled brown leather inlaid with varicolored strapwork, 12 1/4" x 10" x 1 3/4"
British Library, Add. 51314, f.2

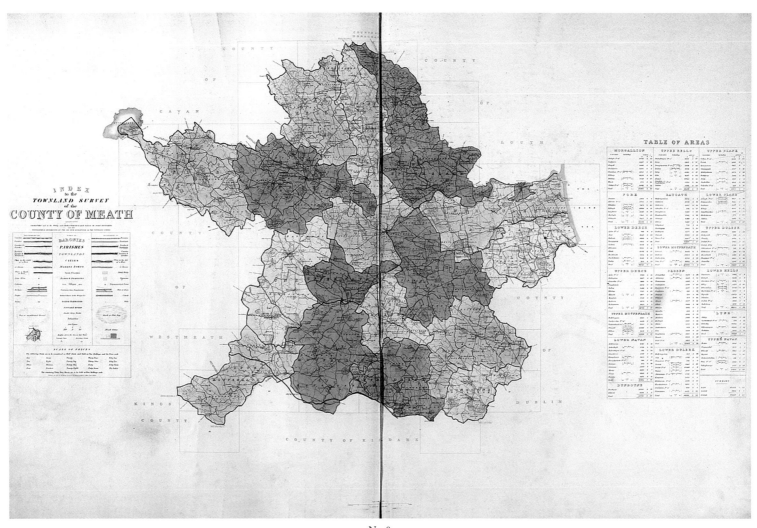

No. 8
Ordnance Survey of Ireland from *Index to the Townland Survey of the County Meath*, 1837
lithograph and watercolor on paper mounted on linen, bound, 26" x 42" x 3" open
Dublin: Published and sold for His Majesty's government by Hodges and Smith
John J. Burns Library, Boston College

anon

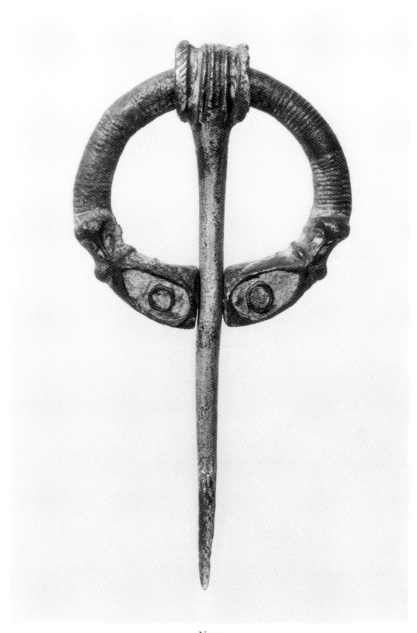

No. 9
Penannular Brooch
Ireland, 7th century
copper alloy and enamel, Diameter: 1 1/8" Length (pin): 3 3/8"
Metropolitan Museum of Art, Gift of Alastair B. Martin, 1953. 53.48.5

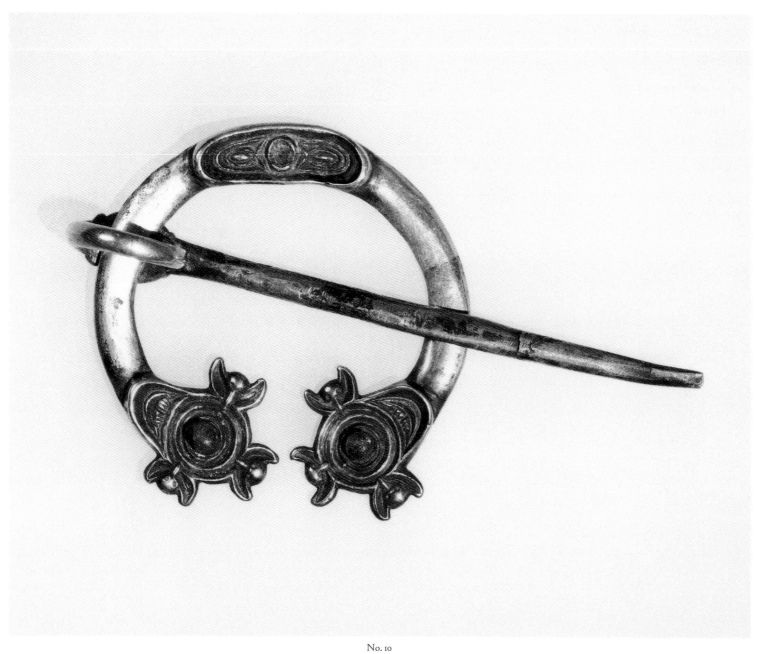

No. 10
Penannular Brooch
Ireland or Pictland, 9th century, unearthed 1853, near Galway
silver and amber, Diameter: 2 3/8"; Length (pin): 3 3/4"
Metropolitan Museum of Art, Purchase, Rogers Fund and Gift of J. Pierpont Morgan, by Exchange, 1981. 1981.413

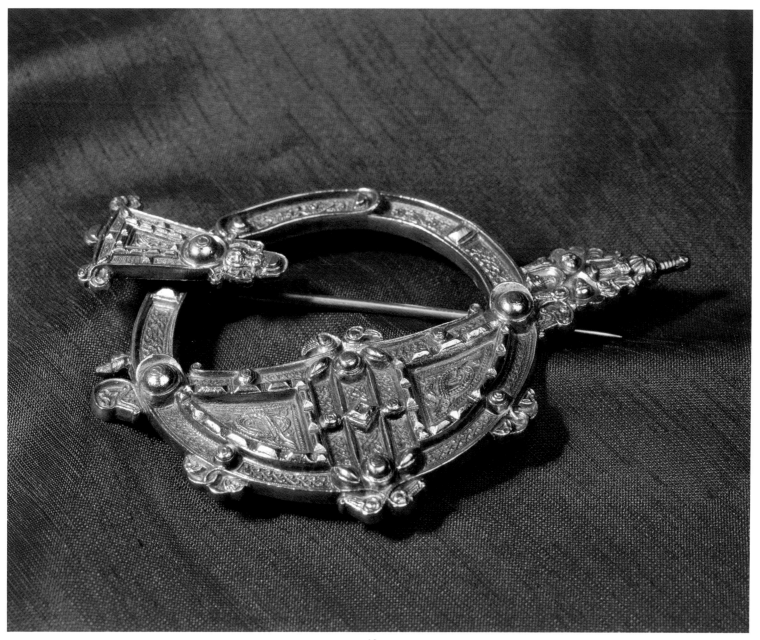

No. 11
Waterhouse and Company, Dublin
Reproduction of Tara Brooch, Ireland, second half of the nineteenth century
silver, Diameter: 2 1/2"
Private Collection

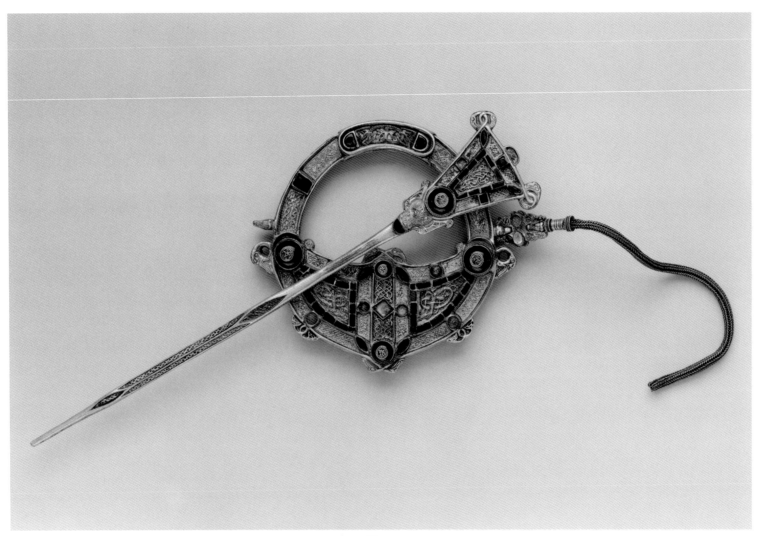

No. 12
Edmond Johnson (Irish, b. 1840s – d. before 1902)
Reproduction of Tara Brooch, Ireland, c. 1900
bronze gilt, Diameter: 3 1/2" x Length (pin): 8 1/4"
Metropolitan Museum of Art, Rogers Fund, 1906. 07.65.7

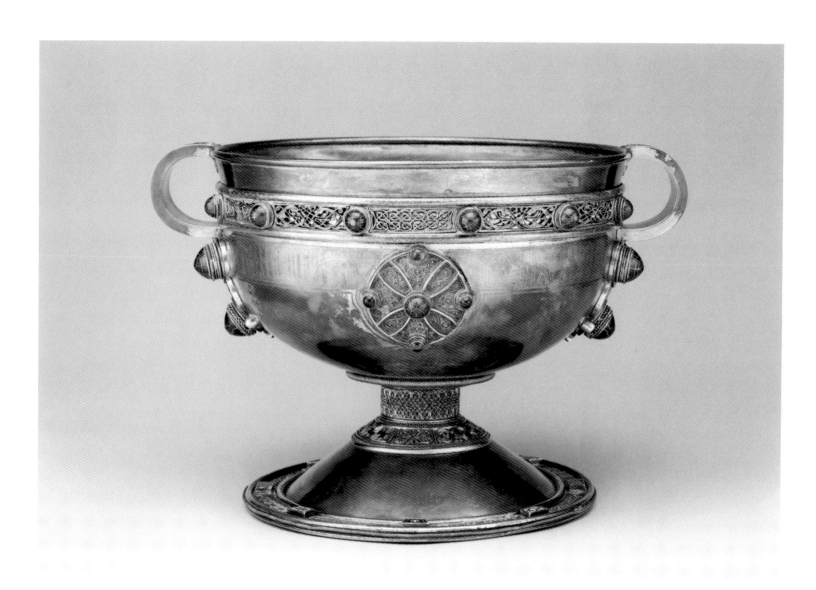

No. 13
Edmond Johnson (Irish, b. 1840s – d. before 1902)
Reproduction of Ardagh Chalice, Ireland, c. 1900
silver and enamel, 6 1/4" x 7 1/2" x 7"
Metropolitan Museum of Art, Rogers Fund, 1906. 07.65.8

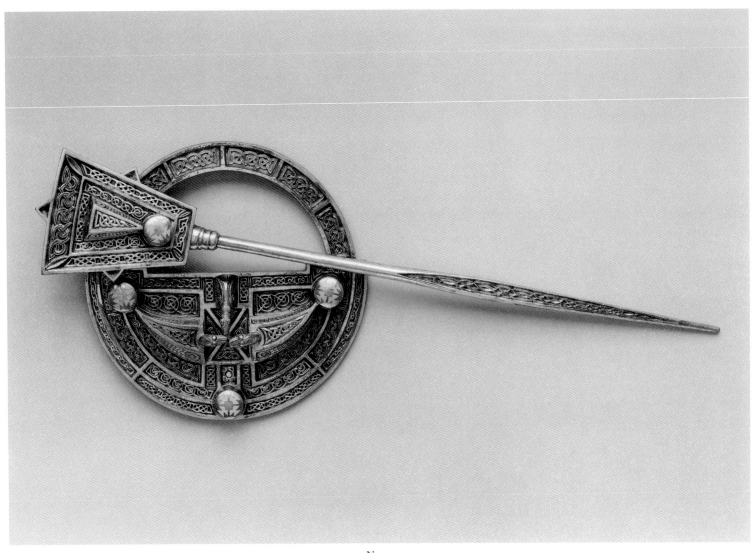

No. 14
Edmond Johnson (Irish, b. 1840s – d. before 1902)
Reproduction of Ardagh Brooch, Ireland, c. 1900
bronze gilt, Diameter: 5 1/2"; Length (pin): 13 1/2"; Depth: 3 1/2"
Metropolitan Museum of Art, Rogers Fund, 1906. 07.65.3

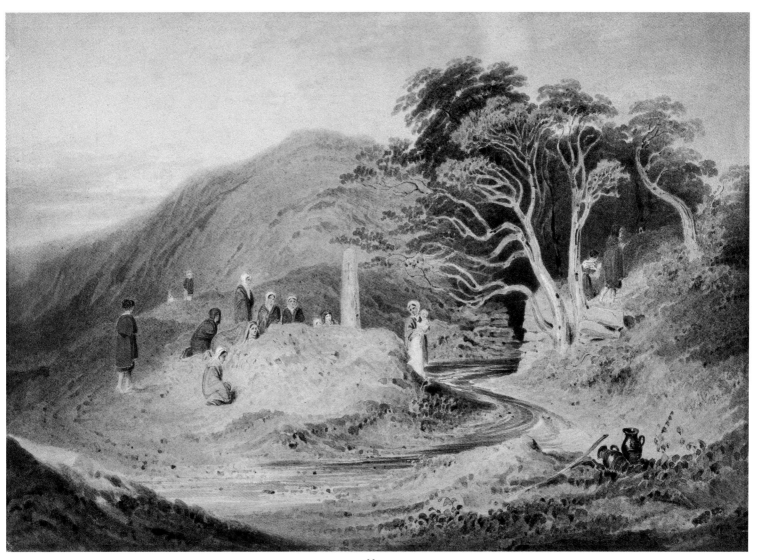

No. 15
George Petrie (b. Dublin 1789 – d. 1866)
St. Brigit's Well, 1830
watercolor on paper, 7 1/4" x 10 1/4"
Courtesy of the National Gallery of Ireland, NGI 2382

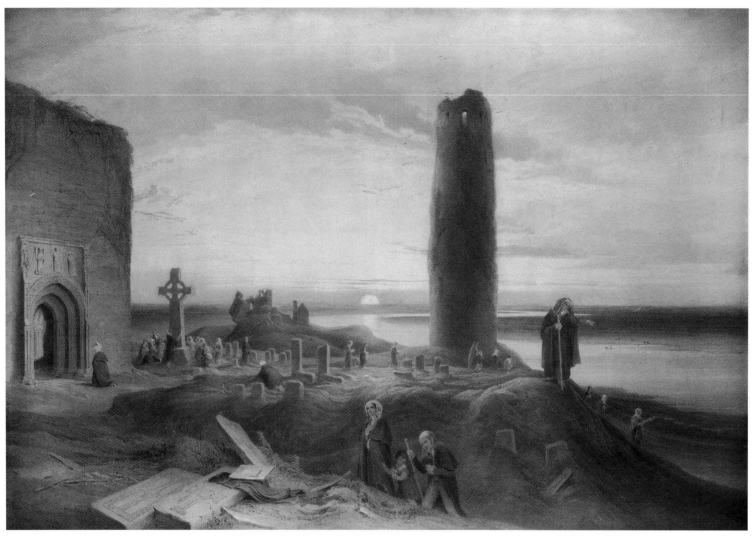

No. 16
George Petrie (b. Dublin 1789 – d. 1866)
Last Circuit of Pilgrims at Clonmacnoise, 1828
watercolor on paper, 25" x 39"
Courtesy of the National Gallery of Ireland, NGI 2230

THE TORY IDEA OF "CONCILIATION."

No. 17
Anon.
"The Tory Idea of 'Conciliation,'" Weekly Freeman, December 10, 1887
lithograph on paper, 13 1/4" x 19 1/4"
John J. Burns Library, Boston College

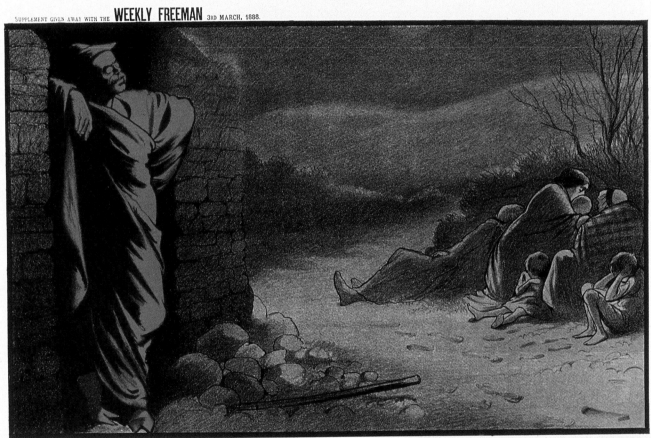

"THIS DEVIL'S WORK."

No. 18
Thomas Fitzpatrick (b. Cork 1860 – d. Dublin? 1912)
"This Devil's Work," Weekly Freeman, March 3, 1888
lithograph on paper, 13 1/4" x 19 1/4"
John J. Burns Library, Boston College

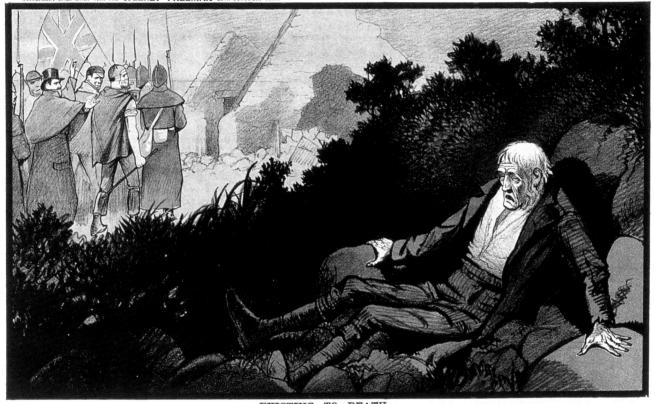

EVICTING TO DEATH.

On Thursday, October 11th, a poor old man, 80 years of age, named James Dunne, was flung out on the side of the road by Balfour's gang of Emergency Men, although he informed them *prophetically* that he had only half an hour to live——his words came only too true.

No. 19
Thomas Fitzpatrick (b. Cork 1860 – d. Dublin? 1912)
"Evicting to Death," Weekly Freeman, October 20, 1888
lithograph on paper, 13 1/4" x 19 1/4"
John J. Burns Library, Boston College

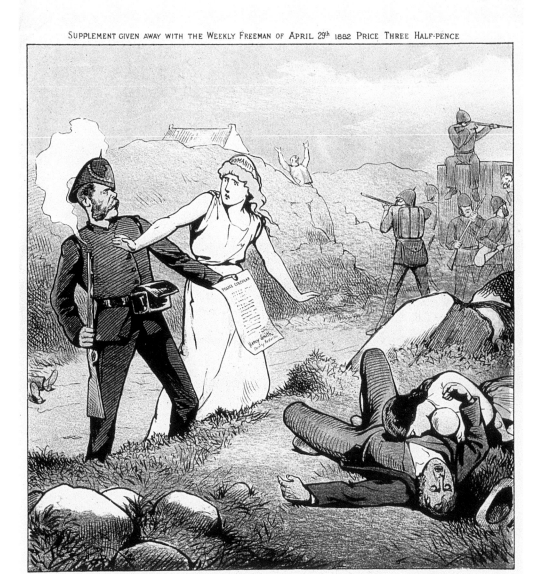

LLOYD'S "CIRCULAR" TOUR THROUGH CLARE.

HUMANITY—"Great Heavens! Have these people done anything to deserve instant and unexpected death."
POLICEMAN—"Nothing, that I know of; but my instructions are, to kill everybody that *might* commit murder; and sure these were within "shooting distance" of the Major."
HUMANITY—"Stop this infamous and murderous proceeding at once. I declare I have never been so outraged or so shocked in my life."

No. 20
Anon.
"Lloyd's 'Circular' Tour through Clare," Weekly Freeman, April 29, 1882
lithograph on paper, 13 3/4" x 11 1/2"
John J. Burns Library, Boston College

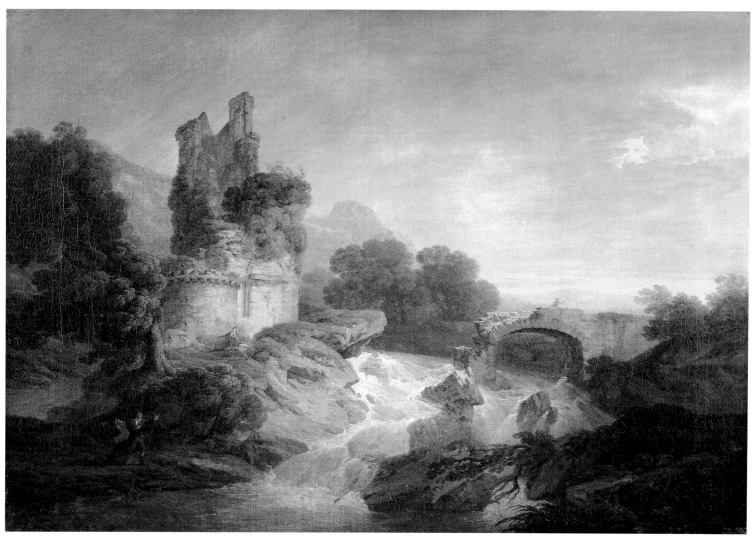

No. 21
Thomas Roberts (b. Waterford 1748 – d. Lisbon 1778)
A Landstorm with Waterfall, 1769
oil on canvas, 16 1/2" x 24 1/2"
Private Collection

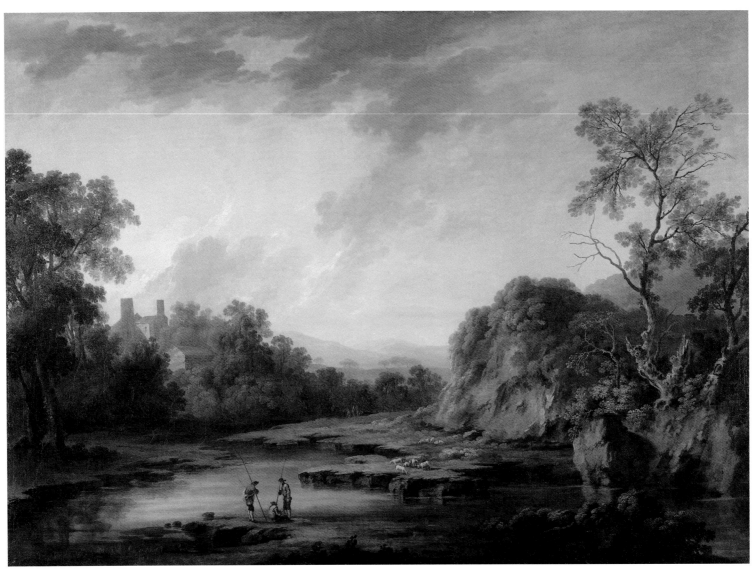

No. 22
George Barret (b. Dublin 1728 – d. London 1784)
Extensive Landscape, mid-eighteenth century
oil on canvas, 49" x 68 1/2"
Private Collection

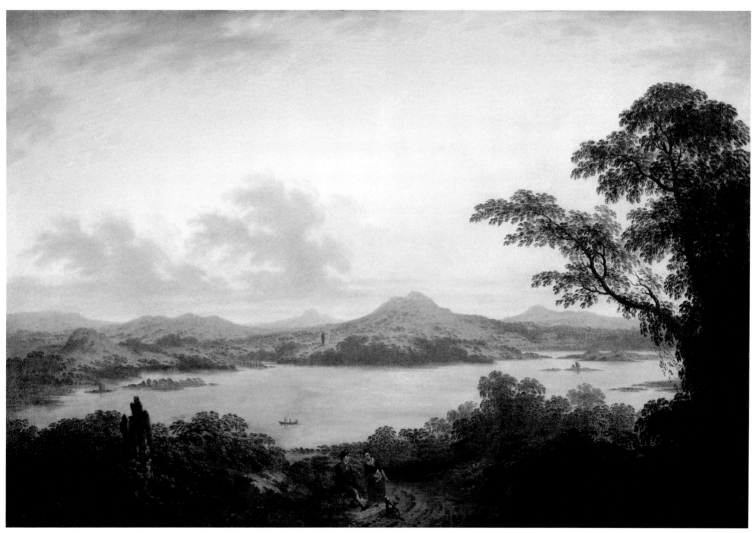

No. 23
Jonathan Fisher (b. Dublin ? – d. Dublin 1809)
Killarney Landscape, late-eighteenth century
oil on canvas, 34" x 50"
Private Collection

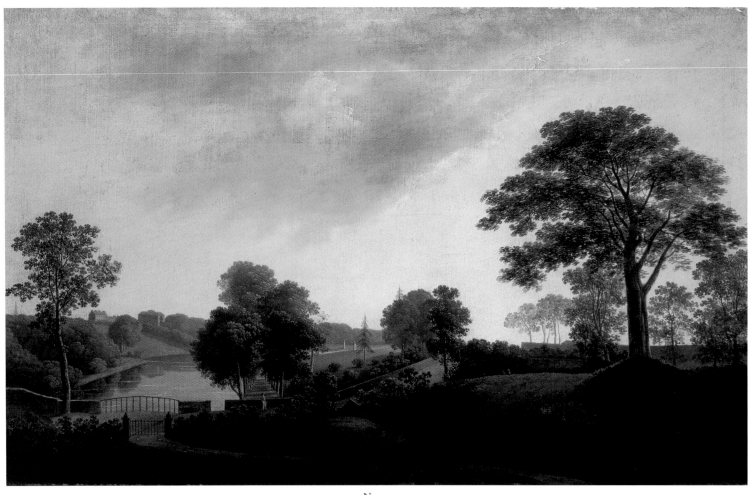

No. 24
James O'Connor (b. Dublin 1792 – d. London 1841)
The Pleasure Grounds, Ballinrobe, Co. Mayo, 1818
oil on canvas, 16" x 28"
Courtesy of the National Gallery of Ireland, NGI 4021

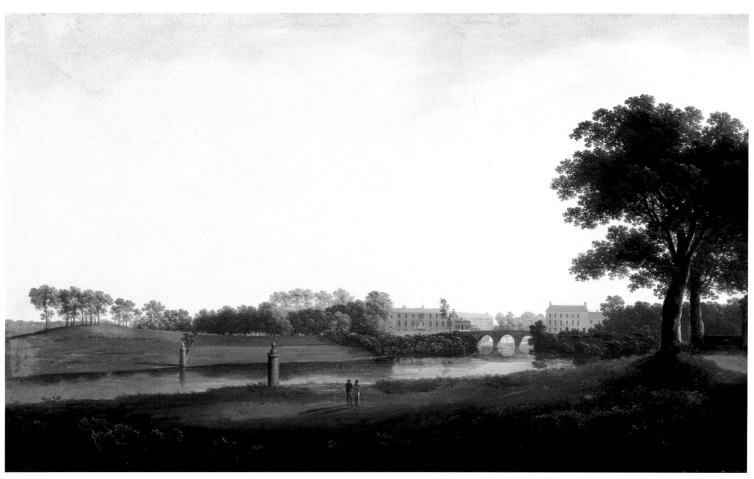

No. 25
James O'Connor (b. Dublin 1792 – d. London 1841)
Ballinrobe House, 1818
oil on canvas, 16 1/2" x 28"
Courtesy of the National Gallery of Ireland, NGI 4010

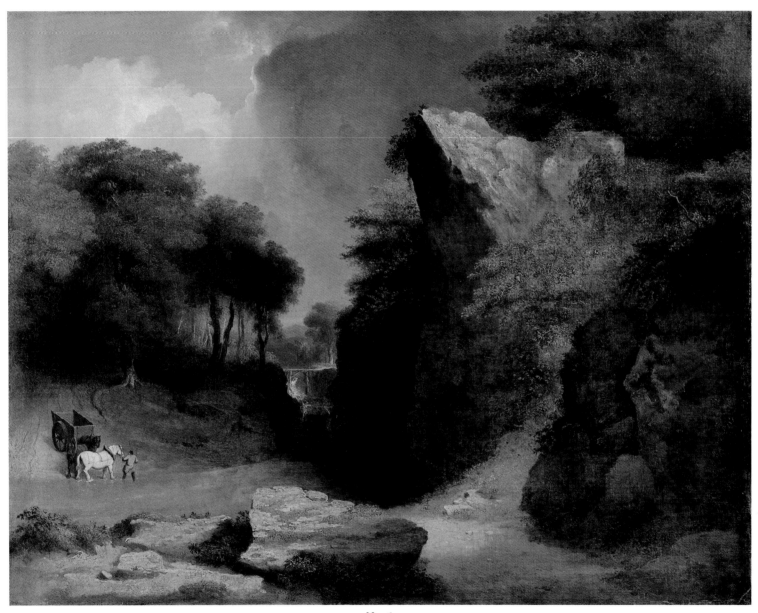

No. 26
James O'Connor (b. Dublin 1792 – d. London 1841)
The Eagle's Nest, 1830
oil on canvas, 27" x 35"
Private Collection

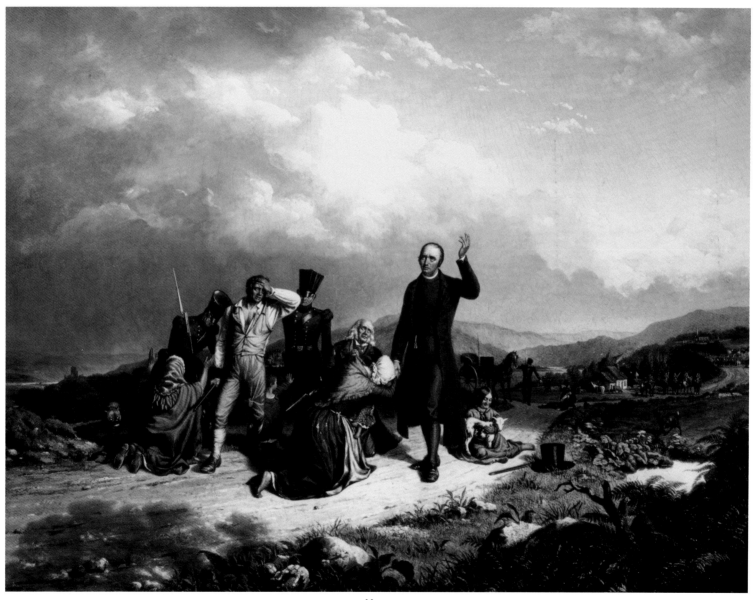

No. 27
Robert G. Kelly (b. Dublin 1822 – d. 1910)
An Ejectment in Ireland (A Tear and A Prayer for Erin), 1848
oil on canvas, 46" x 57" x 4"
From the Collection of Anthony J. Mourek on loan to the John J. Burns Library, Boston College

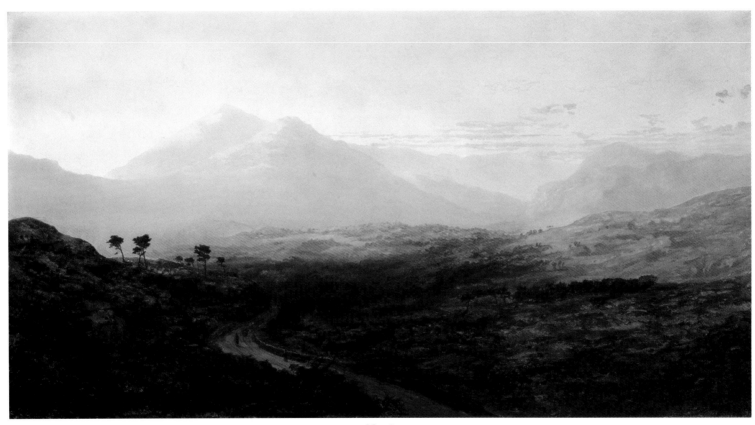

No. 28
William McEvoy (dates unknown; flourished 1858–1880)
Glengariffe From the Kenmare Road, Evening, 1862
oil on canvas, 28" x 52"
Brian P. Burns Irish Art Collection

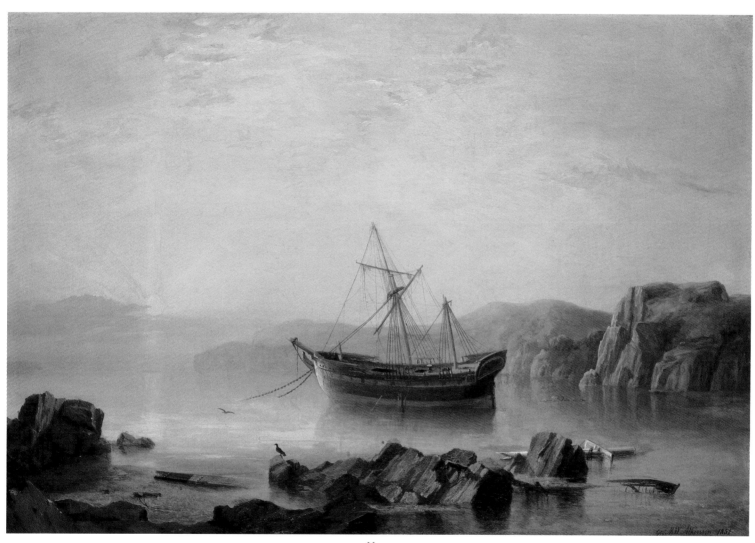

No. 29
George M. W. Atkinson (b. Cork 1806 – d. Cork 1884)
A Ship at Anchor at Sunset, 1851
oil on canvas, 24" x 34 1/4"
Private Collection

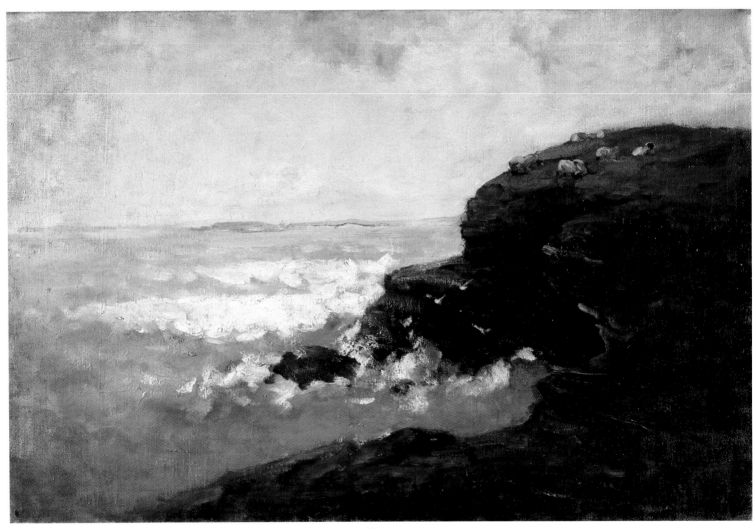

No. 30
Nathaniel Hone (b. Dublin 1831 – d. Dublin 1917)
Coast of Clare, c. 1891
oil on canvas, 24" x 36 1/4"
Courtesy of the National Gallery in Ireland, NGI 1442

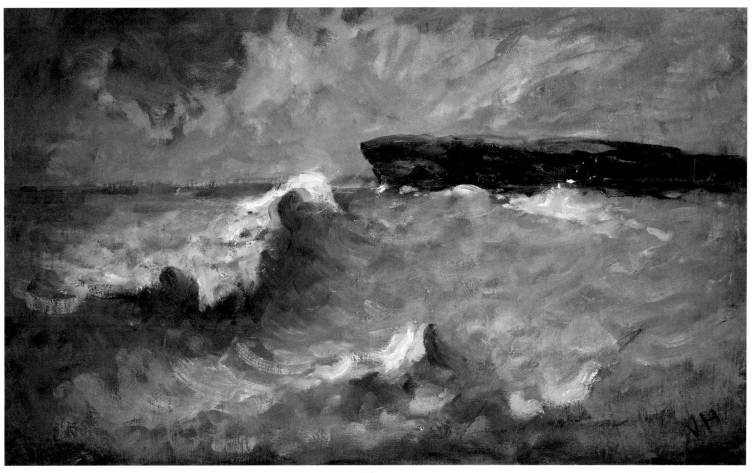

No. 31
Nathaniel Hone (b. Dublin 1831 – d. Dublin 1917)
St. George's Head, n.d.
oil on canvas, 24 1/2" x 39 3/4"
Brian P. Burns Irish Art Collection

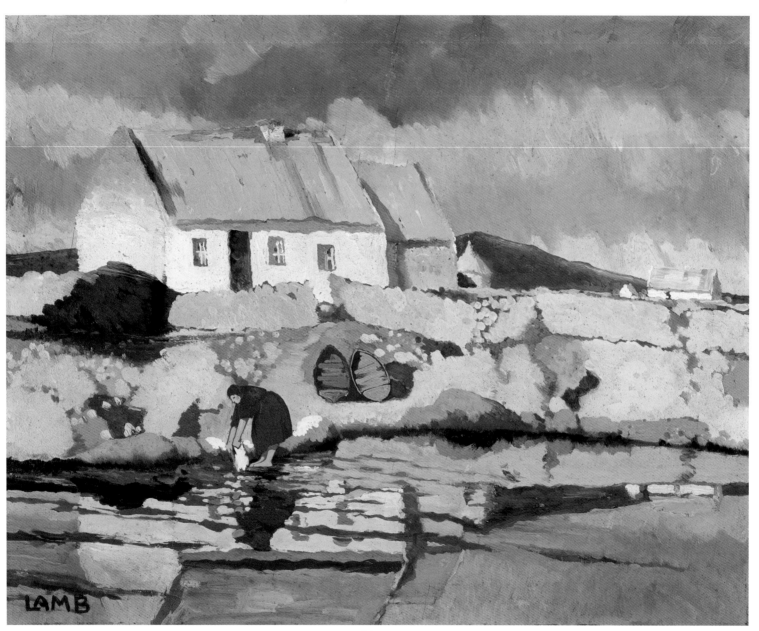

No. 32
Charles Lamb (b. Belfast 1893 – d. Connemara 1964)
The Mill Lake, early-twentieth century
oil on canvas, 15 3/4" x 19 3/4"
Courtesy of the National Gallery of Ireland, NGI 4670

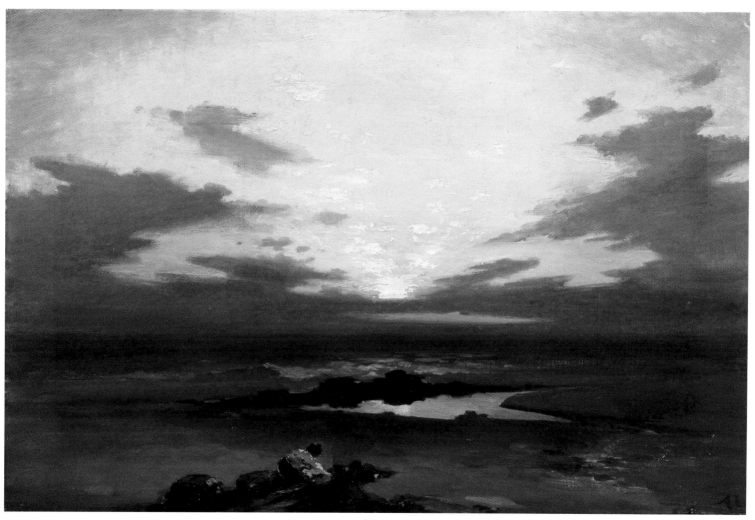

No. 33
George Russell (b. Lurgan 1867 – d. Bournemouth 1935)
Carlo Point Edge—On the Beach, n.d.
oil on canvas, 21" x 32"
Brian P. Burns Irish Art Collection

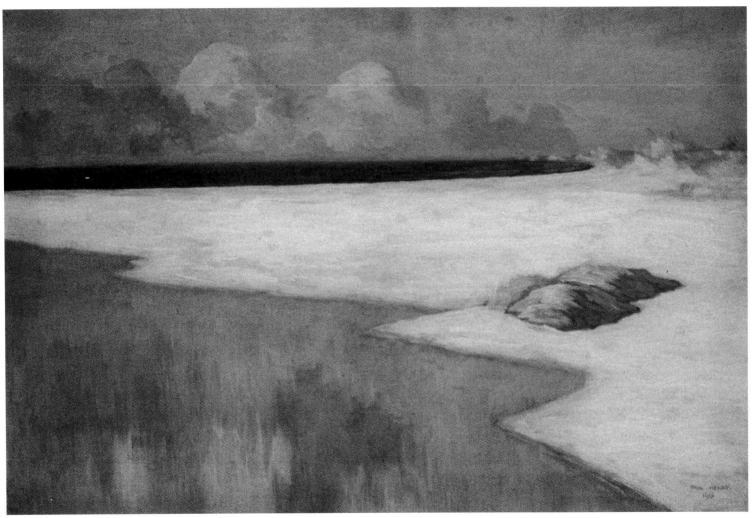

No. 34
Paul Henry (b. Belfast 1876 – d. Co. Wicklow 1958)
Mulraney Beach, 1913
oil on canvas, 16" x 24"
Collection of Stephen and Bessie Seiler

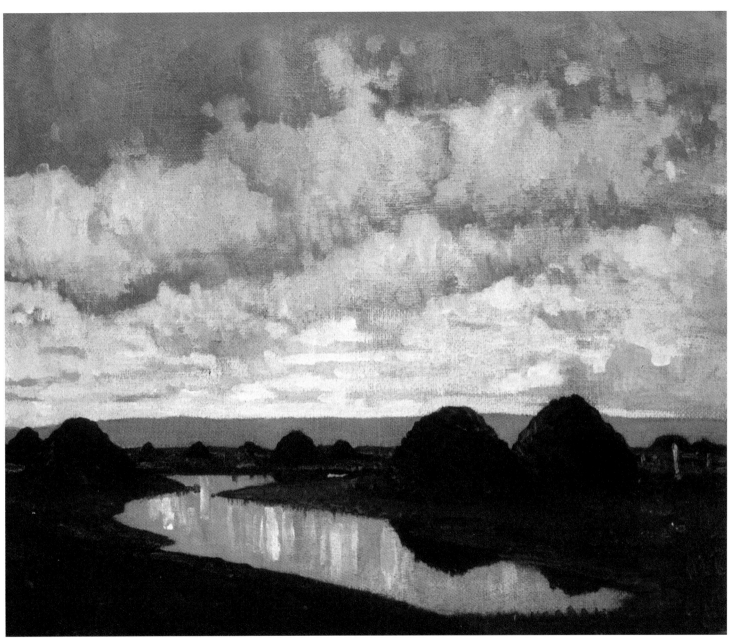

No. 35
Paul Henry (b. Belfast 1876 – d. Co. Wicklow 1958)
Turf Stacks in Donegal, n.d.
oil on canvas, 18" x 24"
Collection of Stephen and Bessie Seiler

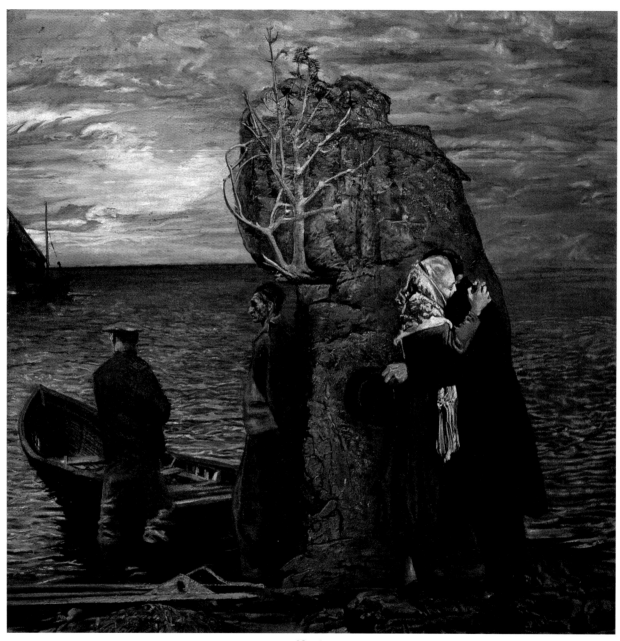

No. 36
Seán Keating (b. Limerick 1889 – d. Dublin 1977)
Economic Pressure, 1936
oil on board, 48" x 48"
Crawford Municipal Art Gallery, Cork, Ireland

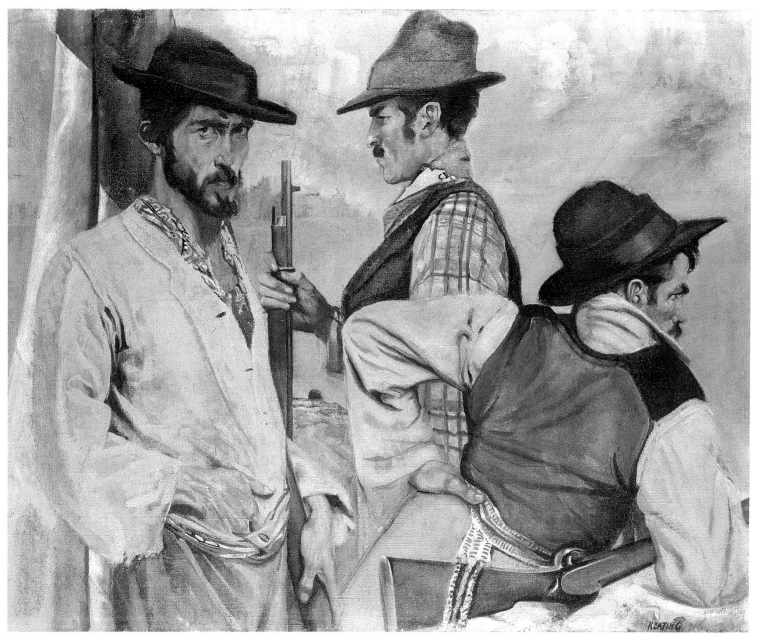

No. 37
Seán Keating (b. Limerick 1889 – d. Dublin 1977)
Men of the West, 1917
oil on board, 45 1/2" x 56" x 2 1/2"
Hugh Lane Municipal Gallery, Dublin, Ireland

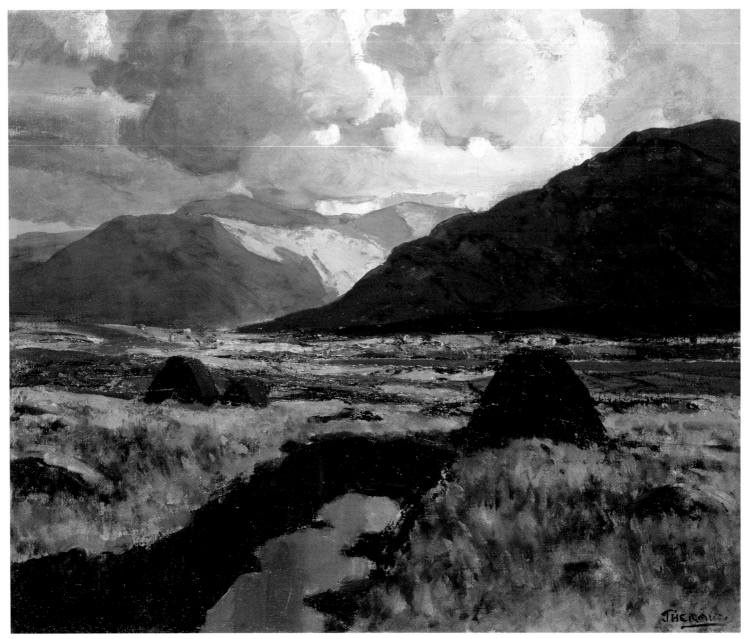

No. 38
James H. Craig (b. Belfast 1878 – d. ?)
In County Mayo (or Connemara Bog and Mountain scene), n.d.
oil on canvas, 20" x 24"
Brian P. Burns Irish Art Collection

No. 39
Jack B. Yeats (b. London 1871 – d. Dublin 1957)
1898 Ireland
sketchbook, 3" x 5"
O'Malley Collection

No. 40
Jack B. Yeats (b. London 1871 – d. Dublin 1957)
1899 #5 Co. Galway, Isle of Aran
sketchbook, 3" x 5"
O'Malley Collection

No. 41
Jack B. Yeats (b. London 1871 – d. Dublin 1957)
1899 #6 Co. Galway, (Galway-Dublin)
sketchbook, 3" x 5"
O'Malley Collection

No. 42
Jack B. Yeats (b. London 1871 – d. Dublin 1957)
1900 Galway (Galway Races)
sketchbook, 3" x 5"
O'Malley Collection

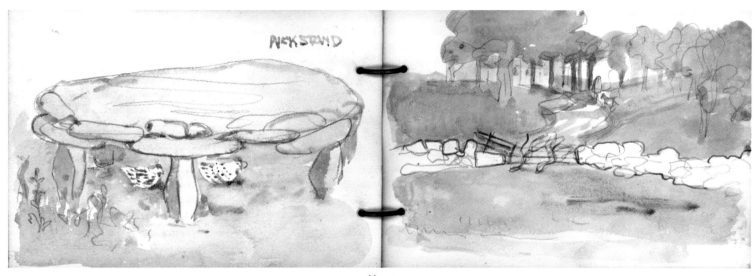

No. 43
Jack B. Yeats (b. London 1871 – d. Dublin 1957)
1900 Galway (Gort-Galway, Raffertys)
sketchbook, 3" x 5"
O'Malley Collection

No. 44
Jack B. Yeats (b. London 1871 – d. Dublin 1957)
1900 Galway (Old Glory)
sketchbook, 3" x 5"
O'Malley Collection

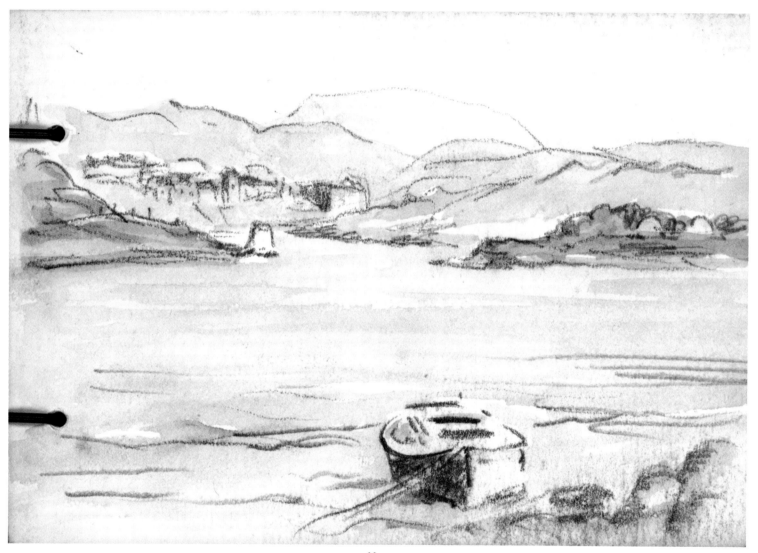

No. 45
Jack B. Yeats (b. London 1871 – d. Dublin 1957)
1907 Clifden
sketchbook, 3" x 5"
O'Malley Collection

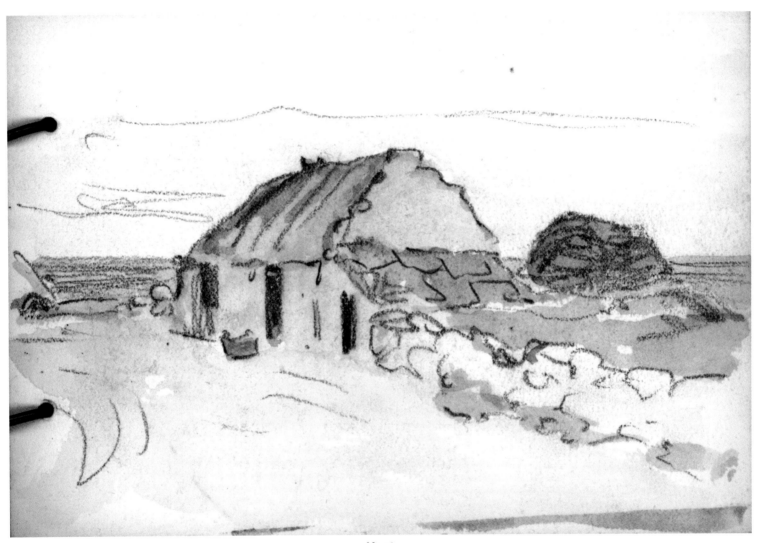

No. 46
Jack B. Yeats (b. London 1871 – d. Dublin 1957)
1908 Harvey's and the Point
sketchbook, 3" x 5"
O'Malley Collection

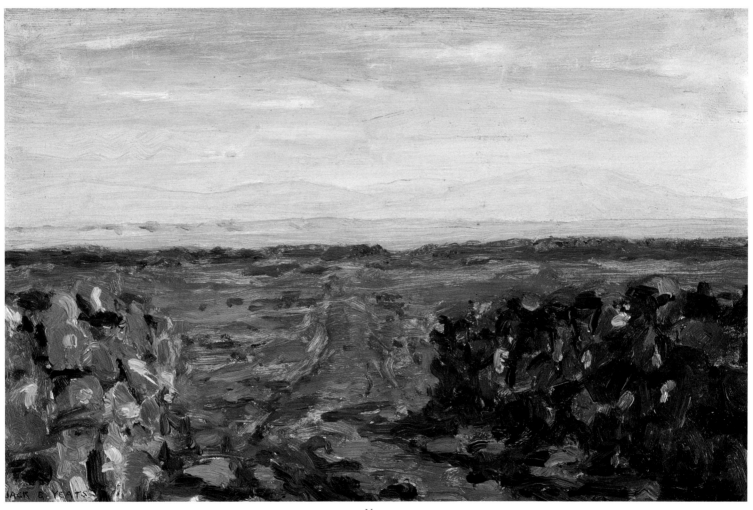

No. 47
Jack B. Yeats (b. London 1871 – d. Dublin 1957)
The Road/Lane to the Pasture, 1922
oil on panel, 9" x 14"
J. Connors Collection

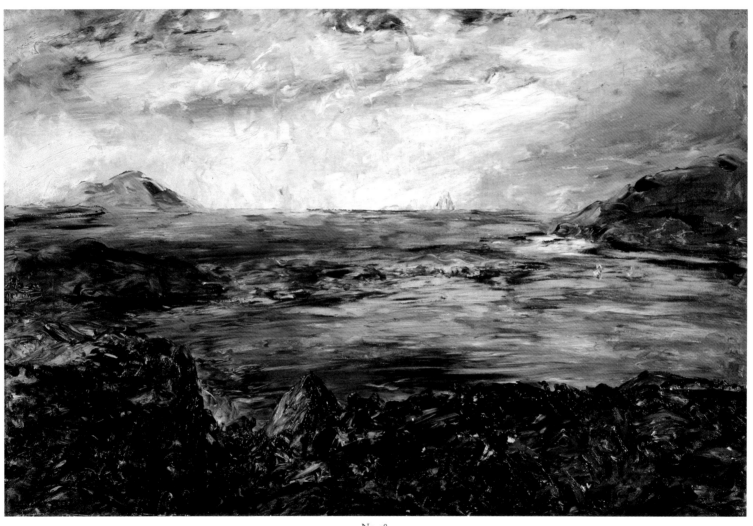

No. 48
Jack B. Yeats (b. London 1871 – d. Dublin 1957)
Derrynane, 1927
oil on canvas, 24" x 36"
O'Malley Collection

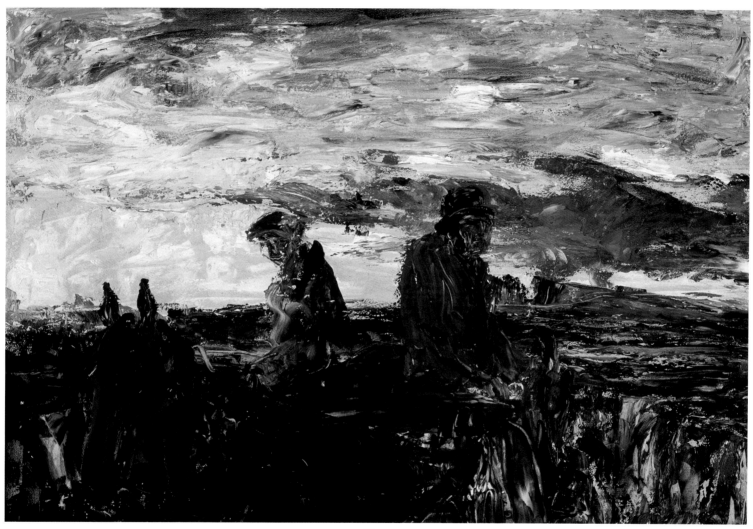

No. 49
Jack B. Yeats (b. London 1871 – d. Dublin 1957)
Farewell to Mayo, 1929
oil on canvas, 24" x 36"
Friends of Boston College

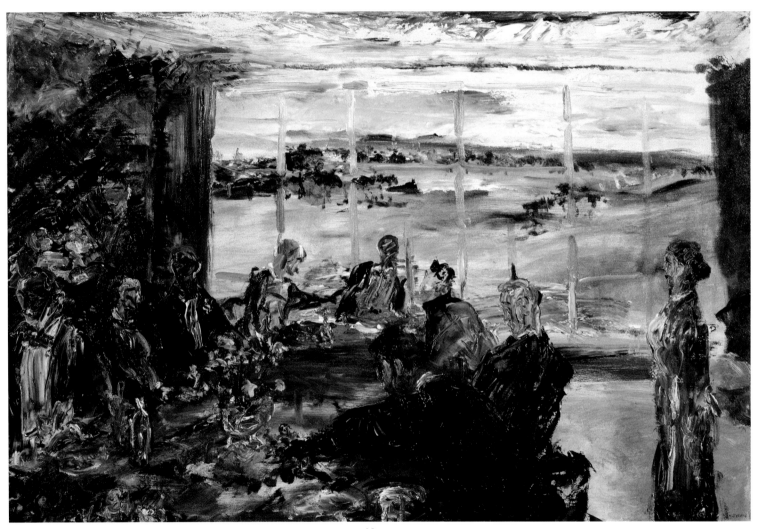

No. 50
Jack B. Yeats (b. London 1871 – d. Dublin 1957)
Evening in Spring, 1937
oil on canvas, 24" x 36"
O'Malley Collection

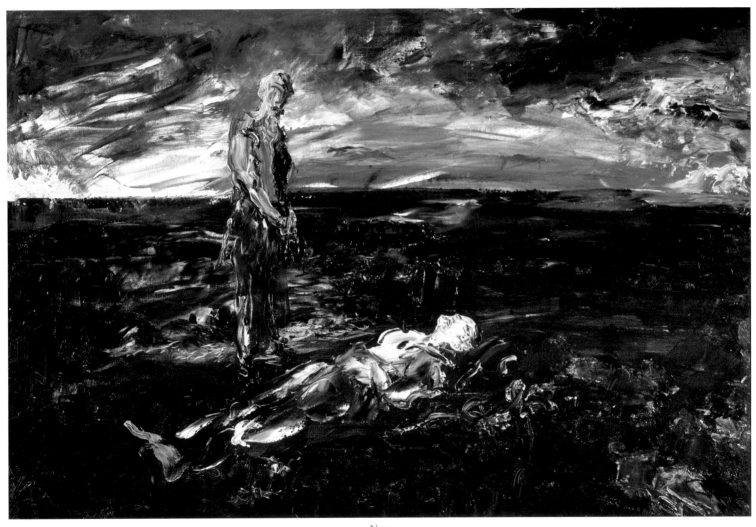

No. 51
Jack B. Yeats (b. London 1871 – d. Dublin 1957)
Death For Only One, 1937
oil on canvas, 24" x 36"
O'Malley Collection

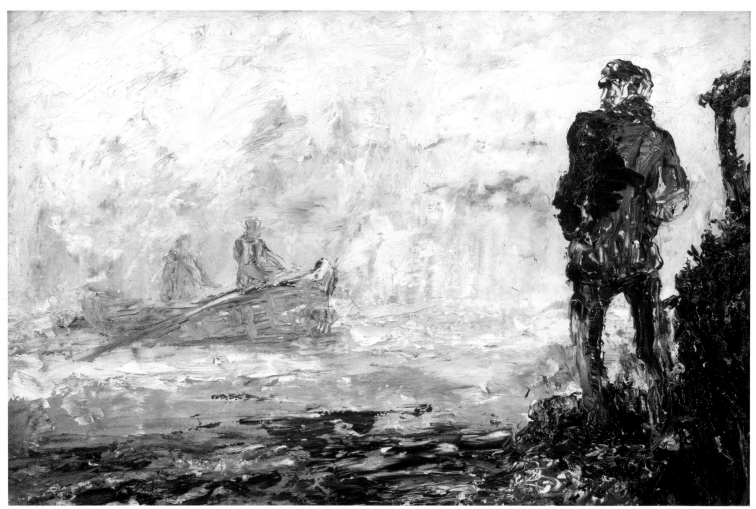

No. 52
Jack B. Yeats (b. London 1871 – d. Dublin 1957)
Misty Morning, c. 1945
oil on canvas, 9" x 14"
Brian P. Burns Irish Art Collection

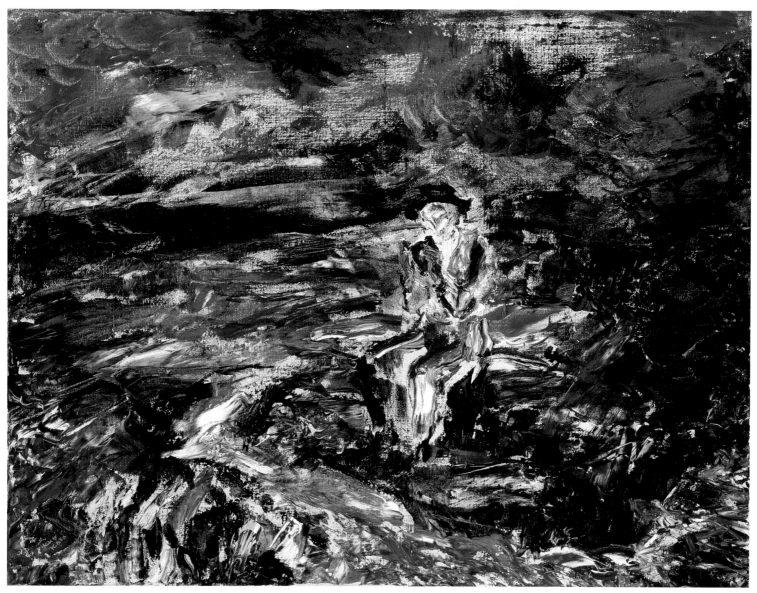

No. 53
Jack B. Yeats (b. London 1871 – d. Dublin 1957)
Rushing Waters, 1947
oil on canvas, 18" x 23 1/4"
Friends of Boston College

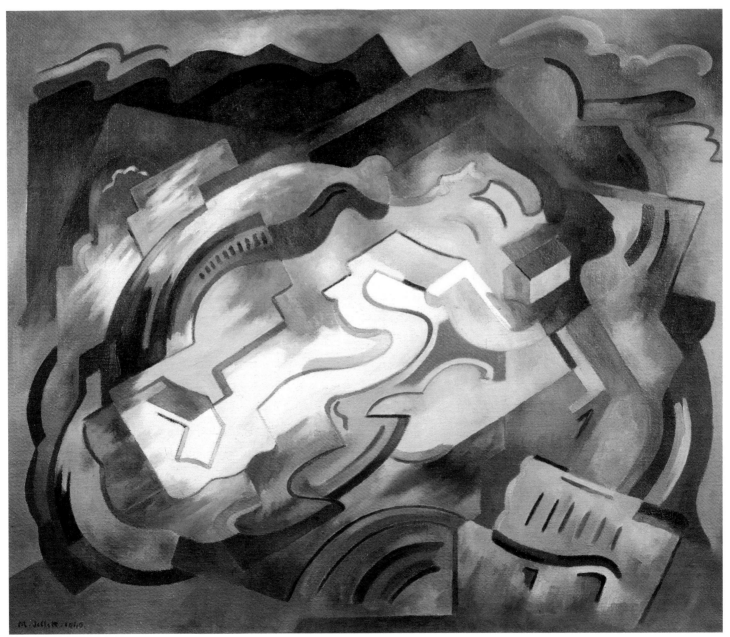

No. 54
Mainie Jellet (b. Dublin 1897 – d. Dublin 1944)
Mise Eire, 1940
oil on canvas, 24 1/2" x 29 1/2"
O'Malley Collection

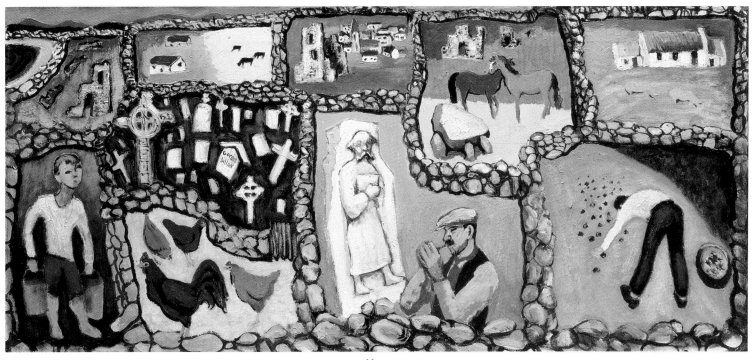

No. 55
Gerard Dillon (b. Belfast 1916 – d. Dublin 1971)
The Little Fields, c.1945
oil on canvas, 16" x 35"
Courtesy of the National Gallery of Ireland, NGI 4520

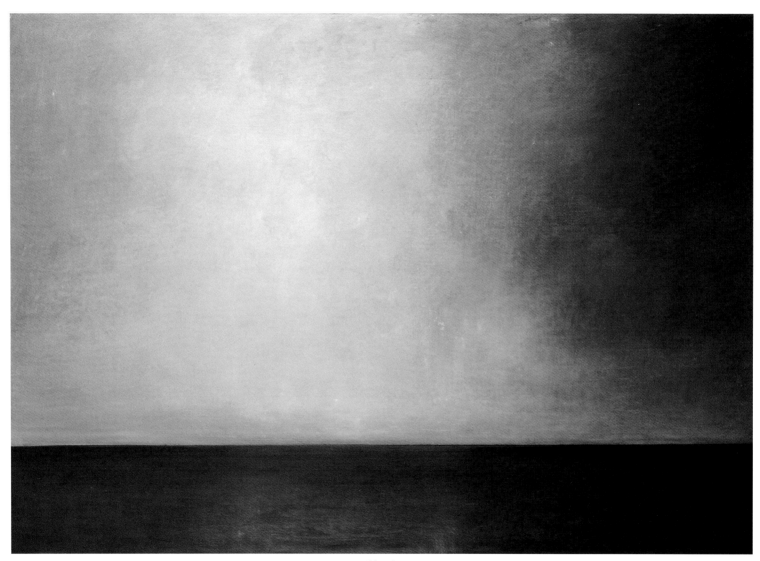

No. 56
Cynthia Knott (American)
Eminence, 1999
oil on canvas, 38" x 58"
Collection of Michael Kulp

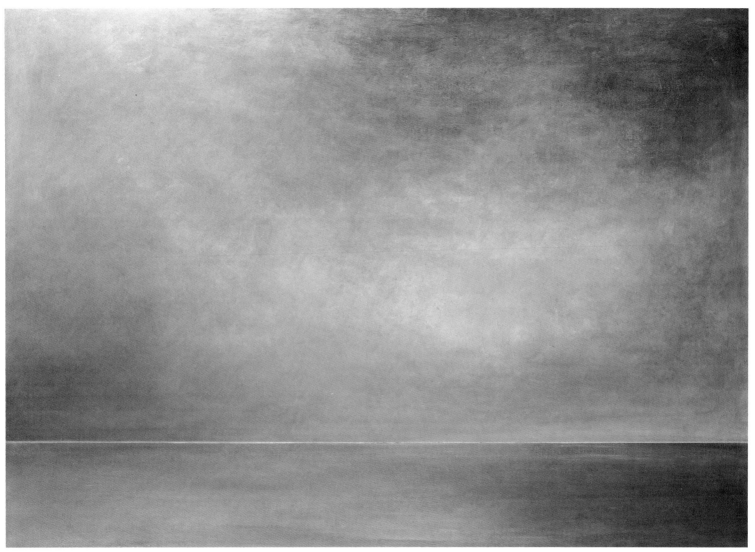

No. 57
Cynthia Knott (American)
Casir, 1999
oil, encaustic, and metallic on linen, 38" x 54"
Private Collection, Boston

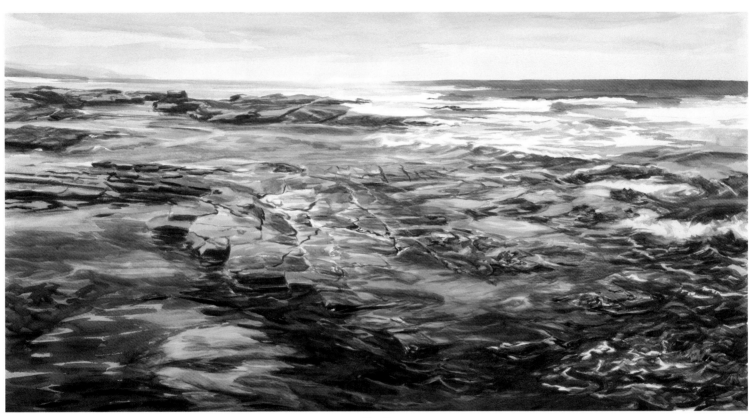

No. 58
Susan Shatter (American)
Irish Moss, 1999
watercolor on paper, 40" x 72"
Private Collection

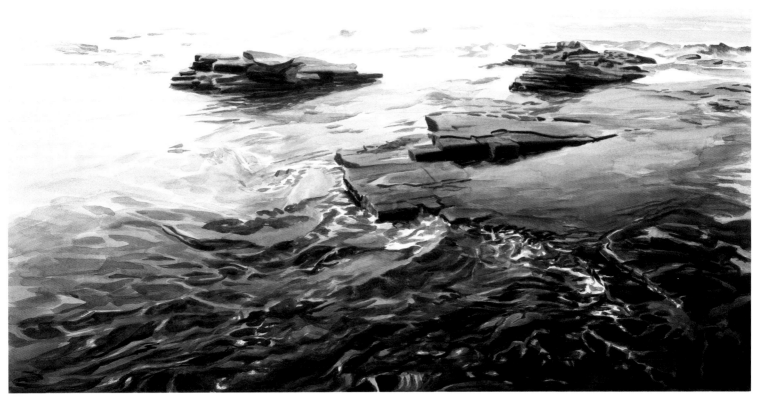

No. 59
Susan Shatter (American)
Sea Ledge, 2000
watercolor on paper, 40" x 60"
Courtesy of The Lyons-Wier Gallery, New York

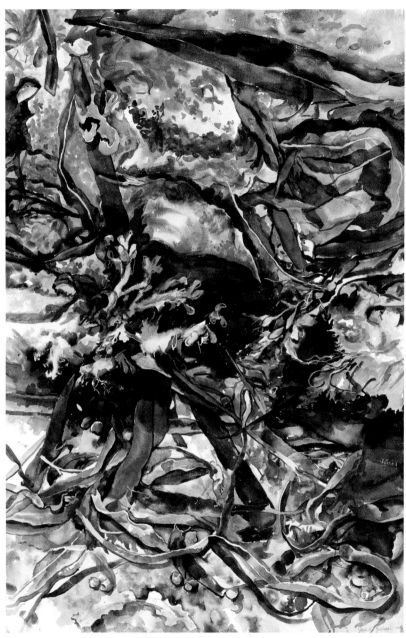

No. 60
Jane Goldman (American)
Tidal Pool #2, 1994
watercolor, 60" x 40"
Collection of the Artist

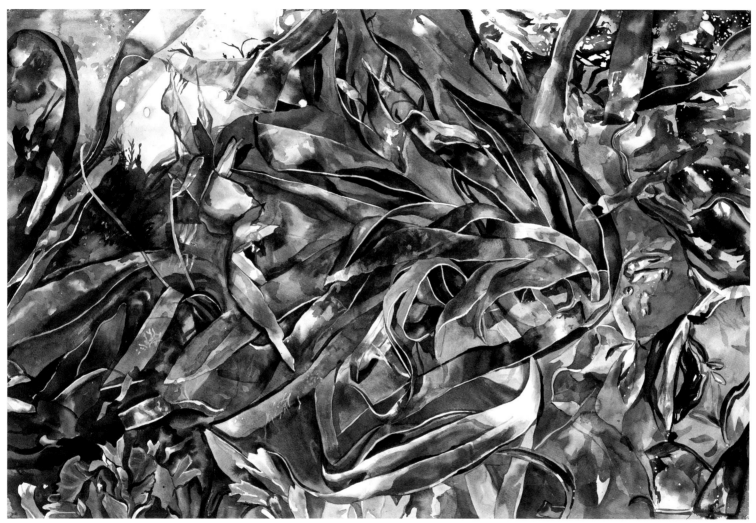

No. 61
Jane Goldman (American)
Tidal Pool #14, 2001
watercolor, 40" x 60"
Collection of the Artist

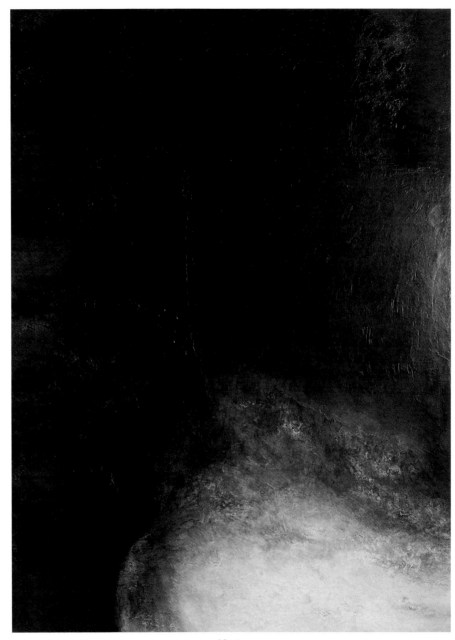

No. 62
Gwen O'Dowd (Irish)
Uaimh #69, 2001
mixed media on canvas on board, 66" x 48"
Collection of the Artist

No. 63
Jane Proctor (Irish)
Black Lines, 1998
India ink on Japanese Paper, 23 1/2" x 35 1/2"
Collection of the McMullen Museum of Art; Gift of the Patrons

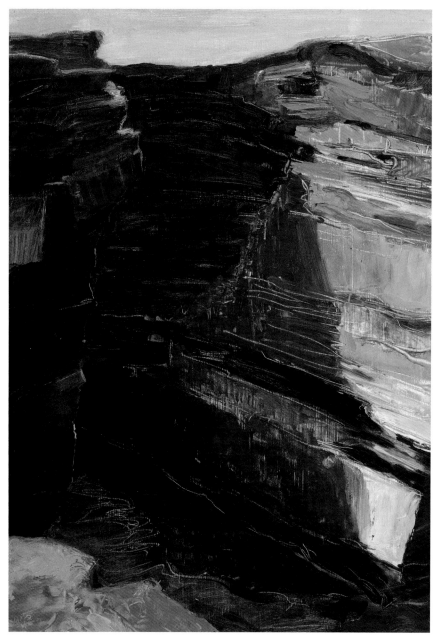

No. 64
Wendy Prellwitz (American)
Downpatrick Cliffs #2, 1998
oil on panel, 20" x 14"
Collection of the Artist

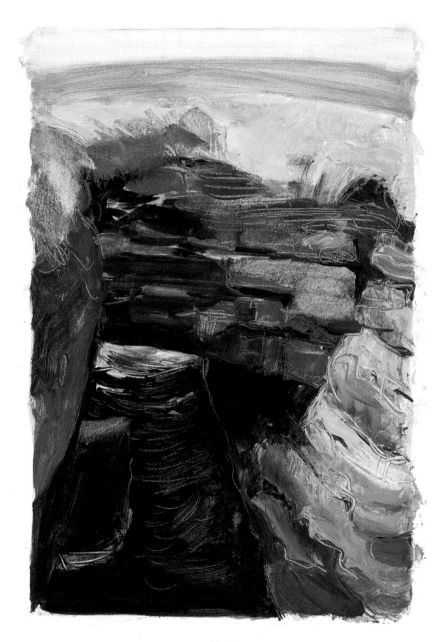

No. 65
Wendy Prellwitz (American)
Blow Hole, 1998
oil on paper, 13" x 9"
J. Connors Collection

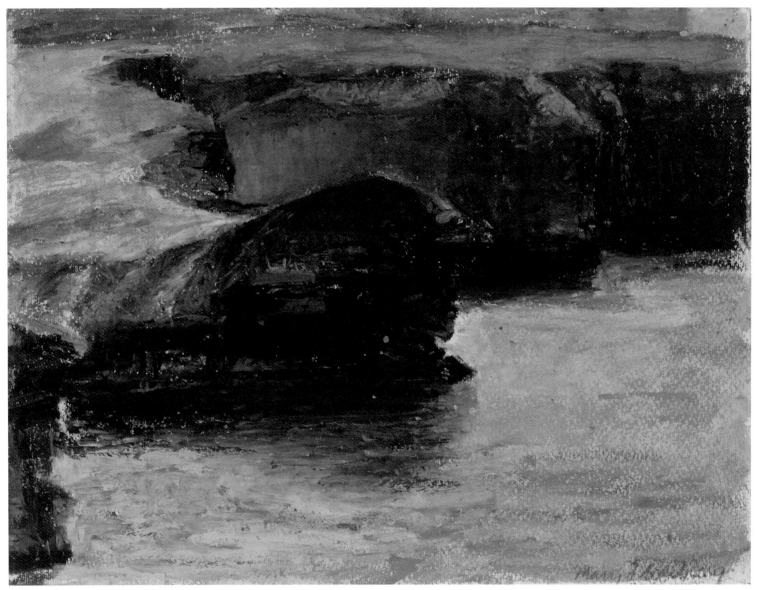

No. 66
Mary Armstrong (American)
Ceide Cliffs, Looking West, 1996
oil pastel on paper, 18 1/4" x 20 3/4"
Collection of the Artist

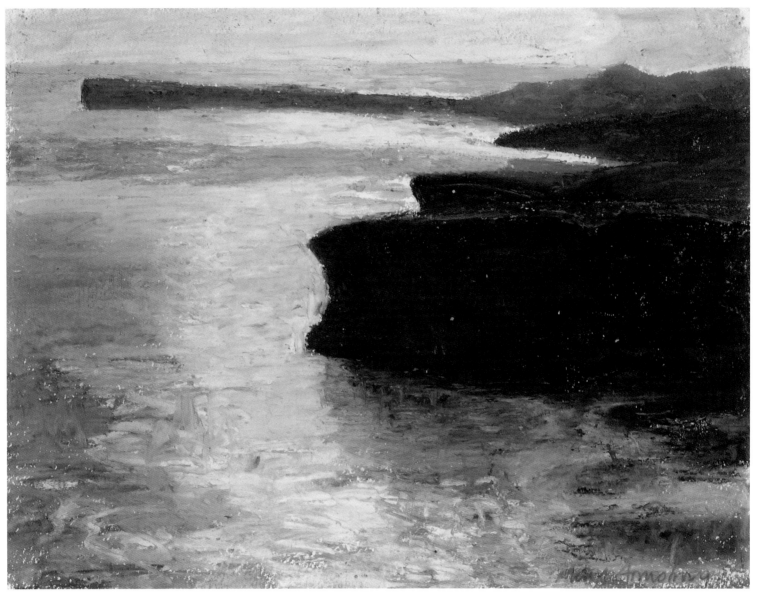

No. 67
Mary Armstrong (American)
Ceide Cliffs, Looking East, 1996
oil pastel on paper, 18 1/4" x 20 3/4"
Collection of the Artist

No. 68
Deirdre O'Mahony (Irish)
Surface #2, 2001
watercolor, gouache, walnut skin ink on paper, 10" x 12 1/2"
Collection of the McMullen Museum of Art; Gift of the Patrons

No. 69
Deirdre O'Mahony (Irish)
Surface #3, 2001
watercolor, gouache, walnut skin ink on paper, 10" x 12 1/2"
Collection of the McMullen Museum of Art; Gift of the Patrons

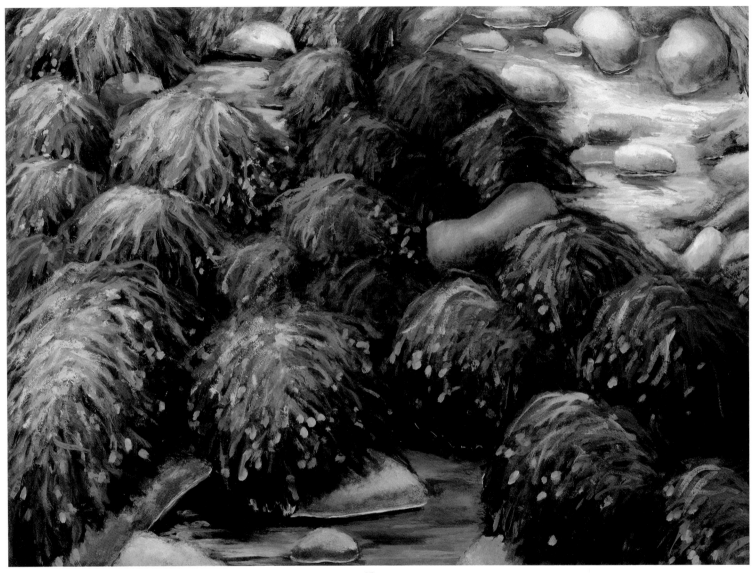

No. 70
Cynthia Back (American)
Seawood and Rocks at Ballycastle Pier, 1997
oil on paper mounted on canvas, 22" x 30"
Collection of the Artist

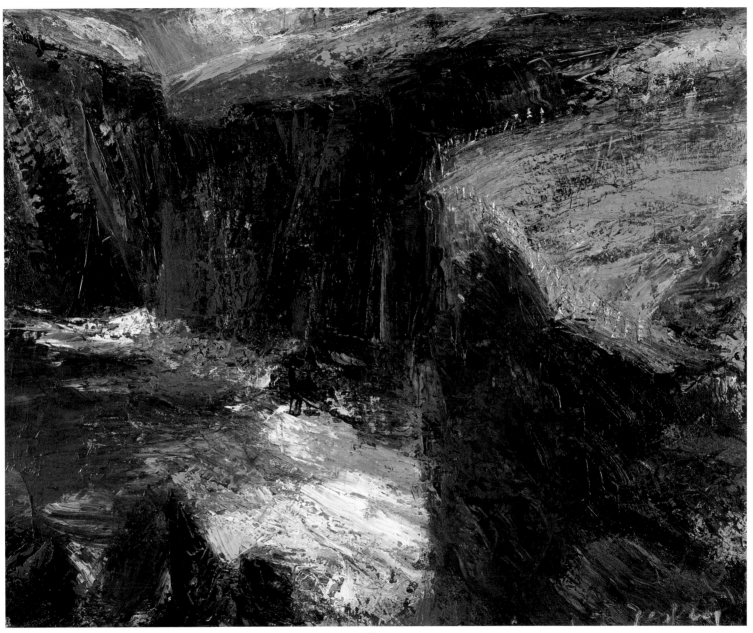

No. 71
Donald Teskey (Irish)
Benwee Head III, 2001
oil on canvas, 24" x 30 1/2"
Private Collection, Ireland and Courtesy of the Rubicon Gallery, Dublin

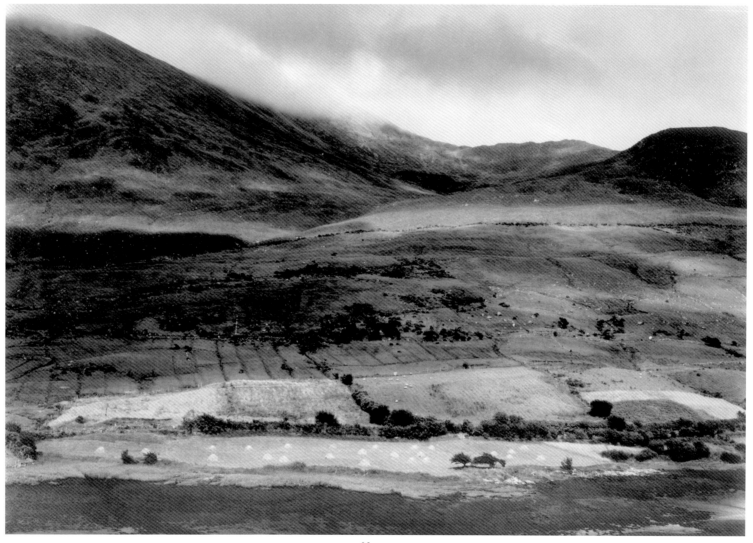

No. 72
Linda Mahoney (American)
Killary Harbor, County Mayo, 1976
silver gelatin print, 16" x 20"
Collection of the Artist

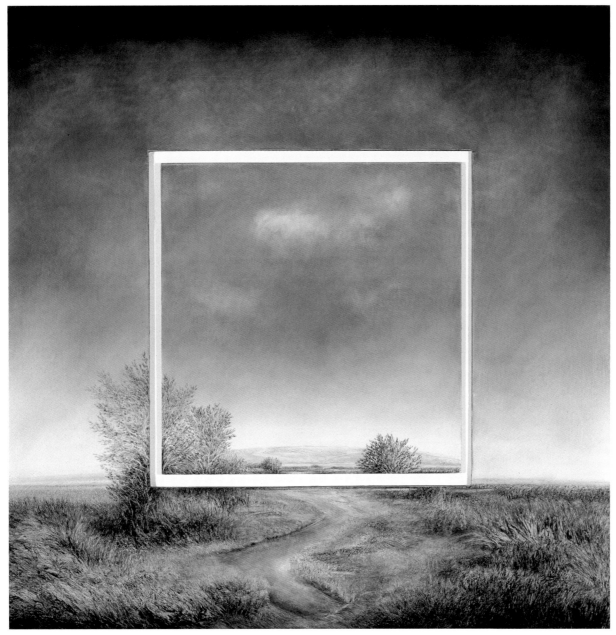

No. 73
Peter Brooke (American)
Suiffin, 1999
oil on panel, 24" x 24"
Courtesy of Fidelity Investments Corporate Art Collection

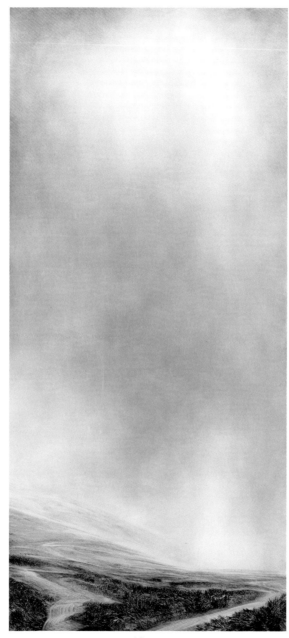

No. 74
Peter Brooke (American)
Foidin Mearaidhe, 1999
oil on panel, 60" x 28"
Courtesy of Gallery Naga, Boston

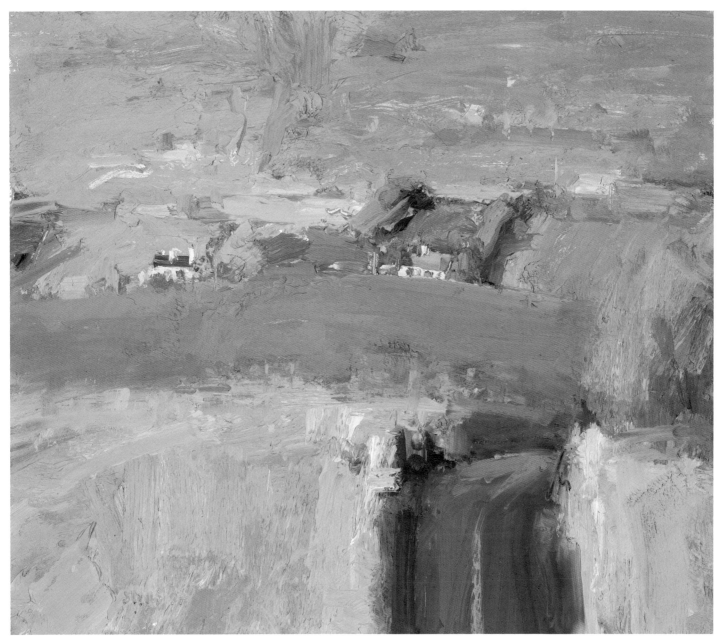

No. 75
Stuart Shils (American)
Ballyglass Fields From the Turf Road, 1997
oil on paper, 12 3/8" x 14 3/8"
Collection of Ray Roberts

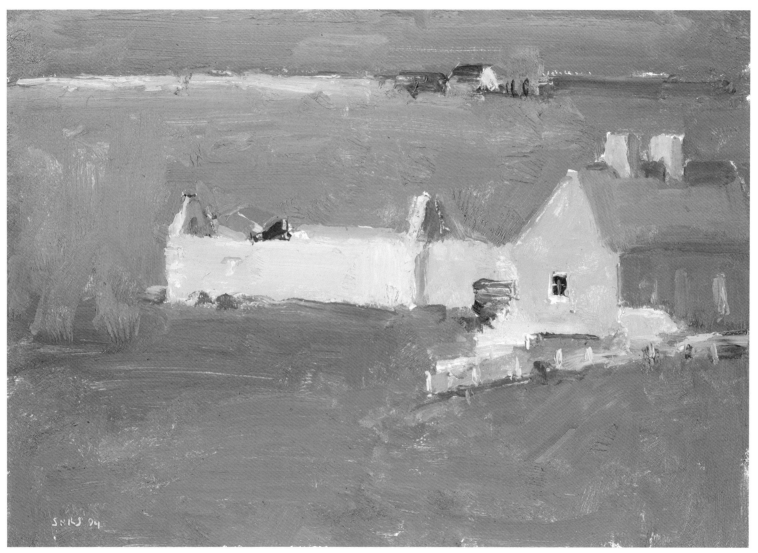

No. 76
Stuart Shils (American)
Farmhouse, Ireland, 1994
oil on paper, 8 1/8" x 11 5/8"
Collection of Ray Roberts

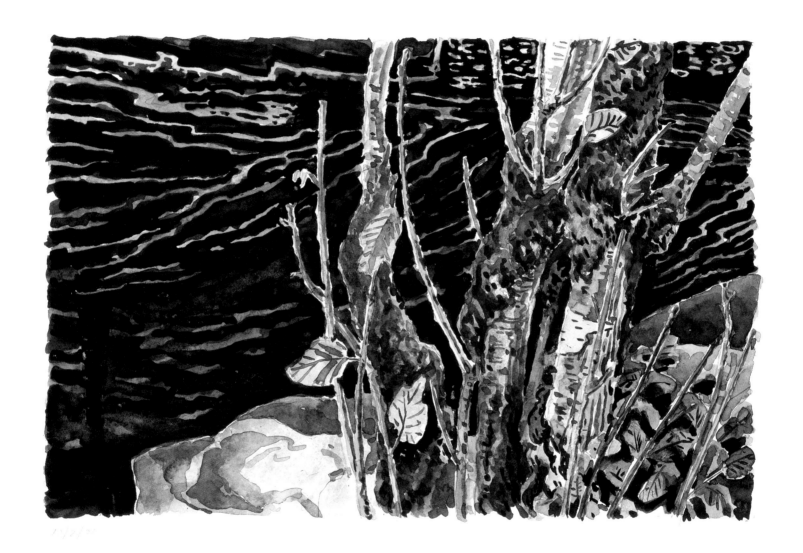

No. 77
Catherine Kernan (American)
Keerglen Ravine #3 10/2/01
watercolor on paper, 9" x 14"
Collection of the Artist

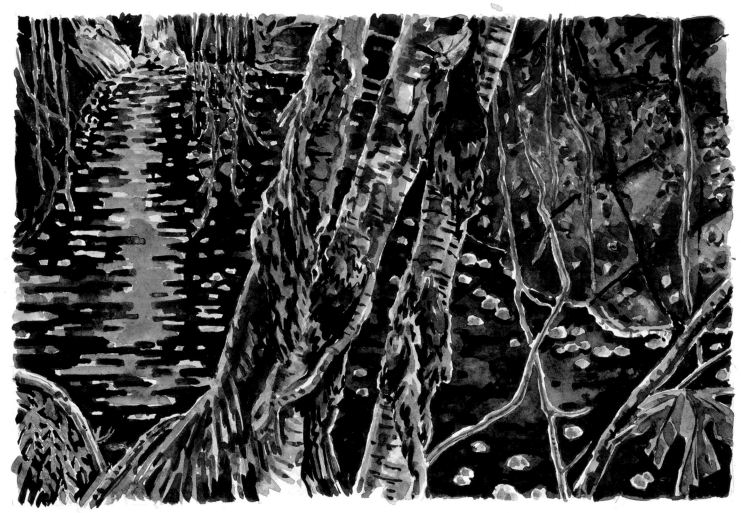

10/3/01 Pollaphouca

No. 78
Catherine Kernan (American)
Pollaphouca Ravine 10/3/01
watercolor on paper, 9" x 14"
Collection of the Artist

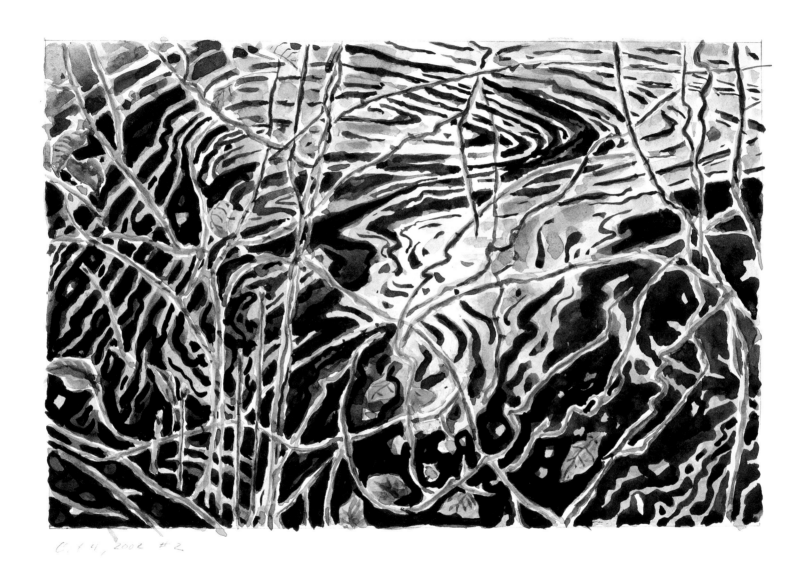

C. † 4, 2002 #2

No. 79
Catherine Kernan (American)
Keerglen Ravine Sketchbook 2002
watercolor on paper, 12" x 15 1/2"
Collection of the Artist

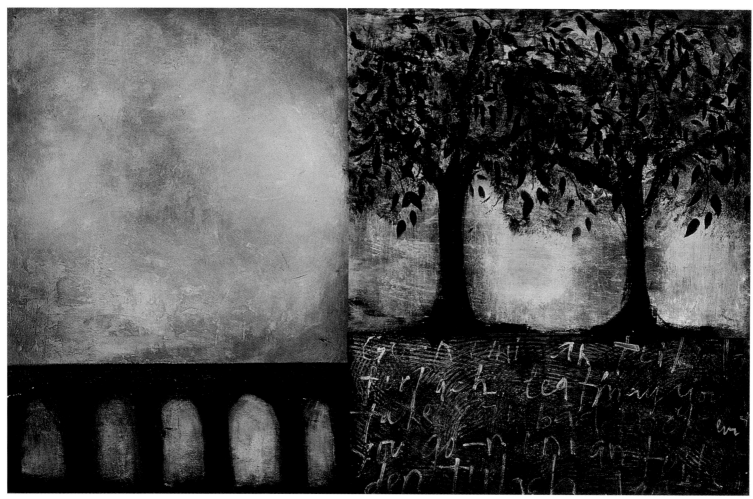

No. 80
Cheryl Warrick (American)
Take Your Bad Luck, 2000
acrylic and mixed media on paper, 26" x 40"
Courtesy of Gallery Naga, Boston

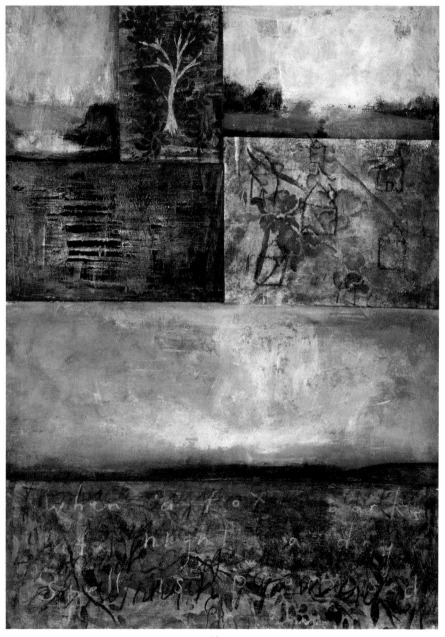

No. 81
Cheryl Warrick (American)
A Dry Spell, 2000
acrylic and mixed media on paper, 30" x 22"
Courtesy of Gallery Naga, Boston

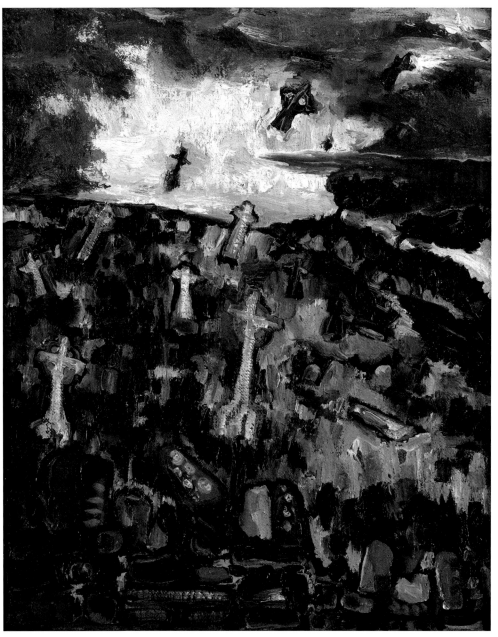

No. 82
Anne Neely (American)
All Souls, 1998
oil on canvas, 11" x 9"
Collection of the Artist

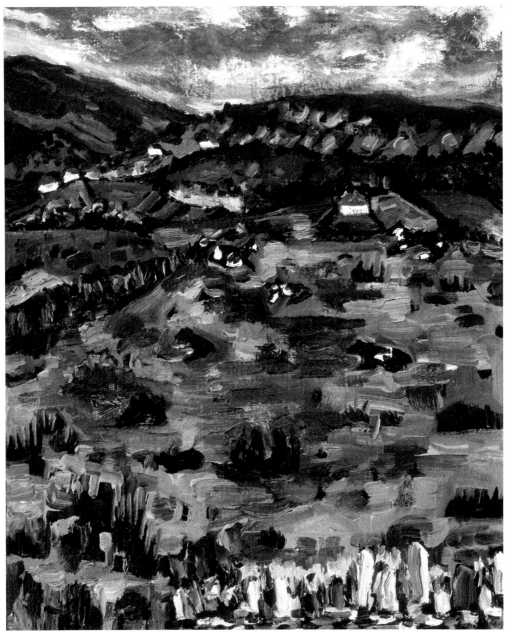

No. 83
Anne Neely (American)
My Neighbor's Cows, 1998
oil on canvas, 11" x 9"
J. Connors Collection

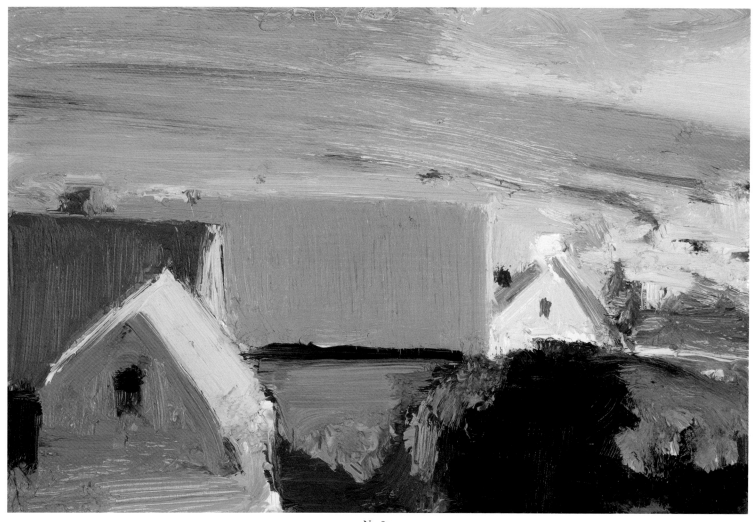

No. 84
Eric Aho (American)
Behind Ballycastle, 1998
oil on canvas, 7 5/8" x 11 5/8"
Collection of the Artist

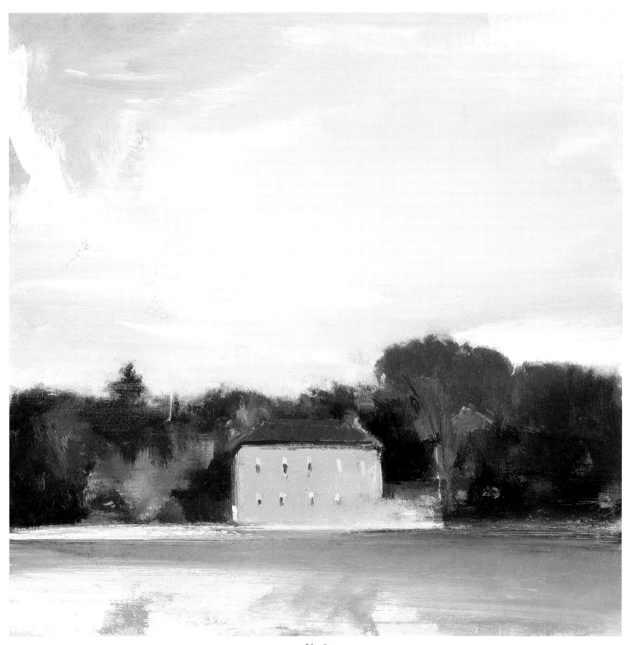

No. 85
Eric Aho (American)
Enniscoe, Calm Evening, 2001
oil on canvas, 24" x 24"
Courtesy of the Alpha Gallery, Boston

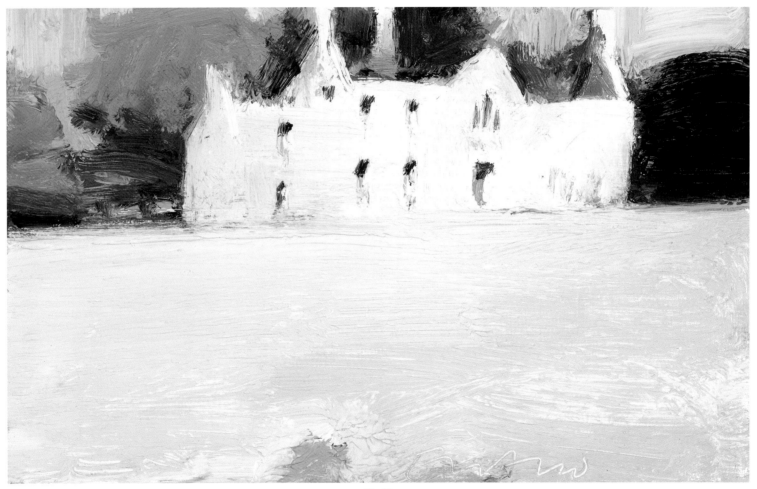

No. 86
Eric Aho (American)
Small Ruin, Co. Mayo, 1997
oil on canvas, 6 5/8" x 10 5/8"
Collection of the Artist

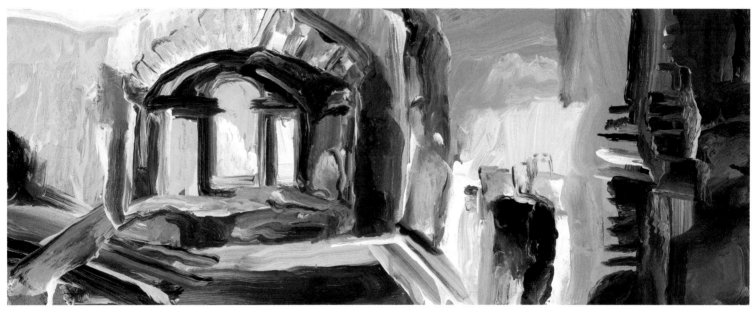

No. 87
David Brewster (American)
Upstairs in Summerhill House, 1996
oil on masonite, 12" x 30"
Collection of the Artist

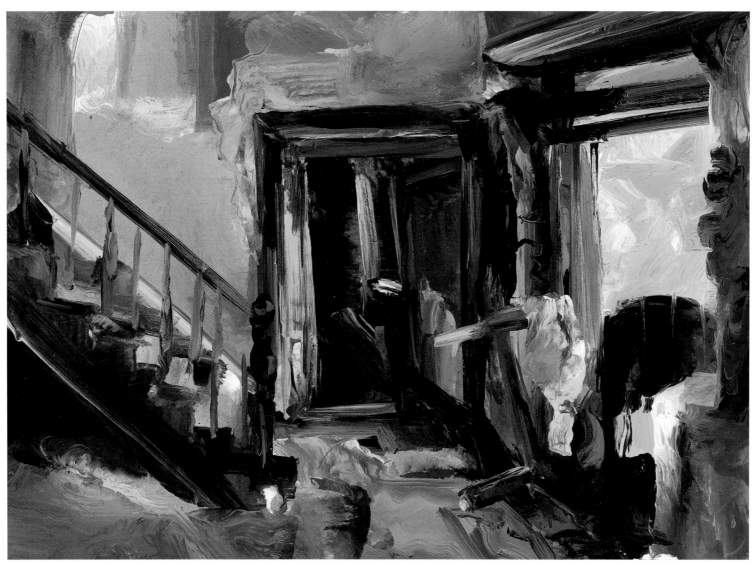

No. 88
David Brewster (American)
Cabintown Staircase, 1997
oil on masonite, 10 3/4" x 15"
Lent by Gordon M. Loos, Haverford, PA

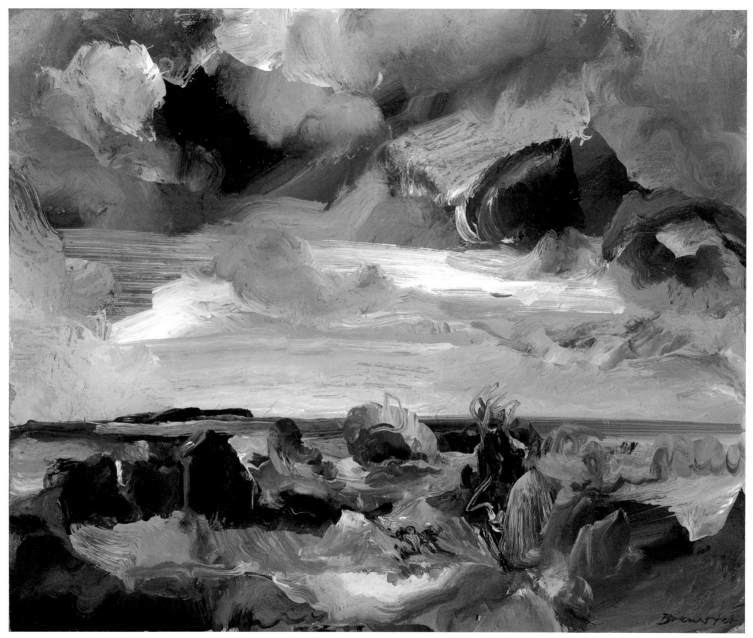

No. 89
David Brewster (American)
Famine Cottage, 1996
oil on masonite, 13 1/2" x 16 1/2"
Dr. and Mrs. Tim Gardener, Chatom, PA

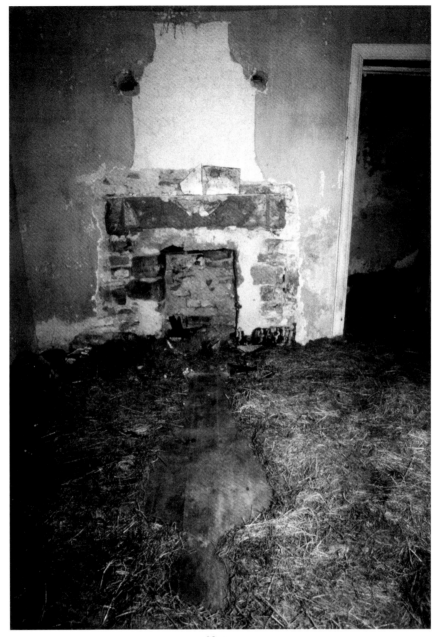

No. 90
Kathy Herbert (Irish)
Angel in the Hay, 1996
photograph, 16" x 10 1/2"
Collection of the McMullen Museum of Art; Gift of the Patrons

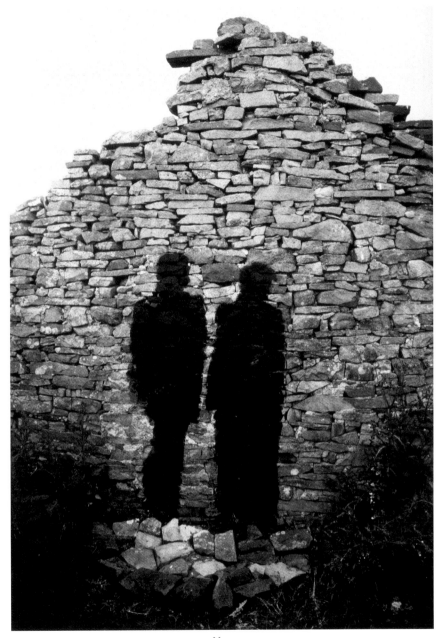

No. 91
Kathy Herbert (Irish)
Shadows, 1996
photograph, 16" x 10 1/2"
Collection of the McMullen Museum of Art; Gift of the Patrons

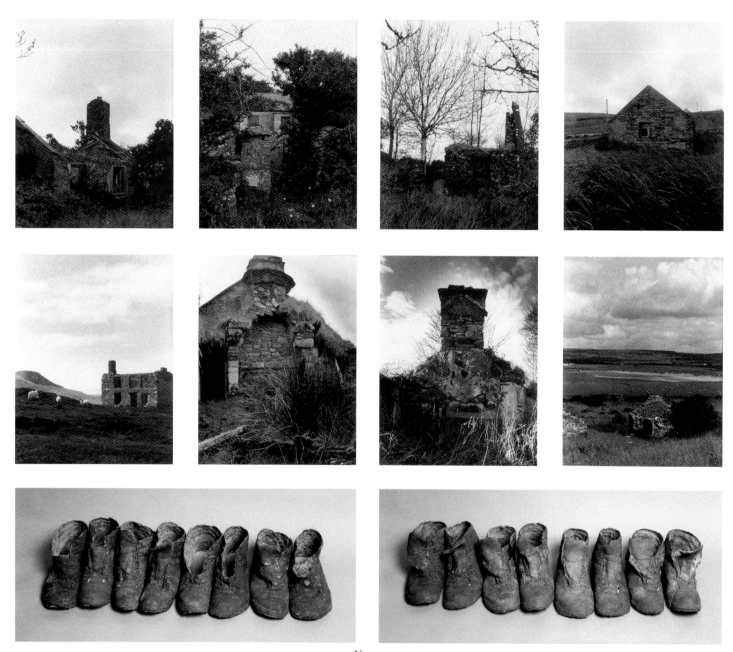

No. 92
Kathy Herbert (Irish)
Absent, 1996
installation: 8 b&w photographs 16" x 10 1/2" each, shelf, 8 pairs of boots, cement, scrim tape, PVA
Collection of the McMullen Museum of Art; Gift of the Patrons

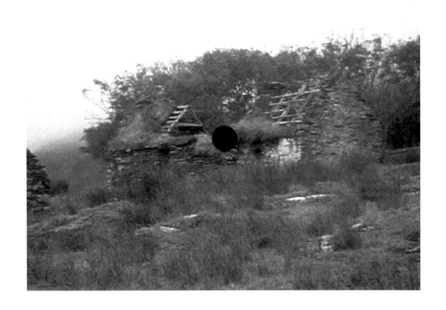

No. 93
Dorothy Cross (Irish)
Endarken, 2000
excerpts from video
Courtesy of the artist and the Kerlin Gallery, Dublin

No. 94
Fergus Bourke (Irish)
Famine Burial Ground/Flight 133 to Boston, 29/50, 1995
silver gelatin print, 15" x 17"
Collection of the McMullen Museum of Art; Gift of the Patrons

No. 95
Brian Tolle (American), Artist
Artist's Design Team: 1100 Architect, Gail Wittwer-Laird ASLA
Irish Hunger Memorial, Battery Park City, New York, Proposal: Arial, 2001
digital print (Rendering: Brian Clyne), 19" x 19"
Courtesy of the Artist

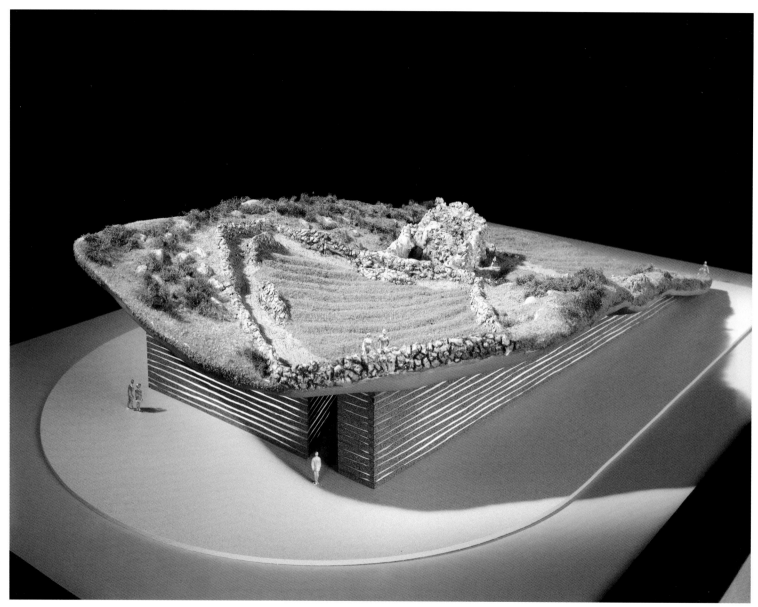

No. 96
Brian Tolle (American), Artist
Artist's Design Team: 1100 Architect, Gail Wittwer-Laird ASLA
Irish Hunger Memorial, Battery Park City, New York, Model, 2001
aqua resin, plexi-glass, acrylic paint, steel wool and flocking, 13 1/2" h x 20 1/8" w x 28 3/8" deep
Courtesy of Hugh L. Carey, Battery Park City Authority

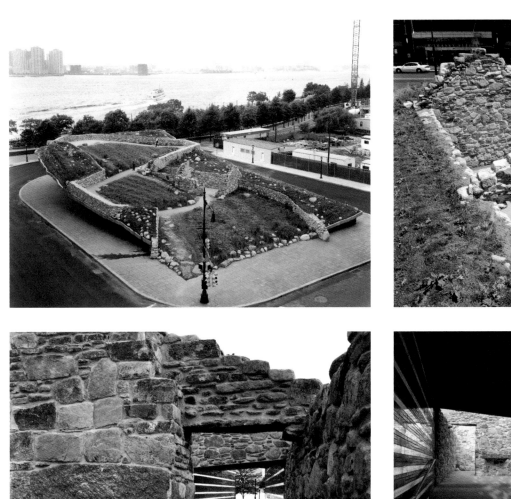
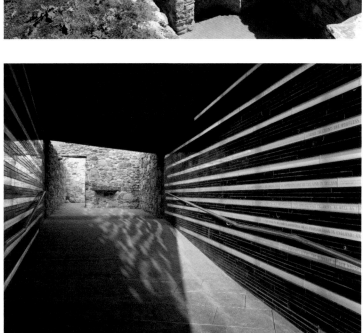

No. 97
Brian Tolle (American), Artist
Artist's Design Team: 1100 Architect, Gail Wittwer-Laird ASLA
Irish Hunger Memorial, Battery Park City, New York, 2002
Color photographs, 8" x 10" each